Dream Chasing

My Four Decades of Success and Failure with

WALT DISNEY Imagineering

Bob Weis

Editorial Director: Wendy Lefkon
Senior Design Manager: Winnie Ho
Compositor: Susan Gerber
Illustrator: Grace Lee
Managing Editor: Monica Vasquez
Production: Anne Peters

Printed in the United States of America
First Hardcover Edition, September 2024
10 9 8 7 6 5 4 3 2 1
ISBN 978-1-368-10103-5

FAC-067395-24176

Dream Chasing

My Four Decades of Success and Failure with

Walt Disney Imagineering

Bob Weis

Foreword by Bob Iger

DISNEP

EDITIONS

Los Angeles • New York

For my wonderful wife,

Jun

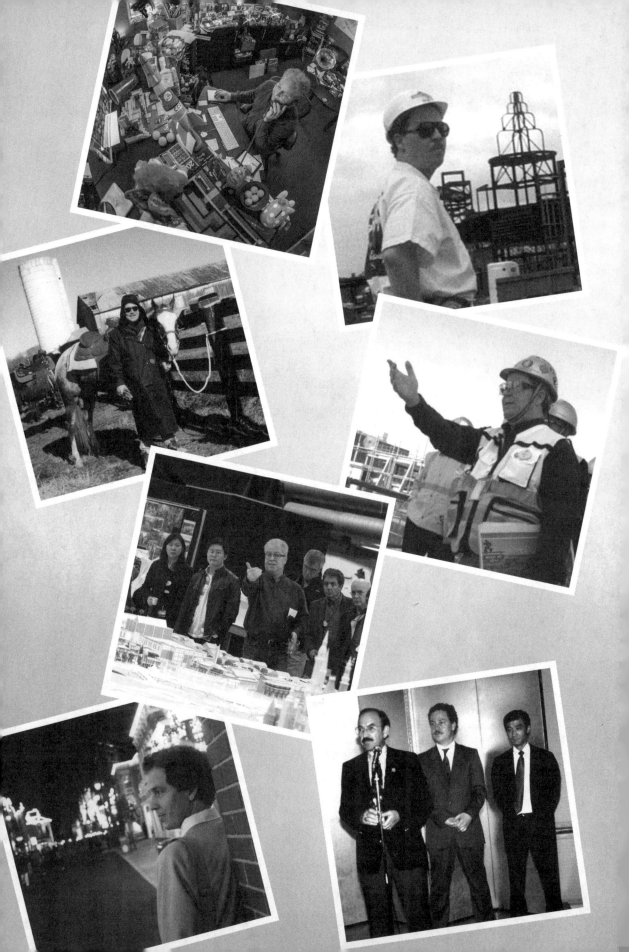

Contents

Foreword

Back in 2013, when we first began exploring the idea of creating a *Star Wars* land in our theme parks, I met with the Disney Imagineers at their headquarters in Glendale. The direction I gave them was simple: "Be the most ambitious that you have ever been." Now, keep in mind I was talking to Imagineers! Since their department's founding in 1952, they have been the driving force behind Disney's most creative, innovative, and memorable attractions and experiences, and there I was challenging them to be their most ambitious *ever*.

They did not disappoint. Six years later, at the grand opening of *Star Wars: Galaxy's Edge* at Disneyland Resort, we unveiled the most technologically advanced and immersive experience in the history of The Walt Disney Company. That night in May 2019, Bob Weis and I stood onstage with Harrison Ford, Mark Hamill, Billy Dee Williams, and George Lucas with a full-scale *Millennium Falcon* behind us, its engine rumbling, and we marveled at what the teams had accomplished. Walt Disney famously said, "It's kind of fun to do the impossible." And in creating this fully immersive *Star Wars*–themed land, the Imagineers had, once again, found a way to make the impossible *possible*.

One of the most enjoyable parts of my job as CEO is getting to spend time with our Imagineers, talking about their new ideas and concepts designed to bring Disney's stories, characters, and worlds to life. I firmly believe that you don't innovate without being curious about what can be—and there isn't a more curious bunch, in my view, than the Imagineers. At the heart of everything they do is curiosity. I always leave our meetings or the project sites energized, inspired, and excited for what's to come.

In *Dream Chasing*, Disney Legend Bob Weis shares the wonderful story of his decades-long experience with Walt Disney Imagineering (WDI), culminating in his roles as president

of the division from 2016 to 2021 and Global Ambassador in 2022. Over the years, Bob played an integral part in the creation and transformation of many of Disney's most iconic attractions, theme parks, resorts, and cruise ships, including Tokyo Disney Resort, Disney's Hollywood Studios Park, Disney California Adventure Park, the *Disney Wish*, and the hugely ambitious Shanghai Disney Resort. Through his leadership and singular creative vision, he has left an indelible mark on WDI, The Walt Disney Company, and generations of Disney fans around the globe.

This is a story filled with grit, emotion, humor, and, most of all, heart. *Enjoy!*

Bob Iger
Chief Executive Officer
The Walt Disney Company

A Note

We all dream.

As the song says, "A dream is a wish your heart makes."

"A Dream Is a Wish Your Heart Makes" debuted as the title song of *Cinderella* in 1950. In the song, Cinderella encourages her animal friends to never stop dreaming. That same year, Disney released its first full-length live-action film, *Treasure Island,* and debuted its first television special, *One Hour in Wonderland.*

Dreams come from a place of infinite possibilities, from a part of us that doesn't recognize limits. As Walt once said, "Everybody in the world was once a child. So, in planning a new picture, we don't think of grown-ups, and we don't think of children, but just of that fine, clean, unspoiled spot down deep in every one of us that maybe the world has made us forget and that maybe our pictures can help recall."

That philosophy can be seen in just about everything we read about Walt Disney, and to emerge so creatively strong from the darkness of World War II, he must have had extraordinary internal optimism. It was also around that time he began to gather a ragtag team of artists and engineers to help him formulate dreams that more than seven years later would become Disneyland.

Walt's team of dreamers all shared certain attributes. They could expand on his notions, give them form and shape—and provide a semblance of reality. They had no fear of opening new doors or trying new things. They were curious, and willing to explore ideas by heading down new paths. Ultimately, Walt described his dreamers as possessing a blending of

creative imagination with technical know-how. They called it "Imagineering," and most of all they could dream together. They could collaborate with Walt, and they could collaborate with each other.

I was lucky enough to be a part of the second generation of Imagineers. We started after Walt was gone, but we learned from many of those who'd worked side by side with him. When I started, there were two Disney theme parks in the world. By the time I retired from Disney in 2023, there were twelve.

Dreams are exciting, frustrating, and sometimes elusive, as hard to hold on to as pixie dust, like glitter falling through your fingers. Sometimes they are meant to happen, and they do, sometimes they are meant to happen, and they don't . . . and then there's every combination in between. Built or unbuilt, every dream was a journey, and one many of us took together.

This is how I remember them.

Bob Weis
Los Angeles
2023

Prologue

Winter 2016

An Apartment, Los Angeles

I woke up coughing. I had fallen asleep on two pillows, so I figured I was just coughing because my neck was in an odd position. I sat up and had no idea where I was. I fumbled for a light, wondering what hotel I was in. The cough returned, but more violent this time, a deep horsey cough, like a dog that has been in a kennel too long. My throat was on fire, and my lungs made a loud knocking sound as I did my best to breathe in and out.

With the light on, I realized I was back in my apartment in Glendale, California, in the Marc building of the Americana at Brand. I looked out the wide windows onto the Disneyland-inspired brick streets and sparkling trees. It was two o'clock in the morning and the streets were wet and empty. The cough returned. My suitcase had been opened but not unpacked. I rummaged around looking for cough medicine, but there wasn't any. Maybe an allergy pill, but no, I had run out of those, too.

I coughed and wheezed my way to the bathroom. I had been away and there was a new Amazon package. I tore it open, but it contained only toothpaste and shampoo. There was nothing helpful anywhere.

Breathing was becoming increasingly difficult. I was struggling to pull a small amount of air into my lungs, and it usually just got violently coughed back up again. I was lightheaded and getting anxious, and my chest was feeling more painful with each breath.

Call 9-1-1? It dawned on me that that was probably a good idea. But in my confusion, I didn't think I could actually direct 9-1-1 to where I was, inside the Americana at an apartment that required a specific elevator and long corridors with security gates. I threw on some sweats and lumbered my way to the elevator and to my car. I was just hoping I could drive myself to the emergency room faster than I could call for help.

Shanghai

72 Hours Earlier

Bob Iger had been our vision leader, our collaborator, and in the months leading up to completion of construction he was flying to Shanghai on a nearly monthly schedule to review our work. No one could inspire a team like Bob could. He'd walk everywhere, he'd encourage everyone; he shook hands relentlessly, with Disney executives, Shanghai politicians, construction executives, and the droves of itinerant Chinese workers, standing in mud with home-fashioned tools.

Bob regularly took our senior team to dinner. These were casual, chatty, and fun gatherings. He talked about other parts of the company, and about the future. But the conversation inevitably ended with the same question: "When can we announce the opening?"

During several of these trips, we asked Bob to wait, to give us another season, another chance to press the contractors about one delay or another. More time to see if workers would stay, to see if the rain or heat or air pollution would subside. Because Bob was willing to walk the site and see progress in real time, he understood, he was patient. But a lot was riding on this big experiment. He said many times his two priorities were the rollout of *Star Wars* after the Lucasfilm acquisition and the opening of our massive Disney resort in China.

As much as we tried to be positive, much of our team, including me, had a grave sense that we really didn't have a clear path to completing the seven-square-kilometer mini city we'd envisioned and were now building, with its unprecedented theme park, resorts, parking, rail station, lake, and shopping, for a predictable cost and schedule. Even with ten thousand workers living and working on-site, we told Bob we couldn't yet commit to when we would be finished and ready to open.

Privately I thought we couldn't yet commit to *if* we could open.

As the dinner ended, Bob thanked everyone, as he always did, and went to his room. We gathered our group at the edge of a balcony, outside the restaurant. We were a diverse team, each of us responsible for part of the puzzle. We trusted each other, but we also disagreed, debated, and never feared to express our varied opinions. On that evening, as Bob departed, we all agreed on one thing: we had failed.

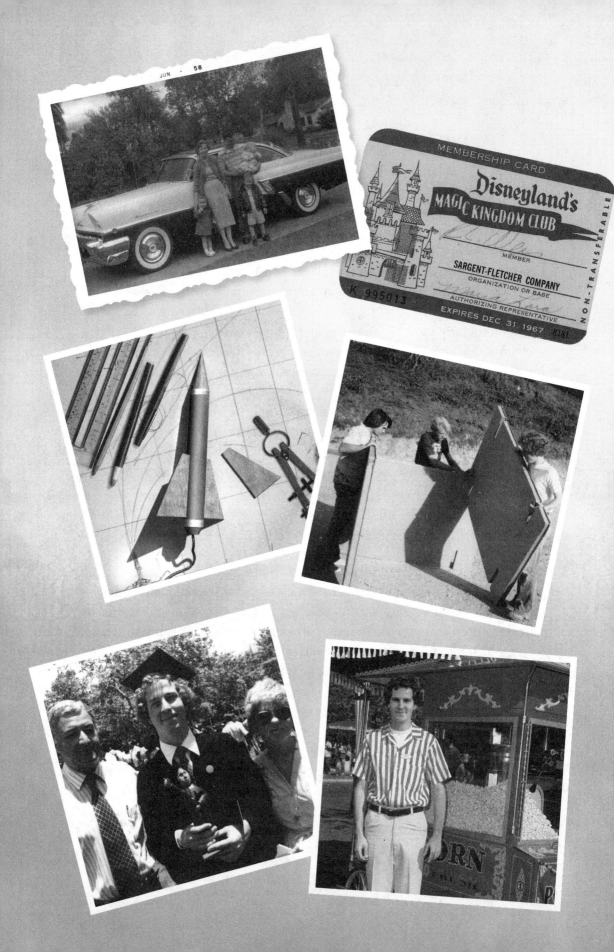

Part 1

1966–1983

Disneyland 1966

From our cul-de-sac tract home, the drive to Disneyland took a little more than an hour. The Chevy Impala bringing us to the park wound through the hills of Brea Canyon, on the Corona Express, a two-lane road that provided access long before highways 57 and 60 were conceived. The Matterhorn, the first tubular steel roller coaster in the world, was the first icon you could see as you got close to Disneyland.

My father worked in aerospace, supporting President John F. Kennedy's challenge at the start of the decade to put a human on the moon before the end of the 1960s. Dad's company was a participant in the Magic Kingdom Club, and he even had a small membership card with his name on it. Our Magic Key Ticket books were purchased, and we headed for attractions.

Between 1965 and 1967 Disneyland had staged an exponential expansion. The attractions developed by Disney for the 1964–65 New York World's Fair had all been relocated to Anaheim. So today, on my ninth birthday, we were about to experience Great Moments with Mr. Lincoln, and "it's a small world." We would visit the newly constructed New Orleans Square and see the mysterious white house that was rumored to become the Haunted Mansion attraction someday.

I was recovering from an upper respiratory infection, and I am certain my brother and sister had a far better time celebrating my birthday than I did.

I spent a lot of the day out of breath on a bench with my mother. Nonetheless, Disneyland was magical to me. Main Street with its small shops knitted together, its horse-drawn trolley, and the dreams of adventure it beckoned were a muse for anyone with an imagination and a tendency to conduct a constant internal dialogue, like me.

Tomorrowland was a promise of what the future might look like. I insisted that everyone had to go to the Rocket to the Moon. The circular theater the attraction was in surrounded two center screens, one looking up and the other looking down, giving us a unique vantage point of a launch and landing on the moon. And for extra realism, the seats inflated and deflated to conjure the g-forces of launch, and the wonders of weightlessness.

I did reach a huge milestone during this trip. My father let me go on the Flying Saucers ride alone! It was a combination of a lawn chair and an air hockey puck. I was intimidated and amazed as I floated magically out onto the play floor, a giant sliding slab with tiny air holes that kept the entire scrum of saucers afloat. And when I leaned one way or the other, I could direct the saucer. If you had a good imagination, you were in orbit, controlling a personal spacecraft. It was exhilarating, and I remember thinking, *I have to ride this every time we come to Disneyland.*

For me, Tomorrowland was optimism, a belief in the future that was approaching, a future with success for all practically guaranteed. A space race to be easily won. A future in which everyone would benefit.

But my innocence didn't last forever. By the end of that summer, the Flying Saucers ride had closed.

Walt Disney would die three months later on December 15, 1966.

And within a few months—February 1967—three of our country's astronauts, Gus Grissom, Ed White, and Roger Chaffee, had all died preparing for the very first Apollo mission at the Kennedy Space Center.

Goldfish

When I was in the second grade, some relative gave me a fishbowl; it was no ordinary fishbowl. This was a *really* impressive fishbowl. It was wide and made of heavy glass—and inside was a salmon-colored fantasy castle and several colorful strands of artificial seaweed, some rocks, and two happy goldfish. They swam around with their wide, pectoral fins, waving in the watery world of the bowl. I was fascinated by them.

The walk from that tract house on the cul-de-sac to my elementary school classroom was probably less than half a mile. It involved crossing only one small street, where a crossing guard monitored things. So, one morning it occurred to me that I could carry the goldfish bowl to school and show it to my classmates.

I thought again about the walk, the crosswalk, and how I'd have to carry my pack with a few books over my shoulder and still have two hands free to balance the goldfish bowl and hopefully not spill much water out of it. But then I looked again at those glistening goldfish, and their huge pectoral fins, and I was sure it was worth it.

And even more than that, I was sure I could pull off this feat. It was quite a balancing act though from the start, to get the bowl intact out the front door and then close the door behind me. But going down the cul-de-sac, I was encouraged, because it wasn't that long a distance, only about six houses. I

turned down the short street and met the crossing guard. "Nice goldfish, beautiful bowl," he said.

"I'm taking it to show my class."

"I'm sure they'll love it."

Soon I was at school only steps from my classroom. I was confident, and even though a few waves had crested over the top edge of the bowl, I was feeling victory was at hand. But just then, without warning, the crystal bowl slipped out of my hands. And as if in slow motion, I watched it fall toward the pavement and shatter into a hundred pieces of glass, followed by a massive wave of slippery current. I stood in soaked green sneakers for what seemed like many seconds not knowing what to do. The halls were empty.

And then I knew exactly what to do. I reached into the glittery mass of broken glass and grabbed the two squirming goldfish and ran. I got to the classroom, threw open the door, where I remember my teacher yelling out, "Weis, what are you doing?" But I didn't stop. I ran toward the aquarium in the classroom, and as fast as I could, quickly and efficiently released the goldfish into it. They swam out of my hands, wiggled their way into the water, and settled on the bottom, their gills moving quickly. The other fish were trying to figure out what world these two visitors had suddenly appeared from.

My classmates crowded around, looking first at me, out of breath, my shirt soaked, and then into the aquarium. Everyone was trying to figure out the depths behind this averted tragedy. I don't know who cleaned up the wrecked fishbowl, its pile of shards left out in the hallway, probably one of the custodians who'd heard the crash. But by the time I got back out for recess, there was no evidence of a fishbowl . . . or glass . . . or water. But the traumatic moment—the crash, the sound, and sight of it—was deeply ingrained in my memory.

There were nights that I woke up thinking of how embarrassed I was, how crazy I must have looked running into a classroom in the middle of a session, holding a fish in each hand and releasing them into the aquarium. I even fretted at night about how the fish must have felt, experiencing a terrible accident followed by immediate introduction into an unfamiliar tank with strange fish wondering how they had dropped in from the sky. The image of it and the humiliation of it stayed with me.

An aside—why is this goldfish story relevant? Why does it still move me today? I learned that a decision to act can take less than a second. A decision to act, if you're someone comfortable with forward initiative, can be hard to

reroute. But the consequences of a poor decision, and the feeling of failure or humiliation, can stay with you for years.

One good thing: I once was told that goldfish have a short memory, only about two to ten seconds. It gave me some comfort to know that whatever trauma I had caused, at least from the fish's point of view, was likely forgotten before I had even dried my hands.*

*Unfortunately, I learned a few years ago that Culum Brown, an Australian expert in fish cognition, spent much of his career disputing this belief. He claimed that goldfish had much longer memories, spanning weeks and months. But by this point I had mostly pushed aside the incident to something of a distant memory.

Pomona

I was an *introvert* before I was aware there was any such term for it. My brother was outgoing. He was in the Cub Scouts and on sports teams. My sister was in the Camp Fire Girls. And although I felt a little left out, I really never had any interest in being part of a large social organization. I had a small group of friends. I think we were all introverts, and we were all competitive.

The space race was on, and we were a part of it. Each of us had a dream to build a rocket that could fly, and we were serious about it.

Most of our attempts yielded smoke and a little flash, but none of our rockets ever went up. We explored every possible way to create combustion. There were easy ways that you could find in science books, such as combining vinegar and baking soda. Had it been today, we would've had the option of combining Diet Pepsi and Mentos. But these were primitive times.

Hardware stores and drugstores yielded a lot of raw materials that could be ground up and mixed together to make a weak equivalent of solid rocket fuel. We were sure these incendiary powder concoctions, when packed into casings that might be anything from a toilet paper roll to the small paper cylinder my sister sometimes left in her bathroom waste bin, could be ignited, build up pressure, and possibly create upward motion in a "rocket" if it was designed with fins to keep it stable during the lighting process.

It's hard for me to believe that any of us still have all our fingers and eyes.

These were dangerous times, but the stakes were high. The space race was a matter of national pride, so rockets and the idea of rockets, and the idea of space travel, were not just something on television, but something we took personally and took competitively into our home laboratories.

I was the first to have success, and it was an incredible moment. I took the center of the cul-de-sac, placing my improvised launchpad on top of the spot's iron manhole cover. I lit the short fuse and moved away. All our neighbors had shown up to watch the launch. A small fizz of smoke started to exit the base of the rocket. Then it popped in a big orange flash, flew across the street, and expelled its remaining burning propellant onto the wood shingles of the neighbor's roof. It had traveled at least fifty feet.

I reveled in my success. And to prove it, I repeated the successful launch several times.

Then one day I discovered a new material that was potentially useful when it came to the packing of our improvised rocket engines. On top of the dryer was a small drawer, and if you pulled that drawer up, out came a curved screen; and on it was lint it had collected from inside the dryer. And I was fascinated by this lint because it was soft and uniform, and looked like something that could be easily stuffed into a canister shape.

I rolled up a big pile of this lint and after not seeing anything else to work with, took an old glass pickle jar and added to it some of the improvised ingredients that we had used to make other types of combustion materials. I put the lid on loosely and gave the glass a shake, and the combustion materials seem to do a good job of coating the lint, almost as if I was using Shake 'N Bake. Gaining some confidence, I shook the jar again. I don't know what happened next other than it exploded in my hands. The jar shattered, and pieces of glass flew everywhere.

I escaped the smoky garage, where I had been conducting this latest experiment, and looked around. I felt confident that both my eyes were still working normally. It wasn't until I went into the house and checked the bathroom mirror that I realized there were tiny little pockmarks caused by the exploding glass that had made little bloody impressions across my face, nose, hands, and lower forearms. The mess was easy to clean up, but the human toll was hard to hide; it didn't take long for my mother to ask me why I had pockmarks all over me, and I had to admit that they were small pieces of glass from a challenging attempt at advancing the state of science. That was the end of my contributions to

America's space program. I was firmly directed to clear out everything related to my laboratory, and that included creating a burial ground for all my jars and dumping out all my chemicals, including all my improvised rocket designs, never again to slip the surly bonds of Earth.

I said goodbye, not to space, not to the dream of being an astronaut, but to chemistry! It was probably not my thing anyway.

Camping

The baby boom generation is defined in the United States as those born between 1946, at the end of World War II, and 1964. (The average baby boomer family had 2.5 children.) Since it's hard to split the baby, my parents had three. The so-called nuclear family may have been a unit of importance to social and American values, but truthfully, my family didn't spend much time together. The normal weekday was a hastily prepared utilitarian breakfast with everyone getting ready for their own day. And then we all quickly went in our separate directions. My father left early for his hour-plus commute to his work in the aerospace field. My mother left fairly early to get to her job as an elementary school secretary at the school that I was attending. And each of us (my brother, sister, and I) walked off toward our three different public schools. There we attended different classrooms and were subjected to an array of varied teaching styles during those formative years . . . until 3:00 p.m. And then we had different friends and activities until we all regrouped in time for the evening. When my father came home at night, he was generally tired and read the rest of his newspaper, had dinner, watched the news with newscaster Walter Cronkite, "the most trusted man in America," chatted with my mother, and that was it. As kids, we did the dishes, and as little homework as we could, and then took over the television.

I have to imagine that for parents who were watching their 2.5 kids growing,

changing every day, there was a moment when they must have realized they had only so much time—and only so much ability—to influence their children as they moved forward into life, as they got more mature, more opinionated, and more detached from their parents.

At the same time, automobile companies were creating a new product: the van. The van was perfectly designed for the baby boom family: two adult seats in the front with cup holders and two rows of bench seats in the back. There are windows for everyone, as well as air vents for all. It was a dream—a half ton of blue striped aluminum and steel, plastic, and rubber, with the potential to unify a normally dispersed family. Its purchase would certainly bring the family back together as a single unit. And it even had a radio. But generally speaking, it was used to drop the kids off at a school and one parent at their workplace, where the van waited, ready to be called into action at any moment. At thirty-two cents a gallon for regular gasoline (to keep it fueled and running), it was probably worth it.

As if through some coordinated plan, the national parks were coming into popularity and getting noticed by more and more around this time. Combine that with the National Traffic and Motor Vehicle Safety Act, which made travel on the nation's highways safer, and you have the chemistry for the dream of the American vacation for the sixties generation, and on a massive scale.

I remember that night when my dad brought the sleek new van home; at that time, I saw everything through the lens of space exploration. I thought the van was awesome and had this almost spaceship-like quality. There was even a place in it to hold maps, and a light to read them by. My father had stopped on the way home just so he could install a vacuum-sealed rubber compass at the top of the windshield, adding essential navigation and a sense of guaranteed adventure. It was the first time I sensed there was something out there called business class.

My father used the moment to announce his idea: we would circumnavigate the United States in this van in the summer of 1972, during the maximum summer vacation time he could take off, which was three weeks.

A route was planned, and brochures were acquired through various tourism services. Remember, these were the days before the Internet. So, you wrote a letter to a state's tourism bureau, licked a gooey strip to seal the envelope, licked a federally manufactured sticky square to apply a stamp, and waited. In a few weeks, the bureau sent you a lovely envelope filled with information about the great attractions in their state. Throughout the year, we would receive

these envelopes and you could open one up and find out about the great things that could be done in, say, Idaho as we passed through it.

Another great invention at the time was something called the automobile club TripTik. You told the automobile club what you wanted to do, and they would personalize your directions and print out a spiral-bound, reporter-sized notebook that was easily posted on the dash of the car, which gave you step-by-step directions for wherever you were headed. It was the Stone Age version of GPS or MapQuest. There were also free books covering hotels, hotel guides, and motel guides that could be consulted when you were looking for a room as you entered a city and it was late in the evening.

My father objected to many things; among the strongest, motel rooms and restaurants. He didn't like paying for motel rooms, didn't like staying in them, and he certainly didn't want to spend three weeks with all of us eating fast food; he couldn't afford for all of us to eat in what for us would be expensive restaurants. And so, over the weeks, the interior design of the van became, in Apollo-speak, a command module, a bubble of daily life, to be ferried along with us.

By the time it was outfitted, it included a tent, a table for a Tupperware-lined dish sink, a folding table for a propane gas stove, a bag of charcoal briquettes, an old milk can gifted by my uncle (which we kept filled with water), and two very large ice chests. Above all of that was a hanging rack for a few changes of clothes. There was an empty space in the center of the van between the back of the driver and passenger seats and the growing mountain of provisions, a space of about four feet by five feet. And this we understood was where we three almost teenagers and fairly combative sojourners would be riding for the next three weeks. There were to be no banks of beautiful vinyl seats for us. Just a hard floor.

We looked through the double doors. I can't help to think that our reaction wasn't dissimilar to the way the first seven Mercury astronauts must have reacted as they peered into their capsule for the first time. It dawned on us that we were going to be in this mobile prison for twenty-one days. My dad tried to cheer us up by saying, "Just grab a few sleeping bags and make it comfortable in there." And so, we left, sitting around on the floor, occasionally catching camp gear as it slid off the stack, having to go up on our knees in order to look out the window. But from our knees, or stooped on ice chests, we were damn well going to see America.

My views of the world, but mostly America, are no doubt deeply influenced

by this nine-thousand-mile, twenty-one-day trip. We wanted to see America from all angles, but we also had a major destination. And just like NASA's moon program, we had a destination so far away, so aspirational, so unreachable, that we were not even certain we could achieve the goal. We chose to go, and do the other things, not because they were easy, but because they were hard.

Our destination was Walt Disney World.

But Walt Disney World would have to wait while we followed the Snake River through Oregon and Idaho and Montana, before we headed on to see Mount Rushmore in South Dakota. We moved from icon to icon, from a view of the Grand Canyon to a view of something else. And when I say view, I mean view. It could be a seven-hour drive between icons, sometimes more. But we endured the seven-hour drive, ran out of the van long enough to stretch and see the scene, to pose for Polaroids, to "look natural" in movies, and then settle back into our mobile hovel for some sibling rivalry with a few cans of Cactus Cooler.

My father drove most of the time. We'd stop midday in some park or parking lot, cook a barbecued lunch, or make sandwiches. And so, we would arrive at, say, Mount Rushmore, legs numb from being cramped on the floor of the van, irritable from the long drive. But undaunted, we'd head up the steep hill entrance to see the site and remember the greatness of the four great white men of American ideals carved into a stone hill by one of the great white men of art.

We'd then make a quick stop at the visitor center for a bathroom break, which also gave my mother the opportunity to collect what she called a "curio." We'd then quickly head back to the van and start out for the next two-hour drive that would hopefully end with us finding our next campsite. Very little was planned in advance beyond the TripTik route. Campsites were found in a camping index book, which my mother, as she tracked the progress of the van, would look through and read us descriptions from. "Freeway close" was in the eye of the beholder. Never select something that promised "primitive toilets." Beware of "rustic." "KOA" campground designation was usually a good bet. A playground could often be a dog run that also had a tree with a tire swing.

On rare occasions, and only under deep duress, usually triggered either by exhaustion or evading extreme rain and hail the size of golf balls, we might stay in a motel. So, we always carried an "AAA Approved" motel index for each state, to be broken out only in an emergency. And my mother would similarly read a hotel description that was some distance away. And if we liked it, she

would call them and book for that night. It's worth reminding that by *calling*, I mean we would drive through a small town and look for a telephone booth where she could get out, insert quarters, and call the desk to book.

What I loved about motels was there were water glasses, squat round water glasses, wrapped in wax paper bags. There were tiny soaps. We ordered two full-size beds, one reserved for the parents and the other reserved for some combination of the three kids, one of whom either got the floor or, if we were lucky, a rollaway. Everybody wanted the rollaway. So, we had some strategic plan to share the prime time of the rollaway. Yet even in a motel, we could not escape our mobile bubble, because as noted earlier, it came packed with camping gear, the ice chests, the milk can of water, our necessities. And presciently, my mother had also brought the genius kitchen appliance of the 1960s, the Corning Ware Electric Skillet P-12-ES Casserole, complete with blue cornflower graphic. A nearly complete kitchen, with its own lid and electric heating element.

In the 1940s, Corning Glass Works began experimenting with a formula for opal glass, later called Pyrex, and eventually developed it into durable mess ware for the military during World War ll.

Not to be left out of the innovation customary to wars, the Italian government experimented with the concept of canning ravioli and spicy tomato sauce in a form that could be easily distributed to troops on the front. The battalions won the Battle of Algiers probably due to one thing, the invention of canned ravioli to keep their troops sufficiently fed. Chef Boyardee adapted the same canned recipe of ravioli, and it proliferated through America in the 1950s and 1960s on grocery shelves. Which explains how it settled into our Motel 6 room—with its two beds and a rollaway, the smell of tomato sauce bubbling on the Corning Ware wafting throughout. It may sound rudimentary, but we would enjoy the red-orange stuff served on a paper plate along with something that we rarely saw when we took a trip: television.

The trip went on. I insisted we take a side trip to Concord, Massachusetts, where my literary icon, Henry David Thoreau, had written, gone, and stayed in a cabin on a lake he called Walden. Years later, I played Thoreau in a play by Jerome Lawrence and Robert E. Lee and seemed to be slowly adopting his attitudes on the Earth and about civilization. Here truly was the inspirer of all introverts.

We went to Washington, D.C., where we saw aviation achievements at the National Air and Space Museum; heroism and innovations represented in the

National Museum of American History; and the austere serenity of the Tomb of the Unknown Soldier at Arlington National Cemetery. And finally, at this solemn place, we saw the eternal light of John F. Kennedy's resting place, and what had only recently been added, several yards away, a simple white cross where his brother Bobby, also cut down by an assassin, rested. I had no notion of what it must be like to be Richard Nixon sitting in that big White House, deciding whether to carry out carpet bombing in Vietnam. I was intrigued by the idea of the Congress, especially the White House, knowing it was unlikely I would ever be invited to go. What an inspiration it might be to walk inside the White House and be welcomed there as a guest.

Alas, the final stretch of our trip awaited. Of all the places from a geographic point of view, I most fell in love with North Carolina and the shores of Cape Hatteras. My internal dialogue took me to a small crab shack on a spit of land as a solitary writer with a typewriter, a kind of literary version of Andrew Wyeth, wearing a dark peacoat and writing plays and novels. That would be my aspiration, for a time anyway.

Walt Disney World 1972

Passing a billboard that said WELCOME TO FLORIDA, we could taste victory as we headed toward the ultimate goal: Walt Disney World. Walt Disney World had just opened the previous fall, and we were to be among those first visitors during its first big summer in 1972. If my father was barely able to give up his campsite in favor of a Motel 6, he certainly was not going to assign precious budget to a Walt Disney World Resort hotel. And so, we stayed in a nice motel called the Colonial Inn, which was about ten miles away in a place called Winter Park. And after resting for the night, we were in the car and driving into the pristine utopia of Walt Disney World. Well, if not utopia, at least into the massive parking lot, with license plates from everywhere—the Northeast, Midwest, and South.

At Disneyland, in Anaheim, we parked and took a small tram to get to the entrance. At Walt Disney World, it was the ultimate adventure. You parked, took a tram to a transportation center from which you could go to the park by monorail or via various boats. We selected the boat, which beautifully transitioned us across Bay Lake. During the excursion, the captain told us all about how Bay Lake had been cleaned and refilled and had become the center of Walt Disney World. Upon arriving by boat, you were at the main entrance, getting your tickets. And the wonders of a perfect world awaited.

My overriding memory of Walt Disney World was the heat. It was the hottest

temperature any of us had ever experienced. Okay, maybe not the hottest, but it seemed like it because of the intense humidity. Plus, the park was filled with visitors who had obviously come to Walt Disney World as unprepared as we were for the intensity of the heat and humidity. And in the park's relative newness, those who had planned the park were scrambling to deal with human comfort due to weather conditions. I remember my mother pointing out to me that park guests seemed to be wearing what appeared to be pajamas or, in some cases, underwear, thinking they must have not packed the right clothes. It was very odd to my young eyes.

The classics though were all there. "it's a small world," Pirates of the Caribbean, along with nice original touches such as the patriotic Liberty Square, and the new and stunning exhibit of all the presidents, not just Lincoln. They nodded and looked thoughtful, and Nixon did a great job, considering what was about to publicly transpire.

And there were plenty of new things to do, such as going out on a boat tour of Bay Lake and a visit to Discovery Island and riding the Monorail right through the lobby of the Contemporary Resort.

I remember distinctly watching a parade on Main Street. There was a little rain. Not a downpour, just a boggy, misty rain. The characters came out in colorful costumes, but the misty air made all the colors look gray and richly lavender. But they nonetheless performed to make the crowd happy, to make the world seem like a better place. I looked over at my mother and realized tears were flowing down her face. She noticed that I was looking at her and explained, "I'm just so sad that Walt never got to see this."

Drama

In 1968, I was eleven years old and in Mr. Clark's sixth-grade classroom. It was about that time I remember all of us students becoming aware of what was happening in the world. My friends and I were becoming highly opinionated.

And 1968 gave us much to think about. The assassination of Dr. Martin Luther King Jr., the race riots that erupted around the country, the assassination of Robert Kennedy in our own backyard in Los Angeles, Vietnam, the presidential election. We had transitioned from didactic education to almost all teachers using the Socratic method. We were all expected to have opinions and express them. I found myself coming out of my introverted shell, and willing to put opinions out there when I felt strongly about things.

Pomona was a very diverse city, and my school reflected that. There were periodic disagreements that often played out in racial altercations between classes. But inside, most teachers encouraged peaceful discourse and open dialogue. I loved writing and literary analysis, but I was a slow reader. So, *Moby-Dick* and *The Invisible Man* were tough slogs, but I was happy Mr. Richards made us read them and debate their meanings.

It was drama where I really found my calling. A kid with occasional asthma and bronchitis was probably unlikely to become a football star (my brother was a guard). I became interested in drama during junior high school, and drama was a defining factor of my school life through high school and college. The

majority of my time was spent working on plays rather than studying for my French class or doing well in algebra or anything technical like that. I was never destined to be an engineer like my father. I tended to have more of my mother's creative sensibilities.

By the beginning of high school, I had a little community of friends and collaborators who did plays together, some of us musically inclined and talented. John Alberts was the high school drama teacher, and he was a bit of a tortured soul, with a passion for making students work hard and work emotionally. We had a nice intimate studio theater. Instead of a yearly big production of something like *Oklahoma!*, his vision was a community of artists working together constantly and creating together. We did a weekly showcase, with performances every Friday at lunch time. On Mondays you needed to submit ideas, and if they made the cut by Friday, you had to have them written and rehearsed . . . and ready to go on. The most aggressive creators among us pushed hard to try a lot of things, and to have some kind of little experiment on the menu every week. Many of our political and social leanings showed up as topics, as did our visual tricks and innovations in format. We tried to create mystery, intrigue, like what we saw in old movies and television shows like *The Twilight Zone.*

As I look back, all we had were a few chairs, some ladders, an old piano, a few lights, and each other's imaginations. But most important, we had a ready weekly audience. I never saw the immediacy of a weekly deadline as a limitation of creativity; if anything, it helped.

College 1977

California Polytechnic State University

In the wee hours of the morning, I was scenic painting for a stage show. To get the work done in time, I decided to pull an all-nighter (along with my assistant scenic artist, Katha Feffer) mixing colors, spattering scenic flats, and using an air spray to soften the construction edges. I would look back and forth between details of props, sets, and elements, and then step back ten or twenty feet to look at the larger picture and how it was coming together. Once in a while I'd go down the steps to the back of the Cal Poly Studio Theater and look at the whole stage composition.

It was while standing at the top of the aisle looking at the stage that I realized I couldn't really see clearly. I was so tired and could not paint one more brushstroke. I had planned to go back home and get a few hours of sleep but instead grabbed my jacket off a theater seat and lay down in the aisle for a "short" nap.

At some point, Katha lay down next to me and slowly scrunched her way against me. I chalked this up to her being cold, sharing my coat, and soon after we were both asleep until about 6:30 in the morning.

I had been impressed with Katha for many reasons; yes, she was warm, but she also had real acting ability. She was an acting major, and I was an acting/directing major. Regardless of your major, everyone in the drama major was required to do production—to be part of the unskilled labor pool needed to

put large stage shows together. You could choose between set construction, props, painting, design, costuming, anything you might want to do, but you had to put in a certain number of hours during each semester. I'm sure that I put in (and so did Katha) enough hours to cover two or three semesters on the scenic painting for this complex show, and yet I felt connected to the project and responsible for making it great.

The morning after an all-nighter is never pleasant. I at least thought about the possibility of not attending class and getting some real sleep. But it turned out that I had booked an advisor's conference with the head of the scenic department. Professor Michael Devine was already an idol of mine. He was a quiet introvert, but he spoke loudly with pencil and charcoal. I had met him a few times and had a couple of classes with him and admired his incredible design sensibility and desire to drive students.

It was my second year at Cal Poly Pomona, which is what I would call a modest school. Modest in price at the time, which was good for my family. And modest in the sense that it was geared toward educating students for actual professions like agriculture and engineering. But those of us who were creative or artistically oriented still managed to build our own community. And if you looked for them, resources were available to fund artistic productions. If you were willing to invest the time and effort, the talented professors could teach you a lot.

I began to realize that as much as I enjoyed acting, I didn't see it as a viable profession. I had certainly gotten pressure from my father about this, but I had also had to look inward and know that I didn't necessarily have the true skills, either. I loved words, especially the raw, tough words of Peter Shaffer and David Mamet. And I loved to express emotion in acting out the single scenes that were often a part of our workshop classes. I was probably terrible.

But the other actors, as we critiqued each other, critiqued me as being great with words, great with dialogue, but stiff in my movement, reserved in my physical presence. And I took these notes to heart and thought that I had neither the look nor the physical presence to really be a successful actor. This was my self-critique. As far as directing went, it was still an option and a dream, but as I progressed, I began to dream more toward design and the visual presence of design in spectacular theater context. During the two years that I had been in the drama school, I had done more and more scenic painting, physical construction and composition, lighting, and design, enough to feel confident that specializing in design felt more natural to me. I had an affinity for it, and in

the long run it offered more varied professional applications. I was concerned about getting a job after college. I felt I could probably survive not making much money, but I would never survive not being able to do creative work.

So, I gathered a portfolio, or rather I should say an envelope of sketches, drawings, painted samples, and other things that I had accumulated over the production time, to review them with Professor Devine and get his input on what he thought I should focus on going forward.

Professor Devine told me to call him Mike. Mike always had a shaky hand, and he used his shaky-hand drawings as a trademark for his design style. When I got there, he had a cup of black coffee in that shaky hand, and he smiled and invited me to sit down in the guest chair of his office. I proceeded nervously to spread out my single sheets of drawings. It is not at all to say that I am or have ever been a fine artist. But I expressed a talent for drawing things, particularly hard objects like props or sets or buildings, and for sketching physical details of inanimate subjects.

Mike told me that he thought I drew very well and that I had a really good design sense. He asked me what I wanted to do. I told him I felt that I should specialize in design. And he said, "Well, this may be a strange thing to hear from me, but with your natural affinity, your portfolio, and your interests, I would go up and try to change your major to architecture."

I said, "I'm not a particularly technical person, and I hadn't really thought about architecture because I love the theater."

Mike was thoughtful and said, "You can stay at theater, but if you want to get rigorous design training, if you really want to have a strong background in all aspects of design, drawing, model building, and design theory, you could go up and get all of that in the architecture department. And if you bring that back to theater, you will be a top player."

I considered Mike's suggestions with quite a bit of interest, and I certainly trusted him. So, I left the theater department, and I walked up the hill. Cal Poly is on a steep hill, and way at the top, nestled in the upper reaches of the campus was a rather modern-looking building. And inside were exciting-looking art and design studios, all of them with glass walls so that you could see the students working and drawing, cutting up cardboard for models, coloring plans. And many of their plans and drawings were exhibited in the main hall so that you could see what they did. Both the students and the work captured my imagination.

I made an appointment to visit the architecture department—and my

dream was immediately crushed. The architecture department at Cal Poly was what was called impacted, meaning there were more students who wanted to enter the program than there were places. Most of the students there had awesome portfolios of artwork and design and had been planning architecture careers since high school or even junior high school. But the counselor was helpful and said that the urban planning department had space and would probably be impressed with my portfolio. Plus, the first-year urban planning curriculum was almost identical to the one in the architecture program.

Soon I was saying farewell to my fellow students in the drama department and moving up the hill to take on majoring in urban planning. I found the lectures fascinating. I became interested in what was referred to at the time as urban geography, which was the study of the ways cities are created and how they grow and change over time. The urban stage, or canvas, was huge.

The classes were challenging because I lacked prior experience and study in the field. But I stuck with it. Within a year I was transferred into the architecture department. But my love of theater didn't lessen one bit. I stayed in shape by walking between the two departments, doing my architecture classes and projects and then hiking back down to spend afternoons and late nights in the theater department.

Oversized Books

As much as my soul was being filled exploring the great plays, and the ingenious architects of the Renaissance, I was getting tired of being broke. I found it hard to concentrate after 9:00 p.m., and I didn't have enough coins to get a microwave burrito from the vending machine. I had a very part-time job at the university library. I earned a tiny stipend, but in retrospect it was one of the best jobs of my life. I had a clean private office, and I illustrated annual library reports, user diagrams, and installed the occasional glass-case exhibit for the head of the library. When I was between duties, my boss invited me to study or otherwise take advantage of the stacks.

Whenever I could, I went to the oversized books section. I would sit cross-legged on the floor and go through every book I could reach. A different section every day. It was everything from Audubon paintings to Indian architecture, to grotesque photography in New York in the 1930s. I learned from each of these giant books and remember many of them (and their contents) today. I ended up with a lifelong affection for libraries and used books stores. And some of those most memorable books made it into my collection years later when I could afford them. One of these was *Places for People* by John Portman. Portman had not been mentioned in my classes, but his work gave me a reason to stay in architecture. He wanted to build places of color and life and vitality with the

visitor at the core. I wondered, could I ever aspire to work with such an architectural genius?

The environmental design projects were also breaking me. Every dollar I could scrounge I had to spend on pens, markers, and countless boards, X-Acto blades for sharp cuts, and Band-Aids for misses. Although my work was technically improving, I didn't feel at all prepared to work for an architect. And there were only a few paid jobs around in the theater.

At the same time, a friend and I had started a touring puppet theater troupe. We were inspired by Jim Henson's Muppets. We created a cast of puppet characters and an easily movable stage. Everything could be carried around in the trunk of a car, and we could do the shows together; or either of us could do them solo. At the time, public education was focused on the idea of recycling rather than throwing out aluminum cans. We created a puppet show based on a campaign called "Pitch In." A beverage distributor paid us a stipend to do the show all over Los Angeles County at elementary schools. It didn't pay much, but we could call ourselves professional puppeteers! We were even invited to do some really rewarding shows for schools on diversity, tolerance, and some specialized shows for children with hearing disabilities.

I heard that some Cal Poly students were getting jobs at Disneyland, though I couldn't imagine anyone actually having a job at Disneyland. It would have to be just amazing. I had visions of what it might be like to work at Disneyland, to be the person who helps load people onto Pirates of the Caribbean, to sit in the tower, from which one must be controlling the lights or the safety or the scenes of the attraction. What an incredible time it must be to be able to go to Disneyland every day. So, I was determined to apply for a job.

My mother bought me a Levi's denim suit. It was pale blue, and I felt great in it. Confident. Cool. A technically skilled, fast-learning candidate with potential in any creative area. I carried an extra-wide tan fountain pen in my jacket pocket.

Disneyland's backstage offices were surprising. There were cheap telescoping dividing walls between rooms, and the floors were covered in very worn brown indoor-outdoor carpet. There were some improvised cubicles, and there was a ravaged little coffee area with a watercooler. Disneyland magic seemed to have missed the recruiting room. But I finally got a few minutes with the recruiter, and I told him about my interest in design and theater and creativity. I probably went on and on. He didn't say much, but that didn't stop

me. I figured go for it, so I talked, gestured, and got drawings out. Something about that new light-blue denim suit gave me a sense of confidence.

I told him about my theater shows, my set design, my transfer to architecture, my desire to change the world. I don't even remember what I said, but I assume that at some point I must have paused because he said, "I'm going to hire you and I'm going to hire you right now." He picked up a big manila envelope, wrote something on the front, and handed it to me. Then he quickly ushered me out.

"Congratulations, Mr. Weis," he said.

I've landed it, I thought. I've landed a job at Disneyland! I'm going to run the Flight to the Moon, or I'm going to captain a boat on Rivers of America, or perhaps control the Pirates of the Caribbean. I quickly tried to read the writing on my envelope. I read it again:

ROBERT WEIS
OUTDOOR ICE CREAM AND POPCORN VENDOR

Amusement Parks

By this point, I already had a pretty good knowledge of parks. When I was young, my mother developed a passion for braided rugs. They had become a trend, and people would create long braids, often out of a variety of wool and fabrics, using everything from clothes no longer worn to neckties in a rainbow of colors. The individual braids would later be sewn into a carpet. It was a bad year for Goodwill that year—anything that was woolen was being shredded and braided.

The best place in Southern California to gain instruction, materials, and kinship about the braided rug craze was Knott's Berry Farm in Buena Park. Knott's Berry Farm at the time was in its first evolution after having literally been a berry farm started by Walter Knott, where they sold fresh berries and preserves straight from the farm. It was Walter Knott's vision to add a couple of standard rides and for his wife to make chicken dinners, thereby creating a true roadside stop in Southern California. By the time my mother's braided rugs came along, Knott's had grown into a true theme park, with lots of rides and an Old West theme.

My mother would take us down to Knott's. There was no admission ticket. You got in for free because they saw the value of people coming to shop and dine. And she would buy us a few ride tickets, which were sold on an individual basis, before sending us on our way. At the long counter of the shop, she was

quickly and deeply engaged for a few hours in a Socratic debate on braiding, as she and her fellow braiders learned reasoning, logic, and technique. Ultimately, they'd find holes in their own theories and then patch them up . . . or at least get to patching up the rugs.

We three—my sister, brother, and I—were transported to the Old West. I loved Knott's. It was an *immersive experience* fifty years before anyone coined the term. I imagined I was deep into the Old West; there were the sights and the smells, real animals. There were settlers, miners, and Native Americans. I don't know how authentic anybody was, but the guns and knives seemed real; tough men good and bad, and resilient women who could demonstrate the arts and ingenuities of living on the land a hundred years ago.

But the amazing thing to me was that the steam train. I remember it being so real and so massive, with steam belching out of the chamber, smoke coming out of the stack. It chugged right through the middle of the park, not separated by a berm or railings or trees, not by anything. It came right down through the center of the park where it would stop, and you could board it. With one ticket, you could drive a real Ford Model T. You yourself, a kid, driving along a road in a Model T with no track, no guide track, just you, learning how to drive—at the amusement park!

And then there was the Calico Mine Ride, the finale, a rickety old mine car being pulled by a locomotive through dangerous tunnels, beautiful caverns, and a gigantic working mine. It never occurred to me it was all fake; I had fully suspended my disbelief at the turnstile. I had no way of knowing the ride was the artistic and technical achievement of the legendary ride designer Wendell "Bud" Hurlbut, who conceived, built, and operated it. A veritable one-man founder of the modern themed ride.

Parks and Piers

If you're lucky to know or have known your grandparents, they may have had an impact on your life. Mine did. I had quite a few great-, great-great-, and step-grandparents. They were all gifts to me. Grandmother Virginia and Grandfather Milford on my father's side were second parents. They lived near enough that we saw them all the time. My grandmother would stop by with doughnuts in the morning. Or she'd go around and pick up me, my brother, my sister, and her other five grandchildren and have us all over for the weekend. She'd improvise sleeping arrangements on sofas and the floor, cook for all of us. These were great days.

Milford was more introverted, though he'd clown around projecting his false teeth out of his mouth or crushing our wrists until we couldn't move our fingers anymore. But at some point, he would retreat to his study for a little quiet, or if we were out, he would take me for a walk. He was my best friend. We might take a car ride up to Long Beach (just south of Los Angeles). We would walk along where the boats were docked. He loved sailing, loved boats, and had even invested in something, which I never quite understood, a boat made of cement. It never seemed to be around when we walked the docks; I suspected it was down under a reef somewhere.

He could make the sounds of a boat with his mouth. He would talk about a kind of piston engine that would go "*tuckita, tuckita, tuckita, tuck.*" And he

knew a great deal about rigging. He warned me that if I ever had a boat, I'd need a pole so I could rig up a sail in case the engine failed.

I remember Pacific Ocean Park, on a pier in Santa Monica. It was dirty and edgy, but I loved it. We would invariably run into a gentleman with a hand-cranked organ and a ubiquitous monkey. My grandfather would give me a couple of nickels, and the monkey would grab the nickels with his little scrawny hand. I thought this was unique to Pacific Ocean Park, but it turns out that monkeys and their organ-grinders were a part of amusement areas from long ago. I even had an iron piggy bank where you could put a nickel into the monkey's mouth. When you pulled the lever, the coin would fly through the air and into the bank where it could then be saved for your first home or for the next monkey that might come along.

A Cast Member

I was welcomed as I drove through the Harbor Boulevard gate. I was able to park my car literally inside the barrier just between Harbor Boulevard and the inside of the park. Every day, the wardrobe counter would give me a freshly laundered and pressed yellow outfit with blue and red stripes down the pants. I had made it.

Like any great profession there were keys to success in the popcorn and ice cream racket. Count your starting cash deposit, which was $25 in small bills and rolled coins, and neatly install it in your cash drawer. No point-of-sales computers or touchless transactions. Memorize the $.35 multiplication table—$.35, $.70, $1.05, $2.10. I'm proud to say that while this skill is useless, I still remember it.

In 1924, Thomas B. Slate applied for a U.S. patent to sell dry ice commercially. Without this compressed form of CO_2, no one would be walking around eating that last scrape of vanilla off the wood stick of a chocolate-covered ice cream bar. In this job, I soon discovered that an invention, even a patent, is not enough. It takes, as Walt said, "people to make it a reality." The boxes the ice cream bars and sandwiches came in doubled as efficient fans. It wasn't an exact science by any means, but you had to fan the dry ice block to keep the perfect temperature for ice cream. Fan too much, and guests will complain

the sandwiches are rock solid. Fan too little, the ice cream bars go soft. The ice cream would melt and ooze to the front of the bars making them unsellable. They were called spoils and had to be accounted for, along with all cash, at the end of each shift.

One night as I was checking out, my lead told me they'd be shooting a commercial at my ice cream station the next day. "Look nice," he said.

It was my chance to get back to acting! I was especially careful to glue down my frizzy hair, get a very well-pressed uniform, and polish my shoes (even though they'd be hidden behind the wagon).

My wagon was spotless. A crew showed up. They set up cameras and lights. They tested me with a light meter. They seemed all ready to go, and with my acting experience, I tried to look natural, to show the artistry, the flow of taking an ice cream sandwich out, and handing it to a waiting guest. The friendliness of a cast member of a themed show, not a vendor. At the last moment they asked me to step aside, and a cast member from the entertainment union stepped into my place. This had been the plan all along. I'd demonstrated my technique, helped them set the shot and the lighting, and then this *yutz* steps up at the last second. Soon the director called "cut," and I stepped back up, regaining control of my wagon. *My wagon*. As they cleared away. I fanned my ice, vigorously.

Popcorn was a whole different story.

Ice cream wagons were mobile, but the technical sophistication of the popcorn equipment required that they needed to be locked down. When you arrived at your wagon, you set up your cash drawer as usual, but there the similarity ended. The oil compartment kept warm a mixture of some substances that combine vegetable oil and something to suggest butter. If your oil was low, you needed to cut open a large white bucket, sort of like a five-gallon can of paint. Then you put a big metal scoop in the oil tank to warm it so you could slice into the bucket of grease and add it in. I didn't find this the least bit appetizing, and I tried to be low-key, hoping as few guests as possible would notice.

Popcorn kernels needed to be fully stocked. Salt and paper boxes needed to be ready. I always prefolded six or eight boxes so they were ready to go.

All this was just the lead-up to where the true popcorn magic happens: the high-tech iron kettle that is hung over the shiny glass enclosure. This is the business end of the popcorn operation. Turn a switch and the kettle gets hot, fast, so you'd better toss one ration of corn into the pot, lock the lid, and get your head out of the way. One of nature's wonders is about to happen.

As dry as they seem, popcorn kernels contain 14 percent water. As the kernel is heated to a high enough temperature, this water transforms into steam. Due to the hard and mostly nonporous shell, the steam has nowhere to go, resulting in a buildup of pressure inside the kernel.

Once the pressure gets high enough and the temperature reaches about 180 degrees Celsius (355 degrees Fahrenheit), the kernel hull bursts, and the popcorn is turned inside out. The characteristic popcorn consistency and white-yellowish foamy appearance results from the starch inside the popcorn kernel. At high temperatures, the starch gelatinizes and then expands with the rapid burst of the kernel. Once it cools down, the solidified flake we know as popcorn is formed. The characteristic popping sound does not originate from the cracking of the hull as originally thought but results from the vapor release after the kernel has cracked.

That's the science. But the Disney magic comes in, too. As the "buttery" oil is fed into the blast furnace, a fan kicks off automatically. The smell of the oil, steam, and popped corn coming together is strategically blown into the area surrounding the wagon. Obviously, people would stop, sniff, and make a beeline for the wagon.

I was pretty quiet around the boisterous scene in the Outdoor Foods garage. But when I got out into the park, I came alive. It's a lot of hours on your feet, and a lot of redundant tasks. The guests became my focus. I took their happiness seriously. I wanted them to have the best day possible, and I wanted to be part of it. There were no cameras on me, no one knew how I performed (except me, and the guests in little twenty-second exchanges). But I believed in Disneyland and the part I played in it.

This was 1976. It was a grand celebration of America's bicentennial, and Disneyland was decked out for it. America on Parade was a fifty-float spectacular developed by Bob Jani, who only a few years before had developed the Main Street Electrical Parade. The Sherman brothers wrote the theme song. The parade went by once in the daytime and once at night, and in the evening, it was followed by fireworks synchronized to patriotic anthems. I always wanted to be one of the guys who followed the parade out—holding a rope at the end, radios on my belt, obviously important to the event.

Buddhist monks say performing a repetitive task, such as digging up rocks in your garden, has the effect of releasing your mind from your body and opening you to meditative thought. I experienced this at Disneyland. Once I had the ice cream and popcorn vibe, including greeting my guests, I found

myself being one with Disneyland. As a vendor you moved to a different location each day. Active, passive, different parts of the story and different parts of the environment. I sensed how Disneyland worked, how people flowed naturally from icon to icon, from story to story, and how seamlessly the contrasting environments wove into each other. And how people treated each other; even strangers seemed to have a good-willed projection that was life-affirming. It was a polite place, for that day at least; life just seemed like it was going to be okay. I often saw families who had children who appeared to have some kind of illness or challenge. I never took for granted that this must have been a special time for them, perhaps a once-in-a-lifetime visit.

It was not until years later that I learned that Walt had told his Imagineers to go to Disneyland once a week, just to sit, absorb, and to think about the way the place worked and what would make it better. I was doing it every day, and I was in architecture school at the same time, learning about how to make vibrant places for people.

Nat Lewis was born forty-four years before Disneyland opened. He was a born entrepreneur. In 1956 he began the Mickey Mouse balloon concession at Disneyland and was responsible for the iconic balloons at Disneyland and Walt Disney World until he died in 1977. In fall 1976, the transition of the balloon operation over to Disney began. It naturally fell to Outdoor Foods to take it over. After all, we were the trusty street vendors—friendly, clean, and efficient, plus always ready to help guests with purchases, directions, and anything else they wanted to know.

The day I showed up to train on balloons began uneventfully. But the job quickly descended into hell, or at least Chernabog's hillside retreat.

The balloon area was a high-ceilinged padded room, a latex prison, with no furniture and with carpet on the walls and the floor. There was nothing much that could pop a balloon. I was directed to start by counting out five piles of fifty balloons each. I already mentioned I'm a little short when it comes to technical chops. Numbers had not been my thing since junior high school. I would get to balloon number twenty-five, and I would lose my place. I'd go back and start again. I knew the trainer was wondering why I was taking so long. So, I sped up. He checked my stacks, and some were fifty, some were forty-eight. Going good so far.

Then there was a carpeted bench surrounding the room. At intervals were helium-pressure regulators, with fill valves that tilted on and off. It was simple:

you just put the balloon over the fill-nozzle, and voilà, the balloon fills. But in reality: not so easy. The balloons have ears. If you fill the head too fast, it bursts, or it becomes hard to fill the ears properly. It takes some dexterity and patience to get the feel for it, and some tolerance for balloons popping in your face occasionally. Then the balloon had to be tied, with a red string attached. The balloons just floated up to the high ceiling, and when you were ready you could start organizing strings so that the balloons could be easily slipped out for each customer. Sounds easy.

A striped, multicolored change apron was the final accessory . . . along with a couple of rolls of quarters. It was then I began to feel like the organ-grinder on the pier, and I hadn't even stepped onstage yet.

There are many things I have been bad at in my life, but I was never as bad as I was at selling balloons. The great dark secret is what every parent tells their kid: "We'll get one on the way out." This puts enormous pressure on the vendors at the end of Main Street at the exit. Those parents have promised, and that balloon man is not going to get in the way of them fulfilling it. I felt like something between Elton John and a cat at a coyote gathering. Everyone was yelling and pushing dollar bills in my face. I did my best to make change from my belt. Then I would try my best to unwind the strings by handing one balloon to a guest, and probably releasing four or five into the air in the process. Another vendor finally stepped in and untangled my balloons and helped me with the distribution. With my hands shaking, I did my best to wad up dollars in my belt and feel around for the right number of quarters as change.

The next day I went to see my lead. I told him I was a great cast member. But I could not be a balloon salesman again. He shook his head and said clearly, "Balloons are now part of Outdoor Foods. If you want to be in Outdoor Foods, you have to work balloons."

I took it as a challenge. I had my angle, my opening. I went to personnel. I tried my best to explain everything—my love of guests, Disneyland, excellence in popcorn and ice cream, designer, theater, candidate for architecture, anything to get transferred. I tried it all. She was nice. But in the end, she said I couldn't run away from life, and if balloons were going to be the end of the line, then personnel was going to "purge you from the system."

I didn't know what being "purged from the system" meant, but I suspected my ID was not going to let me into the Harbor gate entry the next day. But I had learned something as I got back into my street clothes. I reflected on it

as I started my car, and drove up the ramp, waving goodbye to the guard as I always did. I had seen the secrets of Disneyland. I had seen the power of it, the flow of it, how it changed throughout the day, how it changed faces and lives. I had been imprinted with the magic of how it all worked.

It was my last day at Disney, but I was taking the magic with me.

The Play's the Thing

On a summer evening in 1941, playwright, composer, and actor Noel Coward was in a club at the Savoy Hotel in London. Outside, aircraft of the enemy German Luftwaffe were blasting the city with hundreds of tons of lethal bombs, and thousands of incendiaries. The streets were piled with shattered glass, broken bricks, and twisted household belongings. The walls of the club were shaking, and a door blew in. Coward was staying at the Savoy because his London home had been bombed, and he had recently learned he was on a Nazi kill list, along with other writers, should the Germans invade Great Britain, which they seemed on the verge of doing.

Coward, undaunted, took the stage and performed a cabaret act, along with other performer friends, entertaining the nervous patrons. He remembered it as an unforgettable evening of resilience. Soon after he slipped away to a coastal town in Wales, and in one week wrote a play about ghosts. The play opened at London's Piccadilly Theatre just six weeks later, and it was on Broadway an astounding four months later. During the darkest days of the London Blitz, the play, *Blithe Spirit*, ran for a record of nearly two thousand performances.

The Cal Poly University Drama Department selected *Blithe Spirit* as the annual large-budget main stage production for 1979. I had lobbied the

department and the Architecture Department to be the production designer and to have it accepted for the first semester of my senior year in architecture. It was a tough sell, but now my architecture professors, academic advisor, and drama professors were all in the audience for the opening night. I sensed the architecture team to be either bored or perplexed.

The enduring magic of *Blithe Spirit* is its dark comedy and supernatural aura. A novelist invites a clairvoyant to his home for a cocktail party to research a book. She unwittingly unleashes the spirit of the novelist's late ex-wife, who then kills his current wife, and he finds himself in his home alone with the ghosts of his feuding two wives. I had combined a neoclassic Michael Graves (one of my architectural idols) rosy, pink beach house with physical effects that brought the ghosts to life; doors slammed by themselves, books and pictures fell or were scattered around, windows and dishes shattered, and a mounted deer head spit a stream of water at the protagonist. (If I'd had the resources at the time, I'm sure I would have upset a fish bowl and shattered it, resulting in water, gravel, and plastic fish scattering everywhere!)

The whole scene was, I realized later, a kind of postmodernist interpretation of my favorite attraction at Disneyland, the Haunted Mansion. I had even managed to get special permission from safety to break real dishes and shatter glass during the climactic finale when the ghost wives destroy the house. The theater department insisted they couldn't afford to break so many props during the run, so I had taken all the cash from my account to the local Goodwill and bought as many plates and platters as I could. I loved the sound and look, and the raucous ghostly destruction definitely woke up the audience. I was certain that Coward himself destroyed the house for a reason, and I didn't want to dilute the point he was trying to make.

As the audience cleared, I invited the professors up onstage to tour them through the scenic elements, the techniques demonstrated, and the learnings.

I stood center stage, presenting. It seemed to me to be a natural meeting point of architectural design, storytelling, and drama. But I realized that the architecture faculty and the theater faculty had congregated on either side of me. I had to turn to address one or the other. I felt like I was a curiosity to them both.

As they finished my critique, the prop master came through, sweeping up all the shattered glass and shards of broken dishes.

~ ~ ~

I decided it was time to set aside my rebellious senior student nature and focus on getting through the last of my five years of college. I had taken in as much school as I could. I had done acceptably in all my general education classes, exceptionally in theater electives, and had just sneaked by in physics, trigonometry, and structures. In design, my work had improved, or my instructors had started to understand me more . . . or some combination of the two. I was showing more confidence, using more color, more curves, and shapes that expressed humanity in spaces, and we students were loosening up our drawing media. Some of us technical pen-weary students had discovered the pencil (actually, it had been around since it was invented in the Napoleonic exploits of the 1790s).

We started drawing and building models with brown corrugated cardboard, thanks to new and renegade architects like Michael Graves and Frank Gehry, and I started drawing in light pencil on yellow tracing paper, with as shaky a hand as possible, then smearing all the forms with white, gray, tan, and pink Prismacolor pencils.

Early in my senior year, the school welcomed a guest lecturer who would soon become the department chair. We were all asked to do posters welcoming him. I did one that apparently he liked, so he invited me in for a chat. His name was Richard Saul Wurman. I had looked him up in periodicals and he was a very unusual faculty member. He was proudly an architect but also did many other things; he was what he called an information architect. He created maps, studied art and psychology, and was excited to embrace the world, to learn new techniques and technologies. I was quickly inspired by Richard. When he announced he needed some teaching assistants, I raced to get one of the positions. (It was not until some years later that Richard and I would meet up in a big way, but more on that later.)

To keep myself enthusiastic, and to appease my architecture professor, I spent the last semester doing a more traditional architectural design exercise. And I even did it in black pen and on whiteboards. But instead of the typical assignment to design a modern office building on a featureless green field, I opted to envision a gritty theater complex for a real location in a depressed area of downtown Los Angeles. It was a renovation and expansion of an old derelict bank building I had found along skid row, into a series of theater spaces and vertical lobbies. Typical of me, I had overthought the storytelling, showing how multiple designers could utilize the theaters, and I had underrepresented the architecture. Juries for final projects could be brutal. One of my instructors

criticized my drawings as being too small, and another said I had not used double pen lines to emphasize stair runs. I was forever grateful for these astute life lessons.

Another criticism I received was for selecting an existing structure. It was considered less of a challenge for a senior architecture student as opposed to being a "form giver," gifting the neighborhood with my brilliance in a completely original structure. I disagreed, and it turns out I disagreed for the rest of my life. This was the very beginning of my design career, but I already believed in one thing, which was context is everything. Context, community, story, and history were what interested me about projects, in the same way a script drives and injects emotional power into a stage design.

I had spent time in the city, roaming skid row, feeling it, experiencing it, and rummaging around back alleys looking for architectural treasures. I had found a declining historical asset that could be reinvented, and that seemed valid to me. (A few years later, someone else discovered the space, and in 1985 it opened as the Los Angeles Theatre Center.)

There was a spectrum in the jury that went from being intrigued by my journey to completely rejecting it. Somehow, I passed.

One thing I was learning about myself, in theater or in architecture, was that when I was working on a project, I worked on it with a passion, with no concern for anything else. All-nighters in the theater or in the design studio were frequent. Next to the Architecture Department was the culinary school, and if we were lucky, they were baking their final projects, too, and we could stop in, and they'd take pity on us. Or we'd hop the fence to the avocado groves that belonged to the Agriculture Department and feast on a bag at 2:00 a.m. Then I would get a decent night's sleep and try to pick up the pieces of other classes. The last few years had been project to project, and with my senior juries behind me, I faced the reality that I had made no plans for what to do after I graduated.

I was building a decent portfolio, but I didn't have a plan for how to enter the theater or design worlds. I had made no plans to go to graduate school. I had made no plans to move to New York or anywhere that might be more of a theater town than Los Angeles, and I had absolutely no job prospects. There was summer stock, but I had been too busy to apply. There were some job board postings for architects, including internships in some of the big offices. I didn't think I had the right kind of clean portfolio to make it, and if I did, I thought it wasn't what I wanted to do anyway.

But I was ready to escape being a poor, starving student for professional work that would give me some financial independence.

As graduation was nearing, I was taking one of my last long walks up the hill from the Theater Department. As I reached the podium of the architecture building, I noticed a job fair was underway. There were various folding tables with company signs, and recruiters were talking to eager students. I raced to my locker and quickly made some sense of my half-finished portfolio pages. I was wearing bib overalls caked in scenic paint, but that couldn't be helped. I came back out to look around.

There was one table that caught my eye. It sported a logo I recognized but couldn't place. The sign read, WED ENTERPRISES. It took me a minute, but I remembered hearing about WED at Disneyland. Space Mountain was under construction, and the mysterious WED was the organization that designed new attractions. Could this be Disney's design organization—right here at a folding table at Cal Poly?

When I got to the front of the WED line, I tried to play it cool. But soon I was flipping through portfolio pages and recalling my old human resources pitches from my days working back in Anaheim. My love of guests, Disneyland, excellence in popcorn and ice cream (I didn't mention balloons), designer, theater, candidate for architecture, storyteller! I tried to get it all out there!

"Oh, so you work at Disneyland, too? I'm so glad you stopped to talk to us!"

I tried to explain, junior and senior years had been too jammed with projects to work. Considering the balloon incident, now I prayed that when HR had said they "purged me from the system," they'd meant business.

When I finally gave the WED recruiter a chance to talk, she said I was perfect. Exactly with the kind of skills they needed. Good design training, graphic skills, communication skills, combined with storytelling and entertainment. She asked me to fill out the application, told me where to mail in my portfolio (these were the days before web pages and QR codes), and said they would contact me soon with a start date.

How could this be? In an hour I had gone from no plan to a perfect plan. I was set, at least for the first stage of my career. I was headed to WED Enterprises! I forgot to ask where they were located, but it didn't matter really, I had landed a job, almost by accident. And now all I had to do was ride out the next few months, then pick up my diploma.

~ ~ ~

Walt Disney founded WED Enterprises, named for his initials (Walter Elias Disney), in 1952, before my parents graduated from high school, and five years before I was born. He was deeply engaged in an idea that would someday become Disneyland, but at the time it was distracting the studio. He wanted to incubate it and own it, and he wanted it to be at arm's length of his other operations.

In 1980, WED was in the biggest expansion mode of its short history. It had been responsible for the conception and building of Disneyland and had taken a huge jump in size, plus artistic and technical prowess, to accomplish setting up five pavilions for the 1964–65 New York World's Fair. Now fourteen years after his death, the company was taking on Walt's last dream, EPCOT (Experimental Prototype Community of Tomorrow) and needed to expand quickly.

WED's business logo had no marking that would suggest it was part of Disney. The logo was elegantly embossed on tan stationery. There was a sparkling star inside the *D*, which connected to a kind of lightning bolt that led down to a hand-lettered word: *Imagineering*. It was nicely positioned on the envelope that appeared in my mailbox, and the stationery inside matched it perfectly, too. I quickly opened the envelope looking for the directions for my first day. I read it and read it again: *Unfortunately, your skills are not a match for our requirements. But we thank you for applying.*

Despite the rejection, a few weeks later I entered the hallowed halls of WED. My sister, showing more compassion than normal, had insisted I call up WED personnel to find out if the letter I had received was a mistake. I knew it wasn't. The letter could not have been more concise or impersonal. A week later my portfolio had been unceremoniously mailed back, without a note of any kind. It was more likely a helium-balloon conspiracy, a life's mistake that would follow me forever. I finally relented, and sheepishly called. I was glad I did. The HR rep didn't admit to any mistake or collusion with Outdoor Foods but just immediately invited me out for another interview. These folks, I thought, must really need people.

WED–Walter Elias Disney

The WED campus in Glendale, California, was hard to find. Hard to find because no one would expect the collection of nondescript old concrete tilt-up buildings to be where any self-respecting creative person would care to work. Getting there early, I scouted the neighborhood. It had to be the right address. But it was just a scattering of gray warehouses and some old aviation hangars. (Grand Central Airport had once occupied the site, explaining the lack of trees, lest Amelia Earhart scrape one on her takeoffs.) Down the street was the Batesville Casket Company, and the site was rounded out by that symbol of storytelling and cultural advancement, the Grand Central Bowl, designed by William Rudolph in the late 1950s and boasting sixty lanes. It also adopted the treeless parking lot scheme for consistency and included a coffee shop and the Gay 90s Room. I suspected the dark bar opened before 10:00 a.m.

The 800 Sonora Avenue building had sounded interesting on the phone, a kind of Disney version of Los Angeles's historic Mexican festival marketplace on Olvera Street. No such luck. It was as plain as a gray shoe box, with a strange batwing concrete rain canopy, looking like it was trying to fly out of its facade. Years later I would hear John Hench, first hired by Walt

Disney to work on *Fantasia*, and a true Disney legend, say, "They don't come out of the show, humming the architecture." They certainly didn't in WED's neighborhood.

In a few hours, I quickly went from a rejection letter to two possible jobs. Inside the concrete jungle, WED changed from an industrial wasteland to Santa's Workshop without the snow. There was exciting work everywhere, models, paintings, robotic creatures, and human figures being built and animated. It was the largest assembly of creativity I could possibly have imagined. Here's where I first heard the term *coordinator*. I didn't know what a coordinator was, but they sure seemed to need a lot of them. I started to believe it might be the balloon salesman of the WED business, the job no one wanted but someone had to do. There seemed to be a lot of chiefs, seniors, and "nine old men" types (though there were more than nine, and they were certainly not all men). These seemed to be the legends entrusted with Walt's last dream, and they knew Walt's dream because they had worked for many years directly with him. Then there was a professional layer that seemed to be coming in, filling the space, like water filling around. The projects had become too large, too complex, and the old ways left too much to chance. And the stakes seemed to be higher than they'd ever been before.

It was at this time, I learned later, that Imagineer Orlando Ferrante had set the vision for the role of coordinator. He saw them as young, hardworking Imagineers who formed the glue—managing projects—knowing everyone, knowing the schedule, and knowing how best to expedite a complex sequence. He saw them coming from any field, and the job being a great jumping-off point to a successful career at WED.

I was offered a job on EPCOT. The future, the dream. I was going to be a part of this massive operation to build Walt's experimental community, to impact the world and design. It would bring everything together—my theater design, my urban planning and architecture. And given the chance, I was planning on coordinating the hell out of it, whatever that meant.

Despite a long day of interviewing, my recruiter asked if I had time and energy for one more. She told me it was not as exciting as what I had seen so far. We walked outside the secure boundary of WED and down toward the Grand Central Bowl. Oh no, I thought. I prayed they weren't recruiting for fry cooks or pinsetters.

We crossed the street and entered another building. This one had none of

the magic of the rest of WED. It looked a bit like a legal or accounting office, with its tan carpet, cubicles, and small offices with white walls.

But the recruiter took me into one room that had a floor-to-ceiling model on the wall. It was obviously a Disney project, but it was surrounded on three sides by water. It was the bayside location of a top secret project called Tokyo Disneyland (TDL).

The TDL office, as it was called, didn't have much to offer me. They made it clear there was very little design to be done; and just a small team. But lots to be figured out; Disney's first attempt to build a project outside the comfort of the United States. On the walls of one big room was a smattering of colored index cards with work items and completion dates typed on them. Part of this new coordinating job would be to turn this wall into a vibrant center of status for the project. Maybe it was my lack of imagination, but I had trouble seeing these cards as the vibrant center of anything, no matter how many colors came in one pack.

But I ended up in the office of Frank Stanek. Frank was clearly the highest executive I had met that day. He was interesting, clear, and professional. And he read my mind immediately. "You just got out of design school, and you want to be creative. I know, I saw your portfolio. But I don't need anyone creative, I need people to get this hard job done!" The only weird thing about Frank is he had a strange laugh, sort of like a seal gasping for oxygen. And I felt strongly that I had come here to design, and be creative, so his laugh wasn't helping.

It was not until years later that Frank said it exactly like this, but I remember he implied it in our first meeting: "Bob, everyone is busy on EPCOT, so I'm going to get this done with a very small team. It's going to be done with the fired, the retired, and the recently hired!" And the laugh again. I could learn everything about Disney on TDL, he said. I could have a lot of responsibility, quickly, he said. "And if you get this done, you'll have lots of new opportunities to design and be creative."

Frank had a coup de grâce, and he hadn't played it. I suspected he was waiting for the right moment. Some influences I'd not heard from my subconscious were welling up for the first time in a while: the world, urban planning, cities, international challenges.

"And it will likely involve travel to Japan, an opportunity to live abroad, and travel to many places in Asia."

Bingo! やった, or Yatta, as the Japanese might say! I started to imagine ways to turn that wall of pastel index cards into a stunning example of information architecture.

Imagineer

In May 1980, the World Health Organization announced the eradication of smallpox, Mount Saint Helens erupted in the largest volcanic explosion in North American history, and I came to work at WED. I had been to orientation at the Disney Studios, at Disneyland, and WED. And after all that I was flying high on what I would later understand was called *pixie dust*. My first meeting was with my senior supervisor, Tom Jones. I knew right away that I would like Tom, and I would idolize him the rest of the time I knew him, and after he passed.

Tom was born in 1924. He was ten years older than my father. He was a graduate of West Point. During his twenty-seven-year career in the Army Corps of Engineers, he commanded troop units in Japan, Korea, and Vietnam, was a military assistant to the governor of the Panama Canal Zone; and was on the team of the chief of staff, U.S. Army, at the Pentagon. He retired from the army in 1969 as the Corps' New York District engineer and supervisor of the harbor of New York. Tom immediately began a significant second career with The Walt Disney Company. In Florida, he was director of Disney's cutting-edge Reedy Creek utility company. He had recently joined the TDL team as managing project director.

But more than all of that, Tom was a whirlwind. He spoke in explosive expressions. "Super job!" he'd say. Or just "super!" He often repeated them

with exuberance. He always wanted to know, "Who has the football?" In my first meeting, he made it clear I was always to have the football. No one worked for Tom and didn't have the football. He was lightning in a bottle, and a champion of management clarity. He told me he hated meeting minutes. He said Disney meeting minutes read like a PTA meeting, recalling who brought cupcakes to the classroom. He wanted me to write with purpose. Minutes were to be a list of what was decided, and who, you guessed it, had the football to follow through with. I felt like I'd earned an MBA in a single week of working for Tom and Frank. They both knew and respected WED as a creative organization. It was all about talent and exploration, innovation, and artistry. But they also imparted to us that we were paddling upstream. There was an entire organization trying to deliver on EPCOT, and if TDL was going to get built, it would be because we pushed it through. It wouldn't happen otherwise. An instinct to never take my foot off the gas or let go of the steering wheel came over me in my first week and stayed with me for the rest of my career.

I discovered my office was to be a narrow cell, which I would be sharing with two other gentlemen: my immediate management leader, Val Usle, and his writer and friend Steve Noceti. For someone who'd never been in the military, Val had an even stronger military bent than Tom did. Val's power alley was information and organization. He stockpiled information as an arsenal for success. Steve was a kind of gentle ex-hippie who liked to write and play folk songs on the guitar. He wrote scopes of work, descriptions of attractions so that contractors, estimators, and manufacturers could understand them. It was dry work, but Steve found a passion for injecting his own creativity into the writing.

With Val's sense of leadership through order, and Steve's laid-back sense of creativity in the middle of a storm, I found myself somewhere in between.

Our cell, it turned out, was a former projection booth (from the days of multiple slide projects running at once). I demonstrated my sense of optimism when I said I shared it with two other people, for a third arrived a week later: Craig Russell. Craig and I got to know each other, because if we leaned back too far our heads would bump. I began to see a grand plan. Craig was just graduating as a mechanical engineer and quickly was coordinating all of WED's engineering disciplines. That put him in the know with such geniuses as accomplished WED Engineer Don Edgren and Walt's own ride vehicle development visionary Bob Gurr. As another just-graduated-design-focused guy, I found myself carrying water, aiding such luminaries of Walt's as Bill Martin, his

architect; Bill Evans, his landscape designer; Joyce Carlson and Claude Coats, two of WED's most prolific show designers; and John Hench, the co-leader of WED and Walt's most trusted expert in design and art direction. In Frank's plan to utilize the fired, retired, and recently hired, it was clear what Craig and I were there to do.

It was a casual atmosphere, but I had a sense I was working with a very special group of people, people who'd worked with Walt himself just fourteen years before my start date. They had built icons of my youth. Years later I would wonder if I had appreciated them and learned from them as much as I could. If I could speak to any of them right now, I'd know a lot more about what to ask.

Our TDL team was tiny. The most experienced Imagineers available had been sent to Tokyo and were already engaged in the knowledge transfer necessary for the partner, Oriental Land Company (OLC), to take responsibility for building the project. A few years before I joined, Frank and his close collaborator and Disney corporate counsel Ron Cayo had convinced Card Walker, CEO of Disney, that the timing was right for the company to engage with a partner in Japan to build a park. Visitors from Japan represented a large percentage of international visitation to Disneyland. And a few cheap knockoff copies of Disneyland had already been built outside Tokyo.

Card Walker was ex–U.S. Navy, assigned to an aircraft carrier in the Pacific during World War II. He had left the ship to go on his home leave, and when he returned, his ship had been attacked and many of his friends had been killed. For some time, Card resisted talking about anything related to building a park for the Japanese.

Although I was born after World War II, it's worth remembering that many of my senior managers at WED at the time had lived through it. And the same situation existed in Japan. Two countries, once enemies, talking about collaborating on a Disney theme park, less than forty years after Pearl Harbor and the U.S. declaration of war against Japan.

Card Walker had other reasons to be reluctant to invest directly in Japan. He was very concerned that the company was severely stretched getting EPCOT done. EPCOT was risking the company's financial security, and its reputation. The entire organization had committed to finishing Walt's last dream, and nothing could be allowed to derail that.

After much relentless negotiation by Frank, Ron, and others before I had ever started at WED, an agreement had been hammered out. WED would basically support an almost direct copy of the Walt Disney World Magic Kingdom.

The Oriental Land Company would be responsible for all local adaptation and construction. WED would play an advisory role and have full approval for project quality. The Disney Parks teams would provide comprehensive operations and business training. The rights of all Disney intellectual property would remain with Disney. OLC was financially responsible, and Disney would receive a royalty.

The result was that our office and the senior members of WED were all funded by the Oriental Land Company and were thereby limited in scope on how large we could be or how much we could do. Craig, Val, Steve, and I, and many others, being among the "recently hired," were there to make a huge knowledge transfer, and to fill a massive gap in expertise and energy.

But for us it meant responsibility way beyond our years, and it was a privilege to be directed and mentored by so many of the best of the best. I quickly became involved in design and creative disciplines, and as Frank and Tom directed us, we worked hard to get the work that was assigned to Glendale finished, and out to the Tokyo team as early as possible. The philosophy was to provide existing documentation and let the Tokyo team manage the modifications as necessary for site conditions, operational differences, and municipal code compliance.

Frank had arranged to buy one of the first Panafax machines ever in service in the United States. It was a wonder of the imagination. One could load a stack of eight-and-a-half-by-eleven-inch sheets of memos or drawings into the machine in Glendale, and in only a few minutes, they'd magically appear on a long continuous run of waxy paper that curled out of a machine in Tokyo. But the transfer was expensive and critical. Every page was logged and tracked. An urgent DHL physical package to Tokyo could take a week or more to arrive. So, when we had to accelerate information delivery, we found we could chop a large sheet into pieces and send it, and all the team there would have to do was tape it together. It saved weeks of time.

Craig and I quickly found ourselves chairing meetings of large groups of senior Imagineers, working to extract information from people who were normally very busy on EPCOT and not used to taking direction from kids just out of school. Once in a while I remembered (or was reminded) that I had been hired to fill the conference room wall with cards and prioritize tasks. I was feeling stretched coordinating the U.S.-based design efforts, so I came up with a system to keep the cards up to date without much effort. I did a card design, inspired by Richard Wurman's information architecture. The cards were

multicolored, but with more muted tones. The typography was bolder, and the margins had little bubbles that could be colored in red, yellow, and blue when finished. Then scanning through the Panafax log every morning, I'd pick up key dates or milestones. An assistant would type those onto cards, and I'd fill in the dreaded status bubble.

It all looked really statusy. The wall conveyed a sense of organization and was always current, up to date. And although I felt the management of the project was not that much truly affected by it, it at least looked like it was central. I even brought in a cabinetmaker who devised a set of rolling boards that gave the room even more space for cards. It was around then I got the nickname Wall Master Weis. Some names are hard to get rid of.

I didn't attend Frank's senior staff meetings. But Val or Tom would convey any key points to us, expecting action immediately. One day Val came out and said Frank had looked at the wall of cards. He said he knew, instinct told him, there were milestones being missed, by WED or Disneyland, and that they didn't always get called out. (Frank's extraordinary prescience was something I picked up on the rest of my working life.) Milestones that repeatedly were missed he referred to as dead rats. They just lay around and decomposed, I guess.

Late that evening, I went through and did my best to identify any chronic abusers of deadlines, sitting in the empty conference room, making calls, sifting through hundreds of pages of memos and meeting minutes, and updating cards. The lights above the huge conference table were fluorescent, and they strained my eyes. I looked up and realized the ceiling panels that housed the lights were easily lifted and removed.

It was nearly Halloween, and I made a weekend trip to a gag store and bought the largest plastic black rat I could find. I came in early on Monday morning, stood on the conference table in my socks, slipped up one of the translucent panels, and laid the rat on its side inside. It looked very, very convincing, complete with long curled tail. I turned off the light and went back to my office.

In Frank's morning meeting, I heard Val explain that I had updated the cards looking for anyone showing a chronic habit of missing schedules. I heard Frank say he wanted everyone to keep an eye out for dead rats. They moved on, and I was so disappointed. It was all so normal. Then I heard someone scream, followed by the whole room breaking out into laughter. It was easy to figure out who the culprit was, and in the years that followed I rarely saw Frank when he didn't bring up the dead rat story.

One of Frank's big dead rats at the time was signage. The signage program at TDL involved about four thousand individual elements. Each was themed to an area, and they were all complex compositions of ornamental metals, custom letters, painted and dimensional, complex lighting, stained glass, and any number of other diverse face materials and bracket details. Each graphic had to be located on OLC's contractor drawings, for structure or electrical support. There was a complex negotiation going on about use of language, English and Japanese, depending on the category, and there was also significant regulatory input on anything dealing with exiting or safety.

The Graphics Department of WED was already overcommitted on delivery of EPCOT, and so I found myself and a small team more and more picking up the details needed to get the TDL scope of work finished. The Graphics Department started looking at the need for someone on their team to move to Tokyo.

~ ~ ~

Tokyo Disneyland's premise was to bring a slice of authentic America to Japan in the form of a copy of Florida's Magic Kingdom Park. The OLC team believed the park needed to be authentically Disney, based on the real American version. There were plenty of "knockoff" versions, and they wanted the audience to know theirs would be the only true Disneyland. For Disney, this was advantageous, because with most of the company focused on EPCOT, the drawings for the Magic Kingdom could be transferred over to OLC contractors without much intermediation. But there were two big caveats to this thinking. They both had to do with language: how would an audience of mostly Japanese non-English speaking guests navigate the park safely and comfortably as was the expectation in America, and how would they understand shows—everything from live "spiels" to show narration and, perhaps most difficult, anything spoken or sung by an Audio-Animatronics figure.

Legal Affairs for Frank Stanek's TDL team was led by Lee Lanselle. Lee was an MBA who'd gotten his bachelor's degree in Japanese studies at Yale. Lee quickly became a friend and mentor. Lee also became the central force in our understanding of the language challenge, framing it up, and making it a successful initiative. It was one of the hardest tasks in the project, but Lee was the perfect executive to handle it. Lee was completely bilingual and had lived extensively in Japan with his wife, Mako, and was calm and thoughtful, important assets when working with a wide constituency of opinionated people inside WED, at Disneyland, and at OLC.

I was grateful to have Lee's mentorship and soon learned that signage was going to be a challenge. WED had a department called Nomenclature, and it was responsible for every written word inside a Disney theme park. This department was backed up by the senior wordsmith of Disney, Marty Sklar, who was laser-focused on making sure language in the parks was consistent, and authentically "Disney," a difficult-to-quantify quality Marty mostly had in his head. He knew it when he saw it. And when it was wrong, he knew it immediately. Marty's sensibilities had been honed by working directly with the source, Walt Disney, during the emergence of Disneyland from a single park to a globally recognized wonder of the world. Time is sometimes hard to fathom, and it still amazes me that the same WED halls I was walking, Marty had walked with Walt himself during the years I was visiting Disneyland with my parents.

Marty shared the leadership of WED with John Hench. John was the senior visual and design leader; he concerned himself with any building, attraction, or show, and his interest went down to the level of every color seen inside the park. If Marty was the voice of Disney, the structurer of all stories, and the editorial leader, setting broad story direction and reading every written word before it left the building, John was the same for every visual design discipline. And John was equally qualified, having also been a direct disciple of Walt himself.

Their jobs were incredibly complex, and they projected themselves as seamless partners. I quickly cemented in my brain that anything with story or words better go by Marty, and anything visual was to be seen and approved by John, especially if it dealt with color.

John was anointed by Walt as keeper of the theory of color in the Disney Parks. John's color theory had been influenced by the Plochere Color System. The Plochere Color System, developed by Gladys and Gustave Plochere, was one of the first commercially available color systems in America. Since its introduction in 1948, it had served as an essential tool for color communication and specification for those in the fields of industry, education, and the arts. The goal was to systemize color so that all hues, tints, tones, and shades were compiled in a logical, thorough, and accessible manner.

Plochere influenced an illustrious circle of clients. Among them were the fashion studio of Max Factor; the architects John Edward Lautner and Richard Neutra; the department stores Bullock's, Nordstrom, Sears, Roebuck and Company; and the paint companies Dunn-Edwards, Benjamin Moore, and Ameritone Devoe. John Hench brought the system to Disney, and it was

closely followed throughout his sixty-year career. But I also once heard from John directly that his simple color theory was based on a roll of candy called Necco Wafers.

At the time of the Civil War, these candies were called "hub wafers" and were carried by Union soldiers. Stephen Crane even mentioned them in his book *The Red Badge of Courage* when he wrote, "The sun was stuck in the sky like a wafer."

By 1914, the colorful disc candies were being advertised as "Necco Wafers," a name they have carried since. During World War II, the United States government ordered Necco to produce its wafers for soldiers overseas. As a result of this action, Necco saw its sales of the wafers soar. Upon returning home, many former soldiers became faithful customers, continued to buy the wafers, and passed them on to a new generation.

I grew up loving Neccos, and I have two rolls that I have kept near my desk ever since John talked to me about them. The important thing about them, according to John, was their perfectly devised range of hues. Although they have every color of the spectrum, they all have a soft compatibility to each other. None is too flashy or garish or dares to stand out independent of the others. Set any two Necco Wafers, or multiples, next to each other, or even paste a yellow one onto a sky blue one, and it works. Try it! It is impossible to come up with any combination that disturbs your sense of well-being. And that, of course, played a big role in the magic of Disneyland.

Lunch Out

My first year at WED was flying by. I learned about many departments—how they worked, and how to get work squeezed in without annoying overworked people. I sat in on a few meetings with John and Marty, mostly in an attempt to get packages approved and ready to go out to Tokyo. I marveled at how focused they could be, seeing undoubtedly thousands of elements from EPCOT every week, and still having to focus on a random pickup package in a rush to go overseas. Steve Noceti, Val Usle, Craig Russell, and I started to be known collectively as the TDL Information Center. We were becoming a brand in the earliest days of personal brands. Instead of shooing us away, departments started calling us, asking us to frame up necessary work streams, to gain information from Tokyo, or to help interpret often confusing questions coming over from the OLC side.

My girlfriend, Georgia, also an architect, had taken a job in downtown Los Angeles, so we decided it was time to move in together. The city's Los Feliz neighborhood seemed like the right place, felt very LA, and was between our two offices. Los Feliz was a few miles away from WED, nicely situated around Griffith Park, and not far from where the Disney brothers' original Hyperion Studio had been located. Los Feliz was fun and diverse and was exploding with new restaurants driven by emerging LA chefs who were collaborating with innovative architects. We could pick up fresh croissants on Sunday morning,

read the *Los Angeles Times* while doing the laundry at the local Laundromat, browse the used art books at Chatterton's (where there was always a big cat sleeping on the stacks), or take in an Australian movie at a small independent art house and then finish things off with a little cheap pasta at Palermo.

Our place in Los Feliz was the rear unit of a duplex. Nothing fancy, but it had an old LA vibe. Our furnishings were typical of a dating, yet to be committed, architectural couple; Georgia and I had made our own dining table and benches from light pine, imported two doors as drafting tables as the living room, had white Chinese lanterns covering bare light bulbs, and we'd polished up some old rolling bread racks for bookshelves. The futon was the bed of choice back then. We met many diverse couples that made up our neighborhood. We felt we were living in a modern and inclusive world. *Hopefulness.* It's what we felt being there.

I decided it was time to invite the now-esteemed TDL Information Center out to the new homestead for lunch. This involved prepared deli sandwiches, getting a bag of gourmet chips, some coleslaw, and scrounging around to make sure there was a total of four chairs available to sit on. Although Val was worried we couldn't afford the time away from the office, I insisted. On the appointed day, we sneaked out to my car at 11:20 a.m. and I drove us all through Griffith Park on the way to my duplex. We drove along congratulating ourselves on our great progress; berating each other's faults, mercilessly; and listening to the loud car radio. As we neared my place, about eight minutes later, the music on the radio was interrupted.

Ronald Reagan, the new president, had been shot.

I had not had time to hook up my television, so Craig and Steven scrambled to hook up the cable, plug it in, and get a network report. Everyone sat on the shag carpet and watched the images. Reagan had been raced away, and paramedics were working to save James Brady, Reagan's new press secretary, and others injured in the attack.

We sat confused and angry together. None of us were particularly Reagan supporters, and arguments had been heard through the offices about Reagan versus former president Jimmy Carter in the election that seemed only to have just ended. But the fear and the uncertainty were still there. Was this our JFK moment?

I laid out my lunch on a drafting table in easy reach of the TV. The food was consumed but with none of the gusto I had intended such a gathering to

generate. But there was still something good about us all being together at this moment of tragedy. We were co-workers on a journey, with a long road ahead. I was reminded many times later—we are not paramedics; we don't do brain surgery. As dreamers, we enrich people's lives, and we take that very seriously. But we don't save them.

A New Boss

It was soon after that I met Dick Kline, who was one of the finest architectural designers in WED history. He was lighthearted, but serious about his work. He drew with a sense of elegance that made me think of Frank Lloyd Wright. He drew on light tracing paper, in either a warm brown or an orange Prismacolor. He controlled the line weight of his pencil the way a watercolorist uses a brush. Dick had a need to draw, and he was prolific; it was in his soul and in his thinking process. But Dick, like many senior talents at WED, was overloaded. He was doing the work of the equivalent of up to four or even six FTEs (full-time equivalents). Shoko Ohto, his amazing assistant in the Tokyo office, had once run track, which made her perfect, since they were always running from one crisis to another.

Dick was part of the small start-up team in Tokyo. The focus was on Disney knowledge transfer. Oriental Land Company staff would receive copies of WED drawings. There were no computers in those days. We sent copies of Walt Disney World drawings, measured in feet and inches, on small index card–sized microfilm cards.

The documents were being used to create the first set of drawings for TDL by a company called Azusa. They were what we called "permit" drawings. Azusa was basically copying Disney drawings, shifting them to metric measurements, and adjusting them as necessary to meet local building and safety codes.

Several things made this process difficult. First, any WED (or now Walt Disney Imagineering) project was complex. The themed architecture was usually historical, scenic, or in some way different from the way conventional buildings are designed. To understand a WED building or attraction, it's necessary to see the drawing to understand the story, but also other details like interior color boards, exterior color boards, and often models and large sample panels representing unique themed finishes such as rockwork of all kinds. The drawings are only the start.

The Azusa drawings looked to us like a diluted version of what we had transferred to them. Much of the detail had been simplified or omitted. It was very hard to translate notes correctly either from the English drawings to Japanese, or vice versa. Tons of important details were being questioned or were missing.

At the same time OLC was fervently analyzing cost with these diluted drawings. Even from this documentation they could predict that the construction of the Disney Park was already over its original budget.

So here was Dick Kline, with a very small team, educating; addressing knowledge transfer, design gaps, changes due to code, and misunderstandings due to translation; pressing for Azusa drawings to be of higher quality; meeting with contractors on materials and site planning; and trying to be an evangelist for Disney quality all at the same time. And that steady hand kept drawing. Being in Japan meant a full day's work in the office, followed often by a second day spent on the phone trying to get information out of Los Angeles.

Dick preferred getting more complete information from the home office. Frank wanted more work done in Japan. The compromise often was to send a person of great knowledge over to Japan and do the work there.

One civil engineer came over many times. He would create grading drawings all day, rarely looking up. He had the office put a drafting table in his hotel room so he could draw all night. This would go on for three weeks straight until on the last night Dick would take him out to dinner to thank him.

In LA, I probably had the best window into Dick's workload. I ran down most of the information he needed, got it to him as quickly as I could. I wrote long explanations for why WED didn't have their homework done on a day he'd promised his OLC colleagues it would be ready.

It was finally time for Dick and his wife, Sandra, to get a home leave. They would have a few weeks back in the United States, some vacation, and we would have the benefit of about a week with Dick in the office.

Because Val was slated soon to move to Tokyo, to support Dick and the design group, he was very busy. He asked if I would take on the coordination of Dick's Glendale agenda and stay with him, keeping track of all the commitments he'd made and, most important, those that WED had made to him during his meetings.

I had never met Dick in person, but I was committed to making myself essential to him in this one week of unique opportunity.

When Dick arrived in the office, I think he wondered a little bit about why I was shadowing him everywhere. But I was relentless, and I took notes in all his meetings, got him coffee if he needed any (it was tough traveling across these time zones), and even called the storage yard where relocation had stored his Lotus and told them it needed to be up on blocks.

By midweek, Dick had taken me on as his interim chief of staff. Instead of me extracting notes from the discussions, he turned to me and asked me to take special note of commitments made. Instead of asking people to follow up with Val, or with Shoko in Tokyo, he asked them to follow up with Bob (me). I viewed Dick as a Disney icon, someone we should all be working to support, who was out there every day making things happen in Tokyo. None of us could guess what he might be going through.

~ ~ ~

In the same conference room where I had planted the "dead rat" and continued to paper the walls with index cards detailing project status, the Tokyo team held a surprise engagement party after I announced that Georgia and I were getting married. There was real champagne, and a subway sandwich that was the length of a conference table. I was unprepared for the thoughtfulness of the team. I never forgot it, and I often remembered it when those I worked with, or who worked for me, had important life events.

After a fairly quick break for the wedding and a trip up the coast to Monterey and Big Sur, I was back to work with my TDL colleagues.

It appeared that when Dick Kline had arrived back in Tokyo, he had been quite happy that my comprehensive notes for follow-up from his trip were already on his desk. And I had already followed up on most of the questions or information needs he had raised during his visit.

Relocations were kind of a miraculous event back then. They emerged through extreme need, and usually involved a senior WED specialist. Behind the scenes, Dick had requested that I relocate as soon as possible and support

him directly. This came as a surprise to the Glendale team, as it put me ahead of Val, my boss, in the relocation queue, and ahead of the next obvious need, which was for a graphics leader. In fact, Frank went to WED management and requested I represent graphics as an administrator, from Tokyo. I went home and asked Georgia if she felt ready to start thinking about moving.

Queen of the Skies

The elegant double-decker Boeing 747 aircraft had a takeoff weight, for an Asian long haul, of nearly one million pounds.

It was fall 1981, and I sat in 1A, a first-class seat, looking out the window, unable to fathom that we were using nearly two miles of runway before lifting off in a behemoth Japan Air Lines aircraft over the sand dunes of Dockweiler State Beach and out over the open blue Pacific.

I was used to flying short domestic routes. A plane would bank to the right if headed toward San Francisco, or more gently left and over Long Beach and Disneyland if headed to the East Coast. But this time the nose simply pointed west, heading toward the nearly five-thousand-nautical-mile journey to Tokyo. We would be flying for twelve hours. These numbers seem so routine today, but I have never lost my sense of wonder at them.

We were beginning what was called a "pre-relocation trip," or an opportunity to try out life in Tokyo before actually committing to move there. In our minds, it was a bonus trip, a chance to meet my colleagues at the office, to tour the city. But we had no intention of saying no. We had already committed to taking on this adventure.

After several hours of deep sleep thanks to the constant roar of the 747's engines, I woke to Richard Clayderman's piano "Ballade pour Adeline" over the plane's audio system. I looked out and through the wispy clouds, saw an

irregular grid, then a tapestry of rice fields and farms scattered as far as the eye could see. Each estate had small houses and a large barn, plus dark waves of tiles and ornamental ridges defining all of the building roofs. There were scattered streams and small bridges and little trucks moving along the curved roads. Between the fluffy white clouds, pink sunset light broke through and side-lighted the buildings and the bamboo forests. It was the most bucolic scene I had ever taken in, and with the piano music, I felt I was already bonding with Japan.

It's said that relocation is one of the most stressful things you can do. But this first trip seemed pretty much like fun to us. The old Tokyo Hilton, in the city's Akasaka district, was a modern relic that the Beatles had stayed in. The hilly surroundings were wonderful place for a 5:00 a.m. jet-lagged walk through bamboo landscaping and up to the nearby temple.

The HR people had their agenda and every intention of being efficient, friendly, yet focused. Their job was closing the deal. Each day, during that first visit, the relocation associate who had been locally hired would take a lumbering, jet-lagged group of about eighteen Americans out to show them the wonders of Tokyo, as best they can be seen from a big air-conditioned bus. Mind you, that many Americans in one place is a lot to handle—particularly that many adult Americans, no kids, steeped in Disney, and thinking about moving and making comparisons between American life and what might be their life in Japan for a few years.

We were young and had nothing except a small duplex apartment in Los Feliz, so every apartment looked luxurious to us. The whole proposition was a pretty good financial deal for us as well as what promised to be a tremendous adventure. So, we just lay low, hoping no one would consider us too eager.

We were surprised at how easy it is to whip up a group of senior employees of a company to complain about small details when the true intent was not to transport your life in the San Fernando Valley to Japan. It was to transport you into another world, and to be taken into that world as a *guest*, an important guest, a well-treated guest, and yet a guest who is there for an important job.

I never felt anything other than the importance of why we were going. I felt like something of a junior ambassador, not just a junior park designer. And the ambassador's side of me felt a great obligation, an obligation I wanted to fulfill, had a passion to fulfill, to reach across the two cultures, to meet people, and to have quality friendships and understanding between us.

Much of the relocation visit seemed to rely on taking Americans to places

that looked like what Americans might like. We took a lot of our pre-arranged meals at coffee shops that had ice cream sundaes and Western-sounding restaurants that had big steaks or spaghetti. We never even had the chance to partake in local dining or shopping. We went to relatively Western markets and saw dozens of Western-style apartments. When one gentleman complained that the kitchen counters in a place had a seam every three feet, I thought to myself, *My entire kitchen counter in LA is only three feet!*

At the conclusion of the pre-relocation trip, we were certainly convinced to come back to Japan, just not with sixteen associates . . . and never again on a bus. We were subway people, walking people, open market people, get-lost-in-the-crowd people. Had they asked us to just stay at that moment, in a one-bedroom place, with a toothbrush, one change of underwear, and nothing shipped from the United States, we would've still taken the deal.

After a long week of Western coffee shops, duty-free stores, and sample apartments in Central Tokyo, I was hungry to go out and see the project we were going there to build.

The big bus pulled into the site office in Urayasu, the small town where Tokyo Disneyland was to be built. As if on cue, Don Edgren appeared in a hard hat and a site jacket to greet us. It was like a dream, and I still remember the moment. Don was a mythical WED figure, a name on communiqués streaming in by Panafax every morning. And here was the man himself, one of WED's great engineers, smiling, humble, welcoming, a gentleman coming out to meet us in person, having only recently suffered a heart attack and still recovering. He led us into the site office where there was a model of the whole development. Then Don escorted us to (and narrated for us, in his wry humorous way) a bouncing bus tour across the muddy 120-acre site that we hoped someday would be the world's third Disneyland.

We were at the end of our first visit. I told my new boss, Dick Kline, that I could stay longer if he needed me to. Everyone in the office was inundated with approvals and requests, so I knew he was heavily stressed, and hoped I could help him get caught up.

"Yes. And would you stay two more weeks?"

~ ~ ~

Back in the United States, the transition was stressful. Georgia had resigned from her architectural job. I was working long hours at the office to prepare everything I needed for the next phase of the project. Packing days, no matter

how small our household, were stressful. As well as all the paperwork, clearances, language classes, and goodbyes to friends and families.

The night before we were to depart, our duplex was empty and had that echo sound that says you're leaving. The packers had come that day and taken everything. I had accidentally broken a glass platter before they came. I packed it up in a box and put it by the trash. I wrote BROKEN GLASS on the box so no one would get cut. Later when we checked the shipping manifest, one item included was 1 BOX BROKEN GLASS. Instead of the trash, it was on its way to Roppongi, the district in Tokyo we'd be moving to. These packers were serious; not a crumb was left over, not the end of a toilet paper roll, or a box of broken glass.

For our lovely final night in LA, HR provided a room at a budget motor lodge in Burbank. It certainly wasn't a place to relax after a stressful few weeks of packing.

We took full advantage of the absence of hospitality and full advantage of our stress levels. It was a perfect place for us to blow off our intense stress for the process and with each other, and that is exactly how the night was spent. I wonder how many couples get to the last night of a major transition and don't make it. We were on the edge, and almost didn't.

And despite a rumbling window air conditioner and the sound of people coming up and down the stairs all night, we did get a few minutes of sleep on two separate beds. Without much conversation, we were up the next day, in the car, and on our way to the airport.

The twelve-hour flight, and incredible service on JAL, calmed us down and even cooled our dispositions a touch. There was no big crowd of Disney people this time, so it was only the two of us in a hired car, this time getting to stay, upon arrival, at the famed Imperial Hotel. The Imperial was located across the way from the Imperial Palace, where Hirohito, the supreme leader of Japan during World War II, still resided. The hotel was a legend in history. The original had been designed by Frank Lloyd Wright. In spite of reports about the damage caused by the 1923 earthquake, and later from Allied bombings in World War II, somehow each time the Imperial had been spared. The original Frank Lloyd Wright structure had since been moved to a museum, and now the hotel was mostly new, but the dark lava stone bar was still there, exactly as Mr. Wright had detailed it in 1915.

Free from our relocation supervisors and co-workers, and untethered from a bus, we took an early evening walk through our new city. It didn't take much of a walk to descend down under the railway tracks. Here under the arches of

the tracks were multiple small stands serving yakitori, or chicken (and many other things), on sticks, on small barrel tables with short stools. The bare light bulbs and wires were coated with years of soy sauce–smoke residue. A gray-haired gentleman with a flat top served us. He quickly gathered that we had no grasp of Japanese and he could pretty well tell we were foreigners. He helped us order chicken sticks, shishito peppers, and a few rounds of Kirin beer. We were eternally grateful for his service, and in the years moving forward, I always went to his shop the first night I arrived in Tokyo, and he was always there. I wish I'd learned his name.

After dinner and showers, we were ready to crash, though the sun was barely setting. The room had heavy blinds, warm wooden furnishings, and heavy woven blankets. There were two small beds, and we managed to squeeze into one of them. Georgia quickly began light snoring next to me. There was an old-fashioned cone-shaped desk lamp next to me. I turned it on, and the little holes in it sent sparkles up into the ceiling. I reflected on how much had happened in only a bit more than a year.

My father was not old enough to really remember World War II, or the Depression, but he had heard about them from his parents. And his mother's best friends, a Japanese family, had been taken away at night from their house to an internment camp, as had many others on the West Coast just after America had entered into World War II. He told me I should be careful in Japan. "You never know what might happen," he said. "You are an American, and so you don't know what animosity you might face." I hadn't taken his advice seriously, and I didn't even share with my parents our flight numbers, or where we would be staying.

As I went to sleep in my comfortable bed, the lights of the city were streaming in the windows and lighting the ceiling above. I had dreamed of being here, and I felt as safe as if I had been in my own bed in my own country.

The sun came up early in Tokyo, about four o'clock in the morning. The news services carried the story that the Hotel New Japan, not far from us, had been engulfed in a terrible raging fire overnight. At least fifty-four people were dead, many of whom had no choice but to jump out of the upper story windows.

By late morning, news services were already blaming faulty builders and bribed building officials. Materials not suited for high-rise construction had accelerated the fire's spread, and the resulting black smoke may have worsened the disaster.

At noon, the shock was still hard to believe. I was picking up a light lunch

at the site commissary. There was a television mounted to the wall, carrying NHK News. There were reports that an airliner, JAL 350, had crashed into Tokyo Bay short of the runway at Haneda Airport and at least twenty-two passengers were confirmed dead.

Preliminary reports said the captain had a history of mental illness and may have crashed the plane intentionally.

~ ~ ~

It suddenly occurred to me that my parents knew neither where we had stayed nor what flight we had taken. I called them, and they were indeed panicked. I made light of it, told them we were fine, and I committed to giving them a little more information about our whereabouts. Their nerves were calmed, but the mood around the office, and we sensed around the city, was apprehensive. The news reports had gone from disbelief to reflection. Japan was at a high point, a global powerhouse by any measure, and lauded in the international press as a stunning success story, of people and government, of cooperation and hard work to benefit the greater whole.

A few of my new acquaintances gave me some perspective after work and usually over a beer. It was hard for them to believe that the success they'd all worked so hard for, the global respect, could all be questioned by the bad judgment of profit-making developers, company executives, and government bureaucrats who were paid to look away. It was a blow to their "face." And "face," I would learn, was an incredibly important part of life and success in Japan.

Working in Tokyo

Much later in my career, I would hear Marty Sklar often talk about a blank sheet of paper. He said it was easy to see a blank sheet of paper as the scariest thing in the world, because no one has made a single mark on it. Marty encouraged all of us to see a blank piece of paper as the most exciting thing in the world—for the same reason—no one has made a single mark on it.

Tokyo Disneyland was the first mass construction site I had ever seen; it was like a 150-acre blank sheet of paper. I saw it like Marty's blank sheet of paper. It was filled with possibilities. It was also the scariest thing in the world.

I had watched Dick Kline work, watched his talent and patience. I'd seen Tom Jones rustle in and out on a cloud of energy, laughing off what were obviously tense meetings. I was the most junior of the Disney team, and it surprised me how quickly I was in over my head.

The TDL field office was a short drive from the building site, and it was comprised of temporary metal buildings, with light-duty staircases, all sitting in the same kind of mudhole that characterized the rest of the district. The office was overwhelmingly staffed by Japanese workers, managers, architects, engineers of all kinds. It was accepted to smoke inside buildings at that time, so there was a constant gray cloud in the air, and the nicotine residue coated every table and drawing. Women were either support assistants or interpreters; the architects and engineers were mostly men. There was a rapport among the

Japanese staff that made me wish I could speak their language. There were lots of versions of "ohayo gozaimasu" called out in the morning. It was one of the few phrases I knew ("good morning"), so I joined in. There were many versions of the greeting, shortened by familiarity. Sometimes just "ohayo," sometimes "hy-yo zaimoos," sometimes just "oos." But always it was cheery and filled with optimism for a good new day.

These very talented professionals were not part of the normal corporate structure of business in Japan or the "shushin koto" (lifetime employment system) we'd all heard about in cultural training. This was a team specially assembled for one purpose, and one alone: to work with Disney to successfully build Tokyo Disneyland. Some were borrowed from contractors, some had small companies they put on hold. Many like me were in their midtwenties, starting their first professional job out of university.

The Disney team they'd met so far were mostly senior, or semiretired, and deeply experienced; they combed their hair carefully and wore business casual clothes, and often neckties, to the field office.

When I first arrived to work in Tokyo, I was still at my thin college weight, and I had frizzy curly blond hair that was quite long. Actually, my hair never grew long, it just grew out, and I never did anything with it, which fit in fine in college theater, and more or less at WED. But I was a very unusual character for the OLC office folks. I was quickly nicknamed John McEnroe, then a young emerging tennis star. I'm absolutely certain I never had the good looks or physical presence (or, thankfully, the temper) of John McEnroe, but for our partners, it seemed to work as a worthy, memorable, colorful description, so I embraced it.

Although I would soon learn there were lots of public transportation options to get from Central Tokyo to Urayasu, where TDL would be located, the relocation folks had set up a private commuter bus system to get us safely to the office every day.

The apartments for most of the expatriates were grouped in relatively central areas, so at the beginning it only took a few buses to handle the commute, picking up ten or twelve people per bus and then getting on the expressway to the site. The site was about an hour from Central Tokyo by bus, and it was a visual ballet to ride through Tokyo. There were layers and layers of urban life to take in, interesting utilitarian buildings, many bridges over the highway and the city's canal network. Trains would pass over us in a wonderfully choreographed procession, a green train going behind a red train, and then a "Shinkansen," or bullet train, racing on another track between them.

From the back of the bus, I would often hear the senior members of our team shout and groan as they played cribbage.

I had never lived in a massive city before. Pomona, California, the town I grew up in, had eighty thousand people. Even LA, where I lived for a short while when I started at WED, was a city of only 7.5 million. In 1981, Tokyo's metropolitan population was twenty-nine million, or nearly four times as many people, and in a smaller area. With my architectural roots, I was always absorbing the diversity of buildings. Everything in Tokyo had a gray look. There was very little color at that time. Buildings were gray and they seemed often to be made of a kind of gray subway tile. They were all modern and boxlike, and everything seemed to have a few years at least of dripping rain residue on it. This left streaks of black on the tiles. Things were interesting, but seemed, even when they were new, to be rather aged.

The shuttle buses would arrive, and we foreigners, "gaijin," would go our separate ways. I was squeezed behind a small drafting table, with a side table, and a bookcase, and I started to unpack. I had prepared thick notebooks of reference photos of graphics at Disneyland, and Walt Disney World, close-ups showing materials and connections. I had boxes of material samples: small pieces of synthetic wood painted and textured to look like Frontierland (which in Tokyo Disneyland is named Westernland) or bamboo for Adventureland. I had my college architecture structures manual, and the important box of Plochere color samples.

I found the coffee station, and a few paper towels to dampen and wipe the months of dust and smoke off the table. It was the last time my table would be cleared off until the park opened.

I started to unroll the pile of drawing sets and stack them on my table, one after another: piles of review sets, approvals needed, details needed, questions and requests that had been submitted days, sometimes weeks, ago.

Shoko Ohto again was our lifeline. She was a combination administrative support, interpreter, doctor, and cultural advisor. She handed me a beeper. It was about the size of a D battery, with a belt clip and one button. Her instructions were clear: if it beeps, find a way to call me. A button reset it, and that was it; no digital message, no phone number. It was the lifeline to Shoko, and that was all I needed.

She set up my first vendor meeting. I was excited to meet my new collaborators. The room was packed. There was me, and about forty men looking for answers. I felt they probably wondered how Disney could send someone so

young for this responsibility. I could feel it, and the pitiful mustache I'd grown was not going to help.

There were about four thousand signs needed to open the park. Most of these had examples from the Magic Kingdom, and these had been sent on microfilm cards to OLC. OLC had subsequently sent half the park signage to a company called Tanseisha and the other half to Nomura, both top sign makers in Japan. The representatives of both companies filled this room, and they had lots of questions. My warm hello and plans for a cultural handshake were quickly replaced by a queue. Each representative had a pile of questions. I went through them, patiently, one by one. I didn't know the answers to most of their questions. As much study and preparation as I had done, I could feel my lack of direct experience showing, and my credibility sinking. I did my best, and for those questions I couldn't answer, a tall pile was left for my follow up.

They all asked, "When will we get our answer?"

"Tomorrow," I promised.

I went through as much of the pile as I could, separating those questions I thought I could answer from those that needed help from Glendale. I quickly drafted a communiqué to the Graphics Department. Shoko typed it out in what felt like seconds, and it was off to Panafax.* The shuttle bus was leaving, and I didn't yet know my way around to get home any other way, so I rolled up a pile of the drawings, grabbed a couple of sharp orange Prismacolor pencils, and ran to catch my bus.

From my seat on the bus, I noticed that at sunset the gray city had come to life with lights and signs, brightly lit graphic billboards, brand marks, simple animation dancing up and down and across tall buildings. It was a master-piece on a canvas with sparkling lights and neon. As down as I felt about my first day, the city soon uplifted me. I got off at the stop near the Ginza (the entertainment/shopping district in Tokyo) and walked. The animated lighting on buildings reflected on the damp sidewalks, creating a kind of stop-motion effect on the pedestrians. Massive neon animated soffits pulled pedestrians in from the sidewalk, luring them in like moths to a porch light. Tokyo was a high design, exciting consumer culture hub, and product was everywhere. Fashion,

*Disney mechanical engineer Dave Schweninger once told me Disneyland was built without Xerox machines. I remember marveling at the thought of that. But here we were, building Tokyo Disneyland with no computers. We used notepads, pencils, and pens, and when you needed something typed, the only typewriters were with the administrative support team.

lifestyle, beautifully wrapped fruit, and technology—cameras, video, lighting, stereo systems—with fans set up by merchants all blowing onto the sidewalk with little streamers tied to them.

A high-tech computer vendor was right next to a shop where a woman was chopping blocks of fresh wet tofu. "Irasshaimase!" It was heard from every doorway, the shopkeepers' welcome. It was always sung by an excited greeter, often in white gloves, who also handed out free small packages of tissues.

Georgia had searched all day for possible apartments, so she was feeling at least as frustrated as I was. We met up in the massive lobby of the Imperial. It was the hub of Tokyo's social business scene, especially for international visitors. It was what I would thereafter think of as a model of a great hotel lobby—wide art glass wall, seating for a few hundred visitors, people passing in and out, the occasional message carrier with a handheld bell and a sign, and attentive servers. We learned to say "Kirin beeru oh kudasai," and it was delivered by magic. My roll of drawings was calling, and I started thinking about room service so I could spread them out in the room.

But I realized that Georgia was dressed up, ready to go out. I could tell she'd had a lonely day. She was too self-confident a traveler to admit it, but I knew being stuck by herself in a strange country was starting to affect her. I dumped the drawing sets, and we headed out to explore a new restaurant somewhere. There is a terrible term in HR: the "trailing spouse." I didn't know it at the time, but the excitement of a foreign assignment is a mixed blessing. For one member of a family, it is a new and stressful job. For others it means absence from home and family, leaving their own career behind; for children it's new schools, and new social pressures. I'd learn this, but the lessons would be very hard.

The sun rose at 4:00 a.m. and I was up with it. My lifelong struggle with jet lag was already beginning. I quietly unrolled the drawings in the light of the bathroom and looked for quick things I could answer. I felt I had enough good responses to get the second meeting started on a positive note, and I knew there'd be some gold in the answers from Glendale in the morning faxes.

But the next meeting with my team was as tense as the first one. My answers were quickly absorbed and overshadowed by a mountain of new questions. There had been no answer to my urgent list of questions, sent the night before to Glendale. I asked Shoko if she would mind checking again—nothing. It was 7:00 p.m. in Glendale, so I doubted I'd get any help.

This cycle was repeated. I'd take a mountain of questions from the vendors,

answer what I could, send questions to Glendale, then meet again. I carried drawings and pages of notes back to the hotel. At times I'd call Glendale at 4:00 a.m. my time, from inside the hotel bathroom, trying to get the most critical questions answered.

The urgency was easy to read on the faces of the vendors. They were now working against impossible deadlines, and they had snippets of documentation, lacking detail . . . and it was all in English.

I began feeling farther and farther behind. And we were both getting weary of living in a hotel. Relocation was saying it could be more than another month before any apartments became available.

I realized, stupidly, that Saturdays were great days to work. I could just take a taxi or subway to the office and have a quiet day to catch up. And a few of us discovered a mecca, or at least what we thought it seemed at the time. Halfway down the bus route between the local subway station and the office complex was a magical place, just steps from the bus stop. This unique invention of Harold Butler and Richard Jezak's had first opened two years before Disneyland, and here was one of them, right in the Urayasu suburbs of Tokyo! Yup, Urayasu had a Denny's. After a Grand Slam breakfast, and a bottomless cup of coffee, all those concerns about work-life balance seemed to melt away. Working until five o'clock on a Saturday seemed downright civilized. But none of it was sustainable, as I would soon find out.

Allies

Less than a month in Tokyo and I knew I was headed toward failure. My self-confidence was drained. The training from Frank Stanek and Tom Jones needed to kick in. Long nights sitting up worrying about work were not going to help me. If those two leaders had taught me anything, it was to go after dead rats, and that I had the football. Wait, what?

I made a mental list of what I had to do to break the logjam:

Find some allies.

Go local.

Share the challenges.

Get a life.

To gain allies, I had to stop looking at my meetings as gatherings with a big group of anxious vendors, competing for answers. I had to see them as talented designers and builders, with massive experience in their own culture, and providers of knowledge I needed to tap. I had to drop the idea that I was some kind of Disney expert, there to impart my wisdom to them. I was their collaborator; we had a big challenging job we were set to embark upon, and we needed all our expertise to do it. It has always been surprising to me that as obvious as this is, it's easy to forget.

Cultural arrogance gets you nowhere.

I sought out four allies: Hiroshima Shinozaki, who was the OLC graphics

lead; Akio Saito, the lead designer/manager for Tanseisha, and Matsuno Sato, his counterpart for the Nomura Sign Company; and Noriko Ishiolka, my interpreter-coordinator. They would become, for me, Shinozaki-san, Saito-san, Sato-san, and Noriko-san. We became bonded in the challenge, trusted compadres. I reached out to them for help, for guidance, and for honesty. This meant talking after work, around a great casual dinner, with cold beer and a warm box of salted sake.

It turned out Shinozaki-san, Saito-san, and Sato-san were under as much pressure as I was, if not more. The stakes were very high for these leaders. Tokyo Disneyland was considered one of the most important projects in the country. Companies were vying for work, for it would be a landmark. But it was not merely a project assignment, it was a responsibility to the city and to the country. We would all shine together, or we would all share an unimaginable loss of "face."

Add to that, OLC had assumed Disney's projected budget to be legitimate, even though it didn't reflect the adjustments to building in Japan, especially at the level of quality that the Disney reputation would require. Now, with the real costs of building the project rolling in, the budget was trending upward, and the time schedule was moving out. The contractor vendor network was under huge pressure to secure Disney approvals, to move forward with production and construction, and to try to save as much money as possible along the way.

My four allies helped me sort out the massive logjam and prioritize what needed to be done first and what could wait. Our vendor meetings became organized. Shinozaki sat next to me. We managed answers and found work-arounds together. I wrote with a fat orange Prismacolor, and he had a mechanical pencil with the thinnest lead imaginable. The vendors saw us collaborating, they saw a rapport developing between us. I showed a genuine sensitivity to the concerns over schedule and budget. The tone of the daily line of vendor questions changed. Sato-san and Saito-san organized their own teams, and they led the presentation of the most important questions for the day.

If I didn't have an immediate answer, we discussed solutions. They made sure everyone got out of the meeting with what they needed, and I knew what was reasonable to find out for the next day.

Go Local

It was fairly easy to come into a new situation and say, "That's the way we do it at Disney." It was as easy as it was ineffective. I was in Japan, not Anaheim, not Orlando, and certainly not in Glendale.

I set out to learn the local process and experience. Lo and behold I found vendors to be very open to my visiting their offices and factories, to explaining how things were done in Japan. It gave me insight into their questions and helped me modify our processes to work more efficiently in this part of the world. I learned pride in craft is something very important in Japan, and even if I had to ask for something to be done over, I tried to make sure I did it with respect and appreciation. I did a lot of handshaking, bowing, and toasting. It was helpful to advance the job and it made it a lot more enjoyable, too.

Sony had just come out around this time with the Walkman. I loved using it (with cassette tapes!); the depth of music and the static-free silence in between was deeply appreciated. I gave my Walkman to Jun Nakai, one of the interpreters, along with a list of about twenty-five phrases I wanted to learn. I didn't have the time or patience for full-on language lessons. But I wanted some phrases I could weave in and out of conversation, at least to show some effort of localization from my side. She recorded them and I listened to them on all my commutes. Here's some I still remember:

Thank you to you and your entire team.

This craftsmanship is excellent.

Are you having fun working on the project?

What food should I order here?

What do you do for fun when you're not working?

When can we review the final drawings?

Is there another way we can do this?

Can you speak more slowly?

I used the last one a lot. They were fun to drop in when the context was right, and they were more impressive than just saying left, right, and where is the bathroom.

I carried little Disney trinkets in my bag when I traveled. If someone had a kid at home or was a Disney fan themselves, I always tried to have something to give away.

Luckily, there wasn't much in the way of food I wouldn't try, so I think the vendor/hosts liked to test me, which gave us something else to bond about. They really couldn't freak me out with abalone intestines, raw writhing shrimp, or warbling bees' larvae. But they tried.

Share the Challenges

There are many personnel reports about the stages of expatriate life. Expats develop a sense that the home office either does or doesn't really understand the local situation. And after a while, the home office starts to wonder about you—who's side is he on? Soon walls come up. I was well on my way toward this way of thinking already.

I sought the counsel of my boss, Tom Jones. Two pieces of his advice most resonated with me now.

First: "Bob, the company put you here because they trust your decision-making; you're the only one who knows what's the best decision to make now, right here on the ground."

Second: "I would rather be fired for doing something, than fired for doing nothing."

I worked hard to have trust in my own instincts and to not worry about being second-guessed. I valued the home office. But instead of sending too many questions, or building a wall, I tried to keep the channels open. I called every few days just to update and chat, to build trust, and I limited the questions to those that really needed Glendale's help. In addition, I tried to weed out too much noise. As frustrated as I might have been about late responses or sometimes no response to overnight requests, I developed some empathy that they were under the pressure of completing EPCOT and its impending opening.

Get a Life

Oh, yeah, that!

I managed to start getting one, at work and at home. Japan was a beautiful land and culture to explore, and I remember every place Georgia and I visited. We carried our cameras every time we went out. We invited family and many friends to visit us from the homeland and loved touring them around Tokyo. We loved going to the antique flea markets on Saturday mornings, sitting under the cherry blossoms and drinking sake amid the tombs in Aoyama Cemetery, going to temples and gardens, and cooking with exotic ingredients from open markets. I bought a Super 8 mm film camera with sound and carried it around with me often.

We often hosted co-workers at our place for dinners. I even tried a Cinco de Mayo barbecue. At the time there were no tortillas available at the local markets. A friend coming on a business trip brought me a big bag of tortillas from LA. I met him on his way in and we had dinner and at least a few beers, and I left the tortillas in the back of the taxi. The party went on, with the guests spending the first half of the afternoon learning to roll out and cook tortillas from scratch. (I also learned that the side of a wine bottle makes a pretty good roller, if covered with flour.) It was an honor to be occasionally invited to a co-worker's home, to meet their families. Many had creative hobbies, including one who collected model train sets, all of them rolling around circuits in his tiny Tokyo apartment.

In April, friends took us across the bridge from the Imperial Hotel into the fortress complex of the Imperial Palace. A hundred thousand people must have had the same idea. It was Emperor Hirohito's eightieth birthday. We were waving little white rising-sun flags like everyone else as he stepped out onto the palace's balcony and waved for a few moments. It was one of those stunning moments in history that often struck me in Japan. As we waved our flags and cheered with the crowd, it was just thirty-seven years since Hirohito had spoken these words to the citizens of Japan, when it agreed to surrender, speaking to them on radio for the very first time: "Unite your total strength, to be devoted to the construction of the future."

Like Hirohito, Walt Disney was born in 1901.

I made a discovery about myself, too. I love being at construction sites. It is like war in some ways, except no one is going to shoot you. They just want to run you over with land-moving equipment and concrete mixers or drop giant loads of rebar on your head when you're not expecting it. Working on a construction site in Japan was a special experience. The workmen (and they were *all* men) were conscientious about every detail. Every few hundred square meters had a broom monitor, and the area was kept swept and dust-free. Workers wore neat vests and often ties. Their boots were two-toed to give them better agility, and they demonstrated a high degree of competence in the use of every tool and technique. Sato-san and Saito-san especially took me under their wings on the site and helped me understand how signs needed to be reinforced, how they got that done given the complexity of approvals necessary to add something to a building package, and how to steer clear of hazards.

The biggest hazards were the latrines and the on-site food service. I grew up watching the *Mash* television show. I don't say our situation could possibly have been that bad, but the food and latrines were probably close. The latrines on the TDL site were lines of stations where men would stand, do their business, as small amounts of water would occasionally pass by to refresh the trench. It was almost intolerable to be there for even a few seconds. The on-site cafeteria was conveniently located directly adjacent to the latrine complex. The cafeteria served one item, more or less. In giant dented stockpots, they boiled rice and yellow curry. The curry had long strings of mystery meat in it. When you had been on-site all morning, and it was cold, and the wind was blowing off Tokyo Bay, a big steaming bowl of mystery meat, yellow curry, and rice was, however terrible, still sustenance. And anyway, the long tables had jars of pickled ginger and hot chili sauce, too. Survival was possible.

~ ~ ~

By early summer 1982, we were hitting a stride. That did not mean the job was getting any easier; in fact, it was very difficult. Budget and schedule problems had created quite a divisive situation between Disney and OLC. OLC was under pressure to make cost cuts, and the Disney team was under pressure to ensure that the project maintained Disney standards. Since most of the project had been only lightly documented with microfilm reference drawings from Florida, there was a huge gap in understanding what we actually required in terms of quality. The fallback on the Disney side was some intangible "Disney quality" standard as defined by whatever we could document, usually photos of existing parks. The OLC fallback was that if it was not on the documentation, it wasn't in the scope of work or in the budget.

Time became leverage on both sides. OLC often refused to make corrections for fear it would jeopardize the opening date being publicized. Disney would withhold approvals, which in turn could jeopardize the opening.

I had four people from the Glendale Graphics Department working in the TDL field office, led by Greg Paul, a true design genius in Disney and in themed vocabulary. Greg never met a curved line he couldn't improve, or a color he couldn't match more closely. I was grateful for him. He led an intense drawing review process, made color and material approvals, edited typography on camera-ready art, and was about to divide the load of vendor visits with me.

I attended to additional concerns Dick Kline had, some which were distracting him from the main core of delivering the Disney Park. Sponsorship was a huge load. As for Disneyland and Walt Disney World, sponsors, including Coca-Cola and a variety of other companies (toy makers, ice cream sellers, meat producers, and banks), vied for brand positioning. And they couldn't understand why they paid such high fees and then saw Disney restrict them to such small logo marks or displays. I spent a lot of time explaining to executives what the Disney-themed show meant, that it was made up of stories and narratives, and that Walt Disney's genius was to take people out of their normal world and into a world of magic, story, and comfort. With Tokyo being such a competitive advertising environment, it was easy to see how they felt.

I insisted on those sponsorship formats that I knew Marty Sklar had developed back at Disneyland. That an attraction is, for instance, "it's a small world," presented by Bank of America at Disneyland in California. In the case of Tokyo Disneyland, it was going to be the Japanese department store chain Sogo

presenting the attraction. But the primary message is the attraction; the secondary message is the sponsor. It was a hard slog. Everyone wanted to go over my head to Dick, and over his head to someone else. It was a unified front we presented to survive.

Language was the next heftiest challenge. The OLC sign vendors lacked American fonts, so often sign typography was all being drawn by hand. At the same time, nomenclature was changing constantly. The agreement, at the strong encouragement of OLC, had been made that TDL should have the look and feel of an "American" visit to Disneyland. Main marquees would carry English only, or sometimes a subhead in Japanese. Secondary marquees, informational graphics, and those focused on safety would use Japanese and English, with Japanese as primary. But everything needed themed typography and rich color design, just as was expected at Disneyland. That meant that signs along Main Street (in Japan known as World Bazaar) needed Japanese characters designed to look like they fit in to 1900s America. In Frontierland (in Japan called Westernland), old signs, looking hand-drawn and made of broken pieces of aged wood, needed Japanese characters that looked like they came from the same improvised setting, usually hand-drawn, and with intentional silly misspellings.

It seemed like just as we'd finalize a sign design, the nomenclature, either in English or Japanese (or both), would change, often for a legitimate reason of clarity or regulation. But it was frustrating. We made a few steps forward and a lot back.

Meanwhile, the time had come for me to take my first home leave. Home leave was a time for you to take a break, visit home, and chill out from work. And if you didn't take it, you lost it. My parents had recently visited, as had Georgia's, so we set our sights on somewhere we could go that was easily accessible from Tokyo, yet a world away. We decided on Australia and New Zealand. It was a fairly straightforward option from Japan, and close to the same time zones. With no computers and no cell phones, it was easy to unplug on a white sandy beach on the north shores of Queensland or go snorkeling off the coast of Cairns. I dreamed about the possibility of being on assignment in Australia, at a Disney Park there complete with beaches and kangaroos. And then there was still time to snow-ski Mount Cook in the middle of August, and to experience the meditative silence of Milford Sound at the southern tip of New Zealand. It was good to remember that there was life outside Disney, however implausible that seemed when we were in the middle of Tokyo.

Upon my return to work, Tom Jones was unhappy. It seemed the graphics deliveries had slowed down, and Glendale had told him they were feeling out of touch (hello—I'm skiing in New Zealand!). Touring new parts of the world gives you fresh optimism, a sense that the world is not such a bad place, that everything is possible, and it wasn't really that bad you had that extra lamb chop and the beer to go with it. But it's hard to come back. If it had been a problem when I left, it had grown worse, and if it had been a budding problem when I left, it was now in full bloom.

But I kept my chin up. I knew our little TDL graphics team had been plugging along and just needed some support, and that Glendale was just feeling a little lonely that I hadn't called them for two weeks. I kept going, with fresh energy. Plus, I had a little pile of Vegemite packets, a dark brown savory spread made from yeast extract and flavored with vegetables and spices, that I could bring to add spice to the commissary lunches.

I loved visiting the facilities of our vendors in Japan. A day would begin usually with a bullet train ride north toward Saitama, or south toward Osaka, or beyond. No one had built a Disneyland in Japan before. Signs are essential, yet they are complex pieces of design, artistry, and engineering. But first and foremost, they need to communicate clearly. In addition, they need to hold up to weather, wind, and time. They also often combine wood, glass, plastic, metals of all kinds, plus interior illumination, special effects, and stained glass. Finally, they need to look and feel compatible with a themed time period. In Japan, once all these factors came into play, as many as five or six vendors could get involved in creating a part of the sign before all those components were brought together to be integrated into one final product.

My vendor visits typically took me to one partner who handled cutting glass, another carving wood, and another forging metals. For one vendor, we took a sledgehammer to old wooden boards to demonstrate how to make Westernland signs look natural instead of fake. Often, letter forms were cut out by non-English speakers, and we had to correct subtleties non-Americans might not comprehend in the same way we couldn't understand obvious mistakes in Japanese characters.

I was called in to show and ride fabrication, and I participated with enthusiasm. To build a Disneyland also involves building rides, and ride vehicles, often involving very complex graphic applications. My two favorites are the steam trains and the *Mark Twain* Riverboat. Where in the modern world, anywhere, can you build a new steam train? But we built authentic steam trains,

boats, and carousel horses, and they all had to be exquisitely detailed. I got to know these wonderful craftspeople, and engineers, and also to travel with my senior Disney co-workers, who were so filled with knowledge and wry humor.

On one visit I was in southern Japan at the shop of a wood-carver. It was a typical day, a long bullet train ride from Tokyo, then a very long car ride across farmland, before we finally arrived at a collection of improvised shops and covered outdoor workspaces, carved out of the middle of a farm field. There I met the company owner. I bowed gracefully (or at least that was what I intended), and then I offered my hand. He didn't take my hand but gave me a gruff look; a low growl came out of his mouth next. "Okay," I said, and with a little clap, I advised Sato-san to move on with the reviews. Table after table was set up with wooden signs, all with hand-carved letters. These were Fantasyland marquees, and many felt like they'd just emerged from *Pinocchio* or *Snow White*. The wood surfaces were so rich I wished we could have hung the originals, but they would have to be cast, and remanufactured in a sustainable synthetic material, then painted. And those would be what guests would actually see. But they hopefully wouldn't be able to see that they were faux wood.

The challenge we frequently faced was that subtle things in English lettering could be overlooked by a carver who spoke only Japanese. I felt there were fairly easy changes to the incised carving of the letters. But each time I made a note, the head of the company would appear to be quite angry. I tried to counter it by being zealous in my praise to the carvers, and to the extraordinarily good craftsmanship on display, citing my changes as relatively minor adjustments. It didn't do much good. At one point, I noticed Sato-san and another of his guys lead the senior head away, obviously trying to silence him so we could get the meeting done.

I felt sad about the way the visit had worked out, but then Sato-san announced that the company had asked us to stay for lunch. I was apprehensive when they seated me right across from the leader. It was a big, long table set up with a beautiful lunch in the garden. Had you not known it, you might have guessed we were on a farm in Italy's Tuscany. But it was even better . . . it was a farm in an artistic compound in southern Japan. I sat down and motioned my thanks to the leader. (This I typically did by holding two hands together like a prayer, and then putting one hand on my heart.)

His wife brought a pitcher of tea. He poured it himself, filling my glass with the tea, which was made of cherry blossoms, a rich pink color, with small flowers mixed in. Sato-san leaned in and told me this was special. I started to

drink some tea, then I realized the leader was raising his glass in a toast. So, I waited. He spoke, and the interpreter translated what he was saying. But in my memory of the moment, I remember his face, his emotions, his voice, and his clear words. I hear him saying them as if in English, direct to me without a moderator:

"I was living right here when the Americans dropped an atomic bomb nearby on Hiroshima. You are the first American I have ever met. Your visit today has convinced me it is time to move on."

Completion

OLC and Disney had agreed on a goal—substantial completion of park elements by the end of the year, leaving January through March as time to deliver late elements, complete programming, make and integrate notes, train cast members, and prepare for the April opening.

On October 1, 1982, Walt Disney World celebrated the completion of the first phase of EPCOT, to thunderous success and international press notice. Marty had undoubtedly achieved what would become one of the largest single commitments of his professional life, a task imparted to him as Walt lay dying in a Burbank hospital. At a time when everyone would have expected Marty to take a long vacation, he did nothing of the sort. Instead, he refocused his attention on the future of the WED organization, and to the completion of TDL.

Marty and his senior team knew who the top WED performers on EPCOT had been, and he wanted them to give some relief to the Tokyo team. A large contingent of EPCOT talent and tribal knowledge came over, and the small TDL team appreciated the expertise and frankly the opportunity to take a short break. It didn't take long for the larger team to gel, and soon an extended WED team was moving forward with the last, most difficult push to complete TDL.

Marty also relied on a cabinet of his best and closest brain trust. He brought his entire senior team over and asked them to provide support to our Tokyo teams in every way possible. Marty knew how to round up the best people

who carried a deep knowledge of what made Disneyland, well . . . Disneyland. It's how I met luminaries like Buddy Baker and Marc Davis, and others, as they spent time walking, riding, and giving notes. Marty's overall message to the team was simple: keep going, and don't stop until it's finished.

Frank Stanek saw an opportunity in these visits, too. The uneven completion and the cost overruns of EPCOT* and the pending new management (Card Walker was about to retire) pointed toward a massive impending workforce reduction of WED. TDL would also soon return many WED Imagineers from Tokyo and there might not be any upcoming assignments.

Frank paired each of us with a senior WED visitor as their host. We'd go with them on tours, help them with the basics of visiting the site, take notes, and take care of follow-through items. Frank paired me with Marty. It was conscious, I realized after. Back in Glendale, which seemed like years ago, Frank had recommended I learn the ropes of the company by doing TDL and then enter creative design when I returned. Frank was concerned my chances in creative would be nil if there were no jobs left. He made sure we all had exposure to management, a chance to show what we'd achieved, and asked WED senior leaders Marty Sklar and John Hench and all the senior team to make sure not to forget the TDL team as they planned for WED's future.

Marty was generous with his praise and his time with me, and I appreciated it. It had been a hard slog and Marty was used to hard slogs. He could relate. Even tired and with jet lag, he was patient and listened to my hopes for my Disney future.

As the executive teams departed, we found ourselves back at work as normal. With so many big things off our list, it was now the mountain of exceptions that had to be addressed: items that were late, or rejected, or forgotten, or had to be modified for the operation. And there were plenty of them. It was all tedious work.

But there we successes, too. Trains arrived and started to run around the park ground's berm, their perfect thematic engineering and pin-striped graphics sparkling, bells ringing. The whistle of the *Mark Twain* could also be heard as it tested its run through Rivers of America.

*TDL was also experiencing high-cost overruns, but since it had no Disney investment and didn't affect Disney's royalties, Frank was less focused on TDL than on EPCOT.

A Friend in Need

Massive signs started to appear at this point above buildings and attractions, along walkways, and inside shows and interiors. I realized I had done a bad job of locating one major marquee sign, for Rivers of America. It sat at the cross-roads of Westernland and Fantasyland and led guests into a beautiful river area that included Tom Sawyer Island, the *Mark Twain*, the steam trains, and the canoes. I'd simply put it too far from the center and too deep into the landscaping. It was a beautifully crafted sign, and it was going to be wasted. I fretted about it. Kept it to myself. And finally I went to Sato-san. I had come to respect Mr. Sato deeply. He was an experienced leader, an excellent designer, but also a kind of old soul. He told me his family had been rescued from China on a freedom ship returning Japanese refugees back to Japan in the darkest moments of World War II. He'd poured himself into TDL, and I hoped deeply it would benefit him and his company. I had to ask him. Could he help with my mistake? I asked him privately. I drew him a sketch; I walked the site with him. He was unhappy, concerned for me, for the sign, but he also didn't see a way out. I thanked him. I could have pressed the issue, I could have said it was a quality issue, an opening day issue. But I didn't want to violate our friendship. I told him I appreciated his consideration.

A day or so later Noriko told me she had spoken to Sato-san. He wanted to know if I could meet him, after hours, about 9:00 p.m. on the site by Rivers of

America. It was an unusual request, but I accepted it. I stayed late at the site office and rode my scooter in the dark out to the site. It was the first time I'd had to use the light on the scooter, and I had to wash the mud off for it to work. I waited at Rivers of America. No Sato-san. The site was empty. I was about to go, when I saw a crane truck moving toward me, lights ablaze. I strained to see who it was. It was, sure enough, Sato-san. His vehicle, treading carefully across final paving—paving that was no longer open to construction traffic.

"Bobu-san, we have to hurry."

He jumped out of the cab, and together we slung a strap around the sign foundation. He pulled back on the strap, it tightened, and I thought it would break, but slowly it pulled the huge concrete sign foundation out of the ground. He raised it high, and he waved to make sure I stayed clear of it.

"Tell me where you want it, Bobu-san!"

I walked across the planter to the very front, to where guests at the cross-roads would all see it, unobstructed except by small plants, a few speakers, and light fixtures.

He moved the crane to place the foundation right where I pointed. Then together we dug the soil out until there was a base large enough to drop the footer back in. He lowered it, and I helped guide it into the fresh hole in the earth. It was heavy and it settled. He took off his glove, and we shook hands, mine caked with dirt. I thanked him. He spoke English to me, which he rarely did.

"I would follow you, Bobu-san, even to hell!"

~ ~ ~

Over the next few days, I would ask Noriko several times what I could send Sato-san as a thank-you gift. Chocolates, fruit, something for his family? I never got an answer. I remembered a night on a vendor trip. A group of us had dinner, and although I was half asleep, they took me to a karaoke bar. A bunch of guys sitting around drinking and singing bad covers of American pop songs was the last thing I needed. I probably did my typical terrible rendition of "Beast of Burden" as the Rolling Stones' Mick Jagger. I remember Sato-san sang "Take Me Home, Country Roads" by John Denver. He had a nice baritone and sounded a lot more American than any of us. I thought, what the hell was he drinking?

Noriko and I canvassed the other members who were there that night. The consensus was Sato was having Johnnie Walker. But finally, another detail emerged: it was not just Johnnie Walker, it was Johnnie Walker Red Label. I probably could have gotten a bottle of Johnnie Walker Red for him at the Los

Angeles International Airport's duty-free shop for a low price. But I got it at Printemps, the most expensive store in the Ginza, and the only one that had it. It was quite a bill, even with the advantageous exchange rate.

A few weeks later, Sato-san told me, with a big smile, he'd had a meeting the night before with our mutual friend. I didn't know who he meant. Then he said, "With our friend Johnnie." I assumed he didn't mean John Denver.

~ ~ ~

December 1982 in Tokyo was cold and windy. The shop windows along the Ginza had taken on Christmas as a marketing concept and were filled with Christmas lights, elves, and Santa icons, along with sensually dressed fashion mannequins. Decorated trees were in all the hotel lobbies.

Kajima, the contractor for World Bazaar, was in the final completion phase. And they had done a remarkable job duplicating Main Street, U.S.A., in facade and interior detail and building it under a wide-spanning arcade canopy. We all admired their work and dedication to TDL. Our contacts at Kajima invited us to a "substantial completion" party. It turned out to be a magical evening, the beginning of a sense of how special the introduction of TDL was about to be. Kajima had set up food tables on the street and made sure all festoon lighting of the facades was turned on. There were many handshakes and toasts. There were speeches, as there always were. Everyone was still in hard hats and warmed by site jackets. And then a sound came forward. It started on the Kajima side before it seemed to spread over the street and was picked up on the other side by all the OLC and Disney guests. The entire group, as one, was singing "Silent Night."

Escaping to China

As of January there were three months yet to go, and those three months were still going to be full of work. I had one more home leave to use, and Georgia and I felt sufficiently fried that it seemed like a good idea. I knew we couldn't do a long-distance trip. But seven days of local travel seemed possible. We looked at Hokkaido (Japan), Korea, and Taiwan as potential destinations. A friend told me about trips opening up to the mainland of China. Now that sounded interesting. There was a new government initiative available to take foreign visitors into the mysterious mainland for the first time in many decades. There was a government application, and then if you got approved, you got a "black box" tour. It was a black box in the sense that you gave them a fixed fee, and it was all inclusive after that; they took you where they wanted, on their schedule, and you were always supervised by a host with a car and driver. We got our approval, our home-leave budget matched their fee, and we were packing for China.

As a historical note, this was only ten years since Richard Nixon had opened diplomatic relations between our country and China. In 1972, Nixon, accompanied by a small team, visited Beijing, Hangzhou, and Shanghai and had conducted the first meeting ever between a sitting U.S. president and China's head, Mao Zedong, who had declared the creation of the People's Republic of China in 1949. Nixon had been a political warrior against communism throughout his career, but he recognized China as a force in the world and that

the United States should have diplomatic relations despite the two countries' differences.

There was very little detail in the itinerary we received. But the outline indicated we'd basically be following Nixon's itinerary. We'd be flown into China from Hong Kong, start in Beijing, then visit Shanghai before spending a few days in Hangzhou and Suzhou. There were no other details. No hotels or contacts were listed, and we were to be met by a different host at each stop when we arrived.

We kicked off our break with a weekend in Hong Kong. Hong Kong was a colorful and vibrant place—boisterous people, exciting markets, and innovative architecture appearing along the harbor. Then we showed up for our flight at the appointed time and found ourselves on a two-thousand-mile flight across China to Beijing. It had only been three years since *Beijing* had replaced the mythical namesake Peking.

A driver and guide met us in the baggage area, and soon we were on our way into central Beijing. My impression was one of rubble. There was rubble of brick and stone everywhere and the dust from piles of rubble being moved and repurposed into new structures. The combination of dust and coal smoke turned the setting sun a perfect smoky Necco Wafer pink.

We approached the tallest building. It rose like an anomaly in the otherwise one- or two-story brick reconstructions we were going past. It was nine stories tall. It was our hotel, and there was nothing else around it. When we checked in and went to our rooms, we couldn't help but notice the hotel was all new, even the elevators, but the furnishings looked old, like they'd been salvaged from another building.

Our host met us for a wonderful eleven-plate Chinese feast on a round table. The plates kept coming until they were all around the table and we were stuffed. He told us about China, about how it was growing, about the potential. He was young, positive, and full of pride.

In three days, he took us to the Forbidden City, Tiananmen Square; we hiked the Great Wall and visited the Ming Tomb mausoleums built by the emperors of the Ming Dynasty of China.

I had just spent a year and a half building replicas of coal-burning steam trains in Japan. We saw many of them along our routes in China, still in service, white and black smoke pouring out of authentic stacks. We had great food, great conversation over beer and mao-tai, the Chinese local brandy. We were free to ask any question, and to take whatever photos we wanted. But we never

roamed. Our guide was almost like a bodyguard, making sure we were well insulated wherever we went.

One early morning, we departed on a CAAC Airlines flight from Beijing to Shanghai. Except for the two of us, the passengers were all local. And there were at least a few caged chickens on board. As we were waiting for the flight attendant to close the door, the plane engines started, and the cabin filled with thick white smoke. I grabbed Georgia's arm and thought about heading out the door, but the entry stairs had been removed and it would be quite a drop. A few passengers opened an emergency door, and everyone helped fan the smoke out. Then we took off. What happened? We never knew, but it was a hair-raising ride to Shanghai.

Shanghai in 1983 was a romantic, beautiful city with a sense of the richness of China combined with a turn-of-the-century colonial past. Western buildings, banks, and hotels lined the Bund, a beautiful crescent-shaped street that edged the river, and boats of all types nestled against the wide urban avenue. The Huangpu River was active with giant flat cargo ships, carrying all kinds of supplies up and down it. As far as we could see from our room at the Peace Hotel, the other side of the river was marshland, nothing for miles.

We took a train down to the canal town of Suzhou, the Venice of the East,* a waterside paradise of Chinese architecture and gardens dating back to the eleventh century with ancient artistry, silk, seafood, and dumplings, all along winding canals and beautiful circular stone bridges.

A second train took us to one of the most magical places I've ever visited, in China or anywhere else: the West Lake, a still, wide, mirrored lake, misty and silent, with pagodas, islands, bridges, and gardens, all ideally composed and perfectly reflected. The West Lake has inspired poets, artists, and landscape designers for centuries. It was meditative, an idealized world. I knew I had to return there, not just to the place, but somehow to the state of mind.

In Shanghai we hungered for a little time away from our guides. Not much, I said. I just want to walk down a regular street, maybe roam through a bookstore. The guide was not comfortable with the idea and offered to take us anywhere we wanted to go. I finally convinced him to let us walk a couple of blocks without him. We got out of the car on Nanking Road, a few blocks from

* According to Li Bai, an ancient Chinese poet, at least insofar as EPCOT's *Reflections of China* Circle-Vision, made just a year before our visit, Venice should be called "the Suzhou of the West."

the Bund. We walked purposefully, like we were from around there. It made no sense; everyone knew we were not from around there.

The bookstore was quiet, a beautifully lit room with high ceilings, shelves and tables piled with volumes of all kinds. I hastened to the oversize art books, and with reserve, thumbed through some of them. A young man approached me. He spoke perfect English. He asked, "Could you find a copy of *The Odyssey*, translated directly from Greek to English?" In China, he could only find it already translated into Mandarin, and he wanted to do his own translation. I handed him my sketchbook and he wrote down his address. Another young man approached and made another literary request. I wrote that down, too. This happened a few times. Georgia called out to me, and I looked up, realizing that there was a crowd gathered around me, and it looked like a lot more requests were coming. I felt a tug on my arm. I thought it was Georgia, but it was our guide, and before I could realize what was happening, I was out of the shop and back in the car.

I knew the guide had been right. We had a story we would never forget, but I worried he could have lost his job or been in some other worse trouble, and all because I did something selfish and with poor judgment in an environment I really couldn't understand. We dutifully stayed with him for our remaining time in Shanghai. I did mail that copy of *The Odyssey* to the young man's address; I am not sure if he ever received it.

When I returned, I had lots of deadlines to meet, fixes to negotiate, problems to overcome. There is always a huge punch list close to the end. A punch list is a document that lists the final work items remaining before a construction project is considered complete. The list was so long, it was too early to start claiming success. Yet in the end we would deliver on the scope we had committed to for opening day, and then some.

One Dream Finished, Another Begins

Imagineers will tell you the most important, and most emotional, moment of a project is that day it makes the transition from being a dream to being a place. From that day forward these new places will evolve. What we have all worked to conceive as experiences will change and become continually renewed. Generations forward will bring new ideas and new talents to the vision. And the visitor, or the *guest* in Disney language, will define it for themselves.

Tears are shed and time stops for a moment; it is as if the universe knows it should give us some time for the transition. I watched for the first time as Japanese guests came through the gates of the place we had created, now called Tokyo Disneyland. I stood there almost quixotic; the idea, the park, the bustling project had been ours for years. But then I realized it was not ours anymore—it belonged to those who were just entering. In those fresh eyes, knowing nothing about any of us, was reflected a new and magical place to explore, seen and felt for the first time, entered from the outside world. As Walt once said, "To all who come to this happy place, welcome. Disneyland is your land."

It was a moment both humbling and joyful; humbling because I knew the project was no longer mine, yet joyful because I knew it was now theirs.

And in they came, crowds of students in school uniforms, young professionals taking a team day away from their offices, teens, families, kids in

strollers. There was a curious look on their faces at first. Where were they? Then a sense of joy came over them, a freedom, and a sense it was okay to play. I saw grandmothers, some decked out elegantly in full kimonos, do little dances as they walked down the street and toward the castle.

I tried to take pictures until my tears clouded the viewfinder. I just lowered the camera and watched.

Part 2

1983–1995

Moving Back and Moving On

It is often said that the hardest part of relocation is the return to your original home. When you relocate, you're full of excitement about going to a new place, but as the old adage goes, "It's hard to come home again." It's not that different than coming home after college. Your old room seems smaller, and people you know—family and friends, the people you work with—seem not to recognize that you've changed. For you, time feels like it has been flying by, experiences have changed you, but for them, often, time seems to have stopped and they prefer to see you as you were before.

I had been one of the lucky folks to stay in Japan for an extra couple of months with Tom Jones to write what he called an "after-action report," something that he was familiar with doing in the military. I wrote my section and helped with the compilation of the entire report. We'd built a major project in Japan, the first project Disney had ever built outside the United States, and we had done it with a very small team. And so far, at least, the park was tracking to a first year of great success.

We were certainly happy to be back, but it felt awkward. Life in Tokyo hadn't been perfect, but we realized how much we missed it. There was an overall sense of tolerance and politeness; everyone was cordial. No one honked except for taxi drivers. Trains ran on time; everything ran on time. Everything was swept and kept neat. You could leave an envelope of cash outside your

apartment door, and the delivery person would leave groceries or dry cleaning, make the proper change, and leave it with a receipt.

We were excited to see Los Angeles again, to be with family, and to visit places we'd not seen in nearly two years. I wanted real Mexican food! (Well, for accuracy, it was more like Americanized Mexican food, but I still wanted a crunchy taco and some freshly made guacamole.)

But the LA subways didn't run on time because we didn't have any. The evening news seemed filled with reports of drive-by shootings, and there was a mysterious epidemic devastating many communities of the city.*

I was driven down and dropped off to pick up our convertible 1966 Mustang. We had totally restored it before we moved to Japan, and it had been stored as part of my relocation package. It was Georgia's car, and it meant a lot to her. I couldn't wait to bring it home to her.

I was left on my own to roam through the steaming hot storage lot to find the car. I barely recognized it. It had all the characteristics of a car that had been abandoned for nearly two years. The cover had blown off and was nowhere to be found. There was solid dirt and thick mud and bird droppings across the convertible top and the body. The vinyl top was filled with thin fissure cracks from the intense exposure to the sun it had endured in the asphalt parking lot. All four tires were completely deflated—not just flat but settled into the asphalt. Of course, the battery was not only dead but fully encrusted with calcite.

I walked around the big lot looking for someone to help me, but there was no one. And there wasn't a pay phone, either. It was symbolic, as if a life we'd once had and had abandoned and forgotten had forgotten us, too. I came back to the wasted Mustang, slammed my fists against the hood, and cried. Then I got up, walked about a mile down the road, and called a tow truck.

A car is an inanimate object. New tires and a battery, and detailing, can bring it back. It's not so easy with people. I had tried to call my grandmother several times from Tokyo; it had become harder and harder because she seemed not to understand what I was saying. And finally, one day I called and she didn't know who I was.

By the time we got back, she had descended into full-blown Alzheimer's. She never recognized me again. I talked to her anyway. I figured it was okay just

*The AIDS epidemic was emerging into public consciousness, though not very much was known about it. But it was already having an effect, including the loss of beloved Imagineers.

to be a nice young man talking to her. The joys of having done a major project were moderated by the reality of what I had left behind. Things didn't stay the same on-site and were certainly not the same when you came back. Much later I would read that anything you focus on grows more robust. The things you don't focus on slip away. I had been focused entirely on being outside the country, being at Disney and being on a project, and many things that used to be important to my life had somehow been left in an old field of asphalt, weeds, and flat tires, forgotten all this time.

My anxiety was only made worse by returning to the office. There were no congratulations, no party for the TDL team as they returned to thank them for building the first international park. For the most part, people didn't want to hear about what you had been doing, and there was deep anxiety over WED, as there were layoffs coming. Layoffs were secretive and stressful for everyone—who was going and who would stay?—and it all played out around what we used to call the watercooler.

I also found that many in Glendale had a negative attitude toward Tokyo Disneyland. One of my bosses called it the worst park Disney had ever built—a cookie-cutter park, connected by wide oceans of colored asphalt. These misconceptions made it hard to speak positively about my experiences and development.

I was a stranger at WED, in the main building for the first time, and trying to make an impression as a "new" member of the creative organization.

Color and Fun

I was not particularly happy with my first assignment upon returning. It was called officially Color and Fun for EPCOT. Anyone who knew me would say I am not so much a color-and-fun kind of guy. Apparently EPCOT had gotten the big things right, but especially in Future World it lacked the charm and richness and connectivity people expected from Disney. Too many big pavilions floating in a sea of hot concrete and grass. I took the challenge and luckily met Rick Rothschild.

Rick had been a big star on EPCOT, making The American Adventure possible, among other things. He mentored me and arranged for my first trip down to EPCOT. He drove me into the backstage area, where he could take me in, right at the center of World Showcase, in front of The American Adventure. It was impossible to be anything but awestruck by how amazing EPCOT was. The scale, the pavilions, the lake—it was awesome.

Soon I understood what people were saying about Future World. It was a brutal architectural environment with giant pavilions, huge shapes with no human scale, long lines on concrete with no shade, and none of the in-betweens: water, food, shopping, gardens, things to do that are what Disney was known for. If I was going to be about color and fun, it was going to be a lot of color, and I intended it all to be a helluva lot of fun.

I embraced it. I went back to my roots, Disneyland. I studied the analytics

of how it worked and tried to diagram it against Future World. Disneyland was about discovery, about being drawn by storytelling elements from place to place and discovering those big stories where you didn't expect them. I knew we couldn't do that with Future World as it was. But I thought we could give it texture and story, and intimacy.

I was reassigned under Randy Bright, a leader Marty was grooming as his second-in-command. Randy had a very successful career at Disney. He knew the parks, had worked at Disneyland, and was key to the success of EPCOT, having led the charge of major narrative icons like American Adventure, *Wonders of China*, and *Impressions de France*. Randy had a moral compass for Disney, a strong marketing brain, and a keen ability to deliver clearly in a Disney voice.

I don't think some of us appreciated Randy the way we should have. He was a hardworking, dedicated Imagineer, and he had very strong values and very strong ideals. He was less attuned to design, however, and so we often, as designers, had at least slightly rebelled in reaction toward his directions for us. We often had meetings that ended with a bit of bluster from both sides. And I am sure I was among the team members who both impressed him and annoyed him. I was learning that being a creative was not about agreeing or following; it was about putting forward creative, and always trying to push the envelope.

But Randy was impressed with my analysis of what was missing in Future World. He thought the architecture looked like a "dentist's office," and so I had an ally. He helped me pull together some of the great creative minds in show development at the time. And I quickly developed a menu of ideas to bring to the color-and-fun initiative.

In a short time, I found myself presenting ideas to Randy, then to Marty, and quickly to the new leadership of the company since Card Walker had retired. Ron Miller was now president and Ray Watson was CEO; together they were the gateway to project approvals. Ron, to me, was Walt's son-in-law, but also the guy who had the guts to create Touchstone Pictures, an attempt to bring Disney films out of the Dark Ages. Ray Watson was a real estate developer who'd help steer the development of Irvine, California. We didn't really know it at the time, but Ray was convinced WED didn't need to really exist. He'd built Irvine with all consultants. The true value potential of Disney, as he saw it, was the massive land assets of Walt Disney World—it's twenty-seven thousand acres. Ray was going to develop that value and was not seeking the help of WED.

Despite my label as the Color and Fun guy, I went with confidence. I was

an architect and creative thinker (I told myself), and I knew what Future World needed. I waded into the analytics, the comparisons to how Disneyland works. I had a list of small projects I thought could be done quickly:

- More street theater and characters in Future World: action, juggling, guest interaction, reinterpretations of the classic Disney characters in Future World roles. The space was devoid of such character connections.
- Use World Showcase Lagoon as an entertainment venue—it was a beautiful lake but static. Along with my new colleagues from entertainment, we thought it was an opportunity to do something big, in the sky and on the water, in daytime and at night.
- Bring the pavilions out into the land—if we talked about energy, why not have lots of wind turbines outside, why not have robots running around, or big artistic kinetic sculptures that demonstrated science concepts, but outside where the people were?
- Food carts and stands (once a popcorn man always a popcorn man). I thought too much food was locked up in big fast-food facilities that were convenient to operate but boring to sit in. Food and entertainment needed to be intertwined, as it was at Disneyland.
- Banners—I met a wonderfully talented woman, Michele Iacobucci, a bundle of energy, and we proposed to create a system of colorful soft banners, inside and out, a way to counter the stark gray architecture and add life and softness, color, and animation—and do it quickly.

There were other things: electric sustainable tram systems, mini-pavilions and displays, more fun music.

I kept the coup de grâce for last—I wanted to fill the edge of the lagoon near Future World with flamingos.

"Real flamingos?" one of the team members asked. I researched it. We had lots of flamingos out at Discovery Island. We could move a bunch of them to the edge of Future World. People would photograph them; they'd be noticed immediately.

Ron and Ray gave their approval to my color-and-fun presentation. There was no budget committed, but the idea was agreed upon. Entertainment got more money for character development in Future World and a boost of energy behind doing something big in the lagoon. I put out a contract for banners and

topiaries, and the horticulture group got money to add colorful flower beds on the ground level and flower baskets for lamp poles. And many outdoor food venues were added in and around Future World.

A year later, when the operations team did a guest survey on whether these little projects had any true measurable impact on the perceptions of Future World guests, the number-one mentioned element was my little colony of pink flamingos.*

Black Friday, as everyone called it, was looming. EPCOT's budget overage was still sapping the company's resources. Movie box office results were lackluster. I kept going on my Color and Fun agenda, and it included a huge inflatable Figment that was deployable from a small suitcase. In a test, Herb Hanson, a wonderful director and street theater performer, brought the Figment balloon to life, interacting with guests. Guests loved being photographed with the big Figment, but the operators said they couldn't sustain the daily cast cost. So, my animated Figment was packed back into his silver suitcase and shipped back to Japan.

I also joined an exciting games project that was underway, the Game Grid. It was to take advantage of the great interest generated by the ImageWorks multimedia center that had opened with Journey Into Imagination. There were experiments with taking guests into immersive worlds and early and primitive ideas for talking with AI characters, but in the cost-cutting environment then being enforced it was all too easy of a unit to delete. Most of my co-workers were laid off in the first wave when it hit.

*The flamingos have since been sent off to Animal Kingdom, so don't look for them at EPCOT anymore.

Back Home, to Tokyo

The tight-knit Tokyo contingent had been spread back out around the company. Many of us longed for a reunion. WED had become a lonely place for us. Our contributions seemed forgotten, and our sense of belonging to a team was lost. I wanted to be reunited with my Tokyo family, too. I knew it was unhealthy, a sense of wanting to return to the familiar at a time when everything seemed tough and uncertain. Yet I still missed the park, and the team, and I had plenty of ideas for the park's future.

It turned out I had a chance to go back to the Tokyo team, in a small way, and I couldn't resist the draw of the familiar. Jim Cora, who had led the operations group for opening and now led Disneyland International, was managing the Tokyo park and moving forward toward Europe. He was interested in pressing Chairman Masatomo Takahashi and OLC management to set up a five-year-growth master plan. I was very lucky Cora seemed to trust me . . . and so did Marty. I was doing creative work and architectural work, really for the first time. We printed huge site plans of Tokyo and sketched out possible new areas and improvements to bring the park into an even richer quality than we'd had the resources to do the first time around. It was my first experience with true park planning, thinking about possibilities, working with the operating partners on how they saw their needs and then finding creative solutions.

I made my first trip back to Tokyo and it was like going home. I was anxious

to land, to get all the presentation boards, and I was supposed to have more than a few hours to work in the room to be ready for the next day's presentation. As it turned out, we landed in a historic snowstorm. The roads were closed, and Jim Cora had to use every influence he had to get us rooms at the hotel at Narita Airport.

We spent four days there, plenty of time to finish the drawings, refine our speeches, and be bored out of our minds. Finally we were able to board a van for Tokyo. The Imperial Hotel was waiting, and the presentation was waiting, too.

It was familiar territory, though it was the first time I was there to present WED as future vision. I presented to Chairman Takahashi and his staff in formal meetings. The work was well received, and I soon realized these discussions were more than just dreaming about the future. The master-planning effort represented a healing process between Disney and OLC. Relationships had been strained by the difficult and high-stress run-up to opening. Now we were talking about the future, possibilities, growth. It was a positive gathering for everyone.

What I remember about this era was a feeling, tentatively at least, like I was beginning to stand on firm ground. Tokyo was familiar, but I was in an entirely new role. I had contacts and projects at EPCOT that helped me break out of my Tokyo shell. I had at least the beginning of relationships with Marty, Randy Bright, and other senior mentors whom I'd not really spent time with because I had been out of the country so long.

Georgia and I stretched and bought a "little pink house," as John Mellencamp was singing at the time, a small California bungalow nestled in the hills of south Glendale, and started spending our evenings and weekends coated in drywall dust, putting in sweat equity.

And just as I felt things were settling a little bit, just as I felt I was regaining my grounding, one day everything changed.

Greenmail

In June 1984, barely a year after we'd opened Tokyo Disneyland, Saul Steinberg, an activist investor, saw Disney as a weak company with under-leveraged assets. He began to amass stock in Disney, and it became clear that his intent was to perform a hostile takeover. Steinberg believed that Disney assets, including the movie company and the parks, could be sold in pieces for more than the value of the whole.

In response, Ron Miller and Ray Watson accelerated the land development of Walt Disney World by purchasing a real estate developer, Arvida. Their mission was to unlock the assets in Florida, perhaps selling some of them as residential new-town developments. The executives who came in from Arvida were not entertainment people; they were all business and used outside consultants to achieve fast results.

Above all, many of their leaders believed the theme park business was dead and, as a cash cow, should get minimal new investment just to keep the flow of cash predictable. There would be no investment in new parks.

WED's days, it seemed to me, were numbered.

By the time the greenmail episode ended, Saul Steinberg was $45 million richer, Disney stockholders were outraged, and CEO Ray Watson and President Ron Miller were both embarrassed and compromised. And there was a malaise over the fans and the cast of Disney. There was a general feeling that Disney

had become a pure money business, and storytelling and creative invention became low priorities. And many of the best people were leaving or had been laid off.

Disney's top executives had allowed the creative side of the company to wither while they focused their attention on real estate. Roy E. Disney, Walt's nephew, grew more and more outraged by the company's performance, and its attitude. And thankfully, Roy was able to do something about it, as he was the largest individual stockholder and owned 3 percent of the company. "I remember thinking that if that pattern went on much longer, the company would become a museum in honor of Walt," said Roy at the time. "Movies are the fountainhead of ideas, the impetus for all the rest. Without *Fantasia* and *Snow White*, Disneyland couldn't have been built." Yet Disney's management rejected Roy's advice.

My ongoing EPCOT assignment, Color and Fun, seemed all the more ironic. I didn't feel colorful, and I certainly was not having any fun. I felt work was becoming a kind of business, a false sense of purpose. The only reason the TDL work was exciting was we had an outside partner, OLC, and they at least seemed committed to Disney values, and to expanding their already-successful business. But we all felt adrift, for what seemed like months.

News started to leak out that Disney was searching for a new CEO. The stories began to propagate around the possibility of Michael Eisner, a creative leader at Paramount, or Frank Wells, a leader at Warner Bros.

It was a surprise to me, and I think to a lot of Imagineers, when it was announced the company would have a combined leadership team of Michael Eisner as the new CEO and Frank Wells as president.

The way you knew something was important back then is you got called out to the patio, a big asphalt lot between the production buildings, with a tree-canopied section where our commissary was located. It was late afternoon, and we were all on the patio, anticipating the arrival of our newly minted leadership. And we waited. Who could they be? What was going to happen next to us? The skeleton staff of WED that had dedicated themselves to building EPCOT and TDL wanted to know if they had a future.

Ray Watson finally entered the patio area and took the improvised podium. It was the first and last time he ever spoke to the WED team. I hardly knew Ray. I'd tried hard to reach out in our presentations, but he'd not made much of an impression on anyone except that he wanted to build the real estate portfolio and didn't have much use for WED. Ray did say something interesting that day:

"A year ago when I became CEO my job was to find strong new management for the company, and I'm happy to announce to you today, that job is done."

If that had been Ray's job description, I don't think anyone realized it.*

I took a deep breath. With all we'd been through, it was at least a little scary to think of Paramount's and Warner's executives coming into the Disney environment from the outside. But my apprehension didn't last long. Within a few moments of Michael Eisner and Frank Wells taking the podium, the entire tone had changed. I was immediately enchanted by them both.

Michael was funny, spoke off the cuff, just looked like an odd creative person who, had he applied for a job at WED, might have made a great Imagineer. Frank was incredibly articulate, genuine, friendly, and wanted to reach out. You could feel it. A great collaboration could already be seen between the two of them. They interrupted each other, finished each other's sentences, and everything was about excitement and enthusiasm. Ray Watson quickly faded into the background; I don't even remember when he left, because the instant bond would from then on be known as Michael and Frank. I thought of the Big Thunder Mountain Railroad attraction announcement: "Hold on to them hats and glasses, cause this here's the wildest ride in the wilderness." I didn't know it at the time, but it was going to be just like that.

Among the most memorable words I ever heard at Disney came from Frank that afternoon when he said, "I'm not going to leave here today until I have shaken hands with every one of you." It took him the rest of the afternoon, but he did.

* If Ray wanted to demonstrate his interest in WED, he did so by getting lost on the five-minute drive from the studio in Burbank to WED's offices one town over in Glendale with Michael and Frank in his car. I hope he had a Thomas Guide map, and that someone had the sense to use it.

Instant Genius

I think it's a good idea to talk about the creative process now, since it is going to dominate much of the story moving forward. At this point I was about to leave my management focus aside, transitioning toward being comfortable being creative, or what Walt Disney himself said, "exhibiting instant genius." We were all going to need it, working for Eisner.

Imagination lies somewhere between the possible and the impossible. Often a creative or artistic or technological invention is the result of one person's brilliance. In a complex product like an animated movie, or a vast theme park, it's different. Creativity, somehow for me, has always been a spark that arcs between at least a few if not several minds, minds who all think differently, who all see the world differently, and who all process criteria differently. It could be a spark that occurs in a formal meeting. It could be a spark that occurs in a serendipitous hallway passing. It could be something over a shared lunch or a couple of drinks and dozens of sketches on cocktail napkins. Most often for me, it occurred in the form of what we call a *charrette*. People often ask, "What is a charrette and what is the correct way to spell it?" And I can attest that the correct way to spell it is the way that I'm spelling it here: two r's and two t's.

The origins of the term *charrette* go back to nineteenth-century France during the time of the École des Beaux-Arts, the renowned art school in Paris.

Back then, on the day that students' projects were to be completed, a cart called a charrette would roll through the streets of Paris, stopping at all the students' apartments to collect their projects. When the cart got to you, you were supposed to load your canvases onto the cart, and that was pretty much your deadline. Your only option, should you not be finished, would be to squeeze onto the cart yourself, with your paintings, and try to continue working, as the cart was driving down through the cobblestone streets of Paris.

Imagine this colorful image: a wooden cart with big wheels shaking along the cobblestones, packed with drawings and canvases and a number of late students trying frantically to finish their paintings. But more than a colorful image, it has come to mean something, certainly more than brainstorming. A charrette has a sense of urgency. If you don't have a deadline, and in fact, if you don't have an impossible deadline, it's best to create one; otherwise a charrette is more like a normal research project.

And there's something about everybody crowding together into a cart. It's a journey, a difficult one. Gear up for it. If the room is too big, too luxurious, if you don't have diverse people, if everyone is relaxed, half engaged and texting all the time, it's not a charrette, either. A charrette is a combination of urgency and difficulty and passion. Everyone has to be in it together. To jump on a rolling cart with your drawings, you have to have something pretty important you want to finish, and charrettes tend to carry with them a sense of importance and urgency.

There are few major creative endeavors I have worked on that didn't start with a charrette of some kind. It is hard to fail at a charrette if you are open to the possibilities of finding something new. The best way to fail is to not be receptive to the group dynamics or the free nature of diverse dialogue. If you're not willing to discover something new, or find something controversial, better not to have a charrette at all. And it is important not to critique every individual idea as it comes out. I always treat charrettes as golden time, encouraging participants to be fearless, to put forward crazy ideas and not criticize or evaluate them; evaluation comes later—lots of analysis and hard work come later. This is the time to dream and dream big, to think outside the proverbial box.

Part of the magic that comes out of a well-run charrette is those synapses that spark between people of different backgrounds, different perspectives, to yield something beyond what the same group of people, working by themselves, would likely have yielded. A charrette, with five or six or eight people, is a kind of journey, and at the end of the journey, if you're lucky, everyone realizes it

wasn't about whose idea was best. It was about the fusion of everyone's ideas. It's impossible to determine whose idea it is. The dream belongs to all of us, and the result is usually something that bonds the group together, and often, carries them through the long process of bringing the idea to reality.

A New Era Begins

Within hours we were beginning the journey with Michael and Frank at the helm. It was exciting. It was explosive. The two of them worked as an incredible team, and they seemed to be at Imagineering every few days. Frank Wells said he wanted to know everything about us. Michael Eisner wanted to meet artists, meet designers, and fly through creative ideas. He was a prolific generator of ideas. He was a collaborator. He was outrageous. He was such a change from any management we had seen before. I had a feeling we were all a little stuck in the mud. We were too stuck in the traditions of Disney and in the rules that had to be followed as if we somehow were following in Walt's footsteps. We respected Walt, as we have ever since, but suddenly we weren't walking in Walt's footsteps. We were running to keep up with the footsteps of two new minds that were trying to think about how Walt would think, not in the past, but forward into the future.

One of the great assets of Michael at the time was he had two sons. They kept him connected to contemporary pop culture. Coming from television, Michael brought a tremendous breath of fresh thinking to Imagineering; conversations were rapid-fire, stream of consciousness. He often used language that we'd never heard spoken in the halls of Imagineering. I loved it. I loved the loose nature, the craziness of it all, and how anyone's contribution was important to consider as long as it wasn't boring.

Marty impressed me with his genius, as he always had. He responded to Michael in a refreshing way. He came in with handwritten idea boards, brought in all levels of creative folks, and had no fear of putting any of us first; if we wanted to walk the plank, he encouraged us! Marty was comfortable inviting many of us into sessions that in the past might have only been at the executive level, because Marty had an interest in understanding where Michael was coming from and wanted to take advantage of Michael's natural sense of collaboration. He wanted Michael to meet and interact with a wide range of WED staff. And so many of us, like me, got exposure to these energetic, or some might say crazy, meetings in a way that we would never have had before.

Michael and Frank's visits were frequent, and they left many assignments when they departed. It might take an hour or more after they left to sort out what needed to be done next, by whom, and how fast.

What's next for Walt Disney World?

What's the next park after EPCOT?

What can we do to make a more complete vacation?

Can we have new formats—smaller, more intimate vacation experiences?

How can we use our amazing land for more immersive resort experiences?

By the time we'd had a day or two to fill a room with flip charts, sketches, and sometimes projects pulled out of the archive, there would be a quick review. Then they'd move on to the next topic.

What do we do to bring new audiences into Disneyland?

Should we own an airline? A car company?

Should we make movies about Park attractions?

Why is there nothing to do at night at Walt Disney World?

On the last topic, we talked about our outside-the-park offerings being dull shopping with no magic or fun at night. The entire focus was on parks, but sometimes people wanted to do something else, and we were not providing it. An entrepreneur, Bob Snow, was amassing a spectacular menu of entertainment venues in a historic section of downtown Orlando, about a thirty-minute drive from the Disney property. Church Street Station already had Rosie O'Grady's, the Cheyenne Saloon, and a very large, dedicated night-time audience.

Michael immediately called Frank, who was in Florida, "Frank, there's nothing to do at night. These guys say go see Church Street Station!"

Michael's opinions and ideas came honest and fast. I remember seeing

Marty bristle when Michael had returned from Walt Disney World and said that EPCOT was boring. Michael just had no filter when it came to reviews. He didn't believe in politeness if it slowed down progress. He believed in directness, but he also kept it fun. EPCOT was too documentary-oriented, not fun enough, not exciting enough. He did like the original Murray Lerner *Magic Journeys* film, which was the first 3D film by Disney. And he thought we should bring it to California quickly, but maybe do something new with it.

Quickly our agenda was getting filled. Charrettes were taking place all over the building. Time was short, a day or two for each response. Everyone was getting used to fast thinking, quick-sketch impression art, and index cards on the wall. I was back to index cards, thousands of them. Randy Bright coined the expression "Lock them all in a room and pass food under the door!" It certainly felt like that some days.

Soon ideas were going on all at the same time:

Expansion of Resorts, with more immersive recreation

Expansion of Disney Village into a nighttime experience

Water Parks

New Attractions for EPCOT

Teams were quickly brainstorming on the idea for a new 3D film, and Michael shifted the discussion by suggesting it should feature Michael Jackson and we should brainstorm on ideas with Michael Jackson himself.

The idea of Michael Jackson at Disneyland was a shocker for the Imagineers and certainly would soon be for the Disneyland audience, but it was exactly the injection of energy Disneyland needed, and Michael Eisner knew that. And we soon realized that Disney now had the capacity not only to bring Michael Jackson over to Imagineering for a brainstorming session on what the 3D movie could be, but to bring in George Lucas to develop it and produce it . . . and to bring in Francis Ford Coppola to direct it. The new access to stars and talent was in part thanks to the third member of Disney's new management, Jeffrey Katzenberg. Jeffrey had come over from Paramount, like Michael, and he was running the studio with the same energy Michael and Frank were running the company with. Animation was being reenergized, and dozens of movies were being developed. And Jeffrey liked WED, too, and was tremendously valuable, plussing up the new initiative.

As an Imagineer, I felt suddenly connected to the center of Disney. Instead of being considered an offshoot of the parks business, or a necessary evil, as

they sometimes put it, we were a creative wellspring. We developed a unique brand of content, and we did it in concert with our other very exciting content development partners in film and television. Synergy was cultivated. Synergy in action was when different divisions of a company could act as one. It was back to Walt's original dream: films, television, books, products, all connected to Disneyland. We were back to it, but it was supercharged now.

A New Opportunity

"I think it's strange," Michael said. "It's strange to me that you have industries represented at EPCOT, from transportation to energy to communications, and we don't have our business at EPCOT. We don't have a pavilion about entertainment there."

I remember many of the people who were most involved in EPCOT thinking, "Entertainment doesn't seem like an EPCOT topic." But Michael said, "Entertainment is a creative process and a production process, and it is every bit as important to culture as any other industry. And I think we should have a pavilion about it." Somehow, I'm not sure how, I got pulled into moderating an express charrette on the topic. There were so many thoughts, ideas, and requests going on at once that Marty quickly put together teams to respond. And responses were expected fast.

Some teams were generating brand-new ideas. Other teams were mining our archives to find ideas that Marty thought were good but hadn't been executed. With this in mind, I managed to get rolling on a brainstorming push about Michael's entertainment pavilion for EPCOT. If I remember correctly, we would have only a week or so to come back with some ideas.

At that time, the dominant media in America and around the world were film, television, music, and radio. So, the quickest organizational idea we

thought would be to develop a big ride based on movies, a theatrical show that celebrated television, and some kind of unique technology in 3D audio production that would pay homage to music and radio. And these three elements could be grouped together in a pavilion. We did a very quick schematic and looked at some possible sites where that pavilion could be located around the Future World loop.

One of the concepts would bring to life well-revered moments in movies. At the time, Audio-Animatronics figures had been a part of the lexicon of Imagineering for quite a while, and many, many of the newest ones were in the big spectacular rides of EPCOT. But they tended to be slow-moving and not very expressive. I knew that it would be cost prohibitive to use live actors instead of figures, but we had the idea that maybe there could be a few live actors intermixed with Audio-Animatronics figures, which had never been done before.

The next idea we came up with was that a live host on the ride vehicle could be ambushed by a live actor hijacking the story. Imagineer Michael Sprout, a richly talented story person, acted it all out for us. We talked about re-creating scenes from classic gangster movies, with the notion that ride vehicles get caught in a shoot-out and one of the gangsters commandeers the ride vehicle as a getaway car. The rest of the ride commentary would suddenly become what you might hear from, say, an Edward G. Robinson, rather than a Disney host.

How could this work? We had no idea. What the rest of it was . . . we had no idea. I went to Frank Armitage, among the finest artists ever to work at WED. (Frank had also worked with Walt on animated and live-action films.) I tried to explain the concept, but he seemed a little skeptical of me, of the idea, and especially of the tight timeline. But the next day he called me in to see a thing of genius. He'd sketched the scene from above, a film noir gangster street, an ambush about to happen, and a Disney ride vehicle right in the middle. Bullets traced from the cars right over the heads of guests. He painted it noir sepia. A few days later I set up a conference room with the pavilion idea—some diagrams, site plans, and Frank's painting.

When Michael walked into the room, he went right up to the painting. We were learning there were no agendas for Michael meetings. He was emotional and intuitive, and he went toward whatever he thought had the most potential to catch the guests' imaginations. If a picture is worth a thousand words, Frank's sold an entire project. We literally had nothing else. We had no idea

what the television show would be. We had no idea what kind of music and radio show or what kind of pavilion we were going to build. Or how much anything would cost.

Michael looked at Frank and said, "We have to do this project."

Without Michael's personal energy, and Frank's strategic support, a project of this kind could never accelerate at the rate that it did. It simply was a level of energy and forward motion that none of us had ever experienced before. I further explained the possible location for the pavilion. Michael suggested we could add a tram or walkway from the entertainment pavilion that would lead to soundstages. He said he and Jeffrey were accelerating film production, and some of the movies could be made in Florida, where our guests could see how they are actually created.

We consulted with the studio production team and quickly laid out a complex of four soundstages just outside the barrier of EPCOT. I should note here, without much surprise, that Universal Studios had for quite a few years been planning to build a project in Orlando. The project had been off and on for many years, but Universal had announced they were moving ahead. I know many people saw Michael's energy behind the entertainment pavilion and soundstages as a strategic response to the threat of Universal Studios' impending presence in Central Florida.* And the speed at which he wanted to develop our studio project gave him some hope that maybe they'd abandon theirs.

I certainly understood that was part of what we were doing, but I never doubted that Michael fully believed in the idea and wanted so badly to create a combination of an entertainment complex and a view of the studio in action. I also never thought there was anything we could do that would dissuade Universal.

Within a few weeks our little pavilion was outgrowing EPCOT. Michael kept tossing in new ideas and writing stream-of-consciousness memos about it. Marty gave a heads-up to Tom Jones, who had returned from Japan to head WED's project management division, that he should assign a project manager and an estimator in case Michael and Frank continued to push toward making

* Within the coming months Michael would express that he loved to see how things got made. He said many times he wondered how toothpaste got into the tube. He was very inquisitive, and we almost built another project illustrating how things are made, one tentatively called "The Workplace."

the project a reality. I met Randy Printz, a very talented strategic thinker and team-oriented project manager who had worked on EPCOT. He started to anticipate all the business questions that would need to be resolved to gain corporate approval. He wanted a conceptual estimate, and to do that we needed a partner from the Walt Disney World operating division. Soon Randy and I teamed up with Bruce Laval from Walt Disney World. I realized I had never been assigned as the creative lead. I was leading the brainstorming sessions and responding to Michael's constant barrage of questions and ideas. But I was also still on TDL and supporting other charrettes at the same time. It was in one meeting that Marty referred to me as the project's chief designer, so I guessed I must have gotten the job.

Both Bruce and Randy would become trusted confidants. Unlike me, Bruce and Randy had deep experience working on EPCOT. Randy had invented the project development process for WED, and Bruce had really invented the science of industrial engineering for Disney, or what they called "guestology." Each of us quickly held one-third of the golden key needed to unlock this new project. I was the novice in the equation. The three of us quickly found ourselves at the center of a fight for control over WED's future in park design.

A Third Gate

Michael was now convinced he wanted the so-called Studio Tour project as a third gate for Walt Disney World. When WDW opened in 1971, a typical guest party (like my family) traveled some distance by car, or came by air, so they tended to buy two-day tickets, spending two days exploring the Magic Kingdom and enjoying their resort before heading off to visit other parts of Florida. When EPCOT opened in 1982, Walt Disney World had gone from one park with a few hotels to an extended-vacation destination. The typical guest would now buy a three-day ticket to see the Magic Kingdom and to explore EPCOT. This brought many more stays at the resorts, justifying more hotels and leisure facilities. Disney had a larger piece of the typical family Florida vacation. It was also an impetus for substantial growth in tourism to the greater Orlando area. I suspect that Michael and Frank had studied this history and knew a third gate would have major impact as well.

Within a few months, our quickly conceived notion of an EPCOT entertainment pavilion combined with soundstages steered out of control. It became one of Michael's pet projects. And his ideas were unlimited. We were outgrowing the original concept.

Back to real estate for a minute: Remember the Arvida purchase during the Saul Steinberg greenmail episode? Even with the exit of Ray Watson, the idea to create value using the twenty-seven-thousand-acre land bank of Walt Disney

World property was still a priority. When Michael and Frank first came in, they flew to Fort Worth, Texas, to meet billionaire developers the Bass brothers, who agreed to invest in Disney over the long term, assuming there was plenty of upside potential for resort and community development in Orlando. Gary Wilson from Marriott was hired as chief financial officer. Gary brought others in from Marriott, including Larry Murphy, who became Disney's chief strategic planner. Bruce, Randy, and I soon found ourselves collaborating with Larry Murphy, who held the keys to getting Michael's third gate, the Studio Tour, approved and on its way to development.

Gary, Larry, and much of the real estate community building inside Disney were skeptical about the long-term prospects for growth in the theme park business. Although Larry didn't really like the idea of a third park at WDW (he was in favor of hotel and community development), he spent time working with us to figure out how to achieve what Michael wanted. The concept was originally developed for a half-day park. The idea was visitors had a half day free—either the day they arrived, or the morning on the day they intended to leave. A half-day park could fill this need and be created with a smaller budget.

The challenge was no one seemed to be willing to reconcile with Michael that his big plans had nothing in common with a half-day concept. A race was on to test the concept with consumers. I had never done a focus group before. But we were quickly asked to do artwork and moderator descriptions that could be sent to a market research company. We soon learned that the market research would be conducted by an outside moderator, and Larry was the liaison. I didn't know much at that time, but I knew the power of WED creative, and I also knew that whoever writes the question normally has outsized influence over what comes back as the answer.

Michael was not just pushing for a Studio Tour. He was also pushing the company toward finalizing a deal to build a resort outside Paris, adding elements to Disneyland and Tokyo Disneyland, plus expansion projects all around Walt Disney World. There was a severe talent shortage at WED. It was hard to get people to choose working on the Studio Tour over possibly relocating to Paris, but we built a small group and also brought in freelance talent. As Michael added ideas, Larry Murphy tried his best to contain us, all while we were drawing as fast as we could.

Marty's experience saved me here. Marty had been around the block too many times not to sense what was happening. He insisted on seeing all the focus group materials ahead of time, and even re-prioritized some key talent to

get us some help. When I told him I wanted to go to the sessions, which were to be held in Boston, Orlando, and other cities, he agreed and gained Michael's support. To Larry's chagrin, he now had Randy, Bruce, and me as part of his focus group entourage.

At the last minute, I still didn't feel like we captured the energy Michael was after. We videotaped every piece of artwork we could come up with, and even some historical Disney Studios material, and quickly edited it into a brief video to tell the story of the project. We even added narration and music. Larry was again concerned, thinking that all this movie glitz was going to make the project seem too good. I learned a big lesson in all this: never try to do anything that is anything less than excellent, and never let anyone convince you a presentation is too good.

The focus groups started. The research company took direction only from Larry until I insisted on spending some time explaining the concept to the moderator myself and improving his presentation. We all sat in a soundproof room, as guests commented on our work, wondering who was behind the two-way glass. Larry would write little messages, questions he wanted to ask, on scraps of paper and send them into the room to the moderator. I got the idea this was cool and started to do the same thing. This drove the moderator nuts because now the guests were really wondering who the heck the people behind the glass really were. The sessions went well, the moderator dutifully explained the concept from the boards, and people asked good questions. Then the video played. When it ended, people smiled and said things like, "When will it open?" The video had clarity and emotion the moderator couldn't match, and people for the most part thought the concept was a great idea, and said they'd plan to visit.

Until . . .

The last part of the session focused on price. I was worried. I knew our budget was not going to be anything close to what it took to build the Magic Kingdom or EPCOT. The moderator explained that the park would be a half-day experience, and it would be half the ticket price of the other two parks. People got upset, like they'd already been cheated. Had we not heard their enthusiasm? Who are those people behind the mirror? They just couldn't believe the price would be half—it would undervalue a great idea. They said they wanted a full park, every bit as good as the other parks, and they were more than willing to extend their stay and pay full price.

No matter where we went, the result was the same. The moderator's

presentation was fair, the video sold the idea, and people became very skeptical when they heard it would be a half day and half price. When would you ever expect guests to be upset that you're not charging enough? It was simple: they wanted Disney quality, and they were smart enough to know that wasn't going to happen unless the park was all in—full day, full price.

I was glad that we had pressed to be present at all the focus groups, and from then on, I attended them for all projects I was involved in. The report, edited, clean, and coming out a few weeks later, was after the fact. It was the impressions everyone had drawn from observing the focus groups that carried all the weight. And they were in circulation long before the report came out. Our team was gratified by the reactions of real people evaluating our work, and the idea of a half-day park quickly was dismissed. But the battle to size the park was not by any means resolved.

One thing about Michael Eisner: he loved big ideas, but as he himself said, "It has to be great, but it doesn't have to be seamless!" As a result of the focus groups, Walt Disney World developed a demand study that showed the proposed new park drawing twice the amount of ticket sales that had been projected given a smaller, half-day experience. But Paris was already struggling with budget, as were some of the first projects WED had started under Michael and Frank. They applauded our can-do Studio Tour team, and Michael stressed that the concept lent itself to breaking a lot of rules that couldn't be broken in Paris. We could leverage "behind the scenes" as a conceit, yielding a more cost-efficient strategy.

We formulated a plan. The idea was to have only two main "lands." The entry and first land would be based on Hollywood, an idealized version of it. Author Jim Heimann had recently come out with a few books on Hollywood history. His first book, *California Crazy*, documented the trend of Californian Pop Architecture in the 1920s to 1930s, from roadside diners to buildings shaped as animals, cameras, anything that would catch a driver's eye. Heimann's book was written right at the time when so many of these landmarks were disappearing. His second book, *Out with the Stars*, documented the unique social scene of 1930s Hollywood, from theaters to elegant restaurants and bars. We talked a lot about the Hollywood that never was, something that existed in fans' imaginations. In the same way that Walt Disney had re-created his hometown of Marceline, Missouri, fifty years later at Walt Disney World, we would create a special, exuberant Hollywood town, complete with crazy roadside architecture, unique dining, and theaters.

Our second "land" would be a working studio. We'd model it after the look of the Disney Studios in Burbank, what John Hench called the brown bread and avocado sandwich, a reference to the brown and green stripes of nearly all buildings at the studio. Backstage we would have soundstages and a microcosm of what it takes to make film and television, as well as some of the more interesting aspects of how to run Walt Disney World.

Our already-stretched budget for attraction capacity would be further challenged by building production and support facilities. Michael was insistent that we have a real working animation facility to tour, as well as a tram tour of the working film and television facilities. (How do they get that toothpaste into the tube again?)

We soon had multiple constituencies on the project. There were Michael and Frank, and of course our bosses at WED, Marty Sklar and John Hench. There was also Walt Disney World, responsible for the long-term operations and business success; The Walt Disney Studios, responsible for the working studio; and Walt Disney Feature Animation, responsible for their own production studio. For these I spent time with Jeffrey Katzenberg, who would become a trusted supporter of our team, the project, and WED in general.

Jeffrey sent over Marty Katz. Like many of the best producers, Marty was lightning in a bottle, someone who could get almost anything done, and was always thinking ahead of most people in the room. He descended on WED one early morning, ready to design a studio immediately. His associate, Campbell Katz, also his wife, noted every detail and was there to make sure Marty was back working on the other twenty films he was producing before lunch.

Marty had been a U.S. Army first lieutenant Combat Pictorial Unit director in Vietnam, then worked for prolific B movie producer Roger Corman, and for Michael Eisner when ABC began making films for television. He'd supervised countless films by the time he came to Disney, including one of my favorites, *Lost in America.*

Marty, in turn, introduced Randy and me to Milt Forman, a wonderfully charming and technically amazing gentleman who'd already had a long career in the movie business by the time he came on our project as a consultant. He was a technical innovator who'd won an Oscar for his moviemaking and editing inventions. He was determined to educate our team on how a movie studio, even a very small one, was supposed to work, and what kind of a team it would take to design and build it.

Planning the Operation

I made a trip to Walt Disney World where we looked at possible sites that could accommodate a new gate, along with its requirements for parking and guest services. With Bruce Laval's leadership, we were to meet with the Walt Disney World team about the requirements for the operation, and how best to position dining, merchandise, and entertainment for the project.

In my Tokyo Disneyland days, I'd worked with an Anaheim team known as Disneyland International. They'd planned the operating program for TDL, meaning what the ultimate operations team would require in attractions, dining, merchandise, and cast and maintenance facilities, everything needed to make the park successful. After TDL, when I started the larger WDI five-year master plan, I became familiar with the first "summer study." Since summer was peak time, the operating teams used it as a time to evaluate the efficiency of the park, and to do a needs assessment. I remember being fascinated by the summer study. It was insightful and complete to every detail, from attraction utilization to toilet flushing, and even included my old alma mater—ice cream and popcorn sales volumes by location. Reading it was akin to getting a PhD in park design in one spiral-bound volume.

If Walt Disney and the Imagineers invented the theme park, it wasn't

until Bruce Laval, an industrial engineer (IE)* and the founder of the science of Disney guestology, that the company really understood the depths of how a theme park worked. The best way I've found to describe it is this: Imagine holding a party, an inaugural, a royal wedding, some kind of massive event for fifty thousand people. Now do that every day of the year—and every guest must be treated like a VIP. That is the definition of how to plan a Disney Park. And it was Bruce who figured it out, along with his team that grew to more than one hundred specialists and assorted complex thinkers from academia. Like all aspects of Disney design, guests don't need to know how complex it is, but they will certainly notice if it's not working.

When Bruce had joined WED's project development team in 1976, WED was struggling with how to make Walt's dream of EPCOT a reality (and I was selling popcorn and ice cream at Disneyland). Bruce was tasked with the unimaginable—developing design criteria for a completely new kind of park. The IE team worked collaboratively as part of the WED team, modeling (without computers, remember) the required program and capacity requirements for all public facilities (attractions, food, and merchandise) and all other support facilities within the park. His involvement in the planning process of EPCOT then led to the position of director of administration/planning for WED, Florida. With the opening of EPCOT in 1982, Laval assumed the role of general manager of EPCOT.

Now back to that party for fifty thousand. Guest service expectations drive everything. How many attractions WED develops is influenced by how many are actually needed—people tend to feel good if they can do not less than one great experience every hour (that is a lot in an eight- to ten-hour day). They all tend to want to eat lunch and dinner in fixed windows of time. And how long they wait in line tends to have a lot to do with how they feel about a place. Entertainment is fun and creative, but it also fulfills direct needs. A band, character appearances, and a parade in the middle of the day can take pressure off the attractions. Fireworks at night tend to encourage people to stay later, and they leave feeling better about the completeness of their day (and they

* Industrial engineering is an engineering profession that is concerned with the optimization of complex processes, systems, or organizations by developing, improving, and implementing integrated systems of people, money, knowledge, information, and equipment. In other words, the things that make Disney Parks tick!

usually have dinner, too!). People expect clean restrooms at certain intervals; benches for rest; refuge from the weather; security, safety, and well-being; nicely appointed baby-care areas; first aid and lost and found; and sometimes an air-conditioned place to board their dog all day. They need a place to park and an easy way to find that car while carrying bags of merchandise, pushing sleeping kids in strollers, and toting a Mickey Mouse balloon or two bought on the way out.

And remember, this is not a party for one night, it's a party every day of every week of every year. Walt Disney famously said, "You can design and create, and build the most wonderful place in the world. But it takes people to make the dream a reality." Disneyland doesn't exist without its cast—a patient, hardworking, fun-loving, inspired, and creative team.

Bruce Laval was soon promoted to director of project development for our new Studio Tour team. In this role he would be the lead operating executive responsible for providing all project design criteria and operational input to the creative and design team.

I'd earned a degree in architecture. I'd learned how to build a park in Tokyo. But I truly learned how to design one from Bruce. By coming in with an open mind, I was able to forge a mutual respect for invention. A preliminary look at the numbers told us we were about to commit to building a park that was going to cost a fraction of EPCOT, on a dollars-spent-per-guest-served basis. A Disneyland- or Magic Kingdom–type project has a lot of small attractions that fill up the day for guests. These have relatively low cycle times, a few minutes on average. That means you need a lot of them to keep your guests busy. EPCOT had relatively longer cycle times on average, with attractions like Spaceship Earth, Universe of Energy, and American Adventure, and not a lot of small stuff.

We developed a preliminary model for the Studio Tour that had an even longer average cycle time than EPCOT. The reasoning was tied to Michael's interest in going behind the scenes. It would take quite a long time to tour guests through a working studio. We thought they'd ride some of the way and walk through things like soundstages and technical areas. Another consideration— the name of the project was Studio Tour, meaning guests coming for the day expected to actually see that tour. It was these two factors that drove the capacity model. The Studio Tour needed to have enough capacity to serve every guest, and by its nature it was going to have substantial length.

Other factors started to take shape as a consequence of these decisions. The movie attraction was going to be the only true Disney ride, and so it would

require a large capacity. And we would rely on a couple of major theater event attractions. One was devoted to television, and we had some compelling ideas. The other was going to be stunt and special effects oriented. We called it Epic, but the only thing epic about it was that it needed to draw two thousand people every hour, and we had no idea what it was going to be!

We also planned dining experiences, going for entertaining concepts relating to Hollywood. And we thought there'd be a lot of interest in shopping if it was fun and a little campier than the traditional Disney retail experience.

We had a creative concept, and an operating concept, starting with a guess at annual capacity and breaking that down to attractions and everything else. I took Bruce down to Hollywood Boulevard on his next visit to Los Angeles. It was seedy; there is no other way to say it. For me, coming from years of tidy Tokyo, and for Bruce, used to running immaculate Disney attractions, it was a shock. We were going to create a Hollywood "that never was," something exuberant, John Hench would say, with neon signs, and billboards, and crazy characters on the streets.

Project Development

We were making progress. We had concepts, projected attendance, and a design program. We had a schedule, and we had a budget number. None of these things were generated on the same basis of information, and it was time to build a concise project development plan. For that we needed Randy Printz.

Many people can put together plans, but it takes a very special individual to look at very early, out-of-sync information and anticipate or predict how it will all come out. It takes knowledge and experience, and it takes a leap of faith.

In Tokyo I'd worked with great project managers, especially Tom Jones. But in Tokyo the ultimate responsibility sat with the Oriental Land Company. For the Studio Tour, it would be all on us.

By the time I was entering WED, Randy Printz had wrapped up a successful career in the U.S. Air Force and was entering his second year as a leader at WED. We both benefited from early employment interviews by Frank Stanek, and Randy had benefited from another he'd had with Orlando Ferrante. Randy's military career had given him a background in managing costs and schedules across a variety of research and development contracts. Frank hired him initially to set up a production management system to handle the simultaneous workload of EPCOT and TDL. He set up shops and systems at Walt Disney World and in California. WED had no such systematic approach at the time, so Randy was an early change agent.

EPCOT was straining the company's finances and executives' nerves. Randy was a kind of inside-outside leader. He knew the details of daily production, but he could also do periodic independent assessments of how the project was progressing overall. It takes a lot of guts to be honest, especially when high-level company officers have their minds made up. But Randy held up and exhibited a kind of integrity and clarity that gained him respect across the company.

Like me, Randy had lived through the dark period of 1983–1984, with layoffs happening, trust in WED at a low ebb, and most of the work available being SLJs.* He'd lived through his own version of my Color and Fun days.

Randy's role came to the forefront once again when Tom Jones got his call from Marty and it seemed like Michael's Studio Tour was about to move ahead at breakneck speed. Randy was the obvious choice as someone who could catch up fast and build a team, and he would be able to draw upon all the lessons that his experience delivering EPCOT provided.

Randy had a lot to sort out. The creative description and art needed to be reconciled to the park program, and that all needed to be looked at from a delivery-cost and estimating point of view. Trade-offs had to be made. A tiny model using blocks of blue foam was built to give estimators and teams a bit of a picture of what we could be building. Most of all, a team had to be put together. I had a sense of the creative team I wanted, and Bruce Laval had a sense of whom he'd pull from Walt Disney World. But the team would need a full complement of construction managers, project managers, producers, architects, and engineers, plus show, ride, interiors, graphics, finance, estimating, and scheduling. It was massive. And tons of folks were getting ready to go to Paris . . . or hoping to.

Randy raised the bar, providing the management credibility we needed. WED was awarded a level of trust to proceed, despite all the unknowns. Randy knew great projects were delivered by great teams. We wanted the best, and we wanted a convergence of purpose and a passion for the success of the project. And we were willing to go wherever we needed to find it.

*SLJs is WED parlance for "shitty little jobs." Most of them are small budget and take a lot of coordination, but are nonetheless fun. They don't really deserve the unkind designation. In tough times, it's nice to have a portfolio of SLJs.

EPCOT Resorts

Back at WED, I was invited to a meeting with Jon Jerde. Jerde was a Los Angeles architect, and a legend in the entertainment-architecture community. I was very intrigued to have a chance to meet with Jon and to hear a pitch he was going to make to the new Disney Development Company (DDC) group, which had been re-formed from Arvida.

There are not that many things in my career that have really shocked me—I mean completely shocked me. Ideas that are so unexpected, so groundbreaking, so impossible; when an idea so shifts your perspective, it takes me a while to really see it, and from then on, it's impossible to unsee it. The world had changed; that is what I saw that morning.

EPCOT itself had been a very innovative plan, but it had followed the rules of Disneyland in its layout, including that it had what we called a berm mentality. The berm of Disneyland is a landscaped, elevated peripheral landform that forms the train route but more importantly protects the sense of Disneyland being its own world. Guests, once they come through a single entrance, are presented with one story, one clear sequence of events that creates a cohesive experience. EPCOT had the same premise. You come in, Spaceship Earth awes you and welcomes you into Future World. And later you enter World Showcase and explore the cultures of other countries. It is, as Marty Sklar says, an organized flow of people and ideas.

What I saw that day was a violation of that Disney rule! And it was beautiful. The drawing showed a new channel that was dredged right through the outer perimeter of EPCOT to connect World Showcase Lagoon to a completely new waterway leading south to what would become the EPCOT Resort Area. Ron Goetz, a wonderfully talented architect at Jon's office, had illustrated a new kind of entertainment town: All along the waterfront were hotels, restaurants, small cafés, and walkways. All were within walking distance to World Showcase; and the Friendship Boats, which currently served EPCOT, would circulate and stop at marinas at each new hotel.

It remains today one of the best plans I have ever seen. But what disappointed me was at the south end of the lake there was a road, and below that road was the Studio Tour site. Not just the site but the backstage fence. They'd assumed the Studio Tour would be off by itself, traditionally located as a park inside a circle, a service area to its north, and parking to its south. And there it would be, looking very old-fashioned and isolated from the rest of this brilliant new resort idea.

I made my pitch to Michael and Frank, and to Peter Rummell, the head of DDC, and I was given the opportunity to sit with Ron Goetz and find a way to integrate the Studio Tour site with the rest of the EPCOT resorts to whatever degree we could. It quickly became obvious that we could not move the road that separated us from the EPCOT resorts, but it would be possible to completely rotate the studio's entrance toward EPCOT resorts and bring the lake down to the entrance of the Studio Tour. This created a pedestrian connection and made it possible to take a Friendship Boat from inside EPCOT all the way to the entrance of the Studio Tour.

The EPCOT resorts and the Studio Tour were about to become incredibly defining parts of the future of Walt Disney World, and now they were able to be integrated into one.

Great Movie Ride

"Oh, no, we're not going to do *Mary Poppins* again, are we?" said Randy Bright, to which I privately thanked him. We were looking at sketches and very rough models for a large-scale attraction that would pay tribute to the movies.

I had not grown up a superfan of Disney movies. I didn't really know the canon too well. I remember summer matinee double features at the Fox Theater in downtown Pomona. I loved the True-Life Adventures that showed before the first film. The Disney films that made the biggest impression on me were *The Absent-Minded Professor*, *The Incredible Journey*, and *The Sword and the Stone*. I loved going to big theaters with my grandmother and remember seeing *The Sound of Music* with her. And there was an unforgettable school trip to see *2001: A Space Odyssey*.

Movies on television were another passion for me. When ABC premiered its series called *The ABC Movie of the Week*, I was glued to the screen every week. These, I would later learn, were high-concept movies. Bold stories told with recognizable studio contract players neatly tucked into a ninety-minute window, including commercial interruptions.

Three years before I graduated from college, my sister dragged me to the ABC Entertainment Center in Century City to see something called *Star Wars*. This was pop pablum, so hyped up, and certainly couldn't be cinema. But by the time Darth Vader boarded the Rebel Alliance ship, I was hooked. And from

then on, my college years included all the *Star Wars* and Indiana Jones movies, plus all the Spielberg and Ridley Scott movies, though I still managed to take in the occasional Australian art film.

And now that we were working on a Studio Tour, there was nothing in the Disney library that interested me. Randy Bright's comment was what we were all thinking: there wasn't much to pick from, even historically, and the classics, like *Mary Poppins* and *20,000 Leagues Under the Sea*, had already been heavily leveraged.

We set up a meeting on the big movie ride idea. We took it in a decidedly popular direction, with titles that people would recognize and that would be excellent to re-create in physical theatrical space. I did some personal brushing up on film academics, and we had advisors come in. It didn't take long to show that there just wasn't enough depth in the Disney library. Frank Wells made light of it, and suggested we just make up movies. But I knew, or at least I hoped, he wasn't serious, and I knew he and Michael realized a certain cache and authenticity was necessary to pull off a credible park. The licensing of clips and characters for use in the theme parks was a relatively new business, new territory, so everyone was concerned about it.

Hollywood Boulevard

It was getting extremely busy. And as a leader, I found myself running from brain-storming to brainstorming, from artist to artist, and from architect to planner, to ride engineer, working with the best to create presentations that we could make in record time. The team was expanding, and as the team expanded, I got exposed to more and more tremendous talent. I was learning how to forge a concept with lots of personalities, helping them all work as a coordinated team.

But many times, I realized I was doing less and less myself. I had plenty of work to do to develop my own skills, but I was more and more managing the talents of others. It made sense, they were all better and more experienced than me. But I wanted to try to be like Dick Kline, someone who'd developed skills over a lifetime of design and artistry. I wanted to hold a pencil, put it to tracing paper, get out my Prismacolors that sat unused most of the time, and even strike a cutline with an X-Acto knife on a study model. My love for LA's grittiness got me interested in taking on, firsthand, the scope of the Hollywood-inspired land.

I dug out my camera, loaded real film, and hit the streets of Hollywood on my own. I walked the blocks of Hollywood Boulevard, between Highland and Cahuenga, up and down Vine Street, and along Sunset. Hollywood is more built-up today, but back then it was really suffering. It was a seedy and pretty

scary place, especially for one person walking around with a camera, obviously a tourist.

I took many photos of buildings and facades. There were many styles for the relatively small area: Spanish Colonial Revival, Modern and Deco, strange combinations of international styles. The theaters all had their own mix of exuberant style, expressed in color and neon. The Hollywood Brown Derby, the classic at Hollywood and Vine, was closed. Many of the theaters and shops were shuttered. But I could get good pictures from the street, or by sneaking around alleys and in and out of private parking lots of construction sites. I was back to my college days, rummaging around back alleys searching for architectural treasures.

I took a lot of shots of Grauman's Chinese Theatre. Nothing else in Hollywood had its presence. It dominated Hollywood Boulevard with its dramatic scale and design.

Sunset had clubs, bars, theaters, mostly closed. Many of the facades that Jim Heimann had documented in his book *California Crazy* were either gone or boarded up. The Crossroads of the World, its spires reaching up and holding a rotating globe, was still there.

The Frolic Room, located next door to the Pantages Theatre, began in 1934 as a private speakeasy. Wrapping the wall is a classic mural created by Al Hirschfeld, a great caricaturist who called himself a "character-ist." The wall is the who's who of Hollywood in the era of the 1940s and includes Albert Einstein, Clark Gable, Laurel and Hardy, Marilyn Monroe, and Tallulah Bankhead on the full color panels. It was still open, and happily, it still is as I write this.

There were Craftsman houses that had been converted into souvenir shops. There were various sizes of palm trees everywhere, and jacaranda trees with their bright purple flowers blooming along the side streets.

At Fairfax, the Pan-Pacific Auditorium's facade still existed, but it was decaying rapidly. It had once been among the finest examples of Streamline Moderne architecture in the United States; the green-and-white stylized towers and flagpoles had been designed to evoke upswept aircraft fins. But now it was sagging, its place in history uncertain.

I guess my immersion with building signs in Tokyo had stuck with me. Hollywood was all signs, and I photographed so many of them, a graphic language for a culture of fame, excess, failure, and resurrection; a place to be noticed, even if your sign was bigger than your whole building.

I had all these images developed and printed in what we used to call "one-hour photo." I pasted them on boards. I looked for archetypes. Walt Disney had selected them for Main Street. He looked for those mystic chords of memory* that his generation would most remember and want to share. The Emporium, the Ice Cream Shop, the Fire House, the Opera House, and the corner drugstore. Walt had captured an indelible collage of Main Street, recalled from his memory. I calculated that if Walt's Main Street was from the late nineteenth century, and he built Disneyland in the mid-1950s, it was about a fifty-year spread or what historians consider about two generations. Grandparents could tell their grandkids about it, as my grandfather had taken me to the pier, as Walt could take his daughters to Main Street as he remembered it. I imagined that if we opened in 1989, Hollywood as it existed in 1939 would be the same generational offset.

It followed that there was a genuine connection many people felt for these old icons of history, even though they'd been sitting vacant for decades. There were lots of social and real estate development reasons why the real Hollywood had been a challenge to bring back, but we had no such challenges; we were starting from—well how else to say it—a blank sheet of paper.

I showed my taped-up photo boards to John Hench. I asked him if it was okay, in a Disney Park, to have architecture this crazy, to have things like billboards on the roofs, big neon signs, buildings in the shape of cameras or dinosaurs. John's point of view was easy: "Have fun with it," he said, "and remember that what defines this era is exuberance; this was an optimistic era, the sky was the limit." I had my direction.

I soon pitched to Michael Eisner that our version of the Chinese theater created by Sid Grauman, where many stars had their handprints and footprints recorded for posterity, should be a combination of the icon or castle of the Studio Tour and also the entrance to the movie ride. Michael wholeheartedly agreed. It would require some work, but Michael took care of it. He contacted Ted Mann, who now owned the theater, under the brand Mann's Chinese Theatre. Ted came over and we gave him a grand tour of our project. He agreed immediately; he wanted to be part of our grand celebration of Hollywood.

*"Mystic chords of memory" probably originated in a speech delivered by Abraham Lincoln about preserving and remembering battlefields. It has come to refer to the many ways we remember the places associated with our history, and how we pass them down through generations.

I continued to put facades and plans together. I could have just looked at plans of Disneyland but really wanted to feel the street. I went down to Disneyland and literally walked off the dimensions (my stride is about thirty-six inches). From one side of the street across to the other along Disneyland's Main Street, U.S.A., the distance is fifty-five feet. I knew the number, but I wanted to feel it. I measured off sidewalks, curbs, and where trees were located. The blocks of Main Street also move inward, creating a sense of a longer street by enhancing forced perspective. I already knew that we didn't have enough program for buildings the size of Main Street (thank you, half-day park concept!), so I did some tricks to make sure we had enough street, without making the buildings too big. I nixed the idea of a town square; we just didn't have enough need. I thought we could use the Pan-Pacific as the entry facade. Once you came in, we could have the Crossroads of the World, only we could add Mickey on top of the globe. I was enchanted with the idea of an old house being converted into a souvenir shop, and with a gas station with a few period cars.

During my EPCOT Color and Fun days, I'd met Herbie Hanson. He was an extraordinarily talented actor, comedian, director. And he had a vision. As he saw the world becoming more high-tech, he wanted to start a company that was high *touch*. Sak Theater was born and created street theater for EPCOT's World Showcase. Herbie and his collaborators proposed characters that could populate and add vibrancy to the atmosphere of the streets of our Hollywood Boulevard. Not singing and dancing but performing improvisational moments in the character of the time and place and involving guests in the story. Streetmosphere was born, and it became a core mission of the Boulevard concept.

I took my new collaborator, studio architect Richard Graham, who'd designed many studios including George Lucas's ranch, to Hollywood and Vine to see the Brown Derby. It had been closed for a very long time. I liked the original for its Spanish Colonial Revival facade, and neon Brown Derby signs (instead of the giant plaster hat that had been adopted in future locations). Richard and I walked around it. He walked off some dimensions and made some sketches and notes. Then we realized that a window along the alley was partially open. We looked at each other, and decided what the heck, and helped each other through the window and into the space. That was the first time I stood in the beautifully proportioned, arched space of the main dining room, and the beautiful cascading bar. As nervous as we both were, we stepped off all the dimensions and the sizes of the grand booths before we departed from the same window we'd entered through.

Bit by bit, a new kind of Hollywood street emerged, with Main Street as a model. I talked to Collin Campbell about it. Collin had a long Disney career in animation and Imagineering, and he also had been in the United States Navy. He'd studied art at Académie Julian in Paris, and was an extraordinary painter, model builder, and art director. He'd worked on the original dimensional visualizations of Walt Disney's Enchanted Tiki Room, Pirates, and many other attractions. Collin looked at my silly boards and got them immediately. He started drawing, and in a few days, he had a painting that expressed the entire idea of what Hollywood Boulevard could be. He was fun, patient, and brilliant, and he would play a major role in making the whole Studio Tour a reality.

I pasted together rough models, and I did a long series of street elevations blending the facades with billboards, benches, and antique vehicles. It soon became obvious that my career as a detailed designer was going to be short-lived. Not only did I not have the extraordinary skills of a Collin Campbell or a Dick Kline, but the project was moving too fast. There were too many different attractions, planning issues, concepts, and stories to be developed. It was clear I was going to have to be content with being what Walt once called a busy bee. "I think of myself as a little bee. I go from one area of the studio to another and gather pollen and sort of stimulate everybody. I guess that's the job I do," he said.

I was never Walt, and I had neither Walt's experience nor talents by any measure. But if being a bee was going to get us going, a bee I was going to be!

Luckily, I realized I had incredible team members who would carry the work forward. Collectively, they would do so much better than I could do by myself. David Ott, a skilled themed architect, carried on the Hollywood Boulevard work. David had joined WED to work on New Orleans Square. I knew I had nothing to worry about.

Brock Thoman, an architect and set designer, picked up the Chinese Theatre project. We determined that we should elevate it, making it a full story (ten feet) higher than the end of Hollywood Boulevard, since it wouldn't otherwise have the gravitas of a castle. But Brock took it from there, caring for every detail. Halfway through, Ted Mann's team at the theater discovered a set of original drawings upstairs. They served to confirm our reproduction was accurate.

We met Walter Scharfe, the entrepreneur who'd purchased the Brown Derby out of bankruptcy and tried to reenergize the chain. Like Ted Mann, Walter saw that our project was going to immortalize the brand, and he wanted to work with us. But it was going to take a lot of energy and hand-holding to

make the design and the deal happen. I called in Steve Miller. I'd been lucky to "borrow" Steve from Marty. He was skilled in managing anything from casting to graphics to architecture to show. We needed him for so many things, but he was willing to take on the Brown Derby, too. He patiently had dozens of long conversations with Walter to make it all happen, including reproducing the little brass "derbies" that lit each booth. He even got us permission to duplicate all the framed caricatures that defined the interior.

Rennie Rau, an artist with a deep connection to pop culture, worked with Tim Kirk, a virtual walking Smithsonian of it. They sketched, pasted, and collaborated. They took on the interiors of all these buildings. But they didn't do interior design—they cracked the buildings open like geodes, discovering the multicolored and magical stories that could exist inside. Collaborating with Barb Dietzel of WED Interiors, they created boards that sold every restaurant concept, every shop; and all of them with a rich story to tell.

Going Public

It was not long before we had a project. We were on point for a scope of work, a budget, a creative concept, and there were a lot of vast assumptions. Most of all there was schedule pressure. Michael wanted the project developed and delivered in thirty-six months. It was unprecedented. But it is not like we said we could do it; it was more like we said, "Okay, we hear you." With the approval of capital almost certain, we turned our attention to building the team of diverse talents necessary to get the project done.

When I was on Tokyo Disneyland, we had to deliver it with a small team, because the entire company was focused on the success of EPCOT. This time around we were a small team again but with a limited budget and resources, because the majority of the company was focused on delivering Disneyland Paris. But I was not able to rely on reference drawings; there was no reference. We gathered a consortium of architects, artists, and storytellers, all of whom loved the topic and the impossible dream of it all; all highly experienced in delivery of specialized studio-type facilities.

But first we had to do a groundbreaking event for the press. Our focus was interrupted to create renderings, models, marketing descriptions, and pitches that could easily be summarized for press materials. Walt Disney World was an expert at this, but it was my first time at bat. There was a whole publicity crew there, under the leadership of Charlie Ridgway. If you could get out of bed and get dressed, they were going to make sure you had a great press event. The

day was selected, and a site was cleared. Buses would drop the press off on the edge of what would be the site. I helped edit the announcement and coached Michael and Frank on the content they would present. Things seemed predictable enough. But Frank Wells had a few more tricks up his sleeve.

Only days before the groundbreaking, Frank and Michael announced that we had a basic agreement with MGM Studios. Our new park would be named Disney-MGM Studios and could use the famed lion, and we would have access to the massive library of MGM films for use in the attractions. It changed everything. It brought focus as well to the attractions. I spoke to Frank, and he told me to watch out for the exclusions. I was too green to know what he meant, but he told me to call one of the attorneys at the studio and they'd send me the exclusions list. If I asked you to name your favorite MGM films, I know you'd name *Gone with the Wind*, *The Wizard of Oz*, maybe the James Bond films. These were all on the exclusions list, meaning we couldn't use them. On top of that, we had stiff restrictions on how long we could show or represent a specific moment, and it would still be our responsibility to convince any actor depicted to be part of the project.

It was all exciting, and disappointing, and too much to take in. We didn't have any time to think, we just needed to do the groundbreaking event. I focused my time on getting materials right, and getting a logo that represented the idea. That was no less than the Disney and MGM names, and the first time Mickey Mouse would be composited with the MGM lion. It was at most a few days before the event when we got approval for a basic logo to announce the project to the world.

Frank had delivered MGM, and now he took on the challenge of bringing one more surprise to the groundbreaking. A star. Someone with enough firepower to garner a lot of press on a remote corner of cleared sand in Florida. The answer was Bob Hope. Bob was at the time an American icon of comedy and, through his nineteen appearances as host of the Academy Awards, synonymous with Hollywood. He was also associated with patriotism, thanks to his many years entertaining American troops, even in various war zones. And Bob had spoken at the Contemporary Hotel as part of Walt Disney World's original grand opening. There wasn't much for Bob to do this time; he'd just be there and be Bob Hope. He was a foil for Frank and Michael and did a few jokes.*

* Ronald Reagan was president of the United States at the time. Hope noted this and said, "There are probably some old actors in Washington who'd like to retire to Florida to find work."

Front-Office Shuffles

It was finally time to get down to serious work.

As the project was clearly divided into two areas, a working studio and a Hollywood attractions area, we decided to structure the construction that way. Our team was small and dedicated. We had two bases—one in Glendale, California, and a construction office in Orlando, Florida.

But WED had two major management changes during the production of Disney-MGM Studios. Management change of any kind usually has positive and negative consequences. For teams working under fixed conditions, fixed budget, fixed schedule, a management change can make the team quite apprehensive, not knowing if management will have other advice or direction that they might have to absorb into their existing plan. That doesn't mean the team's not open to good ideas; it just means good ideas often still have to be developed within the confines of the project that was defined under the previous management.

When Frank Wells and Michael Eisner came into the company, their first charge was to update Disney. Disney had been languishing for quite some time. Studio facilities were out of date, corporate offices were substandard, and there was a perception that there must be a lot of overhead functions that might have been part of a traditional studio years ago but were no longer necessary.

The answer was Jeff Rochlis. Jeff exhibited an aggressive personality and had no problem telling people what they were doing wrong and what they should do to fix it . . . and showing them the door if they didn't care to listen to his direction. Jeff had done lots of work at the studio cleaning out legacy departments (and tossing into dumpsters what today would be priceless history), and Michael and Frank thought the same thing might be needed at WED. Jeff, at the conclusion of his work at the studio, was reassigned to be Marty's partner at WED. Now, Marty over the years had always proven to be a great partner. He adjusted to the conditions of the time, but most of us could see that Jeff and Marty were as close to oil and water as you could imagine.

Marty knew where to focus Michael's and Frank's attention. He widened their sphere of knowledge of the Imagineers, the diversity of talents, disciplines, and passion. He knew that they knew it was a one-of-a-kind organization, and he wanted to make it clear there were some lines not to be crossed. He also pushed for a new name to match the rest of the corporate rebranding going on. I remember Marty saying, "I don't want these tan cards anymore. I don't want an anonymous name anymore. I want a name with Disney in it, and a logo with Mickey Mouse on it." Soon he got his wish. WED Enterprises became Walt Disney Imagineering (WDI) complete with a Mickey Mouse as the Sorcerer's Apprentice in the logo.

But Jeff Rochlis arrived with much fanfare and with no knowledge of how WDI or any other creative business was supposed to work, yet with plenty of criticism of the way it was structured. Project leaders were called on frequently to report where they were. Much good came out of this because some projects were not doing well either with schedule or financial, or with the ability to deliver what had been promised. There was at that time a can-do attitude at WDI, which we always believed was good. But it sometimes left teams believing they could do something although the data did not support it. Teams would sometimes present the status of projects as positive when in fact they might not have solutions to significant issues. Yet they presented as if they were managing them.

Jeff was a skeptical person and did not trust people. He was able to drill down into any issue even if he didn't know anything about it, because all he was looking for was weakness. If he saw weakness, he surfaced it. In that sense, Jeff did a good service to WDI by pressing for complete transparency in projects.

We as the Studio Tour team were endeavoring under the leadership of

Randy Printz to be as transparent as we could possibly be. We brought good news, and we brought bad news, and we brought news of characteristics of the project that could not be resolved for whatever reason, and some of those could be questions that we had about how to incorporate ideas or issues brought in from Michael Eisner himself. It was agreed that WDI management, Marty and Jeff, would sit in our meetings with Michael, and if Michael added something, Michael was going to have to determine if he either wanted to add budget or subtract something else.

I was glad that we had this system, but at the same time, I developed a different attitude about dealing with highly creative leadership. I always took the notes and I always understood, in the case of Michael, what he was saying. And then I felt that it was our job as the Imagineers to go back and study the question and come back to Michael with a solution that was doable within the budget or with whatever impact it might have, but not to try to essentially give him a bill every time he said something or every time he walked out of a meeting. This created friction with Jeff because I wasn't willing to commit in a meeting to what something might cost or whether it was a good idea. I felt that all Michael's or Frank's ideas had merit and that they deserved at least a few hours of study before making a judgment.

Jeff created a process that he called the "Triangle of Success." The Triangle of Success became associated with Jeff and caused a lot of discontent among Imagineers. The fundamental intent of the Triangle of Success was correct and clear. The success of any project depends on three things: intent and quality being delivered, being on budget, and the schedule being met. These seem like obvious parts of any success, and I use them on any project I work on today. But at the time, there was a sense that if WDI delivered something late or if we delivered something over budget, it could be forgiven if the end result was so spectacular and so successful that it helped the parks with their business.

Jeff's point was direct. *We go through a capital authorization process with our corporate leadership, and we decide the value of a project, we decide the budget, and we decide the schedule. And once we do those, it is a contract, and delivering on only one of the legs of the triangle is simply not fair to the company and to ourselves.*

The challenge with the Triangle of Success was not the idea or even the ethic behind it; it was getting everyone to follow it. Michael was willing to add things, and even Frank was willing to accelerate schedules. It became an accounting nightmare to make sure that every individual thing that might cost

more or that might have been sped up even for some legitimate reason was accounted for.

And then it often became a kind of inquisition by Jeff to unravel any change and put the team on probation in effect for not following directions. The Studio Tour team was lucky in that we had a difficult project but a highly collaborative and interdisciplinary team. Each team in the project had a project manager who collaborated very closely with a producer and then had their design, technical, and creative teams aligned. We tended to disagree all the time and then find solutions, so that by the time we got to Jeff's project management inquisitions, we already had a strong and true consensus of where we were.

Jeff had uncovered problems in other projects, and he simply could not believe that the Studio Tour wasn't full of them. He even came to Florida to interview individual team members to see if there was some unspoken wrong that he could uncover. The team members individually spoke the same story as we did as a group, and that was because what we were speaking was the truth. After that I always believed the best way to speak about a project is the *best truth known at that time* because you never want to be caught hiding anything or covering anything up. It was not good for the project or the team's credibility.

In the 1970s, there had been a television show called *The Waltons*, a multigenerational farm family that faced many difficult times but never lost their sense of duty to family. Jeff, in a moment of deep frustration, referred to the Studio Tour team as "The Waltons" because he couldn't get any of us to speak badly of one another. We relished the term The Waltons, and for years later, whenever our teams spoke about the project, we would talk about ourselves as The Waltons. At the low point of the Jeff Rochlis years, a new senior executive came in, and we were again faced with the anticipation that changes to our already-stressed project might be on the way. The new executive was a gentleman named Stanley P. Steinberg, and his nickname was Mickey. You can imagine what it's like for a serious executive to come into a place like WDI with your first name being Mickey. Mickey was not very tall, was schoolyard stocky, and spoke with a refined and pointed Georgia accent. He was quite a standout from the mostly LA crowd at WDI.

He also wore slacks, a white shirt, and a tie every day to an office where most wore jeans and T-shirts. I had a run-in with Mickey in my first meeting with him. Reports went around the table about projects, and I reported on some of our unknowns. We hadn't decided what to do with the stunt theater. We

were concerned how deep the clearing of intellectual property rights might go, the process was holding up design, and we were severely under-resourced. I realized I was talking too much. Mickey said, "This thing smells like a problem to me."

I was steeped now in several months of dealing with Rochlis and felt I wanted to hold my territory in case this guy Mickey was a clone. So, arrogantly I said, "Well, it's unfortunate that you haven't seen the project or observed what we're doing or gotten a full report and you already think the project is a problem."

Mickey looked back calmly at me. He saw a young arrogant kid and said, "I didn't say it's a problem. I said it smells like a problem." Fair enough, and for years since, as I got to know Mickey as someone I respected and as a friend, I realized that if Mickey Steinberg smells a problem, there is one.

Mickey's first visit to the Studio Tour site was rough. Previous management at WDI had made an agreement with a large construction firm called Bechtel. The assumption was that WDI was not a good manager and would be better off doing creative work and then turning over what was called a design-build responsibility to big international contractors. Bechtel had built oil projects across the Middle East and knew a lot about building refineries in Kuwait. But for the most part, they did not have people who were skilled in either the design or the building of conventional real estate projects, especially theme parks.

Someone called me and asked if we could get a hard hat with Mickey's name on it in time for his visit and a couple of mouse ears. I said, "Are you sure you want to do that?" And they said, "Well, we're trying to loosen Mickey up and make him feel like part of the team." I was skeptical, but we produced a beautiful hard hat with Mickey's name on the front and two mouse ears, taken off a pair of commercial mouse ears, taped onto the top. When Mickey arrived, we all put on our hard hats, and I was stuck holding the Mickey hard hat. He looked at me and I looked at him and he said, "I think you want me to wear that, don't you?" And I said, "I guess, it's a team thing." He put it on, and he wore it the entire day. Mickey Steinberg, even with Mickey Mouse ears on his hard hat, was a force to be reckoned with on any construction site.

I didn't really think about it at the time, but when I worked in Tokyo, construction sites were immaculate. They were cleanly swept. Materials were organized, tools were refined and organized. The workers wore neat clothing, and some of them even wore ties. The site of the Studio Tour was a mess. Work

was going on out of sequence: people were working on floors and ceilings at the same time; mechanical work was going on while concrete was still being poured. Mickey got about halfway through the tour and started kicking pieces of plywood out of the way and using numerous expletives saying that this was the worst construction site he'd ever been on. This was the beginning of the Mickey Steinberg era.

Mickey had been a partner of John Portman. John Portman was the inventor of the modern resort hotel and wrote a landmark book I read in college called *Places for People.* I had been a fan of John's for many years, and Mickey had been his partner. Mickey understood design, he understood how difficult complex designs got done. And so, it turned out, as we got to know Mickey, he was wholeheartedly a supporter of WDI's and wanted to be the one who cleared the path for creative people—as he had done for John Portman—to make sure that things were controlled and done well. He knew how important quality was to Disney, and he wasn't going to stand for anything else.

As a result, Mickey stepped up the project management updates. He insisted on transparency. He changed players. He did anything he thought was necessary for teams to be successful, but he never let creative out of his sights. He wanted to understand the design, he wanted to understand the priorities, and he was willing to say no, but he always wanted to understand it first, and he always wanted to go to creative or design for the solution rather than just randomly tell them no or cut a budget. Our admiration for Mickey grew and grew. We all sought him out for advice.

Soon Mickey and Marty struck up a tremendous partnership, and Rochlis was quickly squeezed out. He left one night and we never saw him again. As he departed from his office that evening, it's said that he left his early model cell phone against a security booth window.

The era of Mickey and Marty was, to us, a golden era of WDI, but the project still had to be finished. I know that Randy took on personal responsibility with Bechtel to improve their production process. It was ironic that WDI was saving Bechtel when they'd been hired to do the work because WDI supposedly wasn't up for the job.

The next time Mickey came to the site, there was no debris on the floors of the buildings, work was being done in sequence, buildings were swept and cleaned to provide a path through, and even the outsides of buildings sometimes had landscaping put in early to improve the overall optimism of what we were seeing.

WDI as an organization was challenged well before either Mickey or Jeff got there. Frank Wells was concerned that there was potential for reputational damage to WDI. Frank and Michael wanted WDI to be known as the best partner, the most creative organization, and a team that could deliver anything. So, Frank asked Jeff to write the "Black Book." The Black Book consisted of a series of projects that had failed in the company's eyes even though they had opened and eventually become successful, because they had failed to deliver their full creative potential on their budgets and within their schedules.

Thank goodness the Studio Tour was not included in the Black Book, and we counted ourselves lucky—actually, especially lucky, because the more that we built our credibility with management, the more secure we could feel and the more we could just get our jobs done. I developed huge respect for Randy Printz and his immediate team (who helped us out of many challenges and kept us out of the Black Book). When I really felt we needed something—we needed more time, we needed more money—I always went to Randy first, and I always worked to make a collaborative agreement. And like the Waltons, we rarely spoke up against each other in a meeting. We honestly presented differing points of view, and if we couldn't decide (which we did 90 percent of the time), for that 10 percent we went to management. But we went together, we explained the two sides, and when management made the decision, we never did end runs. We just moved forward.

Bruce Laval was a great ally, and he and his team were always collaborative. Anytime we could celebrate a milestone, say if a restaurant was starting up the kitchen, we would try to feed cast and Imagineers new food items that would be served there. If an attraction was going to have test runs, we would bring out teams to try the rides. We hosted a construction workers' day that included Imagineers, where you could bring your family and friends to see what you were working on. All these things helped advance the project and honored the team. Project life is exciting, but it's difficult and it's lots of time away from home.

Michael Eisner was a great partner and mentor. I enjoyed any time I had a chance to talk to him about the project and show him progress. He once said that he wanted to look at the construction site. We agreed on a time, and I went to meet him at the construction office, but he wasn't there. I asked around the office if anyone had seen Michael Eisner and they said no. I looked outside across the site, which was mostly dirt at that time, and I saw a very tall

man walking through the area. I thought, *I think that's him*. I scooted my way out and discovered Michael Eisner in a suit with no hard hat and probably very expensive shoes hiking through the mud. I gave him a hard hat and expected him to be a little put out by finding himself in the middle of the mess. Instead, he just said, "Isn't this great?"

Known Unknowns

We now turned to the exhilarating but grueling task of delivering the Studio Tour project. Randy, Bruce, and I were particularly worried because we were going full steam ahead on a major project with tight financial goals, and the scope remained relatively undefined. When you start a new project, you have lots of great concepts and ideas, but to produce a concept and then illustrate it to the degree necessary to excite management, to excite focus groups, and to excite the press does not mean you've answered all the questions of what it will take to really deliver it.

The unknowns we faced when we started were unknowns we chased until the end. We made discoveries along the way, and we tried to work through them.

A battery of lawyers started working on intellectual property clearances. Even with the MGM deal, we still had to clear any image of any actor, any clip, any piece of music, pretty much anything that had been created that we were depicting in three dimensions or in media. It sounds obvious now, but at the time no project had used so many film or television clips. It was a long, complex process and was always running two or three steps behind, meaning anything we were building could be subject to change.

We were working intensely with the studio and with production-skilled

architects, but it was still unclear what the nature of the production studio should be. Was it a real working studio or just for show? The studio had leverage because Michael was insisting that they do real production, so they needed it to be not just functional, but optimal. They would be asking talent to come to Florida to produce their projects, and so they needed selling points, unique features, crews, and talent they couldn't get in LA. And a nagging question was, what if we spend all this money, build all these assets, and there isn't enough production, or guests find it boring? What should we do to ensure that the studio is always a vibrant place to visit?

Walt Disney Feature Animation was resistant to the idea of a Florida studio, and resistant to the idea of having animators "on display" to the public. Animators are often introverted, and it was unknown whether Michael's idea of seeing an animation workplace was practical or not. There was a second unknown in animation that had to do with animation's leadership. Animation was being reinvented at the time, starting at the level of Jeffrey Katzenberg, who had entrusted Roy E. Disney and Peter Schneider, a talented leader who was very skeptical of the whole idea of the Florida studio. And Peter wanted input not just on the production side but on the creative side as well. If Disney Animation was going to be presented to the general public, Peter wanted to control it. And basically, we didn't think Peter liked WDI and quite frankly, I don't think he liked me very much, either.

Other unknowns existed. We had designed no ride systems yet to carry the high volume of guests through the studio production area safely and efficiently, and we had not determined what ride system would be used for the high-capacity movie ride.

We had a large-scale theater, partially outdoors, where we had just assumed we would do some kind of major stunt performance multiple times throughout the day. This sounded like a great idea, and we needed the capacity. The theater itself was designed for 2,500 people, but at the time, we had no concept for the show.

We had a studio design, and we had a Hollywood-environment design, but we were missing one piece that is typically a part of a studio: a backlot. I was concerned that we didn't have any budget assigned to a backlot. The studio's initial needs assessment had deleted it as not functionally necessary. But they had been considering producers, not guests. The Disney Studios in Burbank had, at the time, a substantial backlot.

The problems were worked out, each at their own pace. The backstage tour eventually adapted into a hybrid of "real" production and enhanced attraction experiences.

We brought forward to Michael the idea of a "catastrophe canyon," a special effect blowout in an artificial-rockwork-created gorge along the backstage tour. It would have floods, fire, earthquake, anything we could do to attack the passiveness of the otherwise predictable tram ride. We sold the idea based on a sketch; we had no idea how we would actually create it. Chris Brown collaborated with Bob McDonald, a movie-effects designer. Together they created a one-half-size model of a canyon, including, even at half scale, massive water-dump tanks. It was dramatic. The idea developed into a film shoot, with a director calling for action just as the guests on trams entered the ravine. A gas truck would explode in real fire, and a flash flood and earthquake would cause the truck to fall toward the guests.

An indoor special effects experience was also developed, and we planned to fill it with props and magic, and it would be orchestrated to play directly to the audience all the time.

A "tour" stage was set aside, to ensure guests would always have an "active" set to experience. The stage was developed because Marty Katz and the studio had recommended that although they were committed to production in Florida, the big soundstages would simply, by the nature of the business, empty some percentage of the time. And even if they had sets and props in them, they might not be active all the time. The tour stage would be used to film an elaborate short-film sequence, and then all the elements, props, lighting, cameras, every detail, would be left in place. Guests would see how the short film was shot, and then see each subsequent phase of editing and postproduction. *The Lottery* was born, and Bette Midler, the biggest star at Disney at the time, agreed to be the lead. Garry Marshall, a legend in comedy writing and directing, agreed to make the film. The premise was simple: A woman (played by Bette Midler) realizes she has a winning lottery ticket, screams, shouts out the window of her New York City apartment that she's got the ticket, and drops it. A pigeon picks it up and flies away, setting off a chase sequence through New York until she can reunite with her lottery ticket.

It created a cinematic tour de force with Bette's comedy, Garry Marshall's directing, and lots of physical humor, and it was shot entirely inside the stage that guests would walk through, and edited together so that they could see the final product.

As *The Lottery* was in development, Marty Katz had gone to Michael and Frank and convinced them that the studio could not be built without a backlot. He single-handedly got the budget for us to build what he thought the backlot should be—a few blocks of a New York City setting. It would be spectacular for the tour and could be done just in time for Garry Marshall to shoot the chase sequence. A legitimate need for production finally matched up with a legitimate need for the heart of what a studio should feel like. Marty, as a longtime filmmaker, understood that.

And I don't know if I thanked him sufficiently, but I will now, Marty. So, thank you!

Marty also believed that productions needed a quiet residential neighborhood to avoid paying fees to close streets and rent homes.

One of the most popular network programs at the time was *The Golden Girls*, so we would also re-create one of the houses on the backlot as a copy of it. We would even reshoot the opening of the show on our lot so that we could authentically say this was the house used in *The Golden Girls*.

Among his many contributions, Marty introduced me to Bill Creber, a senior Fox production designer, as the right person to design the backlot. In a few conversations with Bill, I felt I'd been to a master class in filmmaking, and I got a lifetime friend and mentor. Bill loved to talk about filmmaking. And he was qualified to talk about it because he was nominated for the Academy Award for such films as *Planet of the Apes*. He was later lauded by the Academy Museum of Motion Pictures as being one of the most important designers in the history of the film business. We were lucky to have his tireless focus, creativity, and adaptability.

~ ~ ~

The 2,500-seat stunt theater languished with half-baked ideas. When we started working with George Lucas on the Star Tours project, WED got rights to use the Indiana Jones character in the parks. When I heard about it, I was immediately taken back to sitting in an Orange County parking lot, waiting in line to see the first Indy movie. I was a huge Indy, Spielberg, Lucas, and Harrison Ford fan. There were lots of ideas for immersive rides and things that I knew would be awesome but would never be considered for our Studio Tour attraction because we were too far along in the time frame.

Our business meetings with Larry Murphy, Michael, and Frank sometimes got pretty raucous. I don't remember the meeting or the agenda, but somehow

in one discussion an opportunity opened, and I passed a note to Michael. He didn't look at it; it just stayed folded in his hand. As Larry went on with his presentation, I noticed Michael open the note. He froze, and with his usual sense of drama, he stopped the meeting. He held up my note. On it I had written:

INDIANA JONES—STUNT THEATER—STUDIO

Indiana Jones—
The Impossible Made Possible

It was now just a bit more than a year before opening. There was a legitimate chorus of very smart people who said it couldn't be done, it was too late, the budget was too small, the technology couldn't be safety-tested in time. I didn't put my head in the sand, but I did drown some of it out. I was on a mission to make this work, and unfortunately I didn't think we really had an alternative. I admit, after a few years at this pace, I probably was losing at least some of my good judgment. *If we give up now*, I thought, *we fail*. We could try this and possibly fail, too. Or there was at least a chance we could try this and succeed.

I immediately turned to Howard Rothman at Lucasfilm who supported the idea and offered to introduce me to Gloria Katz and Willard Huyck, who'd written the screenplay for *Indiana Jones and the Temple of Doom*.

A few of us met Gloria and Willard, who were fast-moving and immediately plugged into the idea. They quickly conceived of a wonderful backstage story, a collection of great setups linked by actors . . . and stuntpeople . . . and effects people . . . and led by a director. It would be twenty-five minutes long, and it seemed both exciting and a draw that could be more evergreen than anything we had been thinking about.

Of course, it had no relation to the remaining budget or time. My concern was who could do the show. This was unlike anything we'd done. I remembered watching a behind-the-scenes video from *Raiders of the Lost Ark*'s Glenn

Randall, the famed stunt director. He had been the second unit director on *Raiders* and had done many of the action sequences. I managed to reach Glenn, who was filming in North Carolina at the time, and fellow Imagineer Tom Fitzgerald. Then I flew to Wilmington to try to squeeze into his production schedule. Over a couple of dinner meetings, we talked about the show and the script, and Glenn began to break down how he might do some of the iconic Indy stunts in a repeatable, safe, and theatrical way. Philip Vaughn, a great production designer and in his own right a terrific sculptor as well, came in, and soon we were on our way to trying to scope out the show.

I went from meetings with Gloria and Willard, and Glenn, to Eugene, Oregon, to meet with Gene Johnson. Gene was another famed art director in movies, and a longtime Imagineer. He was also a spectacular storyboard artist. And he was fast. Gene was retired but agreed to meet me for a whole day at his dining room table. We broke down the script while his wife was harvesting tomatoes and feeding their llama herd. It was one of the most amazing days of my career. Gene had soft pencils that matched his personality, and we broke the show down literally moment by moment. I walked away with about seventy beat-by-beat illustrations of the show. Within a few days he finalized the rest of his work and sent the drawings to me.

The show was a landmark when it opened, a meeting point of a beloved franchise, with live actors, stunts, effects, sound, music, and complex moving-scenery elements. The team took pride in doing things with thrilling stunts, huge-scale fire effects, a flying Wing aircraft, and a real, giant rolling ball. It took a tremendous team to make it happen, and the show, which barely made it in time for opening,* continues to live on, at least as of this writing. It still fills the arena, and some actors in the show have been thrilling the guests since the beginning.

*Well, almost. For the press event, we showed a few scenes and staged a discussion with Michael Eisner and George Lucas. By opening, the show was still missing some elements, and the script was still being reworked.

The Studios Open

In May 1988, our team took a breath and opened the production studios. It was a spectacular achievement. Bob Allen (who ran the studio), Milt Forman, Marty Katz, and Richard Graham (the chief architect) all deserved to take a bow. The opening was celebrated with fanfare, and with events on the new soundstages, including a special performance by the legendary Carol Burnett for The Disney Channel, and appearances by Michael and Frank, Jeffrey, Burt Reynolds, Gene Siskel and Roger Ebert.

Our team's strategy had been to get the production center open so that it could be shaken down and shows could be mobilized in time for the park's grand opening in spring 1989. The studio shone, with dressing rooms, offices, and support spaces directly adjacent to the soundstages and soundproof viewing corridors above the second floor, affording future guests an unobstructed and unobtrusive view of production. The strategy worked. By April 1989, the studio had already hosted films and television miniseries, including Tom Hanks's *From the Earth to the Moon*. Perhaps the most successful was *The All-New Mickey Mouse Club*, which premiered on Disney Channel April 24, 1989. The show was filmed for seven seasons in front of touring guests, who got the very first glimpses of Britney Spears, Christina Aguilera, Ryan Gosling, and Justin Timberlake as young Mouseketeers before they were stars.

As part of the event, I was asked to give a tour of the larger site to Roy E.

Disney and his wife, Patty. I took them around the studio, and we took a peek into the not-yet-completed Hollywood section. Both Roy and Patty had grown up in Hollywood. As we walked down the street, Patty started reminiscing. She pointed out buildings that she knew. One was where she'd go to the dentist, another was where her mother used to shop. I realized something magical was already working. Patty was adding her own experience to the facades we'd selected and the original place we were creating. None were exactly the ones she remembered, but they triggered her memories. It was a joyful moment, and I thought, perhaps this street will be to Hollywood, for some people at least, what Main Street was for Walt's hometown.

As we proceeded down the street, I took them through the Spanish Colonial facade, and into the main, arcaded dining room of the Brown Derby. It was nearly complete—the back bar was there, the beautiful curved ceilings and red leather banquettes, too. Roy ran across the room, up the couple of steps, and sat himself down at a banquette, the brass Brown "Derby" hat lighting the table.

He smiled and said, "This is the booth we always sat in. I sat right here, at this table, and had lunch with my dad and my uncle."

Putting It Together

As Stephen Sondheim once wrote, eventually it's all about "Putting it together. Every detail is important, every contribution counts, it comes together piece by piece, but it all depends on putting it together."

It had been an accelerated and exhilarating journey from a raw idea to an approved capital project, to an operating studio, and now the Studio Tour team needed to move forward in haste with the hard work of just getting it done. Building a park or any major project is a long, arduous slog. There are lots of obstacles. The money is always tight (in our case it was very tight from the beginning), and the time is always short. One crucial thing is human capital, the ability for talented people to stick with it, to be focused and resilient, and to stay the course to the end. And most important, to feel appreciated, and to support each other.

There is a lot of dirt and mud, fountains of welding sparks, and danger; a construction site sometimes feels like what it might be like to be on a battlefield. I have never been on a battlefield, but I've been on a lot of construction sites, and they are raw human endeavors on a huge scale; loud sounds in every direction, danger in every step. You squint your eyes and try to see through the dust and hot sun, something to tell you it is all coming together. And if it is, was the idea right in the first place?

Despite all that construction mess, I look back on the process of building

the project like we were making a massive epic movie. And when I think of that movie, I think of the people who made things happen, heroic things happen, and often with teams that were too small and resources that were severely limited.

When I watch a movie, I always stay until the credits are completely finished. I'm that guy who stays when they're trying to sweep up the popcorn. (Why do popcorn and ice cream follow me everywhere I go?) It turns out the best way for me to remember how we got the Studio Tour project done is to think of people and teams as if they were credits of a movie, something like this:

The Directors
Bruce Laval, Randy Printz, and Bob Weis
I've talked about Bruce and Randy, and I still hold them in the highest esteem. We all share the authorship of what we created. We all worked together many times after the Studio Tour.

The Writers
They would define storytelling in a new park, and for generations to come.

Michael Sprout
A gentle, creative soul with a wicked sense of humor. Michael sold the entire project with his pitch on using cast as part of the story of The Great Movie Ride. He struggled with the SuperStar Television Theater, not because the concept wasn't clear but because the legal clearances were a moving target. In the end, he created something magical that allowed guests a view into live-television production, and a chance to be part of a television classic.

Tom Fitzgerald
Tom was always a giant star at WED. He had done so many things and was such a great writer and director. He had just finished Star Tours, the most groundbreaking achievement to date by WED. I went to Marty Sklar and asked if Tom might make some sense of the Studio Tour. I doubt it was his first choice of next projects.

But Tom made it all his own. And, garnering the support of Jeffrey Katzenberg, Tom and his team created video profiles with big stars who were defining Disney's success, from Tom Selleck to Bette Midler. This added a layer

of magic to everything. But it went even further than that. Tom changed the face of film and media production at WED, using the best talent in the world to perform, to direct, and to produce. The best composers, the best visual effects. Theme Park Productions became a microcosm of the best the film industry had to offer. And it all started with his vision of how to make the Studio Tour something special.

Jerry Rees

A wonderful animation director and story artist, Jerry came in after we had all (me, Peter Schneider, independent producer Bob Rogers) struggled to make sense of the story of Disney Animation. Jerry's genius was to bring in Robin Williams. Robin would learn along with guests by finding himself inside an animated film. And who else to accompany him on this journey than the era's most trusted journalist, Walter Cronkite. It was a match made in animation heaven. When Tom Fitzgerald and I went to New York to pitch the idea to Cronkite, he loved it. We knew we were on to something.

Chuck Workman

In 1987, I was watching the Academy Awards and there was a film nominated for best live-action short, *Precious Images*. It was played in its entirety. It was an emotionally stirring tribute to the history of film, and it was created by director/producer Chuck Workman.

I reached out to Chuck, and we met. I asked Chuck if he would produce a panoramic tribute to filmmaking as the finale for The Great Movie Ride. Chuck agreed, and what he achieved was a beautiful piece of filmmaking, a way for us to honor not only Disney but all of the MGM library, and at the same time landmark films across film history. It was truly a moving way to conclude the ride.

The Cinematographers

Those who drove the visual storytelling . . .

Tim Kirk

Quiet, sardonic, and extremely prolific, Tim approached Hollywood like a true fan, especially for the crazy and exuberant side of it. His contributions were everywhere, including Min and Bill's Dockside Diner and Dinosaur Gertie's Ice Cream of Extinction. His simple black-and-white drawings told amazingly

complex stories and sold them. On the construction site, he kept the team on track with story, visual literacy, authenticity, and fun.

John Roberdeau Drury

John's an amazingly prolific environmental graphics designer and artist. From the time I met him in Tokyo in 1982 until we finished the Studio Tour, I never saw him go more than a few hours without drawing. And his sense of story-telling with period imagery and typography was a wonder to see. His work is everywhere across the studio, beginning at the front gate with Sid Cahuenga's, all through Hollywood Boulevard, and everywhere else.

Frank Armitage

By the time I met Frank, he had already painted his way into Disney history on such films as *Peter Pan* and *Lady and the Tramp*. But he was also committed to human wellness. He studied health and acupuncture and was instrumental in developing concepts for the Wonders of Life pavilion at EPCOT. Frank sold the entire Studio Tour project with his first rendition of the noir, gangster hijackers scene for The Great Movie Ride. But he went on to illustrate many things, including the *Casablanca* sequences in the ride.

Collin Campbell

Friend and inspiring mentor, and all-around fun to be with guy, Collin had worked in animation on *Lady and the Tramp* and *One Hundred and One Dalmatians*, among others. He worked on the Enchanted Tiki Room, Pirates of the Caribbean, and many other park attractions. How was I so lucky to get him on the Studio Tour? He came to Florida in his midsixties to be my chief field art director. He did the earliest landmark paintings that sold the Hollywood Land concept.

Katie Olsen

Katie at the time was the Disney color guru, having been mentored by John Hench. She knew how to use paint to tell a story, for time periods, themes, and even for simple industrial buildings inside the working studio. She knew how to encourage people to feel emotions only color could convey. She taught me that Florida light is different than California light. She spent untold hours in the field approving samples and making adjustments. She taught contractors how to mix and match colors accurately. And she believed a true color swatch

wasn't a couple of inches, but four feet by eight feet, if not one wall of the whole building. She took color seriously.

The Production Designers
Rennie Rau and Barbara Dietzel
These two women collaborated to invent a new kind of storytelling for Disney and food. The dining experiences they created have lived far beyond the temporary fads of themed dining and are classics in their own right. Count the resurrection of the Brown Derby and its Catwalk Bar (now Club 33) among them. There's also the Sci-Fi Dine-In Theater Restaurant, where guests are served in classic cars as B movies fill the big screen, and servers zoom around in roller skates. And the 50's Prime Time Café, a tribute to the 1950s family, and 1950s comfort food. All are served up by an incredible cast who you suddenly believe might really be your mother, and really will make you eat your vegetables.

Richard Graham
One of the most influential and prolific architects in Disney Parks history who actually never even worked for WED, Richard was a San Francisco–based architect who'd designed George Lucas's ranch and the legendary technical building Skywalker. He conveyed the concept of "studio" in the work he did and accomplished what it took to tell stories and to use buildings for actual production. We became lifelong friends and worked together on many subsequent projects. His easygoing personality masked his brilliance and commitment to great design. Our work took us around the world together for many years.

Bill Creber
A lauded film production designer, who was generous with his time, talents, and mentorship. Although most of the original backlot is gone, many pieces remain. You can find them in corners around the studio, wherever their warmth and history reach out to you. Creber's brilliant scenography also lives on in the many movies and television shows shot here, and in the images many of the guests who visited retain.

The Cast
It took more than 1,700 cast members to bring the Studio Tour to fruition, including many who put themselves out there playing characters for the first

time. They had to do the normal training process, then take part in rehearsals on top of that, and deal with construction crews and Imagineers coming in and out, making changes and shifting scripts around. Putting the cast front and center was an ethic of the Studio Tour's design and served as a precursor to what would become the role cast members played in future developments like *Star Wars: Galaxy's Edge*. As I write this, there are some Disney cast members getting ready to celebrate their thirty-fifth anniversary working at the Disney Hollywood Studios, the little park where their Disney careers started.

Special Effects—all creative and technical geniuses . . .
Chris Brown
From the beginning, I asked our teams to think about how effects are done in the movies. There are no red silk scraps blowing in the wind. There is fire, there is smoke, and there is flooding water. Chris took the commitment to authenticity seriously and built a crew of movie professionals to bring big physical effects to The Great Movie Ride, Indy, and Catastrophe Canyon. I remember standing with Chris the first time we tested Cat Canyon, unleashing fifty thousand gallons of water right at us. It was scary and unprecedented, and we realized all we had to do was make sure it happened exactly on cue, thirty times a day.

Eric Jacobson
The Great Movie Ride couldn't have been done without him.

Doug Griffith
Doug figured out how to design and program Audio-Animatronics figures to depict personalities people had seen so many times. They knew exactly how they moved, and every gesture. He demonstrated his artistry from Clint Eastwood to Sigourney Weaver, from my favorite, Margaret Hamilton, to Harrison Ford, and from Humphrey Bogart to Ingrid Bergman.

Ed Fritz
Our rides required big capacity and reliability, and it all had to be done quickly and forcefully. Ed was a calm and true innovator who made things happen and in record time, with an entrepreneur's mindset.

Script Supervisors

Gary Landrum and Cindy Cote

Some people play functional roles that mask who they really are. Gary and Cindy were quite simply the kind of glue that keeps hardworking teams together. They never forgot that people are human, not necessarily superhuman, at least not all the time. And remembering people's birthdays, times to celebrate, and times to blow off steam can make the difference when everything is stretched so thin, you can just hear it's about to snap.

And also . . .

There are so many people who achieved greatness on the Studio Tour, as creators, as inventors, as implementors. The credits—if it were a movie—would roll on and on. I celebrate the heroics and good humor of Robin Reardon, Steve Miller, Laine Houser, and so many who made impossible things happen and took time to make thoughtful things happen for each other. My closest Imagineering collaborator, Craig Russell, is an exemplary one. We'd started nine years earlier in the TDL office sharing a defunct projection booth with two others. His drive, determination, and ability to lead never fails to move me. It was the second project, after TDL, and I knew it would never have happened without him. And there would be more.

Dave Yanchar, a very hardworking, dedicated project manager, never flinched, never wavered. One time we were headed out to the site, and I noticed he stopped by his cubicle, took out a bottle of black Shinola shoe polish, and started polishing his construction boots. I laughed and reminded him we were just about to head out into the mud again. He snapped back a little impatiently. "What did I have to say about it? Why was I making fun of someone who was just doing what they needed to do, to maintain some semblance of sanity in an insane world?" I apologized; it was none of my damn business. I learned from Dave, and so many others, that we all have our way of dealing with stress that occurs over unbelievably long time periods. If Amazon had existed back then, I'd have sent him a case of shoe polish.

~ ~ ~

As the Hollywood portion was getting completed, we started to see the limitations of our landscape budget. Our trees were puny, lacking the lived-in character we had hoped for, and certainly were not going to help provide much shade from the Florida sun.

One morning I came on the site, and I was either seeing things or imagining them. I looked again. The hub around the end of Hollywood Boulevard was suddenly canopied by five huge mature oak trees. It looked like they had been there for eighty years.

At the office, Dick Nunis, head of the entire parks business, left a message for me. No one took a call from Dick Nunis lightly. I called his office and they put me through. He asked how it was going out there. I told him good. He asked if I liked the trees. Dick proceeded to explain. Along Buena Vista Drive, a boulevard in the hotel district, in the median, were a large number of mature oaks that had been there since the early 1970s. Dick had taken it upon himself to move five of the giant trees from Buena Vista to the Studio Tour, and plant them, overnight. Not only did he authorize it, but he also went out himself at two o'clock in the morning to supervise it. Walt Disney, whom Dick had known personally, once said two things: "It takes people" and "It's kind of fun to do the impossible." Apparently, Dick had not forgotten those words.

May 1, 1989

The weather forecast in Orlando that day called for thunderstorms at 6:00 p.m., and it delivered. There were thousands of press invited. There were camera crews, news crews, and long banks of radio crews. I remember wet streets, slippery sidewalks, and perfect reflections of neon signs in large puddles of water. It was a cinematographer's dream. But as an opening it was impossible. The Walt Disney World media team was at the ready, handing out hundreds of umbrellas. But they weren't much use! Women in formal gowns, men in tuxedos . . . everyone might as well have worn bathing suits, except it was oddly cold.

But rain or shine, the teams had delivered the park in time for the May 1 opening. There was a long laundry list of completion tasks, corrections, and many elements where the paint was barely dry.

The amazing thing was everyone seemed to have a great time. People ate shrimp and drank champagne even with dappled raindrops on them. There were stars, there was music, and there was a sense that this was an event, a chance to have a peek at the latest idea to come from Disney, and there was nothing else like it. I remember Michael and Frank thanking Randy and me. I suspect Bruce was at the studio working. Jeffrey Katzenberg hugged me. There were lots of hugs and tears with all my wonderful colleagues. And I can

remember Michael's voice reading the dedication plaque. I had helped him draft it, and I had heard him rehearse it many times:

"The World you have entered was created by The Walt Disney Company and is dedicated to Hollywood—not a place on the map, but a state of mind that exists wherever people dream and wonder and imagine, a place where illusion and reality are fused by technological magic. We welcome you to a Hollywood that never was—and always will be."

One line for me had always been a direct reference to WDI, to our team, to my personal aspirations of what it meant to be a part of an Imagineering team: "A state of mind that exists wherever people dream and wonder and imagine."

A few months before opening, John Hench had walked through the park with me, and he was generous with his enthusiasm. I was happy. We'd not seen him much in Orlando, and Paris was the big project everyone was focused on. But I appreciated John's time and comments so much. I unloaded all my fears on John. He gave me confidence, restored some calm. He said I was focused on the details beyond the larger picture that guests would appreciate. It was one of the few very personal conversations I ever had with John.

In the end, he left me with a thought. "Enjoy this, enjoy this now," he said. "Pretty soon it won't be yours anymore."

And just as John predicted, it wasn't. We no longer needed helmets and safety equipment. We turned over our offices because the operating team needed them. Our radios were turned in as were our construction passes. There was much joy, but there was a bit of melancholy. There was much left to do, but now we'd have to respect opening hours and work late at night or very early in the morning. We couldn't park right offstage as we used to.

We needed to bring in some reinforcements. A fresh WDI crew was needed to support the cast and operating management team through the critical first summer. The rest of us were going for some much-needed rest. I packed up a box of my office files and sent it back to Glendale. It seemed unimaginable that the deadlines could have all passed, that there was nothing that immediately needed to be done.

Late the next evening, I went to my apartment and packed up a suitcase of clothes. I took the remaining old food and take-out containers in my refrigerator and threw it all into the dumpster. The next morning, early, I was headed back to California.

Escape

In 1989, Dubrovnik, known as the "Pearl of the Adriatic," was a prominent city in Yugoslavia. For more than fourteen centuries, Dubrovnik stood as a beacon and gave refuge to coastal residents escaping natural disasters and attacks of one form or another. That was why I was there.

Georgia and I came off the ferry. We'd traveled light, bringing only what we could carry easily, for a month. We could have managed a lot of baggage, but we didn't. No computers. No phones. We were quickly adopted by a local woman who took us up a few flights of stairs to see an apartment she was sure we would want to rent. She was right: The ancient green window shades were open, offering a view down to the street. The calm sea air flowed in. There were window boxes of blooming geraniums, and the soft sound of people's steps floated in as they shuffled along the main street, the *stradun*, down to the *placa*, where the street widened into a commercial square with a tower and romantic outdoor dining terraces. The great city walls break at the placa, revealing an open view out across the ancient marina where fisherman with their nets had departed for centuries to fish the richly diverse Adriatic waters.

Soon we were out on the street, taking pictures, sketching, and walking in the market with its array of fish, eels, lobsters, mussels, and octopus. Travel can be a place where you fall in love, and it can also be a place where you realize

you've fallen out of it. Georgia and I both loved traveling. It was our second visit to Dubrovnik, and we were pretty sure this would be our last trip together.

Walking down a vibrant ancient street is like therapy for me. Dubrovnik is a city made of one material, limestone. Blocks of rough limestone form the face of every building, some four or more stories tall. The cobblestones that form the streets are polished like glass, from hundreds of years of foot traffic. When there is a light rain, the worn parts of the street pavers form small shiny pools of water. There is one kind of hammered-iron streetlight, one kind of orange-clay tile. There is one system for addresses and way-finding signs. Every house has the same window design and the same dark green heavy timber storm windows. Simple authenticity, and aesthetics. A shutter can be closed completely. Or it can be open, and the window and blinds closed. Or the blinds can be open, and window closed, or the window and blind can be completely open. Simple human differences that allow each resident to send a message: Are they open to visits or conversation or closed for privacy?

Somehow the city survived wars, earthquakes, and the dominance of many successive empires. Yet the genius of its anonymous designer endures: the ocean retains its blue-black hue until it meets the only slightly lighter horizon edge of sky. The contrasting warm white of the limestone buildings represents a proud and defiant human-scale vision of the value and resilience of people who have chosen to live together and depend on each other for their collective survival.

Realizing I was thinking too much, I ordered a pizza with garlic and octopus, and a glass of Lasina, among the many wines native to the Dalmatian region. The food was modest and superb, everywhere. These people were not cast members; they were craftspeople, restaurant or guesthouse owners, fishermen and women, artists, and of course tourists. The Yugoslav dinar had collapsed in value and was trading for 28,000 dinars to one U.S. dollar. A lavish seafood feast with wine might cost you over a million dinar, or about $37.00.

Headed Home

We stopped in Paris on the way home, where I started to hear reports on the first month of regular operations of Disney-MGM. I got some English-language newspapers and received a few faxes. I also made a couple of overseas calls.

It was a shock.

Depending on who I talked to, the park was a massive failure, a massive success, or something in between.

Based on bookings and attendance, it was a major success. The audience had shown up in droves. Based on a revised attendance model, the park was now projected to have nearly twice the attendance we had designed and built it to handle.

This was a surprise to some people but not because it hadn't been predicted. The growth that happened back in 1982, when EPCOT opened, shifting many guests from two-day to three-day visits, was happening again, with one big difference: Disney-MGM had about half the capacity of EPCOT and was confined to a smaller site.

The cast was overworked and the traffic strained facilities and infrastructure. Guest satisfaction levels declined because there were longer lines for everything. Bruce Laval and his team reacted by doing everything in their power in the short-term. They added entertainment and showtimes, and sped up the Backstage Studio Tour by adding a break in the middle of the walking

portion. With the posted official park opening time at 9:00 a.m., they opened at 8:00 a.m., trying to get people onto the tram tour earlier. Word of mouth spread, and the park frequently had to close literally a half hour before it was scheduled to open.

As I headed home, my vacation calm quickly disappeared. I started to think ahead to what we might be able to do to bolster the park and extend guest comfort, fun, and capacity. This was EPCOT Color and Fun all over again, except it now seemed more urgent, more serious, and more personal.

The shortcomings in the park design really came to bear. I felt miserable about them, even though we never had enough budget to implement them in a better way. There wasn't enough of pretty much everything. But human comforts had really suffered. I felt as if I were back to steamy Walt Disney World when I first visited in 1972. Most of our queue lines were covered but not air-conditioned. As wait times soared, these spaces in the Florida heat became unbearable. Circulating fans needed to be added as quickly as possible. More walking spaces were needed, more options for guests to wander around and ways to make the park feel bigger, and more attractions to reduce wait times and add value for the price, which, of course, had been set at full, despite our much lower budget, and lower number of offerings compared to EPCOT or the Magic Kingdom.

The only thing we seemed to have enough of was parking. So many guests were extending their visits at Disney hotels, they were all taking WDW buses instead of driving. The transportation system was overloaded, but the parking lot might be half full on a day the park had already closed for capacity.

I was confident in one thing: we had the first major relief underway, the opening of Star Tours, but that would not be until December 15. In the meantime, it would take all of us, the parks team and WDI, to continue to innovate, especially with live entertainment, to serve the onslaught of visitors. When I spoke to Bruce Laval the first time, he was clearly frustrated. The things he needed he needed right away. Things that needed to be added or changed couldn't wait for the design process and long approvals. We agreed to focus WDI's efforts in Orlando, speeding the decision-making and process.

Disney-MGM was considered by some a failure of planning and self-confidence. It had gone back to the EPCOT resorts plan, as well as the focus groups. The focus groups, two years earlier, had already indicated guests planned to come to the park and they expected something only Disney could do, meaning on par with the Magic Kingdom or EPCOT. And no matter how

many ways we said it would be a half day, and half price, the guests didn't believe it. They planned to spend the whole day and they suspected it would be full price.*

The EPCOT resorts had started by turning their back on Disney-MGM. And although we succeeded in integrating the projects with a connected lake, the planners did lock the new park into a smaller-than-advisable site, forever. Overall, the failure was one of lack of confidence in Walt Disney Imagineering and in Walt Disney World. Both benefit from a close relationship with the Disney guest, a relationship built over decades. Knowing the guest is a tenet that parks and WDI share around the world. It has never paid to discount that knowledge, or the combined power of a new WDI project with a thoughtfully planned operation. Over the years, I've seen these underestimated. There was truly no business logic that suggested Disney-MGM be put in a box, not from a creative, guest, or demand point of view.

At least three top managers at the corporate level had no problem calling Disney-MGM Studios a full success (Jeffrey Katzenberg, Michael Eisner, and Frank Wells). And they deserved and got the continued support of all our teams.

Eisner was elated. Having too many people was never a problem for Michael. If you are in the movie business, being sold out is the best thing that can happen. Something could always be done with too much demand, and it was harder to fix if you had too little.

He'd been especially enthusiastic about the *Time* magazine review. It had been written by Richard Corliss, *Time*'s most respected and longest-serving movie critic (and perhaps the magazine's most-quoted writer of all time). He was a perceptive, invaluable guide through three and a half decades of Hollywood films, stars, and trends.

Of Disney-MGM Corliss wrote:

But for now, Universal's Florida movieland is just a script. Disney's is a tangible fantasy—real tinsel draped artfully over Hollywood's phony tinsel; an art industry glammed up as an elegant Deco dream. There is a sanitizing genius to the Disney Parks, with their canny nostalgia for an America that may have existed only in the lace-valentine heart of a young Walt Disney. And the tactic works best when applying a cartoonist's paintbrush to a world that is fiction, on- and offscreen.

*On the subject of price, they were, of course, right.

Disney-MGM Studios marries movies to theme parks with the astuteness of Hollywood's hottest studio and the spell of a professional dream weaver. Here the men are strong and the women beautiful; the moral choices are in glorious black and white; and the ending is always happy.

As much as Michael had been enamored by the star architects who were building the new Disney resorts, our park design team was called out by Paul Goldberger, famed architectural editor of the *New York Times*, in his review:

But for all their exuberance, the Swan and the Dolphin* do not exude the simple, innocent joy of the Disney theme parks: they are simply too knowing. That, in the end, is the real difference between the new, high-design Disney architecture and the Disney design of old. There is a quality to the best parts of the Disney theme parks that—like the spectacular Art Moderne version of Hollywood Boulevard that forms the central spine of the new Disney-MGM Studios at Walt Disney World—brings an instant smile: it is an easy, comfortable dose of the world we know, made more perfect and more endearing than it could ever be in reality. None of Disney's high-design architecture achieves the utter un-self-consciousness, the illusion of complete innocence, which has always been the Disney hallmark.

*The Swan and the Dolphin were designed by famed architect Michael Graves, who had been one of my idols in architecture school.

Don't Rest-Expand

By fall 1989, Michael, Frank, and Jeffrey were already seeing success in the film and television business. Movies were clicking with wide audiences. *The Little Mermaid* had hit theaters, had grabbed the hearts of audiences, and was already being touted as a Disney renaissance in animation. Michael was hosting The Magical World of Disney and couldn't walk through the parks without being asked to sign autographs.

On the park level, Disney-MGM was not the only project that was bringing in more guests than could be handled. *Captain EO* and Star Tours had blasted open at Disneyland, and second-park options for California were being contemplated. Disneyland Paris was already under construction, and a preview center was about to be opened.

But my agenda—and that of my WDI and WDW colleagues—was prioritized to the urgent need for expansion at Disney-MGM. And new competition was looming. Universal had not been intimidated by the park's unveiling; if anything, they had been emboldened by it, and they were slated to open in less than a year.

Walt Disney had once famously said, after the opening of Disneyland, "It's just been sort of a dress rehearsal, and we're just getting started. So, if any of you start resting on your laurels, I mean just forget it, because . . . we are just getting started."

I didn't really know what laurels were, but I knew we didn't have time "to rest" on them. Bruce and his team were already underway with some immediate initiatives to build capacity. Allen Moyer, a very talented project manager, had taken leadership over the WDI team in Florida, and soon Allen and I were collaborating. We set up the first true purpose-built, on-site studio for Imagineers, right behind EPCOT.

We put together lots of attraction options. Star Tours, which had opened the year before at Disneyland, opened at Disney-MGM in December 1989, with an expansive "set" inspired by the moon of Endor and a massive AT-AT (All Terrain Armored Transport) realized by Imagineer Paul Osterhout, working closely with Lucasfilm. The attraction added three important things: ride capacity, thrill, and a highly marketable story brand. Audiences responded, and Disney-MGM became known as a full partner to the other Walt Disney World parks. Park ratings continued to improve.

In rapid-fire, the park got a nighttime fireworks show, a parade, additional dining options, and more strolling areas. Plus, there was a family adventure based on the upcoming movie *Honey, I Shrunk the Kids*; a new version of the classic game show *Let's Make a Deal* that invited guests to play and win prizes; and the studio's own talent audition show/attraction, Mickey's Audition, which gave guests a chance to try out for a role in Disney movies and television shows.

We were all thrilled about the public announcement of an "agreement in principle" for the acquisition by Disney of Jim Henson's Muppets. Plans for Muppets-themed attractions would debut at Disney-MGM and Disneyland the following year.

The WDI agenda was to develop a project with Jim Henson immediately, and to find some highly branded ride-oriented concepts that would be unique to the studios park. We forged a relationship with Jim Henson and his core creative team, and we discovered magic in a bottle. Jim loved the idea of working with WDI—he was in personality a true Imagineer, a creative genius always thinking of new ideas and always excited about them.

Tower of Terror

I kept looking at our models at WDI and thinking the park was too small. With attendance levels rising, it felt to me like Hollywood Boulevard, our Main Street, U.S.A., needed more attractions. Another street could be added. That's when my urban planning side kicked in. A second street, which we thought could be Sunset Boulevard, could add more dining and retail, plus more critical mass, to the park. At the far end of it there was probably room for two, three, maybe four more attractions. But right at the center, in the first phase, there would need to be something compelling, some kind of "E" ticket to draw guests to the area. Something that looked so dramatic they wouldn't want to miss it.

At the same time, a small group of us was interested in something that spoke to the darker side of Hollywood, in a Disney sort of way. We began brainstorming about something like an old Hollywood hotel that might contain memories of old Hollywood characters in ghost form.

The idea languished. Michael Eisner even suggested it could be a real hotel, with an attraction inside of it. We thought about what made thrills. It was a well-known formula in the park business: $F - D = T$, or Fear minus Death equals Thrill. Fear, without the possibility of dying, becomes thrill. The equation is fundamentally at the heart of roller coasters. For seconds, we fear this thing is going to kill us, but in the back of our minds we know it's not going to. We

return exhilarated because we have safely come back from the edge. We're thrilled.

What things, I asked in a brainstorming, do we most fear? We talked about everything from snakes to rodents to clowns. Someone suggested the idea of being stuck in an elevator, which evolved to being stuck in a plummeting elevator. Everyone shared that fear, and it seemed like a thrilling idea to put into a seedy old Hollywood hotel. What better place to have a rusty elevator break loose? As often happens in charrettes, the idea emerged and seemed to have legs.

At the time there were many free-fall rides in parks around the world; the most common one was built by a Swiss-based firm, Intamin. Those who dared to partake were locked into a vehicle with shoulder restraints. They were hoisted to the top of a two-hundred-foot-high (or taller) tower. After hovering (and screaming their heads off) for a bit, participants were dropped at the speed of gravity, feeling true weightlessness for a few seconds. It took a lot of room for the vehicle to slow down after this, so the rides all featured a long run-out distance. Riders were turned onto their backs along a track, then returned to upright positions for unloading. The free-fall, visceral feeling was what we were going for, but components of the ride system couldn't tell our story.

First, we didn't want to give away the surprise, and it's hard not knowing you're going on a thrill ride when someone locks you in a shoulder restraint. Second, we had a very high request for Sir Isaac Newton.* We wanted to drop an elevator full of guests at the acceleration rate of gravity, for as long as we could, and then magically have the vehicle come to a stop before hitting the ground.

*Sir Isaac Newton was an English mathematician and physicist who lived 1642–1727. The legend is that Newton discovered gravity when he saw a falling apple while thinking about the forces of nature.

More Parks

Michael Eisner's enthusiasm for what he considered the unprecedented success of the Disney-MGM didn't stop at expansion. Even before its opening, he had asked Frank Wells to visit the Oriental Land Company and to start getting them excited about building a studio tour as a second park on expansion land next to Tokyo Disneyland. OLC had sent a group to Orlando to visit the construction site, and I took them with Dick Nunis on tour in the heat of the summer, 1988, around the site the year before its opening. OLC had also sent another executive team, this time to be present at the park's opening in May 1989. OLC was slow to react, but Michael was convinced the attendance numbers would get them moving.

When Disney-MGM Studios opened, Disneyland Paris (then called Euro Disneyland), had almost exactly three years to go before it was scheduled to premiere. Michael said he wanted to break ground on a Paris version of the Studio Tour as soon as possible and have it ready to open on the European park's first anniversary.

With no deals in place, and conservative partners in Tokyo and Paris, most of us took Michael's pronouncement as hyperbole. At that moment we were just trying to get the Studio Tour we already had up to the level we needed to match the demand that had been clamored for in its first year. But Michael

kept making it clear he was serious, not just about expansion but about finding new sites as well.

I had worked with OLC leading the first five-year expansion master plan. I knew they had a record of moving conservatively, and in every case they had only added new attractions once they had already been time-tested in U.S. parks.*

Michael was frustrated by the slow OLC response, but he knew Disney could exert more control over expansion in Paris. My head had been buried in Orlando for two years, and I had very little knowledge of how things were going in Paris. I needed to get up to speed quickly, and it was not going to be easy.

* OLC's arrangement to build TDL allowed them essentially free access to any design that already existed in WED's design archive; and all OLC paid for was the design adaptation.

Going Green

By the time Disney-MGM Studios had reached its first anniversary, the park was coming into its own. It had more recognizable branding for marketing to publicize. The summer of 1990 was promoted as the summer to see Star Tours; the Sorcery in the Sky fireworks show above the Chinese Theatre; a live show based on Disney's new movie, *Dick Tracy*; and a live, *Meet the Muppets*, featuring the first use of the Henson characters in walk-around, albeit oversized, form.

I was too old for the Sesame Street generation, but I was heavily influenced by the *Muppet Show* when I was studying theater and creating my own puppet shows. The show aired from 1976 to 1981, bridging my time in college theater, working at Disneyland, and starting at WED. The Muppets were great characters and had great scripts, but the design of everything they did was also remarkable. There were plenty of puppet shows in the history of television, but no one could match Henson's quality.

By the time I met Jim Henson at WDI, he'd been my idol for a very long time. But he was too casual in person to be an idol. He was warm and welcoming, an understated guy, which masked his tremendous creative life force. I had started to grow a beard. It was terrible, it just looked like I hadn't washed my face. When Jim noticed it, I told him it wasn't really working out. He was encouraging and said, "I'm all for more beards!"

Development of the Muppets' land was a priority and on a fast track. Kathy Rogers, one of the top WDI producers, took the lead, with Eric Jacobson art directing. We integrated ourselves with the Muppets team in an artistic, peer-to-peer way. Their famous creature shop was a cousin to our WDI model shops; we brainstormed and had fun in the same ways. We planned to do a whole land, with a ride, an experience, dining, and shopping. The relationship would be kick-started by a new Muppets-hosted 3D film experience to be directed by Jim.

I was invited to New York, where we toured the creature shop. For me it was like visiting the Sistine Chapel (well, almost), and we got to see many of the characters and how the artists puppeteered them.

At the end of the visit, we all went into a conference room. I looked around and realized I was surrounded by Jim Henson, Frank Oz, and other puppeteers and voice actors. Bill Prady, who was writing Muppet*Vision 3D, handed out scripts, and they proceeded to do a table read. It was pure magic, even with no puppets in the room, all the characters were there right with me. Jim read Kermit, the Swedish Chef, and Waldorf; Frank read Miss Piggy and, hilariously as a Disney safety person, Sam Eagle. They were all there: David Goelz as Gonzo, Richard Hunt as Statler. We all laughed, and I held back tears, it was too good. I felt the universe had somehow privileged me to be there for a brief moment with this collection of true geniuses.

Lessons Learned

I write a lot about what makes a project a success or a failure, and how important it is to have a culture of vibrant collaborative teams. But don't think there isn't a lot of drudgery. In addition to all the fun involved in developing new attractions, there is the hard work everyone does to deliver, often in challenging circumstances. Plus, we all try our best to learn from our own mistakes.

Another defining part of this time was an inward focus we were taking on WDI. Paris was coming in with big budget challenges. Budgets on other projects had been off by huge amounts, and the costs of doing business with WDI were also thought to be out of line with commercial standards. There were staff reductions, reorganizations, and calls for WDI to outsource more work to conventional design and build sources.

I had outsourced a lot of the studio's design and production because we'd had no choice; internal resources were simply not available. But the inside-outside point of view of many who'd worked on Disney-MGM was not necessarily appreciated by some in WDI management, or we hadn't gone far enough according to others.

There was no arguing, new projects were costing more. We were influenced by the Paris experience; drawing packages and specifications needed more detail so the scope of jobs was clear from the beginning and contractors couldn't come back later asking for more money. We had things to learn.

The studio park's opening that summer had been very difficult. We needed to go back to air-conditioned holding areas and having more guest comfort. The hardworking cast was overstressed, had little inspiration, and lacked creature comforts in their break areas, plus they had a terrible commissary. We upgraded everything; we needed to think more about the cast experience. And with competitors on our heels, we had pressure from marketing to have more branded experiences with high international recognition.

At the same time, we were looking at the Magic Kingdom, EPCOT, and the older resorts, realizing they were due for upgrades and new attractions as well. WDW overall was beginning to look a little like a sleeping giant. It had been a cash cow for the company for a couple of decades and it clearly needed an infusion of fresh ideas and new capital.

There were many consultants and industry speakers who came in to help us improve our process. Stephen Covey was hired to come in and save us after he authored *The 7 Habits of Highly Effective People*. Ironically, many of those highly effective people came to WDI subsequently to discover how to be more innovative, creative, and freethinking.

One of my favorite saviors was Milt Gerstman. He'd been Disney's leading construction manager during EPCOT's construction. Milt was experienced, and he loved being a curmudgeon. He relished the role, and we loved being berated by him. It was a symbiotic relationship. It was like having your grandfather tell you over and over that you would never amount to anything.

One such session I remember occurred in Orlando on May 16, 1990, roughly a year after Disney-MGM's opening. Our team was gathered in a stuffy room. We had learned a lot of lessons but apparently not the ones Milt thought we should have.

One of Milt's often-repeated criticisms was that WDI, compared to the industry, used too many different tiles in our guest restrooms. "Six different tiles, in one damn bathroom!" Gerstman emphasized. He hammered the point home that it was outrageous, a perfect example of what was wrong at WDI.

In my mind I tried to figure it out. I told Milt that Michael Eisner had once said on a tour that the Brown Derby restrooms were the finest in all of Walt Disney World. You can imagine how well that went over!

I counted to myself—two tiles on the floor; it's the same tile but usually in two shades, so the floors don't show dirt or wear so much. One or two tiles on the wall? Let's say two. There is often a tile baseboard, and at about thirty-six inches up the wall, a small decorative tile strip to define the room with a kind

of wainscot. I added them up. Guilty! Milt was right, we did use six tiles in every bathroom!

At the time and then for years ever since, I have checked every non-Disney bathroom I walk into for the number of tiles used. Not pizza take-out joints or hardware stores, but premium facilities in nice hotels or restaurants. I always look with anticipation. I almost always see two shades on the floor, two on the wall, a baseboard tile, and a wainscot strip. Once you see these things, they're impossible to unsee. Milt was wrong; he'd called us out for something where we were pretty conventional with industry standards, but there was no point arguing with your grandfather. My advice turns out to be the same: bathrooms are as important as everything else!

The Milt Gerstman inquisition was reaching the stage of agony, and everyone wanted to finish up and get back to work. But we had to have as many lessons learned up on flip charts as we could. Someone opened the door and quietly waved toward me. I was so happy to have a chance to step out.

In the hallway, someone in the outer office asked me if I had heard the news. What, I said? She teared up and told me the news that Jim Henson had died. It was unbelievable. We checked the computer nearby; it seemed to be confirmed everywhere.

I stepped in and handed a note to Bruce Laval, who shared it with his colleagues and Randy. I had to be the one to announce it to the team and apologized to Milt that the meeting would have to end for the day. We all went out, but I'm not sure any of us knew what to do next.

I didn't attend the memorial for Jim in New York, but Kathy and Eric did and told the team about it. The clips broadcast on television news programs and segments were emotional and uplifting. It reminded me that there are times when one person really does make a difference. We probably all have the capacity to make a difference, but when one does, like Jim Henson, it's something big about humanity that is revealed. It's like a black sheet is lifted, and for a moment we see another reality that is possible, but unseen most of the time.

The Muppets deal with Disney had been agreed upon by Michael Eisner and Jim Henson. It was a deal of trust and filled with mutual optimism and hope for possibilities. With the deal not finished, and Jim gone, everything seemed to be in disarray. Most of the Muppet attraction plans were put on hold. The film sat idle, until Frank Oz thankfully agreed to finish it based on Jim Henson's vision. The attraction opened at Disney-MGM on the first anniversary of Jim Henson's passing, on May 16, 1991.

Disney Studios Paris

Mickey Steinberg was generous with his limited time and gave me a sober assessment on the status of Disneyland Paris. Unlike Orlando, where Disney controlled most things, Paris had a tough process in place. When Mickey came in (and had his first few disastrous walk-throughs with us on the project), he objected to the entire framework of the Paris plan. He knew the process was not going to work. A design-builder was taking charge, instead of Disney. Costs were going up, and the schedule was stretching out, Steinberg believed, because drawings were being released in incomplete form. Once contractors gave estimates, they'd get new revised drawings, and they'd likewise raise their numbers. Mickey insisted to Frank Wells the process needed to stop; Disney was to manage it, and all work should stop until the design and specifications were truly completed and ready to bid. It was a shocking strategy change, but Frank trusted Mickey's depth of experience and backed up his plan.

I spent some time reaching out to Tony Baxter and my Paris counterparts, and I even hosted Eddie Sotto on a fun visit to Disney-MGM in Orlando. I always respected Eddie, and he was very generous when he saw our little project.

What I quickly realized was that the Paris team had spent a lot of time researching tourism and culture in Europe, and ways to adapt Disney to be relevant. Everything had been looked at—stories, design, food, music, and

especially language. Europe would be only our second park outside the United States, and the only one in a true multi-language environment.*

It was clear to me that just dropping in with an American film Studio Tour was not advisable. It was also clear that the Paris team was already fatigued and overworked. They had hundreds of drawings to check and approve. The idea that they were going to just take a break and help us adapt the Studio Tour, with their learnings, didn't seem possible or practical.

But Michael's interest and drive in accelerating the Studio Tour for Paris was relentless, and so I proposed a compromise. WDI would field a creative team of about ten people to study the feasibility for it and set it up in a temporary office in Paris. The office would be adjacent to the current Disneyland Paris (DLP) offices. That way we could take advantage of the expertise the DLP team had built, without distracting them very much. The team would also visit relevant entertainment sites; meet with film cultural museums, universities, and experts; and generally, do research the best ways to localize the concept for the European audience. It would be an express version of the deep investigative work the DLP team had done, focused on film, television, and media, and we'd avoid redundancy by taking full advantage of the knowledge of the team already there.

I plotted an eight-week schedule, hoping to do the research and have enough time to make sure we would come back with a concept presentation. To my surprise, the plan and my recommended team were both quickly approved, and we set out to find office space and make travel arrangements. I selected people from a diversity of WDI's disciplines: story, concept, design, art, master planning, research, some who had worked on the Studio Tour and some who had not. There were a few what I called Swiss Army Knife people, who could be expected to accomplish just about anything with almost no money and no support (anything from research and cold calls, to setting up an AppleTalk network and a bunch of first-generation Macs). The Paris team supported us with temporary workspace and research resources . . . and as agreed (on a very limited basis), their time.

It still turned out to be a daunting task, but with the team and the

* Anaheim, in the middle of Southern California, is also a multicultural and multi-language environment, but the importance of that didn't start to get truly reflected in content until years after the first European park was completed.

opportunity to be local, we made the most of it. We reviewed everything from dining assumptions to use of languages. We met with academics and film producers, writers, and journalists. We drilled into contacts we could use to get the project done. We traveled to many parks and museums, especially those specializing in cinema or media, and we visited studios, including the legendary Cinecittà, which had been Federico Fellini's artistic center in Rome for decades. We worked with the DLP planning team on a menu of attractions, some that were adaptations from Orlando and some that were new. A few on the team made site visits, looking at everything from shared backstage support to infrastructure expansion, parking, and site layout. We learned how the cast would be deployed and supported, how the resorts would be developed, and what governmental agencies would be involved in administrating the project. We did many peer reviews, seeking local insight.

I got to know Bob Fitzpatrick, the leader of Disneyland Paris and former head of the California Institute of the Arts, who was brought in by Michael. It was good timing, as gaining some credibility with Bob got me on his list for charrettes and discussions for current issues facing the first park in Europe. The park itself and the hotels were all very well developed, but there were occasionally conflicts or unresolved connections between areas, or issues similar to what we had faced with the EPCOT resorts and corporate strategic planning.

I was in a new relationship. Diane was from television and marketing and was now a producer on the *New Mickey Mouse Club*. She was a great story person, incredibly creative, fast with ideas and words, and we explored Paris together when I wasn't working. We'd rented a small walk-up apartment (these were in the days before Airbnb) on the Left Bank, a few steps to a fresh market hall and the Catholic church of Église Saint-Sulpice. Neither of us spoke more than a few survival words of French (*pain* and *fromage* were about it), but we could shop and drag the grocery bags and bottles of Beaujolais nouveau up the stairs and cook on the tiny one-element stove. We explored the cafés and ethnic haunts of the Left Bank. I loved L'Ami Louis, but it was so expensive we only went to it a couple of times, for the baked chicken and the L'Ami potatoes. They were so good I instruct you here and now how to make them: Preheat oven to 400°F. Sauté some garlic in butter. Add sliced potatoes and sauté partially covered for 20–25 minutes until the potatoes begin to brown around the edges. Toss occasionally. Add a little more butter and bake, uncovered, for 20 minutes. They will emerge crisp and golden.

This is the way I cook them now . . . and I only do that occasionally. But

the real magic of L'Ami's version is it's cooked in duck fat, not butter. When in France . . .

I had rented a car in Paris. It was nearly impossible and very expensive to get out to Marne-la-Vallée where Disneyland Paris was being built. There were no open roads to the site, and there was no public transit until the park was to open. I had a kind of billiards-table strategy of getting through Paris. I knew how to navigate from the Left Bank to the Louvre, around Place de la Concorde, up the Champs-Élysées, around the Arc de Triomphe and back again. Anywhere I went, it had to follow this circuit for me to get there and get back either to the apartment or the office. Anywhere else, and I would be lost for hours.

Between the traffic circles, and the tight parking spaces, I'm not sure there was any paint left on the rental when I turned it back in.

The time flew by, and soon we were packing up a large wooden crate of improvised paper models, inspiration boards, program tallies, plans, aerial photographs, scripts, and treatments; everything we'd need to have a thorough review with Marty and Mickey and the senior WDI team when we returned.

For a moment it seemed doable, the idea that we could build another Studio Tour, customize it culturally, and get it done quickly, taking full advantage of the first gate's knowledge. It all seemed possible.

We had no idea what lay ahead, or how quickly the dream of it all, and all the contents of our research and our big plywood crate, could be put on hold, and all packed up for storage.

Tokyo Rising

I had learned that OLC moved slowly and methodically, but when things got going they could speed up quickly—and if a consensus was reached, watch out. We saw it after opening as we quickly authorized the construction of Big Thunder Mountain, a Castle Mystery Tour, Splash Mountain, an expansion of Adventureland, entertainment options, and land enhancements. The original loan necessary to build TDL was quickly paid off, and a robust resort loop was soon under construction.

By 1990, our local team at Walt Disney Attractions, Japan (WDAJ), started getting intelligence that OLC was assigning teams in preparation to study the feasibility of a second park. As we returned from Paris, we were already discussing a possible trip to Tokyo to do reconnaissance on the second gate site. New executives from OLC began setting up visits and workshops to talk about expanding markets, park sizing, and land planning. Nowhere in this work did the term "Studio Tour" crop up. OLC was gearing up to study the idea of a park, distinct from TDL, but the content was not decided, and OLC Chairman Takahashi himself wanted to be involved in the discussion. OLC was headed toward its tenth anniversary, and with such experience it had more insight into its audience and the growth of the business, while Paris was just getting close to opening.

I brought a small team to Tokyo to specifically discuss the second park. As

a young Imagineer in 1982, I'd gone to Tokyo to support the implementation of a Disneyland that was already designed and under construction. Now my perspective was more circumspect, bird's-eye, as I began to understand the OLC land layout being proposed.

The Oriental Land Company was founded in 1960, when I was three years old. The company was to develop a broad peninsula called Maihama, an area of land in Urayasu, about twenty minutes outside Tokyo, which was being created through land reclamation. An adjacent land granted to OLC was to be used for commercial and residential development, but a large tract was to be specifically developed as a recreational leisure property to serve the public interest. In 1962, the company had contacted Disney about building a theme park.

It was not until 1979, the year before I started at WED, that OLC and Disney agreed to build Tokyo Disneyland. Four years later, I stood in front of the castle, watching the first fireworks show on opening day, April 15, 1983. At that time, the total TDL development occupied only a small portion of the total reclaimed land tract in Maihama. Disney guests could drive out to TDL—it had the largest parking lot in Japan. Or they could take public transit, but trains only went as far as Urayasu Station, about fifteen minutes away. At that point, a shuttle bus system ran to and from the main entrance to the park.

Once you stepped outside the fantasy and magic of TDL, it was just flat, silty mud that had once been a bay and from which the park had emerged. A two-story-high seawall separated OLC land from the rest of Tokyo Bay. The remaining land around TDL that was not devoted to the park was referred to in the agreement between Disney and OLC as *peripheral land*, and the agreement gave Disney the right or opportunity, depending on your point of view, to advise or co-venture with OLC on its eventual development.

Once the site was partitioned for theme park, administration, support and cast areas, parking, and an eventual transit hub, there were two categories of land use remaining: sites for multiple hotels, and a five-sided parcel in the corner where OLC studied building a second park. It was considerably smaller than TDL and was surrounded on three sides by the seawall that defined the edge of Tokyo Bay.

On our first visit, we walked the whole second park site, which could be done in a few minutes. It was flat and featureless and had not been touched since it had been originally reclaimed, which meant filled in with sand and aggregate, and the water pumped out. The huge gray stone-and-concrete seawall was being used by bike riders and fisherman, and as a trash dump. The

most interesting characteristic was the three sides that looked back toward Tokyo and out to the bay. None of us considered the view to be particularly scenic. At that time, the Tokyo area was perpetually hazy, and the bay was flat and shallow. Not much of Tokyo's downtown could be seen, and across the bay it was all heavy industry until a break for the expanse of Haneda Airport. But as designers, we loved the idea of a "waterfront" site, even if it was an industrial one.

With all the meetings and stress, it was still a joy to be back in Tokyo. Japan still felt like my second home. Whenever I could bridge a weekend, I would spend a Saturday or Sunday on the Yamanote train line going back to my old haunts—from Shibuya to Shinjuku, to Harajuku, Akihabara, the park in Yoyogi. But nothing stood still there. The area around my old home was built up, as was the old station I used to use. My little tofu vendor had been taken over by a large apartment block. There were new signs, buildings; Western and Japanese brands appeared. It was all familiar but different, and always exciting. I could always get yakitori under the railroad in Hibiya, and there was always fresh eel grilling along my old shopping street in Azabu-Juban.

In the ten years since TDL was built, it had become the most popular resort in Japan. Local resort hotels like Sun Route presented budget options for travelers, and more luxury accommodations, including Hilton and Sheraton, had built multistory towers with quality dining, pools, tennis, shopping, and wedding facilities. For the most part, the hotels catered to TDL guests, for one- or two-night stays, with park tickets included in packages.

One common characteristic that surprised us was that the hotels didn't even try to engage the water views. They tried to hide the bay and the seawall or block it with landscaping and capitalized only on the views of the park.

In an effort to embrace the growing community around TDL, OLC had built a sports-oriented park, providing open space and ball fields, which had been dedicated in perpetuity, so it was a fixed element in our planning, as was the assumption that TDL and second-park guests would share a common entry and parking facilities.

My first comment to OLC was that the park site was too small. I knew this even without any concept having been agreed on. I was still reeling from the half-day Disney-MGM Studios experience. We had been fighting an uphill battle for capacity and land since we opened. And the TDL situation seemed potentially more out of balance than the one at Walt Disney World. TDL had seen healthy growth in attendance every year since it opened. But then the

Maihama railway station opened, making it possible to arrive by train from Central Tokyo, with no bus connection, in less than twenty minutes, and from many places throughout Japan by streamlined rail service. The year the railway station opened we were also culminating that first five-year master plan, adding a menu of major park expansions and enhancements. Attendance exploded, and hotel occupancy broke industry records, even by Walt Disney World standards, with many guests opting to stay in on-site hotels to get vacation packages that included park access.

Despite reservations about sizing and capacity, we began a conceptual development collaboration with OLC. We reviewed assessments from marketing, guest profiles, projected growth, contemporary culture, and original TDL-needs analysis. Everyone was excited just to begin the discussion, and although Michael Eisner and Frank Wells were very keen to see a studio tour developed, the broader team of WDI and Disneyland International, and our new OLC partners, kept an open mind. There was a dream out there somewhere, but at the time none of us could have predicted what it would become.

Orlando, Paris, Tokyo, and Glendale

Everything was happening at once. For the next year, I was shuttling between Florida, Paris, Tokyo, and Glendale. Meetings in all three locations were exciting and intense. Sometimes it was confusing to think about which project we were talking about, or which team members needed to be where. I would wake up and need a moment to remember which city I was in. But chances are whatever city it was, I had to leave for another one in a day or so. I collected enough frequent-flier miles to earn some kind of wall plaque. I kept hoping I'd get my name on a seat, but that never happened.

For Orlando, the key was getting the Hollywood hotel thrill ride conceived, and the Muppets 3D movie and themed land developed for quick implementation. Dining and retail expansion moved quickly, along with more live entertainment. The use of the production studio stalled, and it became clear that more of the guests' day was going to be driven by attractions, not behind-the-scenes elements, requiring more attractions investment to sustain the attendance. Animation, on the other hand, grew, and with the debut of *Mulan*, Orlando's animation unit's first full-feature assignment, additional facilities for team and production were fast-tracked.

Tokyo work sessions were alternating between Japan and Glendale. OLC considered the film business in Japan to be uninteresting. It seemed impossible to imagine a working studio, even if OLC agreed that the Studio Tour

entertainment attractions might work in Japan. I got to know Takahashi-san. He had been a legendary figure when I began at WED. He was part of TDL from the beginning. With the success of Tokyo Disneyland, he wanted to be personally involved in the decisions related to the development of a second park. He entrusted the management of the details of development to Kagami-san, his number two, but stayed personally involved, and I gave him an update every time I visited Tokyo. Over time, I grew to respect Takahashi-san and his understanding of what he considered true Disney. In my mind he was no less my boss than our other Disney executives.

The results of our extended Paris research trip, shipped back in a crate, were presented to Marty and Mickey, then to Michael and Frank, and they had approved the basics of Disney-MGM Studios Europe. It was familiar but quite different. We had pressed for a greater nod toward European-film cultural contributions. We had begun thinking about the site, and the use of a naturally forested "bois" or park, as part of the environmental scheme for the park. We knew this project would rely less on behind-the-scenes production, and more on branded guest attractions. We had reached out to Rémy Julienne, famed film stunt and car chase director, about a massive show in the style of James Bond. We were considering a huge theatrically developed Hollywood set inside a soundstage as the main entrance, as we found weather in Paris to be more and more of a substantive issue. And we had some great ideas for shows that would bring to life the magic and artistry of film and animation storytelling.

I already felt we were being squeezed down based on fear that the construction of the DLP park and resort were rising in cost. But the schedule was all-powerful. To keep pace with the schedule, an entire second team was assembled just to keep moving ahead rapidly on Disney-MGM Studios Europe (DMSE). Although Michael supported our ideas to localize, and was bullish on sizing, strategic planning was back to their size concerns, and they initially set financial models for the park that were even more conservative than the first time around. It was tough to know whom to listen to.

Moscow

Having been across Europe, to China, Thailand, Australia, and New Zealand, I was always interested in exposure to different and legendary cultures. In July 1991, I took a side trip to Russia, along with a few colleagues. We realized it would be quite easy to make a stopover in Moscow from Paris if there was an available weekend between meetings. We arranged the flights and visas. Someone who'd done the trip gave me a few tips before I left. "Bring food," he said. "There's no food there! Bring a case of American cigarettes to trade, and whatever they tell you, don't use rubles, plan on using dollars only!"

I have never had a problem eating new and strange food, so I disregarded the comment and didn't bring any. I did manage to snag a case of Marlboros at the airport duty-free.

We flew out from prosperous Paris, where there were hundreds of impeccably dressed people sitting at outdoor cafés, fine cheese shops, bakeries, and oyster bars on almost every block. Upon arrival in Russia, the first noticeable difference was the customs agent at Sheremetyevo International Airport outside Moscow. He reviewed my passport and my visa and cleared me. He almost stamped my passport, but his hand stopped in midair. He looked at me.

"Do you want me to stamp your passport?" he asked. Then he held his hand out. "Ten dollars," he said. I didn't know what to do. I knew I needed a passport stamp. Which was better, being arrested for giving money to the

customs agent, or for being in the country illegally? I palmed over an Alexander Hamilton, and suddenly the stamp went down. Pop!

At the money exchange, we had been required to reveal every U.S. dollar we were carrying. It was inventoried and we were given a stamped affidavit to sign! (This was before the customs officer had fleeced me for ten bucks.) We were required to change some dollars into rubles. These came in a brick, about the size of a bonus pack of index cards. Certainly something you couldn't carry around very easily.

"You must only buy in rubles," they ordered. "Your dollars will be counted again when you exit the country."

We entered Moscow and it was a very dreary scene. The city seemed desperate and aimless. Here was the place, as I'd been taught, that was the greatest threat to America and the world. Ronald Reagan had called it an evil empire. It all seemed dusty and destitute.

The hotel was okay. But reality hit us when we wanted to get some food. My friend had been right: he didn't mean I wouldn't like the food, he meant there really wasn't any!

The hotel had some dreary salami and cheese. The bread was dry, and the corners of the salami and cheese were starting to dry out—it had clearly been sitting out a long time. We did what we could with it as it was our only choice. There were no adult beverages either (we missed Paris). But travel is travel, and seeing a wonderful historical country is always a wonder to me. To see the expanse of Red Square, the walled Kremlin, and the complex domes of St. Basil's Cathedral was so much to take in.

I was very excited to see one of the most important architectural and commercial buildings in the U.S.S.R., the famed GUM department store. The building itself had a history dating back to the nineteenth century, and it had been a massive department store since the 1917 Russian Revolution. The trapezoidal structure had a combination of elements of Russian medieval architecture plus a steel framework and a spectacular glass roof in the style of the great nineteenth-century railway stations of London. It looked similar to what we had done, quite a bit more modestly, over TDL's Main Street.

The interior of the glass dome was spectacular. Only a few shoppers were there, bundled up even inside the building, which was freezing. I tried to get a sense of the goods, expecting a wide diversity of the best of Russian culture, and anyway I had a brick of rubles to spend. That is when we realized something terrible was happening. There was nothing on the shelves. In this giant

icon to shopping, nearly every shelf had been cleared. Everything that could be bought had been bought, and the few shoppers were searching around for any last crumb of food or leftover piece of merchandise. After having been in Paris for a while, it was like we had descended into an alternate reality.

The next morning Craig Russell and I met in the lobby. We were hungry to venture out, and desperate for some coffee. We looked at the hotel's dreadfully dried-up breakfast offering and were convinced we could do better on our own. We could go where real people ate, we thought, and off we went to explore.

We walked for miles. It was a great tour of the outskirts of Moscow. We walked and walked. Not a Starbucks to be found.*

Not a Starbucks, nor a McDonald's, nor a Denny's with that bottomless cup of coffee. We really didn't expect any of those, but we'd hoped for any kind of little mom-and-pop hole-in-the-wall with a bakery and a scalding cup of terrible coffee.

But then we finally hit the jackpot. It was a kind of flea market in a dusty, dirt parking lot. People were selling various kinds of junk and wares out of their cars. There was smoke coming out of one station, and the smell of dough cooking—that had to be it. We found the stall where a woman was making a kind of thick flatbread. And we were ready. The line was very long, but we got in it, our bricks of rubles ready for action.

I think Craig and I stood in that line for forty-five minutes. We could smell success; we could almost taste it. I looked back, and the line behind us had gotten even longer. It was filled with grandmothers, grandfathers, young women with children, families with shopping bags. There was a sense of desperation on their faces.

A thought hit me hard, and I elbowed Craig: "You know, I got a feeling most of these people need this a lot more than we do."

Craig agreed, and as hungry as we were, we dropped out of the line and went back to the hotel. There were a few scraps of old cheese and salami left on mostly empty trays, and there was some kind of light brown liquid that warmed us up. Whatever it was, it didn't qualify anywhere in the world as coffee.

It was a great couple of days in Moscow anyway, seeing amazing sites, seeing another culture, lack of food aside. It kept nagging at us though: How do

* Okay, we knew that was not a possibility. Starbucks didn't open in Moscow until 2007. But by 1991 there were about nine hundred Starbucks locations in the Los Angeles region, so you can't fault us for wishing.

these people survive? Everything just seemed so depressed, and any product you could think of was in such short supply.

At one point, we were complaining in the lobby about the lack of dining options. I shouldn't say *options*; it was a lack of dining in general. A local overheard us and gave us a tip. An address, a place he said we could get a great meal, with wine, anything we wanted. We took the challenge. We got the hotel to make a reservation and we were off for an adventure.

A taxi to the address landed us in a residential area. Not only was there no restaurant, but the houses also looked deserted and there was barely any light anywhere along the street. We started to get a little intimidated. But we found the number and decided, against our instinct, to go up onto the porch and knock. The door opened and we were ushered in quickly. Inside was obviously a restaurant, crammed into the ground floor of the house. It was filled with white tableclothed, candlelit tables and obviously well-to-do, dressed-up patrons. We scarfed down soups, salads, appetizers, entrées of beef, seafood, chicken, and wine, wine that was in bottles with no corks and no labels. We seemed to be in a Bolshevik version of a speakeasy.

It was three or four meals in one for us, and the bill, when it came, proved it. We all got out our bricks of rubles. They were so valueless that it took hundreds of them to make up the check. Finally, the manager came by and seeing all our rubles, made it clear that they didn't accept them. I figured we had a choice of dishwashing for the next three days or parting with our dollars. We kind of sensed that whatever customs would do to us about being short on dollars, it was not as bad as what whoever ran this enterprise might do to us if we didn't hurry up and pay. It was as expensive as the most posh place we'd ever tried in Paris, but it was just as good.

It turned out at the airport no one counted our dollars anyway. No one had wanted any packs of Marlboros either, at least not in exchange for dollars. I left a few packs in the room for the housekeeper and gave some out to taxi drivers and luggage handlers as tips along with a few dollars. We stopped by currency exchange at the airport and offered them back our bricks of rubles; we'd spent none of them. The agent looked at us, shook his head with an ironic look, and said, "We don't exchange Russian rubles." Russia, it seemed, was not willing to buy their own currency. The brick was a souvenir of Russia I kept for a long time.

In August, barely a few weeks after we visited, Soviet premier Mikhail Gorbachev and his family were on holiday in Crimea. Two weeks into his

holiday, a group of senior Communist Party figures—the "Gang of Eight"—calling themselves the State Committee on the State of Emergency, launched a coup d'état to seize control of the Soviet Union. The coup plotters publicly announced that Gorbachev was ill and thus Vice President Gennady Yanayev would take charge of the country.

We would realize later that we had visited the Soviet Union in the last few weeks of its existence.

Headquarters

The legendary MAPO building, the manufacturing shop on the historic WDI Glendale campus, was about to be renovated. The building and the operations had been named for *Mary Poppins* because it was the success of that movie that gave Walt Disney cash he could invest more in Imagineering activities. MAPO was the unit of WDI that did all the physical manufacturing of anything Imagineering developed that was very specialized, often complex Audio-Animatronics figures. The first phase of the MAPO building had been the warehouse where all the New York World's Fair attractions—such as Great Moments with Mr. Lincoln, "it's a small world," the Grand Canyon and Primeval World dioramas, and the Carousel of Progress—had been shipped back and rehabilitated before being installed into Disneyland.

The newer, high-tech MAPO was being moved into a modern manufacturing center, so the original building, a piece of history, a shop where everything from presidents, to pirates, tiki birds to monorails had been built, was offered to our expanding global Studio Tour team. Now MAPO was to become our headquarters. I worked closely with our facilities team, and they did a very respectful job. We retained the two-story factory loft configuration, added a bridge, and kept historical references (including the bridge crane that had lifted steam trains and other vehicles across the space). The original shop area was retained and housed a new dedicated model shop.

When the MAPO building was complete, the Disney-MGM Studios, Europe (DMSE) team was the priority because it was mobilizing the fastest. DMSE took most of the building space. I set up a zone that was shared between Florida, TDL, and DMSE and used a team that crossed the projects, hoping to find some "design once, build twice or three times" opportunities. We all had Macs and were astounded by their capability. PowerPoint! Images could be combined with text and form a digital storyboard! We had color printers that could print presentations at the massive size of eleven inches by seventeen inches! At the center I configured four large conference rooms, with interconnecting doors. I remember someone in WDI's administration area criticized me for taking up too much space for conference rooms. And maybe I did, but there were many weeks I remember during this time when every wall was covered in art and storyboards, and a critical meeting or charrette might be going on in all four rooms at the same time, with lunches being served in the connecting foyer. And then there were the times when all four rooms were staged with content from the same project, and we'd walk Michael and Frank through it all in one compact afternoon.

Disneyland Paris

On April 12, 1992, the Euro Disney Resort (now Disneyland Paris) opened to grand fanfare, enthusiastic guest reactions, and positive press reviews. It was a moment the team deserved. I hadn't seen a lot, but from being there a short time with them, it was obviously a tough slog from the muddy fields of Marne-la-Vallée to the unveiling of the most beautiful Disney Park to date.

In addition to the spectacular park, there were 5,200 Disney-owned hotel rooms integrated into the resort complex. Michael Eisner had invited a who's who of architects to contribute to the resort, from Michael Graves to Robert A. M. Stern, and he commissioned Frank Gehry to create an Americana-themed entertainment, dining, and shopping area called Downtown Disney.

Within a few weeks, just like with the Studio Tour opening, depending on whom you talked to, Disneyland Paris was a success or a failure, or somewhere in between. It was an argument that was fervent and would go on for a very long time.

Disneyland Paris opened below expectations, meaning although the reception was positive, attendance was soft, the bookings were below what the pro forma had assumed. There was some early finger-pointing: some DDC folks surmised that WDI had spent too much on the park. Some Imagineers thought DDC had spent too much on hotels and built far too many rooms for the scope of the park. The truth, I assumed, was somewhere in between. But the banks

wanted their payments no matter what, and those loans had piled up due to the increased cost of readying both the park and its resorts.

The financial news hurt the otherwise positive reception. The design team did an amazing job of rolling out a large menu of small additions and attractions they could quickly add to enrich the park experience and increase capacity on peak days. But it seemed like financial news and bank loans received all the attention.

Within a month of opening, our DMSE team was instructed to cut the cost and capacity of the second park by a third. A few weeks into that, we were directed to show a park that was half the size of the original. (Create a half-day park, no need to try to compete with the first park, something to encourage more people to extend their length of stay. Oh, where had I heard this argument before?)

But the agony didn't last long. A few weeks later I stood with other leaders on the balcony of our newly remodeled MAPO building and announced to the team that DMSE had been canceled. The work done was excellent, the team had shown great flexibility in exploring alternatives, but ultimately a complexity of factors had made proceeding impossible. We had already made arguments that funding a few more months to complete this stage, and to properly document the work, would make the project easier to pick up at a later date. But it was not to be. We shut down immediately. Literally in mid-pencil strokes, mid-computer renderings.

Drawings remained piled up on tables, while half-completed models were abandoned in place. Consultants were gone almost immediately, and the majority of the building was cleared out in a couple of days, save for a small leadership team trying to make some sense of the leftover documentation and canceling freshly signed contracts that had been rushed through to meet the aggressive time schedule.

In my little corner of the building, I spent lots of time saying goodbye. There were handshakes, hugs, a few tears, and the thanking of people for their work and dedication. But our pace had barely changed. We were still working on the development of all the additions to Disney-MGM and WDW. And we were now developing multiple schemes for the Studio Tour concept as a second park in Tokyo.

Paris thus dropped off my travel itinerary, but I was still making frequent trips to Orlando and to Tokyo. I couldn't help wondering if those projects would meet the same fate.

Quest to Mount Fuji

Avid adventurer Frank Wells set out in 1983 to climb the highest mountain on each of the world's seven continents within a single year—a feat not yet accomplished at that time. He scaled six, but weather forced him to turn back near the top of Mount Everest. He recalled his experiences in his book, *Seven Summits*, co-authored with Dick Bass and Rick Ridgeway and published in 1986. Mount Fuji didn't make it onto Frank Wells's list; it ranks thirty-fifth in the world based on height, but in Japan it symbolizes the quest for perfection and has been studied by artists and poets for thousands of years.

Sometimes, on a cold morning, from the silty flat expansion land of Tokyo Disney Resort you can get a spectacular view of Mount Fuji, with the park's Cinderella Castle in the foreground. Frank undertook a different kind of challenge, making the dream of a second Disney Park in Tokyo a reality. Michael Eisner was pushing aggressively for creating a copy of Disney-MGM Studios for the Tokyo park. Frank, along with Disney counsel and longtime TDL authority Ron Cayo (and with an added push from global theme park head Dick Nunis), intended to move OLC into a record-fast decision on the project.

I was on Frank's first trip to Tokyo. He was jet-lagged, but we dragged him out to Inakaya, the dinner locale we often chose for new visitors. Inakaya is robatayaki (food is prepared on a grill in front of guests), and if you are only half awake, it's the perfect lively pickup, a meeting point of food, culture, and

theater. Inside a large U-shaped counter, two cooks in traditional garb sit on cushions behind a grill, with baskets and baskets of fresh vegetables and skewers of beef and chicken, seafood, tofu, and . . . uh, whatever. You just point to what you want, and your server shouts out the order. Anyone else in shouting distance shouts it out, too. A cook plucks your selection up out of the pit, prepares it, and hands it across to you on an eight-foot-long wooden paddle.

Normally two tiny crabs came first, as an appetizer. They were plucked live and tossed across the hot grill, where they cooked instantly, freezing them in a fight position. Here, it's crabs in perpetual fight position. Crunch down, and chase with a biru, or a small wooden box of sake, with a little pile of salt on the edge.

Frank enjoyed the show and the amazing food. We talked over all the shouting about the coming days' goals, and then we taxied back to the hotel.

In the next series of meetings, the OLC group's mindset was clear: it was time to build a second park. The audience was there, the length of stay was ready to be extended. The business was extremely successful, and the brand was known and trusted across Japan. More hotel rooms could be added with the addition of the second park.

As for reaction to the Studio Tour proposal? It was tepid. They congratulated us on our success in Orlando. They liked the attractions. They cautioned that unlike Disney, they were not in the film or television business; the idea of running a studio was well outside their expertise.

Each time we presented, we adapted. We intensified the attractions. A volcano and more dramatic scenes were added to the backlot. It was becoming more like lands in Disneyland and no longer much like movie sets. The studio aspect was minimized but remained central to the overall concept. There was a central divide that the WDI team was treading lightly around. Michael believed strongly that a second park needed to be differentiated. It had to have a story that was different from the first one, like EPCOT had when it opened. It was nothing like the Magic Kingdom. On the other hand, OLC had one golden goose. It was Disneyland. They didn't own television, movie, animation, or music businesses. Their success was based on being successors of Walt Disney's vision of a park for families. They never said it in so many words, but they wanted a second park that was exactly like Disneyland!

~ ~ ~

It was impossible not to like Frank Wells—his energy, his good humor, his generosity, his optimism, and how articulate and poetically he formed sentences

on the fly. His respect and encouragement drove me, as did our hardworking team. He performed for OLC, engaging with Takahashi-san and the team personally. He exchanged his tie with Takahashi-san at one dinner. It set off a tie exchange across the table. He always had a new topic or surprise ready. He once suggested that at the next dinner, everyone should bring their wives.*

When the date came up, he made sure everyone knew he'd been serious. Dick Nunis arrived with Mary, his wife, an antique dealer, and Frank brought his wife, Luanne, a patron of the arts, education, and the environment. When the OLC executives arrived, they were accompanied by their very sophisticated wives, all dressed in beautiful full vibrant kimonos.

By the end of 1992, as the tenth anniversary of TDL was approaching, and after nearly five years of discussion, we made what I thought was our final presentation of the Disney Hollywood Studios Tokyo to OLC. Michael and Frank both came for the presentation. Marty came. Ron Cayo was there. We presented from a massive outlay of models, illustrations, plans, and narratives. I presented patiently through the best interpreter. A long question-and-answer session followed, with Michael talking enthusiastically about the concept, Frank supporting it as the culmination of all our sessions together, and Marty speaking about the success of the Disney-OLC collaboration. After the meeting there were thanks, handshakes, bows, congratulations, and assurances that OLC would soon return to us with their input.

I remember sitting with Frank in the lobby of the Hilton. Frank believed we were a step away from a deal. "Frank," I said, "I think we have produced a great park; I don't think we could make this any better, but I just think they don't like it."

Frank was not only surprised, but he also didn't take my opinion seriously. "We are there," he said. "We've all but signed the agreement."

"Frank, I just think they hate the basic idea of a studio, and always have. They love everything we're doing, but they just don't agree with the basic premise of a studio. Disneyland to them is all about imagination, the backstage is never revealed. We did everything we could do; I just don't think they will agree, but they're too polite to say it to you." I challenged Frank to meet with Takahashi-san personally, to ask him how he felt about the concept. Frank

*Yes, indeed, everyone on the negotiation team, no matter what side they were on, was male. The very notion of senior Japanese executives holding an event where they'd bring their spouses was a complete shocker.

readily agreed, and the one-on-one was set for the next day before we were all to depart. He was sure he would prove me wrong.

Though I was not there (actually, no one was except Takahashi-san, Frank, and an interpreter), the outcome was clear. Takahashi-san thanked Frank for all our efforts but said clearly and concisely he did not believe a studio project would be successful as a TDL second park.

By the time we all departed for California, the message was out! All work on a second park for Tokyo Disney Resort was suspended indefinitely.

Digital Revolution

Michael Eisner had once said his favorite thing was to "Go to WDI and immerse myself in all that craziness." It was a quote many of us took seriously, and many of us felt it was a badge of honor. And we always tried to keep WDI a step ahead of his ideas.

Things were changing at WDI. The first computer ever to reach my desk was the Macintosh SE/30. It had a 16 MHz 68030 processor, 4 MB of RAM, and an 80 MB hard drive.

WDI, since Walt Disney's founding, has had a history of always exploring and experimenting. Walt himself defined Imagineering as "The blending of creative imagination with technical know-how." A digital revolution was going on everywhere, including across Disney, where everything from Imagineering to animation to filmmaking and operations was being transformed by new digital tools and access to the World Wide Web.

I felt so cool when a newly named group called Information Technology trained me on a new Macintosh Portable, the first Apple laptop. I had been selected because of my frequent travel. It was the first battery-powered Macintosh, and it featured a fast, sharp, and expensive monochrome active-matrix LCD screen in a hinged design that covered the keyboard when the machine was not in use. It was huge and weighed a ton by today's standards, but

I remember it as sleek and easy to carry; and I remember thinking the fold-up screen that was about the size of a three-by-five index card was amazing.

As I wrote earlier, in 1979 I was a teaching assistant to an incoming professor at the environmental design school at Cal Poly, Richard Saul Wurman. Richard had been different from typical architectural academics at the time and identified himself as an information architect. In the subsequent years, Richard had been instrumental in designing for the 1984 Los Angeles Olympics, and he founded a new kind of travel/map series called Access Guides.

By 1984 Richard was unique in his observation of a powerful convergence that was happening among three fields: technology, entertainment, and design. TED, which he co-founded with Harry Marks, was the first conference to bring these forces together, and it included a demo of the first compact disc, the e-book, and cutting-edge 3D graphics from Lucasfilm. The first TED conference lost money, and Wurman and Marks were not able to mount another one until 1990. In Richard's mind, it could be the second TED, or it might be the last TED. Marty Sklar and Mickey Steinberg had decided TED 2 was an opportunity to draw back the veil of secrecy that had covered WDI so the world could know about Imagineering and its unique creative and technological approach to innovation. And Frank Wells agreed. WDI had the potential to become one of the keys to Disney's being seen as a technological innovator in the new digital world. Plus, Imagineers also needed to embrace the future, and work more collaboratively across creative, R & D, and all design disciplines.

The TED 2 WDI talk was given in a large event hall in the Conference Center in Monterey, California. As Imagineers we were pretty buttoned up. It would be primitive by today's standards, but it was one of the first instances of projection mapping. Our R & D and multimedia team had mapped the entire room in advance and installed what for the time were extremely bright large-scale Pani projectors. Once TED co-founder Harry Marks introduced Marty Sklar, the room became an immersive vehicle, transporting attendees to castles and other environments.

Marty kicked off the presentation with a talk about what he called Mickey's Ten Commandments, inherited from Walt Disney but adapted for a changing world. With 1,400 Imagineers located around the world, it was Marty's concern to make certain the organization retained a certain freewheeling, collaborative approach to knowing the audience and nurturing creative thinking.

Marty's precepts, which I took to heart from then on, were:

- Know your audience!
- Wear your guest's shoes.
- Organize the flow of people and ideas.
- Avoid overload.
- Communicate with visual literacy.
- Tell one story at a time.
- Avoid contradictions.
- For every ounce of treatment, create a ton of treat.
- Keep it up, maintain it.
- Create visual magnets that self-direct the audience.

The simplicity of Marty's message made sense to all of us, though it might have been a little too Disneyesque for a room full of PhDs inventing our digital future.

A few Imagineers followed Marty's talk. I took the mantle and probably talked too much about projects we had done or were doing. After all, TED's mission, as it had established itself, was not to be promos for organizations but insights about the future. My comments contained a bridge I wanted to make between design and entertainment, between my architectural education and my ten years of experiences and growth at Disney—I very well could have written these words years later: "We let story inform everything we do. We not only design buildings and spaces, but we also establish themes, time periods, historical context; and we choreograph the guest experience, as if it was their own movie, scene by scene. Architecture can set the stage for the story, but it can also tell the story. What we do involves design for entertainment, and design as entertainment."

In Marty's opening comments, he'd also made a case for top innovators to consider Imagineering as a career. He noted that there were more than one hundred distinct disciplines, but there was always a need for more.

Marty's presentation script also had a hand-annotated thought in red Flair pen, adding the words, "I think Bran Ferren [who helped us conceptualize the Tower of Terror attraction in the early 1990s] would be right at home."

Newton's Law of Gravity

I met Bran Ferren in East Hampton, New York, on a research trip with other WDI executives. We were visiting Bran's compound, the home of his company, Associates and Bran Ferren. It was a legendary place, from which Bran, with a small team, had impacted many breakthrough projects. He'd done inventive scenic projection design for *Sunday in the Park with George,* one of my favorite Stephen Sondheim Broadway productions. But his work also spanned film, exhibits, and rock concert tours.

Bran had once said, "It's like never having to grow up. If you can be gainfully employed but no one knows exactly what you do, people will say you are a genius." His space showed it. He had every kind of technological toy imaginable, including an electron microscope. But he spoke with an energy and enthusiasm that was infectious for creative people, innovators, or anyone who hoped to innovate.

We were not told so at the time, but WDI was considering a purchase of Bran's operation to benefit the rapid growth of the parks business, and the need to update our approach to technical innovation. For now, we were introduced to Bran as a resource on projects. He would be available to come out to Glendale and brainstorm, make peer reviews, or contribute on anything else we needed.

I immediately saw an opportunity and pitched it to Mickey Steinberg. Tower

of Terror was still progressing, but some of us were sure it was not headed in the best direction. It was getting more and more cumbersome with the ride system and its restraints, plus it was expensive to house it all, and the experience wasn't delivering.

Bran, with his trademark wide red beard and khaki suits, came to Glendale for a week. He had a lot of opinions. We pulled the complete team—creative, story, ride development, building design, and producers. We set up the largest room in the conference area, hung up all the art from the concept stages to current state. We brought in breakfast, and we brought in lunch. We pretty much, as Randy Bright had once said, "locked everyone in the room and passed food under the door."

Often, this kind of meeting generates reams of paper to record it all. This one was simple. Once he had absorbed the *Twilight Zone* concept and the drop concept, and reviewed the current progress, Bran asked a simple question: "If you're trying to do a ride about an elevator, why don't you just use an elevator?"

~ ~ ~

A few weeks later, I arrived in Bristol, Connecticut, with a group of our team members. We drove through farms, forested hills, streams cutting through the landscape, to discover a very odd-looking landmark. It was a four-hundred-foot-high tower, extruded from a very small base, and it had no windows at all.

The elevator engineers we met were having a different day than normal. A visit by a group of Disney Imagineers working on a secret project didn't happen every day. We sat in a conference room and talked about their elevator test tower. It seemed to be this team's pride and joy. We were excited to ride it.

Riding in elevators, it seems, used to be dangerous business. It took Elisha Otis to invent a device that would prevent a passenger elevator from plummeting uncontrollably down if its hoist rope broke. The E.V. Haughwout and Company store in Manhattan had the first, extraordinarily safe, Otis elevator in 1857, and the invention changed the course of city design from then on.

Otis, and this team of experts, had one mission. If Disney's mission was storytelling, theirs was making elevators safe. Their entire engineering division was founded on an elevator never doing what we were trying to imagine it would do as a thrill experience.

We boarded the cabin of the test tower. The control engineer sat on a safety seat with a console. They told us not to lock our knees and to stay relaxed. We crowded around the middle of the elevator. Some of the Otis people decided

to wait outside (our first clue). The engineer said he would take us to the top, four hundred feet, and we would drop about two hundred feet at their fastest possible speed, which would give him a hundred feet or so to stop. He assured us we would be excited. No one spoke and we were really nervous as the elevator ascended. Then it fell. We all steadied ourselves for the few seconds that it was falling. I counted: One, two, three. There was a scream, then it was contained. I realized the scream hadn't come from any of us—it was the control engineer. We reached the bottom. The engineer regained his composure and opened the doors. There was a crowd of engineers standing there with big smiles. "How was it?"

I looked around our team and said to the engineers, "It's not fast enough."

It was clear from our ride that a few factors were fighting our design to create the thrill. First, the elevator didn't really travel in free fall as it was always on a control track. But we could already tell two things: gravity was not going to be enough—and your gut and inner ears couldn't scare you as much your gut, inner ears, and eyes all working together.

Soon we were brainstorming on ways to take the experience to a new level. That was progress. The idea of a conventional gravity drop ride had already been dropped out of our thinking. The job quickly turned to the idea that the elevator would need to be pulled down, not dropped, and with such force that the audience would feel it. So, it would take a heck of a motor system, not just to pull them down but to then slow them down fast enough for a safe landing. We quickly summarized the fun of the concept this way: "If you jump off the building, the ride will get you to the bottom faster!"

We also knew we needed to give the guests a visual-height orientation. Since they would be enclosed for a long time, and hauled to the top, we needed a way to give them a last view, doors that would open at the top, so they'd really know how high up they were.

Another big factor was capacity. To accommodate the number of guests who would probably want to take this ride, we needed lots of capacity, and we needed a story long enough that the attraction was satisfying as a complete Disney experience, rather than what we might otherwise refer to as an iron thrill ride. Just taking people up and dropping them back down would not be enough. And if we wanted to put show elements into the drop tower, it would mean that each ride vehicle would be inside the tower for a long time, meaning less capacity (or we would need more high-speed elevators).

The answers came quickly. There would be two towers with shorter, conventional elevators, ascending seated guests through a few vignettes that set up the story. Then the vehicle guests were seated on would magically *roll out* of the shorter elevators and reset into one of two high-speed towers, where the finale would be experienced in only a few seconds. It would be a mysterious story ride, and then a thrill ride, with a transition in between.

But why? Why would the seated guests just come floating out of their elevator, and what would happen as they slithered along the floor and snapped into the other one?

As happens so often, vexing problems get solved by holding strong to story. The answer was found in the television show's famous opening.

You remember the theme music, and I know you remember narrator and on-camera host of *The Twilight Zone* TV show Rod Serling's narration; if you close your eyes, you can probably play the whole segment in your head. Rod refers to unlocking the door to imagination, and beyond that is another dimension.

The transition between the two elevators would be a magical ride through this other dimension. The fourth-dimension concept was born, complete with the star field and mysterious elements floating by. And once we had lost complete orientation with where we were, a magical door would open, and without our even knowing it, we would be carefully re-indexed into a badass elevator that was about to drop us faster than gravity.

The last touch? Just before the drop, the elevator would haul you up to the top (a sensation everyone can feel by their stomach being pushed down, and your butt being glued to the seat). A large door would open, and for about two seconds you'd realize you were two hundred feet above the park, get your picture taken, scream, and descend into an abyss.

It was like all new ideas, exciting and exhilarating to think about. But it very quickly became clear it was the way to create the experience we were going for. We were creating lots of work for ourselves. Now we had to essentially start over, after much time wasted, money spent, and work completed. It would have been easier to say it was too late. But we knew in our hearts this was the right thing to do.*

* It turned out later that the elevator system was flexible enough to be reprogrammed in various ways. We were able to change the experience, thereby appealing to repeat audiences.

And it followed another lesson that I tried often to remember was a concept Pixar likes to call "Fail Early." If your conscience is telling you that something is not right, face up to it, ask the tough questions, have a peer review. That is what Bran Ferren did. He dared to ask the question many of us were afraid it was too late to ask.

Fall Down Seven Times— Get Up Eight

The team on the ground floor of the MAPO building waited nervously for the full report from my visit to Tokyo, and the reaction to the latest TDL version of Disney Hollywood Studios. Word had already started to trickle in. I was unable to hide my disappointment. I had to inform the team that the project for a second park in Tokyo was on hold indefinitely.

I knew the team had done an incredible job. We'd worked closely with OLC, on everything from the site to the needs assessments, to the marketing and audience growth estimate. We had walked the line between Michael wanting something totally differentiated, to OLC wanting basically something they could see as another version of Disneyland. We had overcome OLC's lack of interest in movies and movie studios by making it more experiential. And we stayed as much as possible within the realm of Disney movies that OLC considered first and foremost Disney. And overall, it would be a beautiful park, fun, exciting, thrilling, all the things they had said they were looking for.

But it was not to be. And that was sort of expected and disappointing all at the same time. Sometimes you meet all the criteria, you make something happen that answers all the prompts. But if no one is excited about it, it doesn't matter. Projects are too hard—they take too much of a personal toll—to be spent on things you half believe in. The team understood.

But failure is an irresistible motivator. We hung around the office that night

until quite late. We reviewed the criteria, re-reviewed the OLC position . . . and the Disney position. OLC wanted something familiar. Disney wanted something different, OLC wanted something new, but they wanted things in it that were time-tested. It was going to be a busy weekend because no one wanted to give up.

Within a few days we were throwing new ideas around. I called it a wet Disneyland. A park with water features instead of land features, boats instead of trains. What if we totally embraced what was special about the site instead of turning our back on it? We were, after all, directly connected to the sea.

In a great charrette it becomes easy to free-associate; to riff from one person's idea to another's. What are the great waterways, water elements that can link stories together in the same way that "lands" can? We started to assemble cards, and soon after, powerful images. Harbors around the world; Sydney, New York, great sites along the Mediterranean. Portofino, Dubrovnik (from recent experience), river deltas, the mouths of the Amazon and the Ganges. Freezing-cold harbors like Nuuk in Greenland. Fictional places reachable only by accident or shipwreck; Jules Verne's *The Mysterious Island*, and Ian Cameron's *Island at the Top of the World*.

We ventured through many discussions in record time. Would Michael agree that a park linked together by great waterways was differentiated enough from a Disneyland? Would OLC see it as recognizable as Disneyland but different enough to encourage the audience to see both parks?

Something different was happening. Ideas were taking form at incredible speed. By this time everyone had a computer and we were able to search the Internet and composite images and words; to put sketches and research images on the same page quickly, and to take rough sketches and enrich them with color and texture. There was a democratizing of image and idea generations. In the past, anyone could contribute an index card with an idea written on it. Now almost everyone could bring a visual idea to the table. And new applications like Adobe Photoshop assured that where one person's visual or story idea stopped, someone else's might begin. Nothing needed to be dried or sent out for printing. Being able to print out materials on eleven-by-seventeen-inch paper might not seem like a big deal today, but it was a luxury. The size gave us flexibility and speed. We began to think more about storyboard frames and beats and less in large single images.

Within a few days (although a shocking number of hours were crammed

into those few days), we had a tabloid deck of about a dozen pages. I used it to ask a succession of questions, all beginning with, "What if?"

I knew that Michael and Frank were coming to WDI that morning. It was usually easy to grab them for a minute if you hung around conspicuously outside Marty's office.

In fact, I was standing there with my printed deck like a process server when Michael and Frank came out of Marty's office. Wow, I had the three of them. I pushed my way into Marty's office like I had two goldfish I had to deliver. "Have you all got five seconds?" I said, well underestimating the time the pitch would take.

I had been getting pretty good at the pitch by this time. It was honed by Michael's television and film culture—fast, attention-getting, quick to the point. This time I was heavily armed. And I knew sometimes you had to pitch fast.

"What if . . ." I asked. "What if we took a completely different approach to the TDL second gate?" Frank shook his head, and he'd obviously briefed Michael that we'd reached an impasse. Marty, as was his style, however, encouraged me to proceed.

I went frame by frame, second by second. Disneyland is linked together by themed lands, places in history, or fantasy, or the future, that form stages for various experiences to be played out. What if a new kind of Disneyland did basically the same thing, but used famous bodies of water, romantic ports of discovery, harbors, river deltas, places where land meets the water's edge creating an immediate sense of departure into adventures?

Our Main Street could be a busy Mediterranean harbor complete with a re-creation of the Italian village of Portofino; a romantic harbor with boats departing for distant places, and real hotel accommodations.

Our central icon could be a mysterious island, complete with a new kind of castle framing a volcano where Jules Verne–inspired adventures existed beyond.

Our Fantasyland could be underwater, a *Little Mermaid*–inspired undersea world.

A bustling New York–inspired waterfront, busy with the departure of a massive cruise ship, a big city background with diverse people, and culture and food from around the world, and Broadway. A collection of false perspective skyscrapers could form a home for the Tower of Terror.

We had ideas for a futuristic port, and a desert port on the Arabian coast, since *Aladdin* had just been released and was a huge success, and even a frozen Arctic location. A river delta inspired by the mouth of the Ganges or the Amazon might form a natural kicking-off point for an Indiana Jones attraction.

There would be water parades, fireworks reflected in water, fountains, transit steamers; everywhere the busy waterways would be brought to life.

My informal five-second pitch took five minutes. Frank looked at Michael, Michael looked at Marty. Three nods said get it going and get ready for another trip to Tokyo.

It turned out the idea to do a second park was still solidly fixed in OLC's mind, especially in the mind of Takahashi-san. But he was patiently waiting for us to bring him the right idea. Tokyo DisneySea, as it quickly became known, was the idea. It had very little development, but Takahashi-san saw the potential. We were quickly doing studies for capacity, for attractions, for dining. We had to engineer a magical and massive-scale waterway on a reclaimed marshy site.

Within months, we staged a huge concept presentation for OLC in the ballroom of a hotel. There was a lot to consider: how the waterways would work, how attractions would integrate and grow, how we'd use Disney characters, entertainment, and the added complexity of a huge luxury hotel above the entrance. But the bones of the idea were there, and Takahashi-san and his team shared in the vision of it. Almost ten years had passed since I'd stood watching fireworks for the opening of Tokyo Disneyland. It would be another eight years before Tokyo DisneySea would become a reality.

And I was celebrating my twelfth year as an Imagineer.

New President—A New Secret

January 20, 1993

I was as warm as I could be in so-called winter clothes brought from Southern California. It was thirty-four degrees, and I was standing on the National Mall with eight hundred thousand other attendees, trying to get a good look at the president-elect.

American author, actress, screenwriter, dancer, poet, and civil rights activist Maya Angelou rose to the podium. Her poem riveted me and, I could tell, the crowd all around me, too. Her epic poem encouraged all Americans to lift up their eyes and be willing to dream again.

The evening before, the president-elect, William Jefferson Clinton, at a concert in front of the Lincoln Memorial, had called for unity, for an American Reunion. In his inaugural address, he famously said: "There is nothing wrong with America that cannot be cured by what is right with America."

Everyone at WDI was busy. The organization had downsized, but the menu of work was rising again. The Disney-MGM Studios had been open for nearly four years, and a huge expansion was underway. EPCOT was undergoing a significant update. Expansion was going on in Paris, and the massive new Discoveryland project was less than two years from opening. The Studio Tour proposal for Paris had been suspended. But the massive new Tokyo DisneySea project was in development and in intense negotiation with the Oriental Land Company. I received a call from Peter Rummell, the head of Disney Development

Company. I had reached out to Peter a few times to compliment DDC on their great work at Walt Disney World—their hotels: the Yacht Club and Beach Club Resorts, BoardWalk Inn, Wilderness Lodge, and others that had been accomplished with extraordinary quality and story. I suggested it would be great to find projects that the hotel group and Imagineers could work on together.

Peter said he had found one.

He asked me to call Mike Reininger, one of his executives. I connected with Mike, whom I had only met a few times. Mike asked me if I could make a trip to talk about something he called Project Venezuela. I had not been to South America, so I was game. But I got confused when he told me to come to Washington, D.C., to talk about the project. Without any thought I said yes—it didn't really matter if it was on the Caribbean Sea or inside the Capital Beltway, I was interested. Mike said he couldn't tell me any more about it in advance.

I realized the date he suggested we meet was the first full working day after the inauguration, and so I called Marty, and he suggested I call the Disney government office in D.C. to see if it might be possible for me to see something of the inaugural festivities if I arrived a few days early. It was my first time speaking with Richard Bates, the senior vice president in charge of our government relations for Disney. It wasn't too long before I realized Richard really was the face of Disney in D.C., and the portal to Disney Government Relations, and that he was not only an accomplished leader and negotiator, but tremendously helpful to visitors. Yet as brilliant as Richard was, he approached everything with just the kind of sense of humor you would imagine he needed to work in Washington.

On the day I arrived, the city was alive with optimism and a spirit of renewal that came with the peaceful transition between George H. W. Bush and Bill Clinton. The National Mall was filled with live music, food, art, and cultural festivals, and I was particularly taken by large stations of folding tables with eleven-by-seventeen-inch white boards and markers; people were invited to write their aspirations for the next president. And those boards, which included notes, drawings, and messages of many kinds and in many languages, were then posted onto huge billboards that people walking along the mall could see.

I was inspired to be in Washington and, frankly, excited to feel a bit like an insider, with an opportunity to see relatively close-up the inauguration ceremony, the parade, and the new first family as they drove down Pennsylvania Avenue on their way to the White House. I went to a huge inaugural party at RFK Stadium attended by the president-elect, vice president–elect Gore, and

their families. It was also headlined as the reunion of Fleetwood Mac, whose "Don't Stop" had fueled Clinton's campaign. I felt I was witnessing a moment when politics was meeting entertainment and pop culture. It did not seem at all odd that the first families appeared onstage with Fleetwood Mac; Washington, it seemed, was waking up to the takeover of the baby boomers, and popular media. And "Bill" even played the saxophone onstage throughout the evening.

On the morning of January 19, the day before the inaugural, I attended the Disney Channel Presidential Inaugural Celebration for Children concert at the Kennedy Center. The concert included performances by Mr. Rogers and the Muppets. The special was written by Bill Prady, who had written Muppet*Vision 3D.

At the end of the concert, musician Raffi played "This Little Light of Mine," inviting all the performers to join Bill and Hillary Clinton onstage. Puppeteers Steve Whitmire and Dave Goelz came on with Kermit and Gonzo, Whitmire crouching behind the Clintons to get Kermit up on Hillary's shoulder as they sang. The Associated Press photo of Kermit on Hillary's shoulder appeared on front pages around the nation.

With ceremonies and parties fading, Mike Reininger picked me up early morning in the porte cochere of the austere brick Four Seasons Hotel in Georgetown. In the car on the way to a location which I still didn't know, Mike gave me my initial briefing. It was a real "WTF" moment. In complete secrecy, DDC had acquired a massive three-thousand-acre site just thirty minutes outside the National Capital Region of D.C., in the very heart of Virginia.

Mike was a senior project manager for DDC and a rising star in the organization. As a combination project manager and skilled developer, he was concise, clear, and aggressive about what he needed, which I completely respected. I was happy I had invested some time with Peter and was now investing in the time with Mike to understand the criteria for the project.

I was always frustrated by the perception held by many business people that WDI was a purely creative, and way too loosely managed, organization. Marty's stated goal was to keep WDI a casual but creative powerhouse, always trying to push new ideas forward. But there were negative stereotypes, too: the beliefs that no one in creative could be challenged, and that creative people had no sense of business. This reputation needed a refresh, as many of us worked hard to show we shared a role in financial responsibility and that we desired to cooperate and collaborate on many levels. The image of WDI as a fully independent creative entity with no interest in operations, success, or the

bottom line was outdated. At least, I believed so after working hard to develop successful relationships with strategic planning, our partners at OLC, and Walt Disney World. Mike was receptive, and we hit it off well.

Driving through the site, it was hard not to be excited about this opportunity. Even in the dead of winter, the land was a beautiful combination of rolling fields broken by occasional dense forest and rocky streams. We looked around as much of the site as was possible by car. We reached the top of a hill, where the hay had been harvested months ago and the cut grass was lightly covered in white snow. I was twelve years into my WDI career as an architect, urban designer, and Imagineer. I had stood on land before, and I always felt it spoke to you. You just had to listen. I heard it when I first rode into the middle of the pines and palmettos of the site for Disney-MGM Studios. I had felt it on the site of Tokyo DisneySea, standing on the flat silt looking out across hazy Tokyo Bay, and along the tree-filled riparian forest on the second site in Paris. And I sensed it here, looking down at the long run of hayfield and across the rolling hills of historical Virginia. I could feel possibilities, and the responsibilities. Whatever this would become, it would have to be worth doing.

We drove the perimeter and visited the quaint town of Haymarket. A few miles down the highway we stopped and walked the Manassas National Battlefield Park, the quiet solitude only slightly disturbed by lawn mowers. As we stood there in 1993, it had been 132 years since the first full-scale battle of the Civil War, a bloody conflict that took the lives of Union and Confederate soldiers and civilians. I find reading about history fascinating and remarkable, but being a kid of the West Coast, I knew more about World War II than the Civil War. I had a lot to learn beyond textbooks and Ken Burns's documentary. There were two sides to this memorial: Northerners called it the First Battle of Bull Run, named for a tributary on the site; Southerners called it the First Battle of Manassas.

Mike and a colleague had spent several months in a near repeat of the days of 1965 when Disney had purchased the land in Florida needed to build Walt Disney World. They had worked under assumed names, used personal credit cards, made reservations that didn't tie in to Disney's corporate systems, and used third-party land attorneys who didn't know who they were, either.

Despite their secrecy, some press hounds were trailing them. Initially, a *Washington Post* reporter began asking questions, and then the *Wall Street Journal* was on to them. It began to look unlikely that the company's responses

of "no-comment" and "we do not react to rumors" were going to hold the story down for very long.

It was decided that a development team needed to start work immediately, in complete secrecy, and that work should accelerate quickly so that an announcement of the project, including the creative vision, could be staged before it was leaked.

Returning to Glendale, Mike and I, and a small team, worked together to find a warehouse on the perimeter of the WDI campus, next to the railroad tracks. It was quickly outfitted: an open plan of tables, a few improvised conference areas, and a large order of 4- by 8-foot white gator boards for use as improvised research storyboards. Team members would have special access cards, and there would be no phones that tied in to the Disney switchboard. The code name, Project Venezuela, stuck, and all assigned team members were asked to diligently refer to the project under that name, including in communications, charge numbers applied to time sheets, calendars, and meetings.

I quickly assembled a team of Imagineers, a range of excellent conceptual minds as diverse as I could find, and a range of talents and disciplines. I polled people for interest in history. Mike did the same for the real estate side. Soon we were holding briefings with our new team, in our new improvised space, with most new members initially thinking they might be headed for a rafting research trip in Venezuela, and instead being shocked to learn the scope and scale of the land acquisition in Virginia, how close it was to the National Mall, and how quickly we needed to be developing the concepts.

No one starts a long endeavor thinking they are going to fail. And even more so when the stakes are high, when the promise of the project is great. There are always frustrations, missteps, and those periodic moments of true creative inspiration. No matter how worthy the dream or how hard the team works to achieve it, once in a while, a day comes when the models get crated up, the papers are loaded into file boxes, and all the drawings get carefully stacked into the wide metal drawers of the appropriately named art morgue as the doors are closed and locked.

But during those exciting meetings when you're just getting started, you never think that could eventually happen.

Disney's America

The idea of Disney's America was cemented in 1955 when Walt Disney read, on live television, the dedication plaque for Disneyland:

> Disneyland is dedicated to the ideals, the dreams, and the
> hard facts that have created America, with the hope that it
> will be a source of joy and inspiration to all the world.

A few steps from where Walt stood to read that dedication is the American flag; to this day, every evening before sunset a Flag Retreat Ceremony is held, retiring the Colors for the night. The Disneyland Band plays the national anthem, passersby stop, many join in. The crowd builds. Active and retired members of the armed forces are encouraged to participate in the ceremony, and an honorary veteran of the day is presented with the flag at the conclusion of the ceremony.

Walt was patriotic. He had given over his studio during World War II to create films such as *Victory Through Air Power*, and he offered his best animators to create bomber insignias to contribute to troop morale.

In 1958, a year after I was born, Disney created the first *America the Beautiful* Circle-Vision 360 movie attraction in what they named at the time Circarama,

for the American exhibit at the 1958 Brussels World's Fair. The film was a major hit and was subsequently dubbed in Russian for a run at the American National Exhibition in Moscow.

America the Beautiful opened as part of a renovation of Tomorrowland at Disneyland in 1967. I probably saw it that year. I was ten years old, and I still remember holding on to the railing and trying to wind my head around to take in all 360 degrees of America. It became something we always saw at Disneyland, and I have no memory of Disneyland without it. Through *America the Beautiful* and Great Moments with Mr. Lincoln, there was always a sense of fulfilling a patriotic purpose, making the Disneyland day more than just fun, but an investment in learning and shared ideals.

The Circle-Vision 360 film technique was developed by Ub Iwerks and his son Don Iwerks and required multiple cameras arranged in a circle. The camera array had traveled the country, sometimes mounted atop a car but also on a hook and ladder fire truck, on several different kinds of watercraft, and suspended from a B-25 bomber. The audience experienced spectacular scenes of America, surrounding them in sight and sound. I never left the show without a sense of inspiration, and I'm sure that our summer camping destinations were inspired, at least in part, by seeing this film.

Great Moments with Mr. Lincoln had started as a concept for a hall of all the presidents, designed to be a static wax works exhibit planned to be part of an addition to Disneyland called Liberty Square. When renowned New York urban planner Robert Moses asked Walt Disney to get involved in planning for the 1964–65 New York World's Fair, an inquiry from the state of Illinois led to the idea of creating a show around Lincoln alone and bringing him to life as a fully animated robotic figure, something that WED would later call Audio-Animatronics figures. Although the studio's animation department had been experimenting with robotic figures, the technology was in no way ready to create the beloved and universally recognized personality of the sixteenth president, who held the Union together through the Civil War until he was assassinated in 1865. But the project was a success, and audience members audibly gasped when the figure rose from his seat to make an emphatic point. Some were convinced Lincoln had been played by a live actor.

The *Great Moments with Mr. Lincoln* attraction moved to Disneyland's Main Street after the fair. The vision of Liberty Square and the Hall of Presidents was transferred to Walt Disney World. We made our first family visit to Walt Disney

World in 1972, and I can still remember being astonished when the curtain rose, revealing the panorama of U.S. presidents, including the current office holder Richard Nixon. They were all gesturing and looking, for the time, quite natural and dignified.

Twenty years later, in fall 1992, Eric Foner, award-winning American historian and faculty member of Columbia University, visited Disneyland with his daughter. They attended the Lincoln show, and it motivated Professor Foner to write a letter to Disney CEO Michael Eisner. Foner, an expert in American Reconstruction, thought the Lincoln show was too superficial, and he suggested in his letter that fundamentally Disneyland was not an appropriate venue for the telling of history. He wrote that the popular theme park just didn't have the time or the context to tell the important story of someone like Lincoln and his place in American history.

Foner's letter made its way to Frank Wells, and to Marty Sklar, and on to Rick Rothschild, my close collaborator at WDI. Rick and I had already begun working on possible renovations of the Hall of Presidents since Bill Clinton had just been elected and soon we would need to add his figure to the production. In fact, the stage was beginning to get a little crowded, the show a little tired, and it really seemed like the time was right for a redo.

Rick worked with Foner, and the Lincoln show at Disneyland was rewritten and reedited with his input. As a result of that experience, Foner said he did see the potential to tell better history at Disneyland, and as a public historian, he realized that Disneyland was so well attended it presented an opportunity for many Americans to have exposure to—if well told—a great lesson in their own history.

With the success of Lincoln, a presentation was made to Michael Eisner and Frank Wells for a completely redone version of Hall of Presidents, along with Eric Foner's agreement to consult. Michael and Frank appreciated the new show, new story, and modern theatrical visual storytelling. But given the range of investments across Walt Disney World at the time, they didn't see this as the top priority. They agreed that the show should be rewritten, and for the first time the new president, in this case, Mr. Clinton, would have a speaking role. It would begin a new tradition. Everyone agreed this would add new drama, and audiences who had seen the show many times would have some surprise and delight, as every new president from here on would be addressing them directly. We hoped to make it a great show and we'd try to minimize the impact of differing political opinions.

Rick went on to put the show into production, with Foner as advisor, and went to the White House after the inauguration to record Clinton's remarks. Maya Angelou's epic poem had made such an impression at Clinton's inauguration ceremony that we agreed to ask her if she would narrate the new show, which for the first time would include references to slavery and Reconstruction. Angelou agreed, and the show, as well as the Audio-Animatronics figure of President Clinton, headed into production.

As we began our work for the new Disney site in Virginia, I felt it was important to engage our leaders in a conversation about our goals and to do it before we started, rather than after we had spent too much time. We did some initial thinking, some cursory research, and filled a large conference room with index cards with ideas and major points scribbled on them. Rick was invaluable, as were many of our team members, in assembling major story points and themes and looking for authentic connections between Disney and the panorama of American history. I requested a date for what I suggested could be an informal conversation about goals and intent of the project. A date was set, and Michael, Frank, Marty, Peter Rummell, and a small group were slated to come over.

When Michael and Frank first visited what we now referred to as the safe house, we gave them a tour, and then we sat in the conference room, where the walls were filled with idea cards and we had staged the table with lots of books on American history. I think the depth of the importance of the meeting struck them. All things sound interesting at the beginning. But now we were sitting on the pending purchase of some three thousand acres of land in Virginia and expecting any day for a reporter to divulge that Disney was going to build a new resort there.

Much of the conversation centered on the fact that this new park was planned to be smaller than our other parks. Seemed like the story of my life: here we were, with not a line on paper, debating how small the park should be, as opposed to how big the idea could be. I took a deep breath. The logic was that the new destination would be a regional draw, intending to bring people out who were already planning to make a vacation to the nation's capital (as millions and millions of Americans did every year at the time). But there was more competition for people's time, and there were lots of free attractions like the Smithsonian. As such, we, DDC and WDI, would have to think differently about costs, programs, and attractions, and generally rethink the economics of how our existing parks worked.

Michael didn't say much. He listened quietly as the business plan was laid out, not paying it too much mind. Then he suddenly challenged the meeting with a bold statement, no doubt influenced by the interaction with Foner. Michael said:

"We want to show that Disney can take the storytelling skills that we have and use them for the purpose of inspiring people about American culture and history. To do this, we have to be bold, and we have to be willing to put in even difficult periods of history and agonizing events, including a descriptive and powerful presentation of slavery that will make people feel history, not just passively read about it or see it in a museum. The role of Disney will be to help visitors feel it. They will experience it in ways that only Disney can do, and it will be a breakthrough that no one has ever tried to do."

There was quite a conversation at the table. Peter, Frank, and others questioned the idea of slavery in a theme park; something that could be so painful, so divisive and difficult to depict, that it maybe should be off the table from the beginning. But Michael was clear that he felt that as a company we shouldn't shy away from controversy.

Michael and I are both part of the baby boomer generation. In fact, we bracket it—he was born at the very beginning and I was born near the end. I know he was confident in his instincts. He'd had great success in television—he knew what all those boomers wanted to watch. I shared Michael's inherent optimism, and working with him, I had learned that being commercially successful didn't necessarily mean you couldn't contribute something culturally meaningful. These ideas were critical to thinking about the lasting importance of theme parks and had always been essential to film and to television.

Michael had been at the ABC Network during the development of Alex Haley's landmark book *Roots* into a miniseries for television. *Roots* brought the reality of America's slavery history into American living rooms, night after night, and dramatized it through well-developed characters portrayed by actors with imagination and empathy. For America's white viewers, Haley's book, and the miniseries inspired by it, amounted to the first prolonged instance of not merely being asked to identify with cultural experiences that were alien to them, but to actually feel them. Michael has noted in recalling the production of *Roots*, developed by producer David Wolper, that the ABC Network was so concerned with the controversy, it decided to air it on eight consecutive nights, where they thought any damage to viewership numbers would be as

minimal as possible. It turned out Americans were riveted by the series, and its impact on television history and the invention of the miniseries have not been matched.*

We took Michael's comments seriously as we always did. We went around the room talking cards and ideas. We made asterisks on cards that were relevant, we pulled some down, and we put up new ones. We talked about teams, about the need for people outside our immediate circle for concept and story development, including historians, cultural experts, educators. Michael encouraged us to draw in John Cooke, who had been head of the Disney Channel since 1985. I luckily had known John since the Disney-MGM development days. John had strong drive and energy, not to mention connections in circles necessary to make the project successful. I knew he would play a huge role.

The meeting wrapped up. There was a sense of momentum, and a sense of the gravity and scale of the work ahead. At no point after the very start of the meeting had anyone dared refer to the project as a little regional park.

Soon we were on our way toward a very compressed conceptual development schedule.

Thankfully, we had established a relationship with Professor Foner, and at the time we didn't know how essential he and his fellow historians would be to every one of our next steps. We had strong directives from Michael, and soon we would have an ally in John Cooke.

*The series first aired on ABC in January 1977. *Roots* received thirty-five Primetime Emmy Award nominations and won nine. It also won a Golden Globe and a Peabody Award. It holds the record as the third-highest-rated miniseries, and the second-most-watched overall series finale in U.S. television history.

The Vision Group

Some weeks later, a group of ophthalmologists checked into a historic hotel in Old Town Alexandria. They were identified in their reservation as the Vision Group and were visiting the D.C. area for their annual meeting, as well as some tourism and social activities. At one point, one of their members appeared at the front desk, his eye looking quite damaged from some kind of accident. He asked if the hotel could recommend an emergency eye clinic. The desk host found this very curious and reminded the gentleman that he was traveling with a group of ophthalmologists. Couldn't one of them help him?

The guest was Tim Kirk, a longtime Imagineer and one of the most talented collaborators I have ever worked with. He had been by my side through the entire Disney-MGM Studios development. And now I had recruited him to be part of the exploration of this new D.C. project. Tim had recently started kickboxing for exercise and had taken a hard hit to his eye, just before we all started this undercover trip to D.C.

Luckily, we found Tim a doctor, his eye would be okay, and our cover was, as far as we could tell, not blown. Not yet anyway.

I had pitched to management that we needed a research trip, despite the confidentiality of the project, to ensure we were making good initial recommendations. I found D.C. a captivating place, filled with symbolism and excitement. The inauguration had also inspired me. It had been such a melding

236

of government and pop culture, history, and modern relevance, it just seemed like the right time for Disney to be introduced as a storytelling experience force, as part of the D.C. vacation ecosystem.

The Vision Group tried their best to survey D.C. inconspicuously; a large group of writers, artists, and designers, carrying sketchbooks and cameras, traveling in big, polished shuttle buses and discussing and sketching along the way. We did extensive visits to the Smithsonian, the National Archives, and the monuments. We tried to absorb the vibe of the national vacation, what worked, and where we might find white space that we could fill and fill respectfully.

Visitors were made up heavily of Midwesterners and East Coasters, families throughout those regions, who visited D.C. sometime during those key years when their children were growing up. Often these were family vacations, and sometimes large school trips. D.C. was not thought of as a particularly family-oriented resort landscape since hotels inside the Beltway were expensive and mostly geared toward business and government. Visitors tended to stay outside the Beltway and travel in to visit the major museums and cultural sites, then return to their hotels, and their hotel pools when the weather was hot.

There was at least some sense of museum fatigue, resulting from families trying to do too many cultural activities in the same few days. And there seemed to be opportunities for more diversity in the kinds of experiences. The Potomac Mills outlet mall had opened in 1985 and was experiencing very large attendance, mostly visitors to the region.

Smithsonian, for its part, had been increasing the immersive quality of its offerings, bringing in popular exhibits, multimedia, and interactivity. *Seeds of Change*, an exhibit at the National Museum of Natural History (NMNH), had opened in 1991 and offered an immersive space, lighting, and sensory view into how Columbus's first visit to the Western Hemisphere had changed the world more than five hundred years ago.

Seeds of Change had been conceptualized by the NMNH curator and historian Dr. Herman Viola. Dr. Viola was interested in telling history by taking it into popular venues and reaching out to audiences to tell stories in exciting and immersive ways. After *Seeds of Change* opened, Dr. Viola and Robert ("Sully") Sullivan, deputy director of the museum, reached out to Van Romans at WED. Van had been instrumental in bringing blockbuster quality museum exhibits to enrich the cultural authenticity of EPCOT's World Showcase. He had engineered the first visit to the United States of the Chinese Terra Cotta Warriors, which had been discovered in Xi'an and had never left the country before.

Sully and Dr. Viola visited us at WDI, and I hosted and moderated a multiday charrette to discuss further development of the museum for next-generation audiences, and the use of design and storytelling techniques normally associated with Disney attractions to convey science and history concepts. The results of our joint charrette became a master plan the museum followed for several years, from which the museum garnered continued success, raising its attendance steadily to reach the previously thought unattainable popularity of the National Air and Space Museum.

Dr. Viola and I hit it off well. I really liked him, and I was always thrilled when he told stories. I started calling him by his first name, Herman, and we were to become lifelong friends and collaborators.

When I got approval for our research trip, I reached out to Herman, and he helped us get special access to museum collections and to the perspectives of deeply knowledgeable scholars who were his peers. Rick Rothschild's unique ability to seek out important and accessible themes, people, and sites became invaluable to the trip planning, as was the work of Van, and of a new associate and friend from the DDC group, Jeanette Dunlap, a fine designer, art director, and strategist.

Richard Bates of the Disney D.C. office had helped us secure access to tour the White House. As a kid visiting D.C. for the first time, I never imagined I'd be clearing through security to enter the president's home and office. And here we were being welcomed in. I was geeking out, and my normally reserved good sense left me. President Clinton had become known for jogging around the White House and even stopping at times at McDonald's for breakfast. As we snaked through the White House security line, a huge gate opened and the president's security detail entered the grounds, heading toward the portico. There he was jogging in the front, with jogging security agents and black SUVs following. Something idiotic came over me, and I yelled out, "Hey, Bill!" Luckily, he looked over, smiled, and waved. I never forgave myself for this stupid outburst and serious break of protocol, and my fellow "ophthalmologists" never let me forget it.

Fantasy Meets Reality

No park is easy. This new idea for a park outside Washington was intriguing and challenging. My respect for Marty and the team that developed EPCOT grew. I couldn't imagine how hard it must have been at the time not only to balance reality and fun, but in their case to do it with so many topics and so many diverse countries. In our case, we were trying to select topics that would make great experiences, balance the park with thought-provoking or emotional presentations, and fun, and do so in a park that already had sizing and financial pressures. There was a lot of research, a lot of frustration, and a lot of diverse opinions flying around all the time. And at the same time, we were isolated in a remote building, unable to widen the talent circle by much and under constant schedule pressure. The hope was to get to a park design that everyone thought could work and which could stand up to more scrutiny than normal, and to do it before some reporter decided to print a story about Disney acquiring land.

At the same time, we were gaining steam on the Tokyo DisneySea project, which, in contrast, was all Disney all the way. Although DisneySea was rooted in many cultures, there was no pretense of representing precise cultures or history. It was challenging, nonetheless. There were attractions to develop, ride systems to consider, stories to refine, and new considerations, such as a very large hotel, extensive site engineering issues, and a desire to deliver on a high level of Disney-themed quality. TDL had added "E" ticket attractions at

a fairly consistent rate since it opened. It was a powerhouse of both marketing and capacity. It was thought to be quite difficult to come in right on its heels with anything less than something amazing, and OLC was still holding to a moderate budget.

We met quite often with the OLC teams and made plenty of visits to Tokyo. OLC had grown to expect a high level of Imagineering presentation. We did very beautiful original paintings, and models, and for anything that was not known from another park, extensive detailed packages to depict concepts and scopes of work. It was at times frustrating for other teams, who felt they were being streamlined, when if you were assigned to TDL you had richer budges. I felt myself toggling back and forth. Ideas, concepts, and constituencies were radically different for TDL versus Disney's America.

In July 1993, the Tokyo DisneySea (TDS) team went to Japan to make an interim presentation on the concept, how it would be built, how much it might cost, and how the business objectives could be achieved. We took Frank Wells to see the new Tokyo Ski Dome, a massive structure that had been built on a temporary lease next to the TDL site. And massive it was—by far, the largest indoor ski slope at the time, and it remains one of the five biggest ever built to this day. Known as the LaLaport Skidome SSAWS ("Spring Summer Autum Winter Snow") indoor snow center, it featured a ski slope five hundred meters long and one hundred meters wide and had to be designed to withstand earthquakes, which might cause an indoor avalanche. We unfortunately didn't ski but rode the escalators to the top, where Frank slipped and fell, hurting nothing except his pride, and scaring the crap out of the rest us.

OLC and Disney now shared the Tokyo DisneySea (TDS) concept. We'd been on a long journey, and it seemed like a deal to proceed was imminent. WDI was developing Animal Kingdom at the time. I had suggested we include a limited number of small exotic live animals in the TDL concept to enrich the nature theme of it. Takahashi-san had set me straight on that: "No live animals," he confirmed. He wanted more of an icon at the front, and we presented numerous options. He felt we needed more of a futurist concept for the Port Discovery area. The exciting and gratifying thing was that Takahashi-san himself, the pioneer who'd first negotiated with fishermen to create the landfill, first approached Disney, and endured ten years to get a deal, was personally invested. And the rapport between him and Frank Wells had built across the long journey to get there. The deal was a tribute to WDI for refusing to give up, and to Takahashi-san and his OLC team for having the boldness to think big,

but it was Frank's deal. He was the adventurer whose spirit was captured in the concept and who made it happen. In the 1993 annual report, Frank posed in a beautiful photo, in our WDI model shop, with the amazing TDS model in the background.

I went out to the seawall on the edge of the site. I had been there many times, but there was an illusion I wanted to see. I remembered my grandparents taking me to the beach when I was a child. It always seemed to me that when I stood on the beach, the ocean seemed like it was going uphill. I had read that the apparent height of the sea on the horizon is due to the curvature of the Earth. As you look out to sea from a shoreline or a ship, the Earth's surface curves away from you, causing objects on the horizon to appear higher than they actually are. This effect is known as the "horizon dip" or "sea dip." I didn't know if this was correct, and there seems to be some debate about it. But what I was hoping was that we could see Tokyo Bay from inside our new park. The trick would be to get the guest walkways elevated enough to have some key views from Port Discovery and our American Waterfront and to connect our internal waterway to the real waterway of the bay. It was a tall order. Separating our internal waterway from Tokyo Bay was hundreds of meters of infrastructure, including roads, a two-story seawall, and a monorail track. We stood on the site, and the local team flew some balloons at various heights to simulate final views. It looked possible that the illusion might work. But in the days before VR and 3D simulations, it was still a guess, an illusion I didn't know would work until years later.

November 10, 1993

On November 10, 1993, Disney announced there would be a surprise press conference about a new project in Haymarket, Virginia. International press and media outlets had reporters and large crews stationed down the road outside the Manassas courthouse awaiting the verdict of John Bobbitt in a sensational case. And so it was quite easy to restage all those big crews and cameras to find out what Disney was up to.

Besides, news about Disney in the nation's capital had been brewing. On November 8, the *Wall Street Journal* ran a story that Disney was planning to announce a park in Virginia. The day before the announcement, the *Washington Post* speculated that opposition would soon form around such a project, including those who would seek to protect the Manassas National Battlefield Park, site of two major Civil War battles. It was also becoming clear, even at this early stage, that there were probably influential constituents of Virginia who might quickly organize against any kind of tourism and traffic increase in the region. Traffic and pollution along the already-challenged Interstate 66 corridor would likely increase, according to the *Post*, making any kind of high-volume tourism controversial.

None of this was news to us in our rented, isolated warehouse in the Grand Central complex of Glendale, California. We'd requisitioned a red London phone booth from Disney Studios props and had it installed. Inside there was

a secure phone. A DDC executive could slip in there and have a private deal conversation. As fast as we could develop our concepts, we solidified them into press-friendly, community-friendly project descriptions. We were promoting economic development, sustainable development, tourism dollars to the region, and an exciting new concept—"Disney meets the American experience." And we were doing it at a record pace.

We were quickly becoming publishers. I was used to giving talks and presentations about projects. But we planned on handing out flyers and information sheets based on early concept work. So, we had to tell a more formal story with clear, approved language and images.

With boards packed, brochures printed, PowerPoints prepared, speakers' notes assembled, sample questions vetted, we departed for Washington.

On the morning of November 10, we went first to Richmond, the capital of Virginia. We had breakfast with George Allen, who had just been elected governor. It was a cordial meeting, and we briefed the governor-elect on all our plans. He was excited by everything we talked about. We asked him if he would come to our announcement, and he agreed. We all drove to the airport and boarded a private jet to head to Manassas, and then boarded SUVs to the announcement site. When we walked into the simple community room, we realized it was already packed with lock-down camera positions, and the parking lot was full of satellite trucks.

After the introductions by officials, Peter Rummell gave the overview and the detailed land descriptions, and then I took the podium to explain the concept. We had visuals for all the main story themes and areas, and they all corresponded to what was in the brochures that would soon be publicly available.

Disney's America, I began, was going to be created to bring strengths that Disney was known for: quality, storytelling, community, celebrations of family, values and respect for history and service and sacrifice, in a place that would turn stories and concepts into experiences.

I looked out at the barrage of television cameras, photographers, reporters with long notebooks, thinking that it had not even been a year since I'd learned the project existed.

Our idea, I explained, was to create a unique, rich, historically detailed storytelling environment in Prince William County, Virginia, to celebrate our nation's richness of diversity, spirit, and innovation—Disney's America. The location had been chosen with great care. Disney's America would be in close proximity to Washington, D.C., a symbol of freedom and democracy and a

vacation destination for nearly every American at some point in their lives.

The history of America, I noted at the time, was closely linked to Virginia. The surrenders ending both the American Revolution and the Civil War occurred there. The state was called the "Mother of Presidents" because eight chief executives were born there. In commerce and inventiveness, Virginia had also been a leader, boasting the first manufacturing plant in the United States, the first iron furnace, and the country's first transportation canal, as well as the invention of the mechanical reaper. It was also the site of the oldest daily newspaper in the republic.

Immediate access to Disney's America for millions of annual visitors, as a complement to their experience of our nation's capital, made the site in Virginia the ideal choice for The Walt Disney Company.

I went on to highlight the main points of the proposed park, staying relatively consistent with the brochure copy. I thought at the time it all told a pretty good story. A large screen behind me had projected images of beautiful art we'd created for each land. It all went something like this:

CROSSROADS USA 1800–1850

Crossroads USA would be the hub of Disney's America, our version of Main Street, a spirited portrait of mid-nineteenth-century commerce. From here guests would depart on an unforgettable journey through the vivid tapestry of American history. We even went back to our Disneyland train roots: an 1840 train trestle bridge marked the entrance to this territory and supported two antique steam trains that visitors would board for a trip around the park's nine territories. A themed hotel would also be included.

PRESIDENTS' SQUARE 1750–1800

Covering the time of the colonists' struggle and the War of Independence to the date of the formation of the United States and its government, Presidents' Square was to celebrate the birth of democracy and the patriots who fought to preserve it. Behind the scenes, Walt Disney World was encouraging us to move the Hall of Presidents to Disney's America, where it was thought it would get more visitation. Probably right, but we wanted not just to move the historic show but to redo it completely and try to tell a broader, more diverse panorama of history.

NATIVE AMERICA 1600–1810

Native America would explore the life of America's first inhabitants, their accord with the environment, and the timeless works of art they created long before European colonization. We had already reached out to Indigenous leaders in the area and talked about collaborating on immersive experiences. Eastern Native American Nations, such as the Powhatan and the Oneida, had played key roles in the region, including fighting in the Revolutionary War. We planned a celebration of early exploration, the Lewis and Clark raft expedition, for a naturally wooded area; it would venture through pounding rapids and churning whirlpools.

CIVIL WAR FORT 1850–1870

Emblematic of our nation's greatest crisis, the Civil War Fort would allow guests to experience the reality of a soldier's daily life. Inside, the storytelling magic of Disney's Circle-Vision 360 technology would transport visitors into the center of Civil War combat; outside, they might encounter an authentic reenactment of a period battle or gather along Freedom Bay for a thrilling nighttime spectacular based on the historic confrontation between the *Monitor* and the *Merrimack*.

WE THE PEOPLE 1870–1930

Framed by a building resembling the immigration center on Ellis Island, We the People would recognize the courage and triumph of our immigrant heritage—from the earliest settlers to the latest political refugees. A powerful multimedia attraction, We the People would explore and explain how the conflicts among these varied cultures continued to help shape this nation.

ENTERPRISE 1870–1930

The factory town of Enterprise would play host to inventions and innovations spawned by the ingenuity and can-do spirit that catapulted America to the forefront of industry. Within Enterprise, those daring enough could climb aboard the Industrial Revolution, a high-speed adventure through a turn-of-the-century mill, culminating in a narrow escape from its fiery vat of molten steel.

VICTORY FIELD 1930–1945

The flight of the Wright brothers opened a new chapter in American history, bringing with it thrilling exploits and military advancements. With the assistance of modern technology, guests at Victory Field might find themselves inside a flying fortress, or parachuting from a plane, or experiencing firsthand what America's soldiers faced in defense of freedom.

STATE FAIR 1930–1945

State Fair would celebrate small-town America at play, with a nostalgic re-creation of such popular rides as a sixty-foot Ferris wheel and a classic wooden roller coaster, as well as a tribute to the country's favorite pastime, baseball. Amid a backdrop of rolling cornfields, fans could have a hot dog, take a seat in an authentic old-fashioned ballpark, and watch America's legendary greats gather for an exhibition competition.

FAMILY FARM 1930–1945

Family Farm would pay homage to the working farm—the heart of early American life. Visitors would see how crops were harvested, learn how to milk a cow or make homemade ice cream, and even participate in a nearby country barn dance.

As I read this in retrospect, it all sounds so middle of the road, so behind the times in terms of how you'd represent America if you were starting today. But we tried to include, in the brochure, a sense of some of our broader thinking:

Every day, a diverse and unlikely society, made up of every culture and race on Earth, is working together to build a great nation. We have a single vision—a new order based on the promise of democracy.

Our resources for building this nation are a rich mixture of land, family* and beliefs—which we apply with our own fiery brand of spirit, humor, and innovation. As the nation has grown and changed, we are

*I'd have preferred to say *people*, but *family* was preferable at the time in Disney nomenclature.

constantly reminded of how impossibly far we've come—and how far we still have to go.

Disney's America celebrates these qualities, which have always been the source of our strength and the beacon of hope to people everywhere.

I channeled Michael, who'd made this case so many times in our concept discussions. I said this would not be a superficial representation of history. I echoed the discussion about Disney's ability to create emotional yet uplifting presentations of difficult parts of history, such as wars and mistreatments of people.

I gave examples, including one that would set the stage for many controversies to come. "We want you to feel history, to experience it, to feel the exhilaration that an enslaved person might have felt, when escaping to freedom through the Underground Railroad."

I don't remember much about the question-and-answer period. But nothing seemed particularly divisive one way or the other. There were lots of comments about economic development, clean industry, and traffic mitigation.

By the time the newspapers came out the following morning, it was clear the project was off to a very controversial start, and there would be a very rough road ahead. The objections came down to three major themes: preservation of nearby battlefields, preservation of the general gateway to the pristine agrarian land of Virginia, and related issues including traffic, increased business, and tourists. And finally, content: the general reaction to the creative presentation was that Disney had no credibility to take on the important and serious topics of American history. My quote was quickly summarized as "Disney says they want to make you feel like a slave." I had done my best to represent the thinking behind the project, the strong feelings of my leader. But I had learned a hard lesson that context is everything, that no media outlet is obligated to get what you said right, or clear, and that a simplified quote is what people would remember, especially if it was repeated again and again.

The next morning, I watched a CNN interview with Dr. James Oliver Horton, the Benjamin Banneker Professor of American Studies and History at George Washington University. He was interviewed about the announcement and said he believed that Disney could not do what it was claiming. He believed history was complex, and nuanced, and the telling of such things as wars and slavery could not be set up properly in the context of an amusement park.

With the help of Dr. Viola, I reached out the same day to Dr. Horton. I introduced myself and said I had seen his interview. I told him I agreed with him—I agreed that Disney was not prepared to tell history with the depth it should be told. But I said we had technology, artistry, storytelling techniques, and immersive interactive technologies we could bring to bear, along with investment. Would he help us? If he would, he could play an important role in reaching a general audience with a responsible retelling of history.

Jim, as I would then call him, agreed. In fact, Jim and Dr. Viola both agreed on one very important concept: history told well, is a good thing, whether it's in a book or in a museum or, as one of them said, on the side of a grocery bag. They were both great storytellers, and if we let them put their hands on the wheels and levers of Disney's resources, they'd have a voice to a new and wide general audience. There had to be potential in that collaboration.

That was where I tried to focus; otherwise, the constant negative press controversy was hard to drown out. We could hold steady to our convictions, go and find a team to make the impossible happen, or I could just crawl into a hole somewhere. My team encouraged me, as did Michael, and we kept moving forward.

The establishment press view was quickly summarized and repeated by many. Richard Moe, the president of the National Trust for Historic Preservation, who instantly became an opponent of the project, summarized it best in a December 1993 op-ed:

> Can the meaning of the Civil War be conveyed next to a roller coaster? Once a visitor has seen the Disney version of Ellis Island, will the real thing retain its appeal? Can slavery be properly interpreted in an amusement park?

For as many new Disney fans as we'd created, for those who were rooting for us, and for those who had started to plan their vacation dates around our opening, we had created just as many detractors, and unfortunately, they had very vocal distribution outlets. To opponents, we represented an existential attack on a pristine landscape, and something that became known quickly as "Mickey Mouse history."

~ ~ ~

The Red Fox Inn & Tavern in Middleburg, Virginia, according to their website, "has been Virginia's Hunt Country jewel since 1728. Standing proudly on the

village's main thoroughfare, The Red Fox is an extraordinary relic to bygone times. . . ."

Soon after the announcement about the planned park, as the controversy was brewing, Mike Reininger dined alone at the Red Fox. I don't know what Mike ordered, but he deserved a good rib eye with fingerling potatoes and some kind of handcrafted cocktail. But he did tell me about the rest of his evening. He was at a small table in the corner. In the center of the room, at a very large and loved table, the Piedmont Environmental Council (PEC) was being formed to fight against the proposed park.

From that moment on, nearly every day there was some kind of negative article in the *Washington Post* about Disney's America. The battle lines had been drawn. The PEC had the influence and money to fight against anything that might disturb the hallowed ground of the Virginia Hunt Country that was not far from the proposed site, stretching into rolling hills with historic estates, farms and vineyards, historic restaurants, and antique shopping. Building a theme park nearby seemed a battle that would be very difficult to win.

We found and engaged thoughtful and recognized historians interested in helping Disney present history to a broad audience in the context of a theme park. Generally, you just needed to take them to EPCOT, and their stereotypical perspective was melted. That is not to say they didn't have lots of suggestions to make EPCOT, especially The American Adventure, better and more representative. But most academics saw the power of entertainment as a viable entry point to interest a wide audience in their own culture and history.

Disney opened a small office in Haymarket. That team received well-wishers, vendors who wanted to sell products, and press looking for some new lead that might show up in the *Washington Post* that day. There was lots of governmental interest generated by the idea, and controversy.

One morning Michael Eisner called me. He said he had told the *Washington Post* that I had misspoken when I'd said we would bring to life painful, tragic aspects of history, including slavery. He told me he knew very well that I hadn't misspoken, that he knew very well I was representing everything he had been saying about what would be important to the vision of the project. He said he was hoping to quell some of the negative noise. I told him I understood. But after I hung up, I felt like a fresh Florida mackerel that had just been hung out to dry.

At that point I put my focus on the work. I played tennis twice a week, hammering the ball. When asked to do an interview, I nearly always declined. I just didn't see any point. Once when asked to do an important one for network

television, I told the communications person I thought they should hire an actor who could play me.

In Glendale, Michael still encouraged us to stand our ground and in effect prove we could do what we said, by doing it. I asked Michael to host an academic conference at Walt Disney World. We would invite independently thinking historians to do a roundtable, personally with Michael and our team. It was an engaging session, and Michael was casual and inquisitive, patient, and articulate. On the whole, the group saw a path that could get us there through a dynamic collaboration. I remember looking around the room. It was the most diverse table I had ever seen in my career at Disney. Top academics, historians, writers, producers, authorities from the Smithsonian, the National Archives, and the Library of Congress. I had gratitude for John Cooke, for Rick Rothschild, for Van Romans, for Richard Bates, and for our D.C. office for assembling such an intelligent, open, and diverse group. I never forgot how articulate Michael was. He was patient and he took a lot of barbs, but he believed that Disney was in a unique role to do this, and I don't think he ever lost that fundamental belief.

Everyone was overloaded. There was a press story every day; there were new contracts, new issues, and new challenges every day. And we were still trying to refine a workable concept that was representative of the best of Disney and America, and economically viable.

I was in my office when an email* came in. My assistant, Karen Dedea, printed it and brought it in to me. It had been widely distributed, including to Michael, Frank, Marty, and other top park executives, WDI, as well as across Disney's America team. It was from Peter Rummell, and the email announced that effective immediately, an executive from the DDC was now in charge of Disney's America. This immediately supplanted partners I was working with, including Mike Reininger. But it said more; it said that the new executive would be responsible for all creative and design. I had embarked on this project as a partnership of WDI and DDC. But this was not that. This was taking a bite out of WDI and throwing a year's worth of hard-won collaboration out the window. I read it at least three times. There was no other way to read it. A new boss from real estate was now completely responsible for Disney's America. WDI was no longer responsible for creative and design, we were no longer partners, and

*I was an early adopter of America Online. It was one of the first ways to go online, and in 1993 they started providing @aol.com email addresses to their fewer than two hundred thousand subscribers, including me.

the company of people Walt had created were transitioning to be advisors and sub-consultants.

I drove home and told Diane I was thinking of resigning. First she asked me why. I had to admit it was an emotional reaction to the reorganization and its complete lack of diplomacy or recognition of the hard work of a team. I was probably being too rash. But Disney's America had become quite a struggle and I was idealistic about it. It meant a lot to me. Then she asked me when? And I said now.

I went to our upstairs office, typed a simple one-page resignation, and used our tiny home fax machine to transmit it to Marty's office. I told Diane I wanted to go out to a nice dinner and celebrate. I was sure that was that.

When we got back late that night, I had ten messages from Marty's office.

The next day Marty and I spoke, and he basically asked me if I would chill out for a couple of days. He said he hadn't known about Peter's memo, either, and he wanted some time to look into it. I always took Marty's advice.

The next call I received was from Frank Wells. It was late afternoon and Frank asked me what I was doing. He asked if he could come over to my house. My house? For a chat, he said. I knew Frank well. But Diane was out, and we had just moved in. I rushed home, making a quick stop at Trader Joe's for a moderately priced chardonnay, a big wedge of brie, and some crackers. I didn't really know what else to do. I did my best to make the front room look like something. It had a cheap IKEA sofa; I had a light Mexican blanket down as a placeholder for a rug. It was too hot to light the fireplace to try to give it all a homey look. I got a couple of side tables from the backyard. I put two glasses, wine, a plate of cheese with a knife near it, and a bowl of crackers on the table. There was a small bathroom downstairs. I straightened it up. I prayed he didn't want to see anything else because we'd literally just moved in. I gave the cat some food and locked him on the balcony. There was a knock at the door.

I never climbed six summits with Frank Wells, but I'd taken at least that many trips to Tokyo with him. We'd fought the battles together, from an unworkable Disney Studios project for Tokyo Disneyland to the growing consensus behind the proposed Tokyo DisneySea. So, he didn't really have to drive to my little house in Glendale to express concern, but I appreciated it.

Frank looked at the two smallish wine glasses and said, "Where is the kitchen?" I didn't have time to point, I just followed him as he went to find it. He opened cabinets, several of them, until he found what he was looking for. He told me he only allowed himself one glass of wine a day, so he needed a

larger glass. He found a lone Los Angeles Dodgers beer glass in the cabinet. I didn't really know how it had gotten there but it seemed to do the trick. He proceeded to fill it. I filled my now very puny wine glass. He pushed the crackers toward me. No carbs, I figured. He took the knife. I understand enough about geometry. To cut the median of a triangle leaves two basically equal triangles. Frank cut the brie crosswise, taking the big wedge at the top and leaving me with a little triangle left over at the bottom, I figured I deserved it.

Whether or not I would leave Disney, or whether it was justified, none of it mattered to me. I had someone I respected so much drinking cheap chardonnay out of a beer glass and eating a wedge of brie in my empty living room. We argued (don't ever argue with a great lawyer), we reminisced. By the time Frank left, I had chilled but not yet agreed to stay. I had laid out my sense of territory. DDC and WDI were two amazing and different Disney assets. But WDI was the lab that Walt built, the place where new ideas and new concepts were developed, and we—me, Marty, and two thousand other Imagineers, countless before and after us—needed to be respected for our role in the company. We were Walt's inventors, not consultants, not short-order cooks. Frank heard me, but more than that, I knew he believed it. I knew he knew, that I knew, that he knew, that we both knew that it was true. Whether I was there or not, WDI was responsible for vision, creative, and design; we were full partners, never subconsultants. Marty once said, "We don't just ride on this spaceship to explore the universe, we drive it."

~ ~ ~

Mickey's sixty-fifth birthday celebration kicked off at Walt Disney World with the unveiling of the *Partners* statue on November 18, 1993. A few days later, on November 21, there was a grand event with extra meaning. Disney had made an agreement with Marian Wright Edelman, founder of the Children's Defense Fund, to be the site of the inaugural launch of National Children's Day. Edelman was a civil rights pioneer who helped create the Head Start program, and she was the first Black woman elected to the Yale board of trustees in 1971.

In 1973, she founded the Children's Defense Fund as a voice for poor children, children of color, and children with disabilities. The organization has served as an advocacy and research center for children's issues, documenting the problems and possible solutions for children in need. The kickoff of National Children's Day was to bring attention to the needs of children and families across the country. To support the event, Disney flew twenty thousand children

to its theme parks in Florida, California, France, and Japan, for activities high-lighted by a children's forum in Lake Buena Vista with First Lady Hillary Clinton. I attended the event, and it reminded me, again, that leadership, ideals, and entertainment could all join forces for good; that government and nonprofits and corporations could collaborate to make things happen.

I had been given a backstage pass to the event and had my picture taken with the First Lady, and when it concluded, I took advantage of my press cre-dential and went onstage. Michael Eisner was wrapping up a conversation with Edelman and the First Lady, and he saw me. He looked somewhere between sad, annoyed, and a little positive.

"So, you do care?" he asked.

"I never stopped caring, Michael," I said. I told him I was more excited and had bought in to the project more than ever. And the harder it got, the more I wanted to work to make it happen. He knew I was upset, and I knew he knew why. But we didn't talk about it.

Earlier First Lady Hillary Rodham Clinton had attended a VIP premiere of the new Hall of Presidents presentation. I sat with Rick Rothschild. She sat in the row right behind us, and Michael had made the introductions.

The show began. The visual splendor and emotion were powerful, as were Maya Angelou's powerful words, as narrator:

As waves of immigrants swelled our population, new voices would rise to insist again and again that *We, the People* must mean all the people. Freedom is a land without boundaries. The work of America will never be done. Each new generation will be asked to discover the part it must play, and each new generation will leave unfinished tasks for the gen-erations that come.

When the presidential roll call began, small pockets of clapping started as the audience recognized their favorites from history. Applause built for the more modern presidents. The First Lady leaned over, her face between Rick and me, and said, "I think I can see where this is going!"

She was right. By the time President Clinton was introduced, applause for the newest president overtook the room. There was a slight pause. I thought about Mrs. Clinton. I could just see her in the corner of my eye. She'd seen her husband speak many times, in person and in every conceivable form of media. But now she'd hear him speak in the Magic Kingdom and for the first time as a

robot, or more accurately a Disney Audio-Animatronics figure. He'd be the first president to speak through this Disney innovation since Lincoln:

> And today our nation stands as a symbol of freedom and an inspiration to people all around the world. There is nothing wrong with America that cannot be cured by what is right with America. And there is nothing wrong with the world that cannot be cured by the ideals that America represents. Those principles have no borders. And we look forward to a day when those principles, extended beyond our borders, will have circled the globe. The quest for democracy must continue until all the people of the world enjoy the freedom we must always fight to preserve.

It would be hard to find words more unifying. Rick and our colleague Justin Segal had developed them, adapting the concept from Clinton's inaugural speech. They'd broadened them, idealized them, giving them a unifying sense of power and optimism that was surely Walt Disney's concept of the attraction from the beginning.

Calm Waters

Diane and I had bought a place at the beach, a little over an hour from Orlando. I'd had as many epiphanies there as I'd had baskets of peel-and-eat shrimp. Psychologists and scientists have found the color blue to be associated with feelings of calm and peace, and that staring at the ocean actually changes our brain waves' frequency and puts us into a mild meditative state. Some studies even found that blue is associated with a boost of creativity.*

I regretted leaving the beach every time we headed back to Walt Disney World or to California. It seemed that I had been working forever although it had only been fourteen years since I had started at WED. But projects were marathons—four years on Tokyo, another four to create Disney-MGM. And in the five years between May 1989 and April 1994, my WDI collaborators and I had been part of a massive amount of work and development. I'd seen two major initiatives go into the archives, the Studio Tours for both Tokyo and Paris, and I'd seen one quickly rise from nothing, Tokyo DisneySea.

Michael and Frank had been incredibly gracious after my attempt to resign, restructuring Disney's America to ensure the Imagineers and the rest of the

*Christina Heiser, "What the Beach Does to Your Brain," NBC News, July 29, 2017, updated July 15, 2018, https://www.nbcnews.com/better/health/what-beach-does-your-brain-ncna787231

company knew that WDI was responsible to them for all creative and design. But as I continued, it was my guess that Disney's America, which had started with such optimism and excitement, was either going to be a long slog to develop or was perhaps headed to the archive soon, too.

I had learned that anger is never a good motivator of action. And now my thoughts were more about what I truly wanted to do next, what I wanted to dream about as my next chapter.

I slept heavily, better than anywhere in the world, at the ocean house. I always left windows open; the sound of the soft, shallow waves lapping at the dunes would flow through the blowing white sheers. Sometimes the moon would sit, perfect and silver, right above the horizon, sending long lines of rippling white light across the black-blue waves coming in. I almost always turned down the answering machine at night. We still had them back then, and if the sound was off, you didn't know if anyone had called until you checked it in the morning.

Tonight, we'd forgotten. I was asleep, but the clicking sound as it started to record woke me up. Then the voice came on. It was my sister calling from California. "I hate to call so late, but I didn't know if you'd seen the news. They're saying Frank Wells died in a helicopter crash."

It was Easter. Frank had died when his ski helicopter had lost control on the side of a glacier in Nevada. I thought about touring the Ski Dome with him in Tokyo, about when we toasted that last sip of chardonnay at my home.

I thought, it can't be possible.

Glendale

I was back to Glendale quickly. I went to check in with Mickey Steinberg, as I figured he was in early, and as I'd hoped, he had strength and resilience to open up. I could tell he'd lost a great friend. Mickey lived close enough to Frank that he'd go to his house in the early morning when there was a big decision to make. He'd take a walk with Frank and explain all the options, then they'd decide. Mickey had a deal with Frank: "After this walk, I'm not writing you a bunch of memos, I'm just going to go like hell." Frank had always agreed.

I came out of Mickey's office and, as I always did, looked around to see who was around the executive hallway early. There was Michael Eisner in a suit but no tie. Usually, if I saw Michael by himself, I would have some kind of joke or pitch ready. I had nothing, only a real sense that if I could exit without seeing him, it would be better. "Hu-llo." His trademark sound. He had seen me. I went over.

"Hello, Michael." Then there were just a few seconds of awkward silence, and he was quickly called over to Marty's office.

I went back to my office with a sense of emptiness. Soon my phone rang; it was that undeniable voice again. "Hu-llo." I said hello to Michael again and asked him how he was doing.

He said he knew we'd had a lot to say in that awkward moment, and we didn't know how to say it, but it was okay. I told him I was thinking about him.

He said we would have lots of time to talk later. He took a deep breath and said, as I might expect, there were people who were incredibly gracious right now.

We left it to that.

Within a few days, on Monday, April 11, four thousand people gathered in Stage 2 at the studio. Stage 2 had been used by the original *Mickey Mouse Club*, for *Mary Poppins*, for the new Pirates of the Caribbean films; and it was even where some of the Disneyland attractions had been built, including the Enchanted Tiki Room and the *Mark Twain* Riverboat.

Frank's memorial was an outpouring of joy for so many of us, inside and outside Disney—friends, family, colleagues, mentees who had been uplifted by Frank's life. I remember Michael saying in a poignant moment that this was the first time he'd had to deal with a company crisis, and he couldn't ask Frank about it. It was hard for me to imagine that the "Michael and Frank" team no longer existed. We mourned the loss of Frank, the extraordinary leader, and the relationship through which so much of our work had been defined and led.

Robert Redford, a close friend of Frank's, said it best, referring to Frank's pursuit of mountain climbing right at the peak of his studio career: "He rose to the heights of a profession. Then he did something that few people would do. He stopped. He wanted to tend to his soul." Frank, had, no doubt, uplifted mine.

Keeping It Moving

Keeping things moving when surrounded by uncertainty is always tough for Imagineers; big projects need decisions and things are shuffling around you. There was a lot of talking in the halls, and I tried to keep all we had to get done top of mind.

We made another attempt on Disney's America, a more detailed plan but with more financial rigor around it. The daily press battle was quieted for us by the folks who now managed the office in Haymarket. We focused on the viability of the hotel. On story we depended on a team of internal writers and some very excellent and visionary consulting ones, including Lloyd Foneville, who wrote a simple poetic audio show we called "A Soldier's Story." At one point I wanted to see more of the site and to think of the site more like a park land. We had beautiful land around us, and we had focused our attention on that part of the gentle clearing that had previously been farmland. But there was much more, and we'd never even seen it.

I arranged for the team to see the entire site by horseback. It was the least disruptive way to see the area, and also the most comprehensive. And the team needed something to do together. We all rode for a full day through thick forest, hardly passable, through rocky ravines with big streams running through them. The idea of this site having resort character and being an escape from the otherwise formal city-based D.C. trip appealed to all of us. I started thinking

of the entire park as having retreat or restorative character, both for the mind and the body. We looked at Asilomar, the historic YWCA retreat designed by architectural pioneer Julia Morgan during the Arts and Crafts Movement in California in the early 1900s. We looked at the evolution of Camp David, the presidential retreat. It had been designed and built by the WPA in 1935, and in 1942, President Franklin D. Roosevelt had converted it to a presidential retreat and renamed it Shangri-La, after the fictional Himalayan paradise.

We had made a few trips to Colonial Williamsburg. We thought our site's character lent itself to living theater and historic fellowships. We thought the site could have some of the Chautauqua* character that had inspired Michael to create the Disney Institute at Walt Disney World.

Our work got better, the site language got more sophisticated, but we were still working in a bubble with the knowledge a lot of powerful people didn't want Disney's America in their backyard, no matter how high the purpose was to be.

The work on TDS continued at a rapid pace. And The Twilight Zone Tower of Terror was being completed and headed for a July opening.

I flew with John Cooke and others up to D.C. on a new project unrelated to Disney's America. The business teams in Orlando had floated the idea of Disney's trying to get the operating concession for the Kennedy Space Center Visitor Complex. The visitor center was rebid every so many years. The contracted operator managed dining and retail, tours of the launch facilities, and interpretive attractions about the importance of NASA initiatives. John Cooke had taken on the assignment of proposing that Disney promise a substantial investment and an increase in attendance by connecting to Walt Disney World (and eventually Disney Cruise Line, which was in its earliest conceptual stages and would be based out of Port Canaveral, not far away). I made a very cursory but enthusiastic presentation to the NASA group, showing all the ways we could improve or replace outdated attractions and design, and the business team presented models for increased attendance and revenue.

Dan Goldin had only recently become the head administrator of NASA. He loved the presentation, agreed with our needs assessment, and saw the benefit

*The Chautauqua touring organization, based in western New York State, brought entertainment and culture to communities, with speakers, teachers, musicians, show people, preachers, and specialists of the day, in the late nineteenth and early twentieth centuries. Michael had read about Chautauqua and used it as a model for retreats he held often.

of tying the visitor center to Walt Disney World. He admitted he was still new enough not to be able to tell whether such an idea could really get through the hurdles of government contracting. He left, smiling and shaking everyone's hands. We seemed off to a good start.

Administrator Goldin was then replaced in the room by two NASA contracting administrators. Our ideas fell flat. What became clear was that the idea of Disney's stepping in and forgoing the bid process (no matter how much money or attendance we might bring) was probably a nonstarter. It would also be impossible for Disney to run the tour concession of a government site, especially one as important as Kennedy Space Center, without being a government contractor. In the end, an administrator said, "For something special like that, you'd probably need to take that up with the White House." John leaned over quietly and asked me for my Social Security number.

I found myself doing something I never dreamed I would—being waved through the gates to park right in front of the White House. John was, needless to say, very well connected. I straightened my tie (a rare time I was happy I'd worn one), and grabbed my little board, a site plan with some cards mounted around it. I wished I'd had a nice big set of boards, an easel, and a few great Frank Armitage paintings. But I had learned, whatever you lack in materials, you just have to make up for in enthusiasm. I got ready to do my best.

We didn't suddenly become part of the president's daily agenda. We just kind of skirted the edge of the White House on our way to the executive office building. Al Gore was likewise not sitting around having coffee, so we didn't get to pitch him, either. But we did meet a gaggle of science administrators, who agreed this looked like a great public-private partnership in the making.

It turns out the project never proceeded much beyond these meetings. But I didn't mind. I'd spent my morning with a fast pass from the head of NASA to the White House to the vice president to the heads of science. If I ever took lightly the privilege it was to be an Imagineer, it was events like this one that proved me wrong.

July 1994

The Tower of Terror and the rest of Sunset Boulevard opened at Disney-MGM Studios July 22. It had always been part of the plan to add a major story-driven thrill experience and much-needed new themed space for guests to the Studios since we had opened on both a compressed site and a challenged budget. The attraction had tremendous lines, Sunset Boulevard was packed with people, and the park was back to experiencing record-breaking daily attendance. Two of the most influential people responsible for the Tower of Terror were not there. Frank Wells had died tragically, just three months before. And a few days before the opening, Michael Eisner had complained of symptoms of a heart attack and left a conference early. Although he hadn't had a heart attack, his doctors at Cedars-Sinai in Los Angeles had performed emergency quadruple bypass surgery.

Michael wasn't down for long, as I had expected. He was back to a partial schedule in a few days, and we were already hearing about how he might restructure the company. He'd been dealing with a lot: Euro Disney had negative news and write-offs; Jeffrey Katzenberg was resigning; Disney's America was still bringing in negative press. Before his heart surgery came up, we had been in his queue to give him a creative update on Disney's America. I figured that would wait a while.

To my surprise we were bumped up in the queue early. I was told that

Michael was not taking large meetings, and he was only working out of the Studio. I would need to present totally on my own. We had lots of boards and models and loads of beautiful original artwork to show. I arranged for a large conference room near his office a few days before. A lot of effort and passion had gone into the project, and I wanted him to get a sense of it all. We staged everything, and my trusted colleagues even brought in pipe and drape and lighting. They'd turned the whole space into a real gallery.

I knew I alone would be presenting, but I expected Michael to have an entourage. But it turned out just to be the two of us. He looked the same, except that his voice sounded a little frail. I walked him through the presentation, trying not to burden him with every detail. But I wanted him to see how the ideas had matured. How we had rethought the idea of attractions being generally quieter and more sophisticated. How we'd discovered the beauty of the site as a resort asset. How we'd brought in education, conferences, culture, and still made it fun, still made it Disney. Ultimately, I just wanted him to know he'd been right, the idea was right, and we could adjust our thinking to adapt to everything we'd learned.

We reached the end of my pitch. There were no chairs, and I sensed someone was probably right outside the curtain waiting to whisk him away to his next meeting. He stopped and thanked me, and I think I remember he shook my hand; he said everything looked great.

And then he said clearly, distinctly, "This was never a failure of vision or creative, it was a failure of foresight on the part of our real estate strategy."

The WDI special services team quickly entered. They packed up all the lighting, the black duvetyn drapes, and put all the boards into crates. I knew they would never need to be unpacked again.

Change

When one of my college architecture professors heard that I was going to take a job at Disney, he said I'd be there three weeks or three months. On September 23, 1994, I had been at Disney for fourteen years and three months. I was a senior vice president and had developed and managed billions of dollars of successful projects and had several billion dollars of investment in the committed queue, including all the construction of our Tokyo DisneySea project, ahead of me.

I took a loop around the campus. Disney had acquired most of the Grand Central complex. I knew almost every address, every otherwise anonymous building in the neighborhood. There was the little TDL building where I'd started; now it was a part of Disney's Animation group. There was our cafeteria, and the patio, where Frank Wells had insisted he wouldn't leave until he'd shaken the hand of every Imagineer. There was our architecture and design department, housed in what had once been the Grand Central Bowling Alley. Two model shops—I had spent so much time in both. There was the innocuous building that had housed the optimistic Disney's America team. The project would be publicly abandoned a few days later.

There was also the library where I had done so much research, the executive office row, nicknamed the gold coast, where I'd gone to so many meetings and disrupted so many more. Service buildings where we had mocked up so

many new rides and experiences, some built and some not. And the MAPO building. It never lost its original name. It was a crossroads of history: so many products, developments, and, in the last several years, new ideas had been conceived and debated there.

I walked into the back of the 800 Sonora building. It was the first building I'd entered fourteen-plus years ago. I signed a few papers and handed in my name tag.

Once, I'd heard someone in strategic planning say, "We need to get some really smart people from outside Disney to think about this."

I was on my way to trying to become one of them.

Part 3

1995–2007

A Bridge

In music, a bridge often connects the verse to the chorus of a song. Quite often, the bridge is intended to provide contrast to the rest of the composition.

I had no idea that my decade or more of post-Disney time would become a bridge. At the time, I thought of it as a new beginning defined by the wide, flat waves that crashed lightly upon the shore of our sand dunes in New Smyrna Beach, Florida. There, I would be less driven by work, and more by creativity and experience. My days would not be an ever-increasing drive of work and travel. No more suitcases packed and always waiting at the door. For her entire life, my dog Boone, a beautiful golden retriever, never liked seeing suitcases.

And above all, this new beginning would be driven by Diane's and my mutual desire to have a child.

That desire, that dream, had proved to be remarkably more challenging to achieve for us than our parents' experience or our education would have led us to believe. Remarkably, many of our friends seemed to have the same challenge. But we'd worked our way through it, and the possibility of having a child of our own was getting closer.

I was in a meeting with Michael Eisner in Burbank. I had worn a suit; I was pretty sure he'd never seen me in one. We talked about business. I was a business owner now, and I updated him on the kinds of projects I thought I'd be doing, including some from Disney, I hoped.

Lucille Martin, executive assistant to Eisner and vice-president and special assistant to the Disney Board of Directors, interrupted to let me know Diane was on the phone. The child we were adopting was about to be born two days before the due date. My wife headed to Bethesda Hospital in Boynton Beach to join the birth mother. I went straight to LAX and booked the first flight I could get to Miami. It was a red-eye—arriving at dawn. By the time it landed, we had a son.

For some reason, the birth mother had been convinced she was going to have a girl, and we'd assumed she would be the expert. She was quickly proven wrong. We had hesitated getting truly prepared, wondering how it would all feel if the adoption plan should fall through. But now it was all going smoother than expected, faster, and we had no name. Luckily for Target, our son was kept in the hospital for a few days with jaundice, and we had time to buy the store out, the entire baby-care section, squeezed down into two carts and a rented SUV. It was an intense two days, setting up a room in my mother-in-law, Adele's, place in Miami, tearful moments with the birth mother, and lessons in diapering, bottle feeding, and bathing, from the hospital nurse.

Before they released him to us, we sat on the floor of a Barnes & Noble searching though baby name books, finally agreeing on Gabriel. A messenger appearing in the Old and New Testaments and other religious texts, Gabriel plays the trumpet, as I did, and shares his name with a music teacher I always revered. By late evening, the night before we would pick Gabriel up, we'd done a pretty great job of setting up an impromptu nursery in record time, complete with a Diaper Genie that I had done a dry run with.

I took a walk outside. I stopped along a curb and sat down as my throat was stiffening. I cried like I couldn't remember crying in my life. Later I would put my finger on the emotion I was feeling. There is no other similar moment in a person's life when one door closes and another one opens, and the rest of life will be different than it has been before then. Marriage, the loss of my parents, there's never been anything that has impacted me as much as the birth of my son (and later, the birth of my daughter).

There was no idyllic bliss that followed, it was all too busy. Moving Gabriel, the almost four-hour drive from Miami home to New Smyrna Beach, was difficult, but somehow we made it.

Design Island

There was a lot of consulting work I had already begun, and much more had been seeded. I wanted it all to go away, or at least be put on pause. I was immersed in fatherhood and didn't want to be distracted. But it seemed like it was time to get some positive cash flow moving again. The house on the beach had a downstairs area that made a good interim office. I could be there with a few associates, and still be nearby to go upstairs and fly the baby around.

I had thought that it would be challenging albeit a learning experience to start a consulting business. I didn't know how to run a business—a small business, that is. I thought I might do a big chunk of consulting work at Disney, but it turns out quite a few interesting personalities came out of the woodwork, and not much time went by before we were trying to figure out how Diane and I could juggle bottles and diapers with client phone calls, and how to deliver a product when you've only got your own resources handy. New Smyrna Beach was a garden spot for vacationers, but not for business. So, the kinds of services and needs that I initially thought I might require were not readily available.

Soon I realized that the consulting world was one where you could make a lot of money, but I realized that wasn't my goal, because it seemed to me that would involve a large volume of work. "Volume" meaning to try to juggle as many clients as possible and have as many associates in the company as possible, so that the quantity of work and likewise the amount of revenue were

large. I realized quickly that I had no interest in this. I was in the consulting world because I wanted time flexibility. I wanted to have some of my freedom back for family, including for my nephew, Stephen, who was in high school, and to explore some things that I wanted to do.

It was up and down throughout this period, and sometimes it worked and sometimes it didn't. There were challenges and great joys along the way. The greatest joy was watching my son grow up, with Diane and me and his grandparents teaching him things, trying new things, sitting on plastic lawn chairs as he played in the shallow waves, teaching him how to wade, riding him in a rear bike seat, learning how to meet the challenges of solid food. There were just so many discoveries every day.

The company evolved—it got big, then it got small, then it got big again. But the model got better. The hardest thing was to make the model work for what I wanted to do rather than have it tailored to just what would earn fees. It was a balance, but when it worked it was awesome. Too much work and travel could mean less satisfaction and more stress; too little and it could be hard to make payroll.

Living by the ocean, I settled on the surfing model. I'm not sure who first made up the analogy, but it's a good one. I can't even surf, but I adopted it. You are one person on a board, the ocean is giant, you are insignificant, the waves will always be stronger than you. You can't stop the waves or even change their course, but you can skim across the surface, using their immense power to create your own creative path. I tried. I rode my bike down the hard white sands to work; I took New York clients night fishing. We served working lunches of sandwiches on the beach out of the back of a pickup. I did my best to select projects I wanted to do or transform projects into what I thought they should really be.

I met visionary clients and I learned so much from them. I never got to build Disney's America, but I almost got another chance working for Milt Peterson. By the time I was born, Milt was already a lieutenant with the U.S. Army Corps of Engineers. He had a passion for land, ideas, and people. I have worked with few people who could match his relentless energy, even under the depths of adversity. It was my honor to help him lay out a huge site on the Potomac River, National Harbor,* a grand resort just minutes from the center of Washington,

* Disney made two attempts to become a part of Peterson's National Harbor project. For one of them I returned to WDI for two years, from 1998 to 2000, to see if we could make something work. When that dream failed, I returned to my consulting journey.

D.C. We worked in what he called his den at his office in Fairfax, Virginia. By the time we quit for the day, the place was a wreck, with twisted and torn lengths of tracing paper everywhere.

I stood at the edge of 30 Rockefeller Center, a seven-hundred-foot sheer drop from a roof deck that had once been a luxury ship deck in the sky over New York but had been closed for decades. We beautifully reimagined and reinvented it for a new generation of New Yorkers and visitors thanks to visionary client Rob Speyer.

I held charrettes on a secret private island in the Orcas, on a luxury yacht, and on a rock star's kitchen table. We worked for people with endless budgets who could never figure out how to get anything done, people who had no money and managed to move mountains, and the whole spectrum in between. We produced immersive exhibits that broke ground teaching young people concepts of history, and STEM, and STEAM, and we renovated historic places that had fallen from grace and just needed a chance at relevance for another set of generations.

As my son was settling into school, I gave him a LEGO set with more than a thousand pieces. Within a few hours he'd finished, using a long book of complex instructions and his small hands that looked to me like baby starfish. We soon accumulated a lot of LEGO models, some with more than ten thousand pieces. I decided LEGOs might be too easy, so we started an HO scale model train set. Together we had to learn complex tiny frustrating parts, wiring, lighting, modeling, painting—so many stages that required patience and handwork. His hands got bigger and more skilled, and he was always better and more patient than I was.

I realized from working with Gabriel and with my many different clients that everyone learns and processes differently. I knew this from working at WDI, where more than a hundred different disciplines work seamlessly together. But in the consulting world it was even more intense, because teams were smaller and had to be more agile. You couldn't just set someone aside because you might not understand them; you had to get to understand them, and do so quickly, and if you could, you had another strategic ally, another visionary col-laborator you could call in the middle of the night. I worked with talents I'd never before had the chance to.

On the morning of September 11, 2001, I was starting a charrette for the Muhammad Ali Center, being developed for Louisville, Kentucky. It was a bright beautiful early morning in Louisville and I was energized by the new center's

mission to use Ali's legacy to foster respect, inspire generations of change-makers, and advance social justice. I had not met Ali yet but was looking forward to it sometime soon.

Someone from the outside office opened the door and told us in a frantic voice we should turn the news on. The big TV in the conference room was soon filled with images of the first tower of the World Trade Center in New York City ablaze, and then, as we watched live, the second tower was burning. We continued to watch in disbelief as one by one the towers collapsed.

With all flights canceled I spent two days in the Courtyard by Marriott watching the news. I finally found a rental car outlet open and decided to drive back to Orlando, with NPR reports on the radio the entire twelve-hour drive.

Within a week every one of our clients had checked in with me, and all of the projects were canceled or put on hold. It wasn't like I was frantic to work; we were all numbed by the developing news. But the holds would basically close down everything for the consulting company for several months.

As things slowly came back, if not to normal, at least to life, I helped existing clients reprioritize their projects and sought out a few new ones.

We moved off the beach to Orlando and found a good school for Gabriel. I progressively cobbled together a new office from space around the perimeter of the Chapman/Leonard Studios in Orlando. Chapman/Leonard had a small compound to serve the periodic needs of film and television production in Orlando and the Southeast. They had a lot of underutilized office space and I took it over like an amoeba, one small office at a time. I shared space and only grew at the rate that new projects required.

The complex's large soundstage was also empty, and the landlord let us use it whenever we needed it. A small group of us built our own little independent creative production house. We had Dave Wallace, who did music and sound for Cirque du Soleil; Greg Jones and Cameron Roberts, who under the code name D-7 did video production and editing. The small core of Design Island besides me was Susan Clippinger, Lisa Miller, artist and media producer Tim Steinouer, and a stream of tremendous talent we brought in and out depending on the slowly developing project load.

Together we all rebuilt our client bases, helped each other, and also invested in projects we found meaningful.

I learned how to edit, how to ask thoughtful questions in an on-camera interview, and, above all, how to listen, how to disarm someone by respecting what they had to say. I interviewed David Rockefeller in New York; director

Ridley Scott in Ouarzazate, Morocco; Smithsonian curator-emeritus Dr. Herman Viola from horseback on the Lolo Trail in Idaho; writer/director Nora Ephron in the shadow of the Empire State Building; Eileen Collins, the first woman to command a space shuttle mission; and Eugene Cernan, the last human to walk on the moon.

Thanks to Susan Clippinger and Lisa Miller, we kept the business running and created wonderful experiences for our clients, whom I always considered guests and partners. The biggest learning for me was that the need for vision and storytelling, the expansiveness of a diverse and multidiscipline charrette, were things organizations across the world hunger for; not just the tools for a few high-end entertainment companies, but for almost anyone who wanted to share a giant or humble dream to change the world. And despite the pressures, we loved being a part of it. As a small organization, we found time to help those who couldn't pay anything or pay much, not just those with deep pockets.

Two examples highlight our relationships with our exemplary clients; they are so different and so similar at the same time. Both had a vision; both had the desire to tell stories as a way of changing lives. They are as great a contrast as one could imagine: the United States Navy, and the Leadership Conference of Women Religious (LCWR), a fellowship of Catholic Sisters across America.

Both connected via chance phone calls.

One day I picked up my phone and a woman introduced herself as a Catholic Sister. Her name was Helen Garvey. She needed help because her nonprofit organization was opening a major exhibit at the Smithsonian in a year, focusing on the contributions of Catholic nuns to America, including education, health care, science, and culture. She asked me if she could fly in the next day, and I couldn't say no. I asked her how I would recognize her at the airport, and she said, "Don't worry, even in street clothes we look like nuns."

It turned out they not only had no exhibit, no collections, and no team, they didn't know anything about doing an exhibit, and they also had no agreement with the Smithsonian. But it would be imprudent to bet against the Sisters. They'd come across America on wagon trains. They'd built some of the earliest hospitals and schools in the country.

We went on a journey with them, led by writer/producer Mellissa Berry, through the diverse experiences and incredibly heroic and humble lives of the Sisters today and over time. We were overwhelmed at the outpouring of support and at the scope of historic artifacts and personal stories gathered. And within a year, as Helen had said, the exhibit we co-authored with

them, *Women & Spirit: Catholic Sisters in America*, opened at the Smithsonian's National Museum of American History, and soon after, a documentary by the same name premiered on public broadcasting. The very notion that their dream might not be fulfilled, that their stories would not be heard, never even occurred to them.

And another chance phone call.

This time it was a United States Navy officer. I already knew something about the Battle Stations project, an immersive training facility for new recruits. He asked if he could drop by my office in the morning. I told him I had a dentist appointment but should be there by ten unless I ran a little late.

It was that morning that my dentist did run a little late. I raced to my office after my dentist appointment, sorry I was keeping the gentleman waiting. When I arrived, the conference room door was open. There were so many navy officers, dressed in uniform, it was standing room only; and some were crowded around the open door.

Their dream was to save lives. In October 2000, the USS *Cole* had been bombed in a suicide attack during a routine refueling stop. Seventeen U.S. Navy sailors were killed and thirty-seven were injured in the deadliest attack against a United States naval vessel in nearly two decades. The after-action reports pointed to insufficient disaster training for recruits. These officers wanted our help. They wanted every tool in the immersive entertainment toolbox to create a first-ever controlled disaster, something so real, so challenging, that every recruit who entered the navy would enter hoping for the best but would be prepared for the worst.

This became a long journey, too. I expected the navy to be big, governmental, and bureaucratic. I was wrong; they were innovative, inquisitive, open to dreaming, and dedicated to storytelling. We soon had hitched rides on many battleships. A battleship, I discovered, lacked most human comforts and any sense of personal space. But at almost any moment, in any corner, people were sharing stories. Stories from the history of the navy, back to its very origins. Stories of failure and stories of heroism. They believed that it was stories that imprinted in sailors' minds, stories that were memorable and were recalled instantly at that moment when someone might most need them.

We created the veritable reality of a ship in a large mega-soundstage for Naval Station Great Lakes, home of the navy's only boot camp, located on over 1,600 acres overlooking Lake Michigan, in Illinois. On their last night of training, navy recruits face an unprecedented disaster, real and massive

explosions and fire, floods of real water up to their necks, and above all, the unknown. It is everything their training has prepared them for, but all in one place, in one night, and totally unpredictable. They bring only two things in with them—their training, and their trust in each other. They leave the next morning exhausted and soaked, with a sense of self-confidence, and wearing new U.S. Navy ball caps.

One time on a flight, I happened to sit next to a navy officer. I don't often strike up conversations with strangers, but I asked him if he knew about the Battle Stations project at Great Lakes. Not only did he know about it, but he had also gone through it successfully, as had every navy recruit now serving. It has operated nearly every night since we completed it.

It is still hard for me to not wax emotional when I think about these two projects and the visionaries behind them. Even more meaningful is the randomness of those first phone calls and how easy it might have been at the time to say we were not interested or were too busy.

Among the many rewards of these ten years of consulting was sharing them with my son, Gabriel, taking him to fabrication reviews and programming sessions, and to experience final products, and traveling with him to far-off places, along with my nephew Stephen, who is like an older son, and opening their eyes to the world outside America—to ideas—and getting the best ideas I could possibly have from them.

In many well-written movies, there is what is called the midpoint. At the midpoint, a protagonist changes. What they thought they were chasing really wasn't what they wanted, and they realize what they are really chasing is even harder to reach. My dream of running a company was the same; what I started out thinking it was, or should or could be, was long forgotten.

The dreams I never anticipated turned out to be the ones I most wanted.

Part 4

2007–2016

Dreamtime

By spring 2007, I was living in a relatively predictable world. My son was eleven. Diane and I had a modest house in a nice part of Winter Park, Florida. I could walk the dog down historic Park Avenue, grab a cup of Starbucks, and then walk back. My son and I could ride our bikes on Park Avenue in the early evening; café customers would yell at us if we rode onto the sidewalk when there were too many cars on the road.

I was in a unique position because my overhead was low enough, and typical creative fees high enough, that the gap between the two helped me do creative projects I wanted to do, like documentaries and short films. And I could invest time in worthy projects or people that didn't quite have their business plans, or their funding, in place. There was a little lake with fish and cranes and alligators right next to my parking space (okay, it was more of a ditch). And I was ten minutes from good BBQ and a great international airport.

When an "818-544" number came up on the phone, Susan was as surprised as I was. We had not heard from Walt Disney Imagineering in Glendale much at all, and not in a long time. And frankly I had been happy not to be dependent on them. But this call was from a good friend, Tom Fitzgerald. We had worked first on Disney-MGM together, and I admired his story genius and his overall understanding of what it took to make an attraction great. And besides, Tom could do impressions like no one I have ever known.

Tom was in the hot seat; most everyone at WDI identified him as Marty's heir. He and Marty were working with Don Goodman, who'd come from the DDC group, in a kind of transitional management of WDI. Tom asked me if I would be willing to help with a project. After I said yes, he told me it was a new kind of project development, and they wanted me to do it as a kind of outside test case.

I was intrigued. Soon I was on the phone with Nick Franklin. I knew Nick as a business innovator at Disney. He was looking for new project ideas "outside the traditional park model." I was in already, but I played it cool. Then he told me the project was in Sydney, Australia. I couldn't play it cool anymore; now I was completely in and just asked Nick, "When do we start?"

As a kid, it had been one of my dreams to visit Australia. It was not until I was an adult and working on Tokyo Disneyland that I finally got there, and it exceeded my expectations. So, if anything might have drawn me back into the Disney fold, this was it. I visited Glendale and had a preliminary talk over a turkey sandwich with Tom Fitz. Then I went to talk turkey with Nick. He wanted a quick-turnaround, all-outside, new kind of product, and he wanted it fast.

Not long after, I had an accepted proposal with Nick and I was on a flight to Sydney. The site in question was incredible. White Bay was really a kind of dog of a site, featureless and decrepit, and industrial. Unless you like that sort of thing, like I do. It was thirty-two acres of dusty, chain-link-fenced, flat industrial asphalt pavement in the shape of the open claw of a Leatherman knife: it was two slivers of land with a large water inlet between them. At the jaw's hinge was a somewhat fatter piece of land, but sitting in the middle of that was an old industrial power station, defunct, but considered enough of a landmark you had to work around it. Context is everything, and these two slivers of land on each side of the inlet lay steps outside the vibrant city. White Bay connects visually and by water to Sydney Harbor. The harbor sits at the edge of a blue-green waterway, a busy port, surrounded by parklands, historic waterfront buildings, a rising downtown, the spectacular 1932 steel bridge, and the uplifting, gracefully interlocking bright white shells of the Sydney Opera House.

Nick's brief was simple and direct. The city was enthusiastic. Sydney could be an anchor for Disney in Australia, where the content was already popular (and the language English). Australia is about the size of the continental U.S. with a population about the size of Florida's. Even considering Australia's relative prosperity, there just wasn't the population necessary to operate a major

Disney Park. Disneyland, by comparison, draws its attendance from the entire western U.S. and international destinations. Disneyland's annual attendance is often more than three times the population of Sydney. Okay, small park, small population, weird land shape, defunct power plant. "Let's get started!" I said.

Within a few months I had made three trips to Australia with Nick, not to mention visits to Glendale. Richard Graham visited the site with me, and we drew most of the plans in the breakfast lounge of our hotel. We forged an idea we thought could work. The idea would break Disney out of the traditional theme park model but apply similar techniques of storytelling through architecture and place-making, unique experiences, and a lively atmosphere in a more urban setting. It would not be gated but would include immersive experiences that were individually ticketed.

We named the idea Disney Wharf. And we pressed for no kind of berm or separation from the rest of the city. The water's edge would be public, the attractions accessible and an extension of the fabric of the city. Instead of a gated park, Disney Wharf would integrate itself into Sydney's vibrant suburbs as a place for families and friends to experience together. As we would write later: "Set in a bustling urban waterfront environment steeped in history and overlooking beautiful Sydney Harbour, Disney Wharf is an exciting showcase for new ideas, innovative technology, entertainment, and creativity. . . . People live, work, and play in Disney Wharf."

It would have been what architects call a mixed-use project, but all with a Disney twist; the best aspects of Disney's worlds pulled into a compact package, close to life and work. There would be great Disney experiences, but also EPCOT-themed dining and exhibits, theater, shopping, events and festivals, and a spectacular water-facing Disney's Grand Australian Hotel. We embraced the derelict power plant and hoped to give the massive brick structure a whole new life as a hotel, conference center, and technology incubator.

I had roasted lamb chops with city administrators, grilled barramundi with planners, and baked Sydney rock oysters and prawns with the mayor. Things seemed to be coming together deliciously.

But the best thing about 2007 turned out to be the summer, or rather the winter in the Southern Hemisphere. I took a ten-day break to take my son, Gabriel, to Australia. I was slightly knowledgeable by then, and I wanted him to have the experience. We spent a few days in Sydney and then went on a primitive outback camping trip out of Alice Springs. Our guide was an experienced

outdoorsman with a grandfatherly lack of humor or patience of any kind. I nicknamed him Crocodile Crotchety.

CC's jeep was packed in like my father's camping van, complete with porta-potty. Looking out the windows we saw a hot dusty desert. But it was a freezing-cold dusty desert. It was great watching my son learn to light a wood fire and cook, and to drink billy tea, boiling water with a long eucalyptus leaf picked right off the ground. To this day I have never again seen that depth of stars and satellites in the night sky.

CC promised we'd see kangaroos in the wild, and I had echoed that promise to Gabriel. Three days in and not a single kangaroo, nothing jumping at all. Fourth, nothing hopping, either. We were almost to sunset on the fifth day, and by that point I would have settled for a little roo poo. Then, suddenly the guide stopped the engine and waved us silent. We followed him as quietly as we could. And there in the cold sunset dust was a roo, and not just one little skippy, but a boomer and a joey, too. I don't know if he'd created the suspense, but it looked to me like he was as relieved as I was that he'd found them.

I had by that time created many kinds of immersive attractions, but seeing my son experience something of wonder, a dream I'd chased for twenty-five years, was the most rewarding experience. This was something authentic and unplanned, something he might never experience again; such as the comets in the incredible show of stars at night, or the sudden transition of the mystical mountain Uluru with our own eyes.

The dream of Australia was pulling me. It wasn't my imagination.

One Door Opens, Another Closes

I took a phone call back in Orlando from Craig Russell, my longtime friend and confidant. Jay Rasulo, the new head of Disney Parks, had decided to reorganize Walt Disney Imagineering. Craig and Bruce Vaughn, head of research and development, would lead the Imagineers. Marty was moving on to a newly created ambassador role. Tom Fitz wanted to return to projects, and Don Goodman moved back to real estate development initiatives. It was the first time in a long time that it felt that WDI had some of its independence and culture returning, or as I might have said at the time, the inmates were running the asylum again. I figured there had to be some trust from the top now, from Bob Iger, and recognition that WDI might be a golden goose, too, a wellspring of ideas that create value, something worth investing in.

Then Craig went on: the company was going to do Australia. "You'll need to come back if you really want to lead it."

Transitions are hard, and there have to be compelling reasons to make a big change. The dream of the Australia project was pretty compelling.

But I had human resources to negotiate with. I had an office with employees, a lease, partners, projects; we managed to work it all out. My biggest concern was our team, and there were some bittersweet times. I managed to hire some of our best talents into WDI, and some others started their own projects or kept going on the ones we hadn't completed.

Tami Garcia, a wonder of the WDI HR world, known for her respect for people and enthusiasm for talent, called me. I was on the ramp leading up to a Delta flight from Atlanta to California. It was early morning, Eastern time; for Tami in California, it must have been 5:00 a.m. She said Craig and Bruce wanted to announce I was coming back at an "All-Hands" that morning.

She asked if she could read me my employment terms over the phone. I stepped to the side so people could pass me on the ramp. She read down each item. And then I said, "Okay, that's it." I had said yes, and the announcement would go ahead. All that was left was to take a deep breath.

It was now more than twenty-seven years since I'd started at WDI. At fifty-one years old, I felt I was stepping into an entirely new life. I knew quite a lot about Disney, and I had some working knowledge about things outside of Disney. I was hoping somehow the combination would make sense.

California Dreaming

Soon I was feeling nostalgic, back in my beloved historic MAPO building, and this time at the top of the stairs. I needed to find a temporary house and plan a move. Craig called and let me know casually that he and Bruce had set up our first meeting with Bob Iger to show him the Australia project. I was freaked out. I had to find the models, decks, and boards that had literally just been shipped. And it was at Bob's office at the Studios, so I would only have a small space in which to present. I didn't have an Imagineering team yet—no one had been assigned. And it turned out neither Bruce nor Craig could be there, but Nick was, along with Jay Rasulo, and of course Bob Iger, and some of his key executives.

My room layout was necessarily simple, and my intro was brief. I wanted to power through the philosophy that had driven the concept. I wanted to talk about the open nature of the mixed-use development, open and integrated with Disney elements, yet flexible in the gating strategy. Being part of a community. The attractions, the festivals, entertainment, and events. It was a smaller project, modest architecturally. In big environmental moves, there were no castles, geodesic domes, or giant trees. It was more of a neighborhood, a Disney one. Bob liked the approach. He said, "The more I learn about these projects, the more I think it's more about what people do than what they see. I took that to heart for a long time. But right then I focused even more on

what guests would do at this new Disney Wharf, why it was Disney, and why they would have the intent to return again and again.

I immediately sensed Bob's gift to put people at ease, even naturally nervous introverts like myself, and soon I was comfortable, chatting and adding details, but getting worried about how much time I was taking. He looked at the water represented in blue resin on the model, how it directly connected White Bay out under the Sydney Harbor Bridge and across the city. He said he liked the idea of keeping his sailboat there. It was all positive and we wrapped up. I started to pull down the boards and cover the model.

Then Bob said, "This is a great project, and I'd love to do it." Then he looked at Jay, and me, and back at Nick, and went on. "But the company's future is in China, not in Australia."

A Dream, Deferred

I called Craig Russell from the car as I left the studio. "I think I just got fired before I got hired!" Craig had not heard the meeting report yet. But I told him someone had made a strategic mistake. Someone thought it was a good time to talk about Australia, when the boss seemed like he was hyper focused on China. It sounded to me like a direct strategy shift.

It was a day or so before the true aftermath of the meeting was understood. And my version was correct. I had held off unpacking boxes in my new office. Craig called again. "Don't worry about Australia," he said. "We have another job for you."

Don't worry about Australia, about the chargrilled lime-and-garlic Balmain bugs? The outback? The mysticism of Uluru and the Anangu people? Don't worry about the lovely apartment I'd imagined renting in a renovated dock warehouse looking out at the bridge, a short walk from the site?

"We have another project for you. We're going to have you lead the fixes to DCA."

It was like he'd told me I was going to return to selling balloons. I had never been to Disney's California Adventure, but not much of its target market apparently had, either. But I knew it was off I-5 in Anaheim, not a ten-thousand-mile flight to Sydney.

There are times when it pays you to take a breath and relax. I tried. Two

divergent Disney cultures were speeding toward each other, and I was tied to the tracks where they were about to collide.

For the years I'd conceptualized, fostered, and supported the deal on Tokyo DisneySea, we'd had a pact with OLC to build something worthy of Tokyo Disneyland. We agreed on quality and authenticity, and OLC accepted nothing less than the best. It was their business, their only business, and they focused every bit of their management energy on it.

I never criticize teams at WDI. Many things I've built have been demolished or renovated at what's now Disney's Hollywood Studios. It's part of the process. We all work to the criteria we have, and we are as creative as we can be with it. Besides, Walt said Disneyland would never be finished; hell, he renovated things multiple times before he died.

As I was working on TDS, another team was developing a second park for Disneyland in Anaheim. The weight of their responsibility was tremendous. The Anaheim resort was struggling, stagnating, and without better stewardship it could decline. Disney and the city needed to work together. And that meant new resorts, a second park to extend length of stay, and an enriched sense of resort quality added to the entire property.

The team in Anaheim was directed to create a different experience than Disneyland. The WESTCOT concept (an EPCOT for California) had been abandoned because its deep detail and scale had been deemed financially unfeasible adjacent to Disneyland.

DCA, formally Disney's California Adventure, was born in a charrette with WDI designers, marketing executives, and park leaders. By celebrating the special environment and craziness of the culture of California, DCA would be positioned as a contrast to Disneyland, not a competitor.*

Many asked why Disney would celebrate California culture when it was located in California. But this California would be romanticized and made exuberant. It was a park, a differentiated idea, and it could be done on a budget.

Bob Iger held a fundamental belief that Disney quality was not negotiable. Quality was the brand, and the brand was quality, and nothing was ever worth compromising that.

* It is worth remembering how much Michael Eisner wanted parks in one property to be differentiated from each other. He thought EPCOT was the best example. In Tokyo he felt we should have built the studios to be different, but he finally relented on the Tokyo DisneySea concept as different enough.

All I knew about DCA was that at the time it was universally criticized by the audience, by the cast, by the Imagineers; and for me, it wasn't Sydney. It was high time I went down there and checked it out. I called Bruce Laval, my go-to for anything dealing with how parks work, even in his retired golfing mode. He told me to watch for the second click. The second click? The first park that a guest enters, that is the first click. If they go to another park next, that entry is disregarded; it doesn't count. The problem with DCA, Bruce said, is it is always the second click.

Whatever damn click it was I was going to have a look. I wasn't a complete employee yet, so I had to park my car and buy a ticket. I went to an actual ticket booth, something I'd not done in a long time, especially in California. I asked for a one-day ticket. He gave me one with no question. I took it up to the entry to DCA. They said they didn't accept it. It was a ticket to Disneyland. I went back to the ticket booth and told them I wanted to go to DCA. The agent told me I would have to extend my ticket to a two-day pass to include DCA. What? I just wanted to go to DCA for one day. I was off to a balloon-seller's start on this exploration.

Sometime before I got involved with DCA, there had been a landmark meeting where the Imagineering team had used unflattering photos of DCA compared to Disneyland and other parks. They formed kind of a good show/ bad show comparison of the general situation at DCA, which was lacking in environmental warmth and that intangible quality of why people love Disney Parks. It had been compared to a regional amusement park, not living up to the expectation of a Disneyland kind of project. There was tremendous analysis done on what was wrong, and it was depicted as so serious a business situation, so serious a creative situation, and with such a gap with the cast and the audience that it was going to take massive investment on all fronts.

DCA needed new attractions, upgraded attractions, new entertainment, dining, shopping; it would require moving cast support facilities and infrastructure. After my first visit (I finally figured out a way to get in), and my review of the work to date, I stood back and thought, are we tearing down this entire park and building a new one, or are we reinventing the one we have? It really looked to me like the plan Imagineers were proposing involved tearing down too many relatively new assets. It didn't make sense to me. But I was told there had been a watershed meeting with Bob Iger, and the team had gone through an analysis of the shortcomings and all the needs, and Bob's direction at the end of the meeting had been, "I want everything that has to be fixed, fixed. Lay

it all out. I don't want to have anything left that doesn't work. I want to know that by the time we finish this, DCA will be a park, it will be the park we want, and it will be the park that we want sitting next to Disneyland." I will never know if those were Bob's exact words, but everyone seemed to quote him with great confidence.

That kind of direction to WDI, as Bob probably learned after a while in his tenure, implies an unlimited budget. When you tell somebody you want everything, that can mean different things to different people. And I always recalled a quote from Michael Eisner when he said, "It just has to be great. It doesn't have to be seamless." This was now the Iger era, but I still had a sense that a solution was waiting somewhere between Imagineers believing they now had license to spend whatever money it took to fix whatever they diagnosed was a problem, and the practical reality of running the business.

There are different ways of dreaming. There is the dream that Marty always liked to refer to as a blank sheet of paper. Whether you find it a scary thing or an exciting thing, it is still blank, and you've got no previous lines to contend with. Then there is the challenge of working within incredible constraints, of trying to be creative when there's quite a bit that is already there. This took me back to my architecture and urban planning days, not to mention my prior more than a decade of working outside Disney. Rarely is there truly a blank canvas. The trick is to find creative solutions that work for the assignment at hand. We'd done that in the crazy confines of White Bay in Sydney and now I could feel myself, damn it, being drawn in to the DCA problem. It was simply too difficult and challenging not to be exciting. No blank sheet of paper for me. Marty was a sports writer; I assume he would've agreed it's not possible to hit it out of the park unless there's a fence around it.

My first stop was Jay Rasulo. Jay and I had known each other since Jay had started as a strategic planner from business school. We worked together on Disney-MGM Studios, and we kind of grew up in the project world together. Now he headed all the parks, and he had a funny, wry humor about everything including WDI and DCA, but he was committed to doing something significant to change the course of history. After the big meeting with Bob Iger, an estimate was done of all the things that the teams thought had to be done to fulfill the mission as he defined it. It was a big number. It was a number bigger than had been spent to build the park in the first place. Such an effort would also have a very high impact on the ability of the park to operate. There was even some discussion about closing the park completely for a few years and

doing all the work that was recommended. But this seemed unrealistic given the scope of the visitation to the Disneyland Resort, and the number of hotel rooms that now were driven by the combined parks. The general economics seemed hemmed in on all sides.

But Jay and I trusted each other. He gave me a budget number. It was a very big number. It was less than the total, but he told me if I could get it to his number, he'd approve our moving ahead. I took the challenge seriously.

My first few months of work had more to do with discovery than creative. Zach Riddley and Janny Mulholland would become essential. Our work was to figure out how to be able to honestly say that DCA had been reinvented, was a direct complement to Disneyland, could have the kind of length of stay and economics to approach what Disneyland had, and, most important, could bring guests and cast members together for one primary purpose, which was to love this park. What is the price of pride and love? That is what I needed to lead the team to find out.

First I brought the entire team out to the park for a late afternoon and evening walk-though. They'd already done this many times, but I wanted us all to do it together. And I brought a secret weapon with me, my son, Gabriel.*

Gabriel and I went in through the main entrance. He was not impressed by the entryway, a "mall," he said. But he immediately took notice when he saw the rafts coming around Grizzly River Run. We did a quick ride on Soarin' Over California. We walked past The Twilight Zone Tower of Terror, through A Bug's Land, and eventually made our way to the Cove Bar at Paradise Pier. We stopped at the railing, and he could see, just across the lake, the Sun Wheel, the Orange Stinger, guests screaming their heads off on the Maliboomer, and the graceful upside-down loop of the California Screamin' roller coaster.

When we met my team in the restaurant, they all looked a little glum, and someone asked Gabriel what he thought about DCA. He said, "This is the coolest park ever!"

*I guess by this time I'd figured out how to buy a ticket into the park.

Follow Your Dreams— But to Where?

When speaking about the Pixar movie *Soul*, Peter Docter once said, "I think we're so used to and conditioned to the idea that just follow your dreams. And that's the answer. And so, we get to kind of turn that on its head a little bit." Pixar differs from Walt Disney Animation Studios in many ways, but often it has been that a character's fulfillment is more complex than simply realizing their dreams. The work to reinvent DCA coincided with the early relationship between WDI and Pixar after Bob Iger had acquired the company in 2006. Pixar's characters found a more immediate home in DCA, which needed new content at a more rapid pace than Disneyland, and in less of a fairy tale way. The first big breakthrough had been the planning of Toy Story Midway Mania!, the first Disney attraction to use game technology on a large scale.

John Lasseter had also seen DCA as a great venue to bring to life other characters and stories, and he wanted to find a place to build a real-life version of Radiator Springs, which he had created for his movie *Cars*.

I first met John Lasseter as I was beginning work on DCA and Toy Story Midway Mania! was in development. He told me he really loved the Hollywood Boulevard re-creation I had produced for Disney-MGM. He was very dedicated to bringing success to DCA, and to the WDI-Pixar relationship. He had also dedicated Roger Gould, one of his top directors, to making the park's relationship successful. Physical animation in parks had stagnated with the high

costs of figures and lukewarm performance delivery. Roger was serious about reinventing the animation development process and pipeline and collaborating with WDI to make attraction animation as vibrant and exciting as animation in films. A test case was in progress with a large and sophisticated toy figure in development for the entrance of the Toy Story attraction, intended to interact with guests in the queue.

Partnership

We had an ideal partnership with our dedicated teams from WDI and Pixar collaborating. We needed to establish a great working relationship with the team in charge of Disneyland Resort. Enter George Kalogridis, who had come to Anaheim from Paris. He had an impeccable reputation for running Parks and Resorts. He was beloved by cast and had a strong vision for Disney quality. George assigned Mary Niven as the development executive representing the Disneyland Resort for the DCA expansion. I couldn't have asked for a better partner, Mary being creative, strategic, and deeply experienced inside and outside Disney. Mary started her new role by charging anyone a dollar if they said *DCA* instead of *Disney's California Adventure*. In her thinking, if we didn't respect the park enough to call it by its name, we weren't going to get anywhere. After all, we didn't call Disneyland "DL," did we?

Mary and I soon became close collaborators. And we made a kind of pact. We agreed that the reinvention of DCA (okay, Mary, I will Venmo you another dollar) was less of an expansion than it was a campaign. This was no less a campaign for the people who loved Disney, too; and that included guests and cast and even press. We had to convince everyone that Disney's California Adventure was every bit as worthy of love as Disneyland, despite a smaller park, a shorter history, and a lot of evolution to come.

Why do people love Disneyland? Why do I love it? These became the key questions as we sorted through all the projects, renovations, and additions,

and then this became the criteria by which we closed the gap between what had been proposed and Jay's challenge for getting it all approved. There were differing opinions within WDI, of course. Some wanted to focus entirely on new attractions and not spend much money on renovations. Some wanted to focus on the name California, dropping it from the concept and excising it from the park. I talked to as many people as I could, sought out opinions, and measured them by Mary's point of view. Some basic facts started to emerge:

- DCA already had among the most popular attractions at Disneyland, including Soarin' Over California, Screamin,' and The Twilight Zone Tower of Terror.
- Guests didn't linger. They came to see the attractions; then they went back to Disneyland, further overloading that park.
- Guests did not spend their evenings strolling around DCA, as they did at Disneyland. The very idea that we would ever have a vibrant nighttime entertainment or dining environment was hard to imagine, and to some people it was laughable.

I kept remembering that first time Rick Rothschild took me into EPCOT and we entered from behind American Adventure, with that stunning view of the park, Spaceship Earth, and World Showcase. There were some basic precepts I was developing in my own head, and I started to socialize them:

- Disney's California Adventure didn't have enough storytelling, and what storytelling there was, was often insincere. The best thing about DCA was Soarin'; people loved it—it was fun, inspiring, sincere, and exciting.
- Insincerity and inside jokes were everywhere. The park didn't seem to take its basic mission seriously. Attraction names were inside jokes or lacked inspiration. The entry, and other areas, seemed to go against basic Disney place-making.
- The basic tenet of Disneyland—HERE YOU LEAVE TODAY AND ENTER THE WORLD OF YESTERDAY, TOMORROW AND FANTASY—was intentionally disrupted.*

* DCA was designed by some of the most talented place-makers in the company's history, so it was not an issue with talent by any means. The collective idea of an anti-Disneyland seemed just to have not worked, in retrospect.

- DCA lacked scope. I had seen this at Disney-MGM with the strategic arguments of "a smaller park, half day, just enhance the resort!" I felt like Cyrano de Bergerac; *here they are again, all my ancient enemies!*
- DCA lacked the characters, the stories, and the vibrancy that people expected at Disney.

And there was one other troubling thing for me: each time I visited DCA, I noticed that the quality was poor. Basic construction quality was not good, and as there was more and more speculation about renovations, deferred maintenance was making the park look that much worse next to Disneyland across the way.

We were stuck in a vicious cycle. I came down to look at holiday decorations. I was shocked to see Disneyland totally decked out at the main entrance, and DCA had almost nothing that was worthy of a photograph. An executive told me, "You gotta fish where the fish are."

One thing I learned from my Australia experience: Bob Iger doesn't mess around, especially when it was with something he worried was a brand detractor. And he was also not afraid of investment in areas where it made good on the Disney promise. By October 17, 2007, I stood with Bob and Jay at a press conference at Imagineering, announcing the "creative evolution" of DCA.

The plans had unfolded very quickly. I had presented the plan to the Disney Board of Directors at the resort, with more details at a subsequent board meeting at WDI. The priorities, as agreed with Jay and Bob, would be an all-new twelve-acre Cars Land, with a major "E" ticket, Radiator Springs Racers, and a new family attraction based on *The Little Mermaid*. It was all even deeper than announced. I had presented the controversial plans to literally tear the entire main entrance back to the steel and reimagine it. How was this justifiable? I told Bob if we didn't get the first act right, we'd never catch up. Like Main Street, U.S.A., the entry needed the sense of optimism and meaning that uplifted guests and transported them.

Against the opinions of some of my WDI collaborators, I lobbied hard for a show called World of Color (WOC), a new spectacular with fountains, lighting, and effects in the lake. It was expensive, but in discussion with George and Mary we were certain that without it, DCA would never deliver the kind of nighttime environment that would allow it to achieve some of the magic of Disneyland. We planned to renovate some attractions and even remove some of them. We planned to add a massive number of trees and landscaping,

reworking insincere graphics and nomenclature, doing new scores for background music, and, in homage to John Hench, changing a lot of colors to be more Disney.

Despite the concerns of many, we didn't back down on the California theme. Instead, we embraced it as part of what made Walt's success, and the press release confirmed it: "The creative evolution of Disney's California Adventure will connect guests to Walt's own California adventure and reflect the place that he found when he first arrived with a cardboard suitcase in his hand and a head full of dreams."

We were on our way. It was the largest renovation of an operating park ever attempted.

We didn't really have all the detailed estimates yet, but we had a glimmer of hope we could do all we were talking about within the budget Jay had promised. And Jay would make good on it.

At a Board of Directors dinner at WDI, I exhibited a model of the new DCA main entrance. It was not my work; it was the genius of master storyteller Tom Fitzgerald and architect Coulter Winn. "If Walt based Main Street on his childhood in Marceline," they theorized, "DCA's new entrance would be based on the vision that first inspired him when he arrived in Los Angeles." It was a simple white model, but it instantly conveyed everything about why it would transform DCA.

The board members stopped by, and I talked about the transformation of DCA and showed this example. They were ushered off to dinner. I realized one board member had lingered back and was studying the model carefully. It was Steve Jobs. It was just me and Steve. He asked a few questions. He told me this was what it was about. He waved his hands over the model and said, "Do more of it, all around the place." I promised him we would.

Two and a Half Years Later

It was two o'clock in the morning, sometime around April or May 2010. I was bundled up and standing next to Paradise Bay with Steven Davison. Steve was the genius behind World of Color. As always, the central creative leader is the point of focus, especially as a project comes down to the wire. I had grown to trust and respect Steve, and I visited at night to see progress whenever I could. It was an incredible canvas he was working on. I wanted to be supportive of him and the team. The pressure was on. There was a complex time sandwich he had to work in. They couldn't start to rehearse the show until the park had cleared and not until it was relatively dark. Then they had agreements with Anaheim for how much noise they could make at night.

And there were lots of notes. Executive reviews, creative input. Each revision that was recommended sent the team back to edit or re-composite media, or to edit and record new music cues, and sometimes it added hours or days to the schedule. But progress was happening.

I remember seeing the more than 1,200 fountains coming alive with the intense saturation of color. They looked like buckets of paint, animating massive shapes. The music was intense and emotional. I looked across DCA. We were making progress. Work was going on everywhere. Next to where we were standing, the WDI team was completing The Little Mermaid ~ Ariel's Undersea Adventure, for its opening also in just a few weeks. That team, led by Chris

Crump* and Larry Nikolai, and dozens of WDI artists, designers, ride engineers, animation and effects personnel, and lighting teams—so many diverse talents—was delivering this new attraction in record time, operating in the constrained site of the working park.

Across the way, on Paradise Pier, Lisa Girolami and a small team completed facelifts that transformed the pier into more of a real Disney look. I had fought to change the lighting on the Sun Wheel to LEDs we could program, along with the addition of the giant Mickey face. And thankfully, Steve had included the lighting in his tapestry for WOC. The Orange Stinger was converted to Silly Symphony Swings, which put an exhilarating spin on the fun of the 1935 cartoon *The Band Concert*. This beloved short features Mickey Mouse as a harried conductor who keeps his orchestra playing, even as a tornado whisks them all high in the sky. Guests flew high above Paradise Pier to a new recording of the Overture to *William Tell*.

The Maliboomer was gone. There were new signs, all tied in with the new more classic turn-of-the-century Paradise Pier theme that had been launched by Toy Story Midway Mania! two years before.

Overall, there were hundreds of new trees, all with uplighting and twinkling effects. There were new places to sit and enjoy the park, and dining opportunities were already more vibrant and culturally diverse.

I stood there as Steve and the WOC team launched a scene based on the Pixar film *WALL·E*. The film opened two years ago and was still having impact as a major creative, commercial, and critical success. When the Thomas Neuman score came on, accompanied by the intense saturated blue of the fountains and the moment from the movie captured on giant screens of water droplets, I nearly lost it. It had been such an intense couple of years. DCA had been crisscrossed by construction fences; some facilities had closed, and others were hard to find. But the guests went along on the ride with us. Early on, Mary and I and our respective teams had decided to open things as soon as they were finished, making them mini celebrations. And we always had a cast-only reception, usually at six in the morning, and we'd thank everyone, give out collectibles, and let the cast and WDI teams be the first guests to ride.

Attractions like the Sun Wheel, converted to the Mickey Wheel, had the same vehicle and the same capacity and the same basic experience. But the

*Chris Crump, a major talent in his own right, is also the son of the late Disney Legend Imagineer Rolly Crump.

ratings and the utilization always went up. The power of Disney story and characters couldn't be better demonstrated.

I calmed myself, took a deep breath. It was late, time to head back, a long ride down the I-5 freeway at 3:00 a.m., but I wanted to see the whole *WALL·E* sequence. It played out emotionally and elegantly. Steve started to make notes. Then I heard it, a muffled sound of people cheering, applauding. It had to be my imagination. But I could hear it, quiet in the misty night. Then everyone heard it. We turned around and realized all the windows of the Grand Californian hotel wing that faces Paradise Pier had people standing in them—parents, kids, grandparents—in bathrobes and pajamas. They had all been watching the middle-of-the-night rehearsal, and now they were cheering. It was muted by the windows, but it was there. They all waved, and we all waved back. It was the best standing ovation I have ever experienced.

It was a moment I will never forget. I had derided DCA, like many. Then we'd pushed high, dreamed big, as we always say. The dream was right, and it was coming, I could feel it. It was going to be the kind of major artistic and cultural transformation we all had hoped for. I felt so lucky to be a part of it.

I drove home, thinking there was nothing I could imagine doing that would ever top this.

I guess by now this sounds like the ideal job. An epiphany at World of Color late at night. A great project, great team, close to home, trusted stable leadership, one big and secure financial authorization, and most of the creative behind us. We were almost to the midpoint of the DCA revitalization schedule, life was good, and everything was going pretty much according to plan.

Except that is not the way it happened.

A Surprising Phone Call

In fall 2008, barely a year into the DCA revitalization project, I got a call from
Jay Rasulo. Jay did not call very often, and he never called just to chitchat. So,
I figured something was up with some part of the DCA work. But it turned
out Jay had called to chitchat. I listened nervously to his small talk, wondering
what he was thinking; but he started out by asking me how I was doing, how
the project was going. I gave him some informal notes about how things were
proceeding and that they were proceeding well. He asked me if I felt stimu-
lated enough.

"Yes, Jay, absolutely. I'm totally stimulated. I've completely bought into the
success of everything we're doing at DCA! And you know, we have four years
to go."

"Well, I was thinking you might get bored, or you might be getting bored."

"One thing I can tell you, Jay, is I'm not bored."

Jay said, "You really are going to get bored, and I think you should think
about taking on an additional assignment."

What I thought was, *Is he crazy? Doesn't he know how busy I am? That this
would be the worst possible time.* But since I rarely turned down assignments,
what I said was "What do you have in mind, Jay?"

"I think you should take over the development of Shanghai."

I hoped he didn't think we'd gotten disconnected. I paused a long time

before speaking again. Once in a while, a project comes up that you didn't think you had any time for, but you just can't turn down. I had been in Shanghai in January 1983 and had written the memo that found its way a few years later to Frank Wells making the case for building a park in China. And here we were, two, almost three decades later, and the head of parks was asking me if I wanted to develop a new park for China, finally. I had to admit to Jay that I would take on the assignment, and still head up DCA.

With DCA at the beginning of construction, and Shanghai at the very infancy of concept, it was time to fasten my seat belt; it was going to be a very bumpy ride.

Cars Land

The completely new Cars Land initiative demanded a great deal of the new DCA team's focus. With a possible site area of more than ten acres, it would be the largest single expansion to the Disneyland Resort since the actual construction of DCA and would utilize land that was in very limited supply for new attractions. We knew it would have to be great, and it would require by far the largest percentage of the project's resources.

Legendary Imagineers Kevin Rafferty and Rob't Coltrin had previously developed a DCA expansion concept for a car-inspired land. It included elements inspired by the film franchise *Cars* in the form of a major family thrill ride attraction, but the land also included tributes to the broader California car culture, in keeping with DCA's original concept of being tied to California as a general theme.

It was not long into the development that our team made the judgment that the movie *Cars*, with its breakout, beloved characters, and the amazingly immersive town of Radiator Springs, was the best focus for the entire land, without any intrusion of elements from the real world.

I lobbied hard for Kathy Mangum as overall producer. Kathy was very creative and strong in management and had already collaborated successfully with Pixar, leading the development of a bug's land at DCA and the *Finding Nemo* update to Disneyland's classic submarine ride.

All major projects require large interdisciplinary teams, but this one was almost a park in itself. The original ride concept developed by Kevin and Rob't was still going to be central to the new land, so it was critical that we have Kevin on the team (Rob't had become very busy on a series of initiatives for Tokyo).

It also was critical that we have creative continuity with the original *Cars* Pixar team from a story development and design point of view. Through our Pixar partners Roger Gould and Liz Gazanno we gained access to critical *Cars*-invention artists including Bill Cone and Jerome Ranft, and Bob Pauley. And we had the guidance of John Lasseter, who'd invented the franchise.

In the invention stage of all of its movies, Pixar used research trips to immerse their artists and storytellers into the worlds they were developing. During the development stage of the first *Cars* movie, their team made a detailed trip through the American Southwest, gathering stories and visual research into the road culture. The Pixar team and consultants generously agreed to restage this extensive tour for the expanding DCA team. This time the cross-country trek included the original Pixar team, as well as Kathy Mangum, Kevin Rafferty, architect Joe Kilanowski, show designers Greg Wilzback and Tom Morris, interiors designer Emily O'Brien, and overall DCA landscape architect and park planner Jon Sorenson. With the trip, and the Pixar-WDI collaboration, the journey to transform Radiator Springs into a real dimensional place guests could explore had begun.

Cars Land was also among the first projects developed using extensive 3D simulation. Kathy spent hours in the CAVE, a domed projection space at WDI.

I had one disruptive recommendation for Kathy, Jon, and Tom as they were laying out the new land. I suggested they push the entire land away from the center of the park as far as possible, to the limits of the service road. I was thinking of Sunset Boulevard and the Tower of Terror in Orlando. I wanted to make DCA seem bigger. It needed more scope to be next to Disneyland, and there needed to be more places to explore. We pushed the plan outward (adding cost for every foot we moved). But the perspective of Cars Land became even more powerful as it became longer, and a beautiful cross street was created, connecting the Tower of Terror, down a quiet back street, right into Cars Land, past Luigi's, and Flo's, and through a beautiful new stone archway and right into Pacific Pier. The shape of the arch was governed by a few things, including overall aesthetics, pedestrian views, and masking the Paradise Pier Hotel from Radiator Springs Racers drivers. It was one of those moves that just felt like it was making DCA more like Disneyland, and today I still think the team created one of the most beautiful walkways in all our parks.

"The Journey of a Thousand Miles Begins with a Single Step"

—Lao-tzu, legendary ancient Chinese Taoist philosopher

A very small team of artists and designers had been working on ideas for Shanghai, how to make a Disneyland-type project but do it in a fresh way in a new market that was completely new to Disney stories. In Mainland China our research confirmed very few people had ever been to a Disney Park. There wasn't even a Disney Channel in China.

There was film distribution, but it was thought not to have a massive influence in creating an overall Disney zeitgeist. In general, it was believed at the time that China's cultural knowledge of Disney was limited and not comparatively as prevalent as the cultural knowledge of Disney had been in Japan in 1980 when I had started on Tokyo Disneyland.

I took a flight from Los Angeles to San Francisco, had a short layover, and then boarded a United 747 for the 6,200-mile journey to Shanghai. It felt like a thirteen-and-a-half-hour ride in a time machine. I was thinking of the China I had seen twenty-seven years ago while reading briefings and looking at maps that in no way mirrored my memories. A few minutes after I landed, it was very clear China had not sat dormant since I'd last been there. It had been moving, more like racing, toward the future.

Pudong Airport was completely modern, with cascading vaults over the huge airport spaces. I was picked up in a brand-new Buick Regal by a driver who whisked me quickly into town to check into the Four Seasons in the Old

French Concession neighborhood. The view from my hotel window was as shocking as it was magical. Some of the old city's Shikumen houses, with their walled enclaves and interlocking courtyards, were still there. But in between were vibrant new neighborhoods with tall buildings, beautiful sky gardens, and park spaces. The city seemed electric with optimism and entrepreneurial spirit. I nearly got run over by a motor scooter when I walked across the street to get my first Starbucks in Shanghai. There were so many streets, angles, lanes, it was hard to understand it all. Elevated expressways, dramatically lit from below, traced their way through the city and seemed to float on air.

The next day we were ready for serious exploring. By midafternoon we'd visited the People's Park, Shanghai Urban Planning Exhibition Hall, and Shanghai Museum, considered one of China's world-class modern museums and famous for its large collection of rare cultural treasures.

By late afternoon we had visited the Yu Yuan Garden, a very special meditative place (if you didn't mind a lot of people around), which I would later visit many times. Translated as the "Garden of Peace and Comfort," the Yu stands in the center of a busy commercial neighborhood steeped in history. Small shops and restaurants dot the area. Inside the Yu are a series of Ming dynasty pavilions, Koi ponds, beautiful bridges, stunning rockwork, all enclosed within a swaying dragon wall. It is an unforgettable place of carved rock, water, plants, and perfection.

Early evening, I made my way down the very crowded East Nanjing Road. The neon lights were still there, but there were much more modern lighting fixtures now. This had been the street where I'd gone rogue twenty-seven years ago and nearly started a riot in a bookstore. I went completely unnoticed here now, just another Western tourist, a potential customer for a laser pen or a fake Rolex.

By the time I reached the end of the street, the Bund curved away from both sides, embracing the beautiful curve of the river. The long-standing classical European buildings were still there—banks, trading companies, stone bastions of international business since the early 1900s. But there was something different. For the first time, I saw something across the river, an area I remembered as marshland. It was Pudong, a new section of the city, and it was a symbol of where this city was headed: it was headed to its future fast.

Among my many mentors at WDI, few had more widely felt impact across Imagineering history than Wing Chao. Wing, executive vice president in charge of master planning, architecture and design for WDI for more than a decade, is

more than a Disney Legend, more than Governor Wing in the *Star Wars* series *The Mandalorian*. Wing is a dear friend who generously educated me, including when I first started looking at the Shanghai project.

But not even Wing's deft explanation of the urban development of Shanghai could prepare me for the city I was about to see for the first time since 1983.

Directly across the river was an area with many skyscrapers called Lujiazui. Known as the new financial center, it was vibrant and animated with neon and giant video screens perfectly reflected in the black water. Pudong, meaning the "east side of the river," once farmland, was now the most booming sector of Shanghai. The tightly choreographed skyline of high-design modern buildings included the Oriental Pearl Tower, also known as the TV Tower; the Jin Mao Tower, a mixed-use development of eighty-eight occupied floors in a series of sixteen tiers, with a Grand Hyatt, offices, shopping, all designed by Chicago architects Skidmore, Owings & Merrill; and the Shanghai World Financial Center, resembling, and known as, the giant bottle opener. The setting was magical, dramatic, and I remember thinking, this will not be your grandmother's Disneyland.

I discovered my favorite food that evening in the French Concession. The so-called concessions were land grants made for foreign communities and embassies, dating back to the late 1880s. The French community's legacy still stands in the form of quiet curving streets of residential architecture, lined with London plane trees or what in the States we call sycamores. And great places to dine.

The cuisine of the Sichuan Province is built on a foundation of a slow, smoldering burn of dried chilies plus the pungent bite of raw garlic, all balanced with dashes of black vinegar mixed with peanuts. This medium can be applied to any kind of meat, tofu, or even large whole fish that might be presented at your table, floating in a vat of oil completely covered in chilies. It doesn't really matter that the food has more red chili peppers than you've ever seen in your life, because each dish also includes handfuls of these tiny, crunchy mouth-numbing Sichuan peppercorns. I came to think of them as a kind of culinary Novocain, ingeniously mixed in to enable you to get through a meal without your throat swelling up and going into anaphylactic shock.

After a few days of our Shanghai experience, and with a lingering smell of garlic, chili, and cigarette smoke on our clothes, we pointed our Buick GL-8 minivans east, toward Pudong, and toward where someday the dream of Shanghai Disneyland might be realized.

After a forty-minute drive we arrived in a southeast suburb of Shanghai's Pudong area, in a place called Chuansha. It was quaint—I wouldn't say cute—but it was quaint. By this point, it was no secret that the town had been in negotiation with the city of Shanghai for a Disney project for a very long time. Had the drone been popularized by this point, and we could have flown one, an aerial shot would have revealed a rectangle of seven square kilometers or about 1,700 acres, more than three times the size of the Disneyland Resort in Anaheim. The dream was for the first phase to occupy about half of that land.

There was already a well-known system for the valuation of properties that would be acquired by the government and assembled to support the Disney partnership. There were points of valuation: first, the basic value to a house, then options—there was a value to a tree and a value to certain external improvements. This was something that residents had caught on to.

As you walked through these neighborhoods, you could tell that people had planted as many trees as they could possibly fit onto their small sites, built as many rock stone walls or structures as possible, and added on to their houses in any way possible. There was a gold rush going on to make sure that when the government evaluated their properties, owners would get the highest value possible. It wasn't easy to see much of the site, but it was fascinating; people on bicycles riding along small roads with beautiful trees forming windbreaks; bridges over muddy small waterways with small boats in them; lots and lots of improvised greenhouses growing vegetables and strawberries. It was not a pretty place like Suzhou or Hangzhou, but it was a charming, real place. People found us curious, and I'm sure we looked plenty curious, too. Another gaggle of Americans with sketchbooks, and this time, iPhones instead of cameras.

I made a rule during this trip to never compare our experience in Japan to that in China. When Oriental Land Company had come to Disney to develop Disneyland in Tokyo, they were quite serious about developing something that was absolutely and authentically Disney, to the degree that even the major graphic elements were done in English without Japanese subtitles. It was important to them that the park be perceived as fundamentally a visit to the United States and to the authentic Walt-inspired Disneyland. A decade later, as our research for Shanghai proceeded, we began to see that there was a great sense of pride in the achievements of China's development and a great sense that it should not be assumed that everything would be Disney, or that everything would be American. It almost immediately felt important that we

find a way to make connections to modern Chinese initiatives and culture as part of the project, as opposed to pretending that we were airlifting some kind of foreign entertainment project direct from the United States.

When I returned to the United States, I felt we absolutely needed to have a panel of advisors who knew China, and we needed to find them right away. But thinking more about it, I said to our team that advisors, per se, can only do so much. I thought back to our advisors on the Disney's America project and how helpful and effective they were. But in this case, I felt like we needed Imagineers who knew China, Imagineers who could work side by side with us, developing the project with us, seamlessly integrated into our team as opposed to separate and apart. We would have, through our Chinese partners Shendi, formal advisors, but I felt we needed our own integrated team, Imagineers who were Chinese.

This set off quite a research project within our team and within HR resources to try to find folks whom we could quickly identify, interview, and, if possible, hire.

The second order of business was to get a deal done. The deal between Disney and Shanghai Shendi (the company charged with building Shanghai Disney Resort) was not finished, and there was some hesitancy about Imagineering expending serious funds on development with no deal in place. The actual deal was not our responsibility, but there was a schedule hovering out there that suggested we needed to start immediately, whether the deal was done or not. We came up with the idea of the CDFA, the Creative Development Funding Agreement. It allowed us to split the cost of development with our Shendi partners, making sure that we both were invested in the project even though a deal was not finished. Slowly we started to assemble a diverse team of Imagineers from America, and a growing small team of Chinese-born Imagineers to be a part of it, and we started to develop what could be the idea of a new kind of Disneyland, for a new kind of Disney fan in China.

Hong Kong A Dress Rehearsal

It is not possible to talk about the development of Shanghai Disneyland Resort without first understanding the history of the Hong Kong Disneyland Resort.

I did not work on Hong Kong as I was away from the company at that time, but it did have an outside influence on the early days of our development for Shanghai. The first choice had been for Disney to go to Shanghai. But a deal in Shanghai had stalled, and instead of waiting, the company had pivoted and decided to proceed to do a project in Hong Kong first. The Hong Kong project was financially challenged almost from the beginning—too small, too low a budget (have we heard this before?); and the team made a strategic decision to build the park quite a bit smaller than any of the other Disney Parks, at about fifty acres.

They also made a strategic decision to make it a very quaint, historically accurate copy of Disneyland. Almost everything about the original Disneyland in Anaheim was copied, including the castle, which by today's standards is beautiful at Disneyland but somewhat small when taken out of the context of Disneyland. Main Street (Hong Kong) was quite compact, and the park had just barely enough programs and activities to keep people busy for a day. It lacked the scope and expansiveness of Walt Disney World Magic Kingdom or Tokyo Disneyland. Another decision the team made: by making it what they were calling a classic Disneyland, there was not much development of new rides

or attractions. There was also very little customization or gesture to the local market, despite Hong Kong's rich history and international diversity.

The reception to Hong Kong Disneyland was positive, but there was a sense that it was a bit of a history lesson for Disney. Some people and press said it felt small and old, although it was all new. It did not reflect a sense in Hong Kong of their burgeoning new technological world or vibrant creative culture.

What I realized by digging into the deal structure for Shanghai was that to put something on the table with the partners in Shanghai, Disney's strategic deal makers had come up with a formula that simply "plussed" Hong Kong Disneyland to the projected attendance of Shanghai. They increased the acreage to a hundred acres instead of fifty and added additional attraction capacity but didn't specify what those attractions might need to be. Additional dining and retail and employee-support facilities were added, all of which were undersized in the original Hong Kong Disneyland.

But there was still no design, no concept, for how this version of Hong Kong Disneyland could really be modified sufficiently to something that worked in Shanghai. I quickly realized that the idea of using Hong Kong as a comparison was problematic, because Hong Kong at that time was an enclave of international business, knowledgeable about Disney, and Hong Kong Disneyland Resort was a beautiful island with hotels and a nice escape from the city.

The staggering data of Shanghai was that we had a potential market of 300 million people, or approximately the population of the United States, within a few hours of transit. We were building a park directly connected, in an urban-planning context, to a very large population, and a very affluent one, and to a lot of young people and young professionals and young families who expected that their Disneyland in China would be something better and completely different than Disneyland anywhere else.

The closest Disney Resort to Shanghai besides Hong Kong was Tokyo Disney Resort. Tokyo Disneyland by this time had almost three decades of growth behind it, and nearly all that growth had been at the high end—successful "E" tickets from other Disney Parks; and OLC had even upscaled those projects. And Tokyo DisneySea was headed toward its tenth year, too. It would not be feasible to meet the expectations of anyone who'd visited Tokyo Disney Resort with something overly conservative.

I considered these challenges worrisome, but somewhat theoretical. I suggested that our team was best to set these challenges aside and start thinking about what kind of park we wanted to build. What did this culture seem to be

telling us? What was the Disneyland that made sense for this market, and this city, and at this moment in time?

I had studied Disneyland since I was a kid, and since I'd been a popcorn, ice cream, and almost balloon vendor. I knew a lot about Disneyland, and I knew a lot about Tokyo Disneyland. I felt this was an opportunity for our team to include some aspects of the other Disneyland sites, which were indeed classic, that were part of the rich DNA of the original park, designed in many ways by Walt Disney himself. But I also felt like this was our opportunity to break through and try some new things, particularly things that people had talked about as possible improvements to Disneyland over the many years of developing it in different locations, including Tokyo, Hong Kong, and even Paris.

Know Your Audience

The first thing we did, like we had on so many other projects, was talk to the audience—and we really talked to our audience. We did dozens of formal qualitative focus groups; we showed people images of Disneyland, talked about stories, talked about experiences, talked about everything from food to resorts to entertainment, and gained their aspirations and their thinking about what they thought a new Disney Park in Shanghai should be.

They were also highly stressful because we had a small team that included the key designers, the operating planning group led by Andrew Bolstein, and others, all squeezed into a small smoke-filled room listening to the sessions, which were held entirely in Mandarin and interpreted for us through a kind of squawk box speaker.

It was tough, but we stayed with it. Everyone stayed with it, and everyone took notes, and everyone learned from the audience. I could go on and on about the kinds of things we learned, but some key items were that there was not a strong connection to the older Americana aspects of the park, including things like Main Street, U.S.A., or the Old West. These felt somewhat irrelevant or not keeping the attention of the audience. We also heard that Tomorrowland was important, and Tomorrowland would have to reflect the growing confidence that China had in its role in defining the future.

A few other key learnings related to whether there should be a specific

Chinese story that would be the basis of an attraction. Some people thought this was a great idea, and the story that most came up was the Monkey King, which is a classic legend. That could be the basis for a ride or a show of some kind in the park, and we could design it using artists and writers from China in much the same way that had been done for Meet the World in Japan.

But input on this idea was generally negative; it was deemed not to be Disney. People felt strongly that there were many theme parks in China and many of them were insufficient copies of Disneyland. It was important to them that this be a real Disneyland, and if Disney or Pixar should create a movie based on the Monkey King and it became part of Disney's lexicon of characters, then they could see why it would be an attraction in this park. But absent that, they felt it was dangerous territory for Disney to tread into Chinese traditional stories just for the sake of trying to localize the new park.

One of the most articulate comments that I always remember from so many groups and so many little boxes of take-out noodles and so much cigarette smoke was a comment a gentleman made about how much Western style or Western perspective should be included across Disneyland. His comment was, "Disneyland does not belong to America. Disneyland belongs to the world." It would be many years before Shanghai Disneyland would be open and many years before we truly saw the kind of tremendous acceptance that the Chinese audience would have for Disney and Disney stories. But ultimately, this gentleman proved correct that Disney did not just belong to America. Disney belonged to the world, which included China, and Shanghai Disneyland would prove that.

I always felt constrained by the format, a third-party moderator presenting our ideas and compiling comments while stuck on the other side of a mirror.

The local office in Shanghai went to work and found opportunities for our team to literally go to people's homes. We'd visit a family at home, have lunch with them, and talk about their daily lives and what kind of entertainment their kids sought out or they sought out as families, and what kinds of places they liked to go when they went out. We had some insightful visits to schools to talk to classrooms filled with young people and their teachers.

The general impression . . . I remember sitting in a school classroom talking about Disneyland with the students, and the teachers asked us to make a strong connection to schools. The insight of one teacher was that we didn't need to be "educational" or try to teach, per se, because the very fact that our students could visit Disneyland and experience new stories and a rich different culture

than they were used to was in itself an education. Many of the teachers felt strongly about this, and we followed their lead.

By the end of one session, a student asked if they could sing us a song, and we said we would love that. The entire class broke out into "Part of Your World" from *The Little Mermaid*. There was not a dry American eye in the room. We quickly realized that the recognition of Disney stories and characters was far greater than any of us had thought or any of our previous analysis had shown. But we had to spend the time getting to know people and having authentic conversations.

~ ~ ~

In January 2010, in the middle of DCA construction, and with early Shanghai Disneyland Resort concepts beginning, WDI got a new boss. My new boss was to be the company's Chief Financial Officer, Tom Staggs. Bob Iger had decided to ask Jay Rasulo and Tom to switch jobs, to extend both of their depth in the company's operations. I had lots of running time with Jay, and we had quite a bit of verbal shorthand.

Jay had never made any pretense of being creative. If anything, he had a kind of dry wit about dealing with creative people, although I always thought we got along well. Tom was an unknown quantity, which is always a source of apprehension when you are in the middle of committed projects.

But I liked Tom, and we developed a good rapport right away. As the new head of Walt Disney Parks and Resorts Worldwide, Tom was deeply inquisitive, fun, and ready to jump into all aspects quickly, including creative and development issues. With DCA pretty much baked at this point, there seemed to be a great advantage in Tom's coming in with a bit of a restart on all the assumptions about Shanghai.

The real work began, and we took some of the sacred elements of Disneyland and threw them up in the air. I decided to take some bold ideas to Bruce Vaughn, and ultimately to Tom Staggs and Bob Iger. They were ideas that were completely outside the box of what had been anticipated to be part of the Shanghai Disneyland project (again, a Hong Kong plus-up, whatever that meant). Whenever I heard directly from Bob, he positioned Shanghai Disneyland as being so important to the initiatives of the company that I felt my responsibility as a creative leader was to present ideas that were way outside the box, even if they were not traditional; way outside the pro forma; or way outside the anticipated deal. We were there to push the envelope.

Ideation

There were several initial big ideas, and they ended up driving the project in many ways.

First, there would be no train around the park. The train had not really been essential in Hong Kong. I felt it was a lot of investment and that it limited the ultimate planning of the park. After traveling around China, an antique steam train just didn't feel like it had the romance or charm that it had in our other parks.

The second big factor was whether Walt's memory of growing up in Marceline, Missouri, was relevant to this audience. My years visiting Disneyland pulled at my heart—there was something about Main Street that seemed fundamental to Disneyland. We decided to propose something new and old at the same time. Main Street in our new Disneyland would become Mickey Avenue. It would have much of the same small-town feel, but the inhabitants would be the classic Disney characters. They'd be right out front, right there to meet you, and they'd be the proprietors of this magic town. As I had learned from Disney-MGM's Hollywood Boulevard, and Buena Vista Street at DCA, if you get the welcome right, it's like the first act of the movie: get them hooked into the story right away, and everything else goes a lot smoother.

Third big item on our list—we heard a lot about people going to visit Hong Kong Disneyland and not being able to intuitively read the park. In other words,

guests didn't understand what they were supposed to do. I wanted, from back in my popcorn/ice cream days, a park that was basically self-explanatory; as a guest, you go where the park draws you, and you have the freedom to explore. But it shouldn't confuse or frustrate you. You should be able to just go with the flow and rest assured you'll get to see it all in good time.

Doris Woodward, whose family came from Shanghai and Hong Kong, was one of the first lead designers I recruited. She was a very experienced Imagineer from back in the EPCOT days, and I trusted her perceptions as a linkage among Chinese culture, American culture, and Disney culture. Doris brought forth the idea of rethinking the hub, a traditional, essential part of the Disneyland plan, which is based on a hub-and-spokes design.

Traditionally, the hub was a circle of pavement with some trees in front of the castle. It served as a transition between Main Street and the rest of the park. From the hub a guest could easily see the "lands," gateways into adventure; and could self-select where they wanted to go.

Doris's concept was to take a couple of attractions usually hidden behind the castle, Dumbo the Flying Elephant, and the carousel, and move them out into the hub so that the hub became a part of Mickey Avenue. The hub would become a real park space, with twinkle lighting and the magic of these family rides visible to guests from the very beginning of their visit. There would be water, topiaries, sculptures, a theater; it would become a kind of tivoli in front of the castle. As fun as it sounded, it was still a controversial idea.

Fourth, we boldly planned to create a completely original castle,* not a copy of any of the castles, including Disneyland's, which had been done in Hong Kong. An original castle reflecting Disney today, reflecting the diversity of Disney form and color.

A new castle had been created for the opening credits of Disney movies. It was seen around the world at the front of every new film, so I knew that anyone in China who'd seen any of our new animated or live-action films would have this castle in their visual memory. It seemed to be a good starting point for something new, but it would also be big, perhaps the largest castle across all our parks.

And fifth, Tomorrowland. How could we create Tomorrowland, in a place

*Tony Baxter had also created an original castle for Disneyland Paris, and it is a beloved symbol, unique to that park.

like Shanghai that was already reaching for tomorrow every day? One of the hotels we often stayed in was located in Tomorrow Square!

It seemed clear that we could not copy any Tomorrowland we had done before. It would have to be new; it would have to be fresh. Technology, new ideas, sustainability. I sought out a young designer, Scot Drake, who had never led a land before. I thought about how many times people like Marty had taken a chance on me. I wanted to take a chance on Scot. I never regretted it.

Scot was thoughtful about Tomorrowland and was ready to rethink every part of it. I encouraged him to think outside the box. We thought that the upcoming release of the movie sequel to *Tron* gave us a possible new alternative to the more traditional Space Mountain: a dynamic new kind of lightcycle vehicle, a media-driven experience, and something very innovative. Rather than copying Space Mountain, we would develop a *Tron* concept, and a big part of that concept would be to go outside the facility and make a kind of victory lap around Tomorrowland. The combination of going outside the building and completely redesigning the ride system to match *Tron* was groundbreaking and impossibly more expensive than just copying the existing Space Mountain ride.

All these crazy notions were presented in one watershed meeting with Bob Iger. I quickly realized that Bob Iger's vision for Shanghai was not limited to what was already in the deal. He wanted new thinking and he wanted to be a part of it all.

No train, no problem.

When I suggested to Bob that we not copy Main Street and that we switch the idea to Mickey Avenue, he not only overwhelmingly approved it, but he said, "If we were doing Disneyland today, I think we would do it this way." He was on board with us in creating the hub into a magical new land, bringing Dumbo and the carousel and those activating attractions forward. He was on board with *Tron*—the film was in production at the time—and he agreed with a complete rethinking of Tomorrowland.

We even presented the idea that we would not do any sort of Old West or Westernland, but extend Pirates, which by then was a massive film franchise, into a complete land of its own. And we would fashion a new kind of Adventureland with more original storytelling.

This was the launch of more than a year of intensive creative development work. We had a new partnership with Bob Iger, and as we met frequently to debate the concept, he gave us license to push forward new ideas.

We also had a new relationship with what would be called Shendi. Shendi

was our partner and co-investor. It was a team of folks who came from government and industry in China. Unlike OLC in Japan, Shendi was more of an advisory group. But whatever their charter, I wanted to reach out to them. They were all senior or mid-career professionals in China, who had lived their lives during the massive cultural and commercial transformation of the last decades, something none of us Americans could imagine or truly understand. But they had careers and families, and most important, they shared a passion to be the ones who brought Disney to Shanghai. I wanted to be on good terms with them, wanted them to know we cared about what they thought and how they thought the audience in China would engage with our new project. And even though I always knew this was Disney's park, and Bob Iger's park, I always made sure Shendi knew we respected their contributions and perspective.

A year sounds like a long time, but it went by in a flash. There were frequent meetings with Bob, and frequent presentations to Shendi. There were research trips, technical challenges, and the constant fight to keep some sense of scope, schedule, and budget in line with what was being negotiated.

And there were big ideas. Pirates of the Caribbean was perhaps the biggest. Walt had introduced the Pirates of the Caribbean attraction along with New Orleans Square in one of his last television shows, and it had opened in 1967, three months after he died. It was repeated almost exactly at Walt Disney World, Tokyo Disneyland, and Disneyland Paris. But by the time we were developing this new park, Pirates had been the subject of four spectacular blockbuster films. The original idea of the attraction had been reinvented on a massive scale of story, characters, and visualization.

In the original version, guests marveled at the realism of the Pirates characters in story vignettes created by Marc Davis, visual splendor developed by Claude Coats, and story and lyrics created by X Atencio. Audio-Animatronics figures had been created by the technical and creative geniuses at WED, and many guests mistook them for actors.

But after the realism and drama of the films, the ride seemed quaint by comparison, especially to a new audience that lacked the nostalgia of those who grew up with Disney. One of the key factors we considered was the boat ride system. Audio-Animatronics figures cycled through their performances, repeating their movements and gestures in short cycles. The boats that carried guests were moved along by currents of water. There was no tight control over scene timing. We wanted something with tighter performances and spectacular movements. We thought we could combine dimensional Audio-Animatronics

figures, real sets, and props with huge projected scenics. To do that we knew we needed to control the timing and the guests' point of view, something the existing ride system couldn't do.

Luc Mayrand and Nancy Seruto led the team and reached out to WDI's R & D team for help. A giant pool was built in the asphalt parking lot of WDI. In it WDI's ride engineers and R & D created a system based on magnetic motion. The guest boats would be free-floating, with no track or guideway, but they would be invisibly controlled by a system of magnets under the water. The first time I rode it I was blown away. Here we were in a completely free-floating boat, but its motion, direction, and timing were exact. It was truly magical, and it proved we could probably do Pirates the way we really needed to do it.

Scot Drake had once experienced a mock-up, created by ride company Vekoma, that featured a small motorcycle on a fast-moving roller coaster track. He loved the uniqueness of riding with no vehicle around him, just strapped onto a small seat accelerating over hills and curves at sixty miles per hour. Scot never forgot it. *Tron* was based on lightcycles, a modern vision of fast-moving cycles of light that was originally created by Steven Lisberger in 1982. They defied gravity and space. The movie was a breakthrough of computer animation, and it flopped at the box office. But many who saw it, as I did in Tokyo, never forgot it. It became something of a cult classic.

Twenty-eight years later, as we were conceptualizing Shanghai Disneyland, a new *Tron* was being made. Lisberger had handed off the reigns to producer Sean Bailey, who would later become president of Walt Disney Studios, and a young commercial director named Joseph Kosinski.

It was a big risk on the movie, and we were asking Bob Iger to double down by turning it into a new attraction. The attraction would be in production before the movie even opened. Space Mountain would have been a safer bet. But this was a time and project where safe bets weren't the norm.

Tron would need a motorcycle-type vehicle that would be safe, could be loaded in seconds, was intuitive, and could adjust instantly to various body sizes of guests. Scot's experience as a vehicle designer, combined with Mark Mesko's genius as a ride designer, and Vekoma's prowess in manufacturing, delivered. We had a technical review in the MAPO building, and "guests" were brought in to test the vehicle out. It worked for a wide range of sizes, and it was clear it would be one of the great thrills of ride design. To add to the complexity, we wanted the vehicles to glow as they would in the movie.

The concept of the new Tomorrowland included a massive semi-enclosed

skylit structure that would reveal the Tron vehicles as they first accelerated out of the load area. And the architecture would respond to each vehicle by following it like a stream of light. Architecture, ride, story, streams of light, and cannons of dollars.*

As has happened so many times, there were financial and schedule pressures that nearly voted the Tron idea down, and especially the necessity for the vehicles to make a lap outside an expensive new kind of architecture. It has not always served me, but when I believe in something and am on a team, I push hard for it. We brought in Sean Bailey who was a great ally.

It came down to Bob Iger, the pitch, and the vehicle mock-up. And soon we were launched to go like hell to make it all happen.

Bob Iger also came to be enchanted with the idea of a new castle, and what he called "a really big castle." Things were just not small in China, and this seemed like time for a new icon and something with extraordinary presence. Doris Woodward brought forth many options. We cut out pictures from Google of classic castles around the world, and I asked our Shendi partners to put Post-it notes on the ones that spoke to them. We involved architects, artists, and production designers at Walt Disney Animation Studios. It was finally brought together by Coulter Winn as a cohesive piece of Disney architecture, and Doris did the color design personally. A young artist from Beijing, Leia Mi, whom I had met during our Imaginations competition, and whom we'd hired after her graduation, also began contributing concepts for the castle, and her impact was to be felt soon throughout the project.

* Technically, it was not dollars but Chinese renminbi or CNY, which means "people's currency," the official currency of the People's Republic of China, but they were big numbers regardless!

DCA Transforms

Sometimes it is hard to pinpoint that one day when everything changes. For Disney's California Adventure, it was June 10, 2010. Tom Staggs had been head of Parks for six months, and I had been briefing him constantly on Shanghai as well as the advancing state of the DCA reinvention. Tom showed nothing but optimism, and he'd brought George Kalogridis, the most experienced operator and leader across all parks, from Paris to marshal the Disneyland Resort through the process. Everyone was worried we might not have enough capacity for World of Color. There seemed to be a lot of buzz, and attendance at DCA was suddenly a hot issue—for the first time! The Little Mermaid was also opening, but it is impossible to overstate how much of the energy was coming from World of Color. My father, who didn't even know what DCA was, called me and asked how he could get tickets for WOC.

After looking at many capacity studies about possible additional standing platforms in the water, and about removal of trees (something I fought against), George made a dramatic move. We would do two, perhaps three, shows on nights that we could. We would use the limited capacity to our advantage. Guests would need to come to DCA and get a FastPass. They'd need to stay close, then queue up to get their spot.

When WOC opened, a dream thought totally impossible three years earlier became a reality. DCA was a must-see, a hot commodity. The park was

packed with people. George had entertainment add another music party in Hollywood. There were construction fences everywhere. But people wanted to be at DCA. The night vibe was awesome, and every restaurant seat was filled. Tom approved the capital to add the Carthay Circle Restaurant, something we'd been trying to do for a year, on the first night he saw the crowds.

World of Color was all over the media and on the cover of the *Los Angeles Times*' calendar section. There were many things to come—Cars Land and Buena Vista Street were only at the start of construction. But the tide was changing; World of Color had changed the conversation. I for one never doubted the transformative power of our team at Disney Parks Entertainment, but here was another example. For a moment, at least, we felt the wind at our backs.

Groundbreaking

"I just want to leave you with this thought, that it's just been sort of a dress rehearsal, and we're just getting started. So, if any of you start resting on your laurels, I mean just forget it, because . . . we are just getting started."

—Walt Disney

Whatever a laurel is, none of us were resting on ours.

Across the Pacific, in Shanghai, the site for the resort had been cleared and compressed and was ready for Disney to take the lead in park implementation. It became obvious it was time to make a public announcement. The site was ready for construction, and we had a vision, and that meant an event to announce the project to the world for the first time.

By April 8, 2011, a huge tent was constructed in the center of a wide, stabilized, silty expanse of land which was to become Shanghai Disneyland Resort. We had early designs for the park, but we had to quickly make them tangible and beautiful for a commercial audience, yet still be illusive on the details. We had developed a unique park, only the sixth Disney Magic Kingdom–style park in the world, with unique touches reflecting Chinese culture from a combination of our growing team of Chinese-born Imagineers, and our Shendi advisors. We had new and reinvented attractions, an exciting new castle, and a vision for the expanded resort with two hotels.

The giant tent had been designed to accommodate press, VIPs, and a live show featuring dozens of Disney characters and performers, flown in from all over the world. There were traditional Chinese dancers, drummers, and choreographers; and directors and technical people from the U.S. and all over China.

Bob Iger was getting ready to give his speech. He was not quite satisfied that we had captured our intention of building something special in China, a project that reflected the spirit of Shanghai and the uniqueness of the time and the location. We talked about the details of what we were doing, ways we were customizing the park, using advisors, and bringing in new Imagineers, our approaches to language, color, graphics, unique new shows. But it was all too detailed for this kind of venue. It was Bob's inspiration, almost at the last minute, that carried the day. "Shanghai Disneyland Resort," he said, was going to be "authentically Disney, and distinctly Chinese." Sometimes there is a moment when things all come together, when months of dreaming can suddenly be caught like lightning in a bottle. This was it. The phrase he was about to introduce would become the central vision for all our work for the next five years. That central idea rang out so clearly that we could come back to it again and again.

A short while later, Bob stood onstage with Tom Staggs, Shanghai Party Secretary Yu Zhengsheng, and Shanghai mayor Han Zheng to officially break ground on the project. Bob called the project a "defining moment in our company's history."

We had five very busy years ahead of us.

Iteration

Over the course of another year, we developed all these concepts into real solutions for the park, and at the same time, we were negotiating the details of a deal with Shendi. Designs "iterate" (we use *iterate* as an operating word). You put something out there, everyone reviews it, you get lots of input from many disciplines, then you go back and do another iteration. It's kind of a spiral. You start at the wide end, when there are lots of options, and as you move forward the time runs out and the options narrow, until ultimately you get a solution. But when you're in it, it can seem like a spinning process with no end.

The WDI development team was expanding. We would grow eventually to more than seven hundred people in Glendale, so large we outgrew the campus and had to take on a mid-rise building in downtown Glendale. Our focus was detailing out all the ideas into drawing packages, checking budgets constantly, and performing regular updates with Bruce and Craig, with our operating partners, and then Tom and Bob. We also had regular updates with Shendi. Not everything could always be kept in sync. There was the deal and its budget, and there was the constant pushing of the envelope, and the optimism that what Disney was doing was the right thing and at the right time.

I wanted to move Tom and Bob through the park land by land. At each meeting, we'd review a new land, and we'd review any notes they'd had from the last review. It was both grueling for the team's schedule and exhilarating

to have so much of Bob Iger's direct influence. This park was going to carry his signature, his vision of what the new Disney meant in the world, and I felt a real responsibility to make that happen.

At the same time many team members were peeling off and moving to Shanghai. Howard Brown had become my trusted partner. He and I were responsible for all the WDI efforts, and I depended on Howard for everything related to the production of the project; we were constantly in sync on strategy. Andrew Bolstein was my partner in planning how the park should work.

But the site was calling out for the beginning of construction, and there was so much knowledge exchange needed, it was clear many of us were headed to Shanghai.

The China Express

In fall 2011, we started planning a trip. Murray King had joined Disney in Shanghai. Murray was a Canadian fluent in Mandarin who had lived in China for fifteen years. Murray's focus was different. There had been much frustration over getting the deal done, over preserving Disney's interests, and over the challenges of dealing with the local partners. But Murray cut through all of that; he knew this was going to be a project that would change the face of Shanghai and change the face of Disney. Murray felt strongly there should be a senior executive visit. Despite all the individual focus groups, research trips, and analysis, he believed it was important that senior executives responsible for the project come over and see what was special about China, see it all in an express manner, and see it all together.

Thanks to Murray, I got an invite, and it was one of the great experiences of my career. In October 2011, I embarked with a half dozen of my senior management colleagues, those of us who would have the outsized influence over the success of Shanghai Disney Resort, and we put ourselves entirely in the care of Murray and his local team, and my friend and photographer John Diefenbach. Insight and knowledge build constantly, but sometimes seeing a lot at once and sharing it with others creates a group learning that is exponential.

In one "Murray" week, we visited five cities, met with a wide range of

geographic and demographic experts, and explored as much art, cuisine, industry, and architecture as was physically possible.

We had conferences in Beijing and walked the diverse food and fashion streets of the Wangfujing shopping district (where I ate my first and last fried scorpion). We met with young fashion designers, visited flea markets, sampled foods and spaces with cutting-edge restaurateurs, visited contemporary urban art venues and classic places like the Terra Cotta Warrior excavation site in Xi'an. We met and learned about the minority ethnic groups of China. We were dazzled by traditional live performers and posed with pandas. We attended rehearsals at the Sichuan Opera, and cooked tofu and dumplings at the Sichuan Higher Institute of Cuisine. We visited art academies and tourism colleges. We rode in planes, high-speed trains, and freezing-cold buses with blankets wrapped around us.

It is still hard to imagine it was one week. And it all culminated in an intimate lunch each of us had with a typical family in Shanghai. We tasted their soup, dumplings, vegetables, talked about their lives and work, chatted with their kids about their homework or listened as they practiced their piano. One thing I've always known about Disney: it brings people together. It certainly did that week.

One Marathon Day

Eventually in the design and creativity business you run out of time. Though Marty Sklar once said that some artists were afraid of a "blank sheet of paper," my most feared phrase is "pencils down." But in Glendale we were rapidly reaching the pencils down moment. The real unknowns were in Shanghai. The sooner we had design resolved and got people and documentation over there, the sooner we could start to have a sense of how the project was really going to get done.

Knowing this might be the last opportunity, I took a bold move and asked for a final review of the Shanghai concept. I wanted it all at once, all in one day. I requested eight solid hours. Even I thought I was crazy. But Bob Iger's office immediately booked the time. Be careful what you ask for.

In one day, Bob, Tom, Bruce, Craig, all the executive teams, came to WDI for breakfast, lunch, masterplan, six themed lands and all their attraction reviews, the Disney Town Retail and Entertainment zone, two hotels, the subway station, and the lake. It was a great culmination of the wide collaboration across the company and how we addressed notes and issues. And we did it as a guest would experience it, traveling from the parking lot or subway station into the park, land by land and out to the resort. And surprisingly, we finished exactly on schedule.

Actually, a half hour early, which I had intended. Some things I look back

on and cringe—did I really do that? I had decided, at the last moment, to ask Bob if he'd address the team, having just seen everything. It was probably the last time the whole Glendale team would see him together. I figured it was still my half hour, and I just sprang it on him. Thankfully, he agreed.

I didn't tell him it would be seven hundred people, they'd probably have beer out, and they'd be expecting him to make a toast. But you don't usually have to tell Bob very much. He got up on some steps and addressed the team. I don't remember the exact words Bob said, but I do remember there probably wasn't a dry eye on the patio. He was grateful and inspiring. There was no doubt he'd loved the collaboration.

The real work of the next phase was about to begin, and we didn't really know how hard that was going to be. But knowing we had Bob with us as we were embarking on the most challenging and important assignments of our career made all the difference.

Everything Is Possible, Nothing Is Easy

This was an expression often heard spoken by foreigners in Shanghai. I am sure like all great lines of wisdom it was at least based on some kind of truth and experience. I'm equally sure some of my Chinese friends who come to the United States would say the same about our systems.

But the reality couldn't be denied: we were going to build the most sophisticated park we'd ever done, in the most unsophisticated labor environment we'd ever worked in.

We had no experience in China, and the architects and engineers, production companies, and especially the workers had no experience working with Disney. The thing to know is that Disney is a very exacting enterprise. When it comes to WDI, we demand something most companies can't afford: near perfection. There are reasons for this, and they are not all creative. Certainly, story and visual quality are hallmarks of what guests expect when they visit any of our properties. But we also have incredibly high—higher than our industry—demands for safety, sustainability, efficiency of operations; just about every aspect of our business requires the best. And the best is not easy. Elsewhere in the world we'd perfected relationships with companies that could meet our standards. In China at the time, typically a contractor was given the concept of a building, even a landmark building, and that contractor gave a price. Then they did the work. The concept was considered a guide. Substitutions were

made as required, details were compromised, all based on capabilities, availability of materials, convention, and many other factors.

Disney projects are highly integrated. Each contractor must work to exact specifications because all elements come together within fractions of an inch. And the same goes for show systems and artificial rockwork and themed facades. As much as we walked contractors through our facilities around the world, they were still not prepared for the level of detail we required. This slowed down work and required better drawings, detailed approval processes, and skilled execution.

At that time construction was not respected much as a profession in Shanghai. Many workers were actually farmers who did construction jobs between busy farm seasons. When planting time came along, for instance, they all went home. Some might return, some might not. Most didn't own or know how to work with formal construction tools. And, of most concern to us, there was not a commonly held standard of worker safety.

To build Shanghai Disneyland Resort it became clear we would need more of our own people, starting from the architectural offices and all the way down the field to the hands-on construction. And we would need a lot of workers. At one point we realized the contractors would be housing about ten thousand workers on-site in dormitory camps.

Howard and his team embarked on a program to bring the Disney culture of safety to China, not in any way a small task. They built a sample worker camp to make sure contractors knew what we expected in terms of safety and quality of life. We expected clean dorms and bathrooms, quality commissary operations, libraries, recreation opportunities during time off. We wanted a place where we could show Disney movies—not just for fun, but because we believe everyone must know the story they're working on.

But most importantly, we needed a culture of safety. And it was not negotiable. It sounds obvious, but workers had to be stopped if they didn't have boots, helmets, safety belts and vests, or if they'd not been properly trained. Imagine how hard that was to achieve, and now imagine a lot of those workers going back to planting on the farm and not coming back, meaning you had to start all over again.

One thing we had in our favor: there is a tremendous arts and craft culture in China. We could see it everywhere we went. The question was how to break into it. Although we employ the finest artists from around the world, many artistic organizations around Shanghai saw working outside, in the dirt, on

a construction site, as not befitting artists. That left our rockwork designers, sculptors, painters, terribly worried about getting the people they needed. The Disney company also has strong international labor standards, so we were worried about work that was contracted being performed where we couldn't be assured of quality and worker safety when we couldn't see it.

Early on we decided to create a Show Production Center (SPC). It was our own building. We taped out the floor and gave contractors assigned spots. We could supervise the work, the quality, the use of materials; coordinate artistic approvals; limit travel of our folks. And it created a kind of university of Disney, allowing contractors to learn from one another.

We created something called SHEILSS, for Safety, Health, Environment, International Labor Standards, and Security. I even got animators to draw comic strips we distributed to workers' accommodations. Our folks gave out equipment and awards.

Imagine all this, and we hadn't gotten to build the park yet!

The Disney teams required education also. WDI artists are often used to doing things their own way. We needed to learn local methods and be willing to spend time with local contractors. The yield could be great, with new talents and strategies we'd never tried but which worked and some of which we've now adopted. WDI is historically a culture that loves the communities we work in and loves to give back. Pretty soon we had Imagineers reading Disney books in local libraries and playing on community badminton teams. But as much fun as we had, it could be grueling also.

Temperatures and pollution levels in the summer often exceeded what we would allow for working outside. Most people had at least a one-hour commute to and from the site; add those two hours to a ten- or twelve-hour day, and that is all the time you have. We had a commissary, but it left a lot to be desired.

One afternoon I went to a meeting with the China division of rapidly expanding Starbucks. They were considering a sponsorship at the resort. It was a productive meeting, and it seemed to be the beginning of a good relationship. I got business cards for all the executives.

A few days later I called the local head of Starbucks. I told him about our teams, the hard work, and the challenges. I asked him (I begged him!) if they could build a small behind-the-scenes Starbucks just for our people, on the ground floor of our temporary offices. It took a while, but when it finally opened, our people celebrated, a lot of lattes got poured, and the line was out the door. But it made a huge difference.

Howard and I gave out chocolate chip cookies and bagels, and we celebrated the first Disney Halloween in China. We catered turkeys for Thanksgiving. (They were a little scrawny by American standards, but turkey went over well with the teams, even the Chinese team members.)

As work progressed, our partners became even tougher on Howard, but they also started to see the scope of what Disney does, the dedication, and the impact our standards were having on contractors, artisans, and workers. It was their dream, too. When you start to see it becoming a reality, it's hard to believe, and if you weren't so tired, you'd take some time to enjoy it.

Back to Cars Land

One of the two jobs I was carrying was getting close to completion. Cars Land was taking shape, and the primary ride, Radiator Springs Racers (RSR), was racing its way to completion. RSR had been to date the closest thing we had to a ride with advance simulation. We'd done a reasonably close facsimile in our wraparound media "dish" in Glendale. Timing of the ride was critical; programming time was tight. Roger Gould of Pixar had used the simulation to drive the design of the huge and complex car-size Audio-Animatronics figures of Mater and Lightning McQueen.

When we first started programming the ride, Kathy Mangum had a bunch of iPods (really!) with the music and narration loaded on them. We all buckled in and put on headphones. As soon as we pulled out of the seat belt check station, we all hit play on our individual iPods. Eventually we had onboard audio, lighting, and effects, and we had many ride-through tests, often with Bob, Tom, Bruce, Craig, John Lasseter, and many of us piled into a few cars.

The themed street of Radiator Springs and the rockwork of the Cadillac Range were spectacular, especially under night lighting.

One night very late, after test rides, I walked through DCA. It was hard to remember what it had looked like before we started. The place had truly been transformed, and it was about to really explode with the opening of Cars Land. I approached Buena Vista Street. It was lit, and the last of the construction

fences had been taken down. I remembered old black-and-white images of Walt Disney walking down Main Street, based on the Marceline of his youth. Buena Vista Street was never a real place but our dream of what Walt might have seen when he first came to Hollywood. I hoped he would have liked what we did.

Cars Land and Buena Vista Street opened June 15, 2012. Like most openings, it remains kind of a blur. But we succeeded in transforming DCA even beyond what the concept or the pro forma had conceived. I was in Los Angeles for a few days and then back to Shanghai, where we had almost exactly four years of hard slog to go. I had been away too much. My son was growing up fast. My suitcase was always packed.

It was thirty-two years since I had first started at WED.

"It's Kind of Fun to Do the Impossible."

—Walt Disney

It is kind of fun to do the impossible—just not every day for half a decade. It's also okay to work sixty-hour weeks to get a project over the hump, as we say. But in the case of Shanghai, it had been at that same pace for years. Nothing was easy.

There are success stories along the way that give you inspiration and convince you that you can keep sprinting toward the dream. Some of my best memories are associated with young people who grew up in China and started their careers with us. Leia Mi was just out of art school at Savannah College of Art and Design and now she was art directing large portions of the massive castle we had underway. Chang Xu had started with us as a graduate student in media. She had led a bunch of lumbering Americans through research in China, through language and storytelling, and color preferences, music, and art. And now she was essential to every show and attraction. Our partner, Andrew Bolstein, who was putting together the entire operation, was engaging his new Disney cast with a diversity of Imagineers, planning training and development, and making sure we were all speaking the same language.

Entertainment was developing shows, designing technical staging in highly complex facilities, writing scripts in native Mandarin, and negotiating the size of fireworks displays local governments would permit.

Experienced WDI team members amazed me daily. Despite all the long

hours, challenges of tight budgets, schedule conundrums, rework, personal difficulties, illness, you just can't keep Imagineers down. And you cannot keep them from thinking creatively, from breaking through with some new technological innovation or production work-around. Walt Disney once said he thought of his people like walking eight dogs. Everyone had their own ideas, their own direction, and he just had to try to steer them in roughly the same direction.

By the end of 2014, with so much happening at once, Bob Iger started visiting the site every month. We didn't know it at the time, but this would go on for the next eighteen months! Howard and I decided on total honesty; we wanted Bob to see the park, wherever it was, each time he came. He walked through mud and dirt and sweat just like we all did every day. He saw the successes and heard us out when we were frustrated by failures or having to tear up work that wasn't right.

Late in the schedule we'd come to an agreement with Shendi to increase the size of the project. We added Soaring Over the Horizon, based on Soarin' Around the World at EPCOT, and a few additional enhancements, including walk-through exhibits based on *Star Wars* and Marvel.*

The additions were going to be a huge boost to the park and the operations, especially Soaring Over the Horizon. But they were a huge strain on the team, already stretched to deliver the original opening day scope of the park.

*Disney purchased Marvel in late 2009, and Lucasfilm in late 2012. But the acquisitions were too late for any major new attractions to be developed for Shanghai's opening day program. We knew pop-up exhibits would be popular, and we needed the capacity. Hong Kong Disneyland was to get the first major Marvel attraction, Iron Man Experience, which opened in January 2017.

Press Reveal to the World

"We are building something truly special here in Shanghai that not only showcases the best of Disney's storytelling but also celebrates and incorporates China's incredibly rich heritage to create a one-of-a-kind destination that will delight and entertain the people of China for generations to come. We are taking everything we've learned from our six decades of exceeding expectations—along with our relentless innovation and famous creativity—to create a truly magical place that is both authentically Disney and distinctly Chinese."

—Bob Iger, July 14, 2015

Disney communications had kept the scope of Shanghai Disneyland under wraps for more than four years, ever since initial teasers were put out at the groundbreaking. It was an extraordinary achievement given the interest in the park from bloggers and the press. But it finally was time for a major reveal. We had plenty of art for the event, but it was going to be a massive effort to put together and make it all consumer and press friendly. I wanted our overall park model for the event, so we'd have something dimensional for Bob to stand in front of, but it needed a lot of cleanup, too.

The press event was set for July 14, 2015. The planning was down to the wire. While we had maintained tight secrecy on the date, we planned to show just about everything regarding the park in detail. When Bob Iger revealed

the huge model of the park, he stretched out his arms, like he was offering it to the people of China. It became the most memorable and widely published photo of the project. After the event, the hall where the presentation was made remained open, giving those from the press and bloggers all the time they wanted to document every detail. The posts rapidly reached the U.S. press, and buzz started circulating about Shanghai Disneyland. For our team members, it was the first time they could send images and articles to friends and family members describing what they'd been secretly working on for the last four or five years. The highlights picked up were detailed:

- Shanghai Disneyland would be a theme park with six themed lands: Adventure Isle, Gardens of Imagination, Mickey Avenue, Tomorrowland, Treasure Cove, and Fantasyland (with its Enchanted Storybook Castle).
- Shanghai Disneyland Hotel and Toy Story Hotel were imaginatively themed and adjacent to the theme park.
- Disneytown, an international shopping, dining, and entertainment district, would be adjacent to Shanghai Disneyland and include the Walt Disney Grand Theatre, home to the first-ever Mandarin production of Disney's Broadway hit *The Lion King*.
- Wishing Star Park would be a central point of the resort, with beautiful gardens, a walking path, and a glittering lake.
- Mickey Avenue, the first main entry at a Disney Park inspired by the colorful personalities of Mickey Mouse and his friends, was unveiled. The neighborhoods of this whimsical avenue would offer guests the opportunity to share a hug and get a photo with some of their all-time favorite Disney characters.
- Gardens of Imagination would celebrate the wonders of nature and the joy of imagination. Guests here could take a spin on the Fantasia Carousel, soar on the back of Dumbo the Flying Elephant, and enjoy the area's iconic Disney entertainment, including Ignite the Dream, a Nighttime Spectacular of Magic and Light, a huge-scale show combining cutting-edge media projection, water effects, and fireworks, all set to dramatic philharmonic music. From several places in this land, guests could enjoy Mickey's Storybook Express, a parade with its own musical soundtrack and colorful performers on the longest parade route in a Disney Park.

- Fantasyland, inspired by Disney's animated films, would be the largest land and home to the Enchanted Storybook Castle and its stage shows. Guests could immerse themselves in familiar Disney stories as they entered Voyage to the Crystal Grotto, went in and out of tunnels glowing with dazzling diamonds on Seven Dwarfs Mine Train, and took flight over the skies of London on Peter Pan's Flight. They'd also be able to explore the Hundred Acre Wood with Winnie the Pooh or follow Alice through a Wonderland maze.
- Adventure Isle would take guests to a newly discovered lost world, filled with hidden treasures. There'd be the mighty Roaring Mountain towering over guests, who would be able to blaze their own trails at Camp Discovery, travel around the world on Soaring Over the Horizon, or embark on the thrilling rafting adventure through the heart of Adventure Isle on Roaring Rapids.
- Treasure Cove would be the first pirate-themed land in a Disney Park, a place to join in the adventures of Captain Jack Sparrow and Davy Jones. Guests exploring this pirate world could enter Pirates of the Caribbean—Battle for the Sunken Treasure, an attraction featuring a boat ride into a journey that offered cutting-edge innovations in robotics, animation, set design, and multimedia. Guests would board a pirate ship, paddle through the scenic cove on Explorer Canoes, and dine at Barbossa's Bounty.
- Tomorrowland would emphasize the limitless possibilities and optimism of the future in Shanghai. Disney's innovative use of technology promised a land where guests could be on the way to infinity and beyond via Buzz Lightyear Planet Rescue, a new space ranger adventure, or could break the bonds of gravity on the attraction Jet Packs. A massive color-shifting canopy would lure guests to Tron Lightcycle Power Run, a coaster-style attraction where guests could board a train of two-wheeled lightcycles for one of the most thrilling adventures at any Disney Park.

It was a relief to all of us to have the news out there. But it highlighted the obvious fact we had about one year to go, and we still didn't know if we could make it all a reality.

Peer Review

Three months later, Bob Iger invited the entire Disney Board of Directors to Shanghai. Bob had continued his cadence of nearly monthly visits and believed the timing was right for a full board visit. It would be a lot of work to get things ready, but we were committed to showing the project as it was, not cleaned up. There was no overly optimistic message ever conveyed; we were realistic and transparent.

Howard was working on lots of decks for the meetings. It was to be a very comprehensive delivery review. The last time the board had seen the whole project was in 2011, when Steve Jobs was still alive. I remembered it clearly because Steve was skeptical that we could do a successful Tomorrowland. But this review covered status, quality, and (as always) projections on when the park would open.

Howard was struggling. Scheduling analysis showed we could open by the summer of 2016. But it was hard to believe that would hold when walking around or looking at drone footage and aerials. There were whole buildings still in steel framing, there wasn't a square meter of paving or landscaping, and none of the truly complex things in the project had been programmed or cycle tested. I suggested to Howard that we compare ourselves at this stage to the opening of EPCOT in 1982. We both knew that all Disney Parks come together at the end. It's basically a strategy of getting the facility contractors

done and out of the way. Once it is mostly about show and ride, and finishing, WDI was always able to deliver. Whether we truly believed it or not, the images we pulled from WDI archives were enlightening. EPCOT looked less finished at this stage, from aerials and schedules, than we did.

We saved the EPCOT comparisons to the end. The board was somewhat relieved by them. But basically, they left with two messages: "Shanghai Disneyland is going to be amazing, and you folks got a lot of work to still do on it."

Huntington Hospital, Pasadena, CA

A Few Months Later

I had driven myself to the hospital's emergency entrance. When I described my difficulty breathing, I was moved immediately to a room and hooked up to a steaming breathing mechanism filled with albuterol. My lungs began to open. It was around three o'clock in the morning. My blood pressure was exceedingly high. Days before in Shanghai I'd been unable to keep food down. On recent visits to California, I had spent entire nights with my head on the bathroom floor, trying to cool down from constant vomiting. Worst of all—I never slept; I woke up every morning around 1:30 a.m. and that was it. A doctor came in and asked me if the albuterol was working, and if anything else extraordinary was bothering me.

I told him about the park, the lack of sleep, being behind schedule, having to disappoint my boss and my colleagues, stress, air pollution, air flights. He kind of shook his head and asked me if I wanted any antidepression medicine. He asked if I could take a month or so off to recoup . . . before realizing that just was not going to happen. He said I should stay on the breather for another few minutes and be careful driving home.

I took a deep breath. I realized nothing I had told him was the true cause. It was not the job, the deadlines, the pollution, nor the air travel. I had simply lost control of my life. No one made me do anything. I had disrespected life so much; I'd been careless with the preciousness of it. I was separated from Diane,

had entered into another relationship, and was trying desperately to salvage a bond with my son who was now away at college. The pace of work had been the same since he'd been a junior in high school. None of this was necessary, and I couldn't blame it on the job, the distance, the pressure, or the loneliness. It was my doing, alone. This was not an accident or a sudden illness. It was a reaction.

I have thought many times since then that how we act or react is entirely up to us, but what we do affects others we care about, and wounds we cause can take a very long time to heal. Or they just never do.

I drove back on the lonely predawn freeway. I still had a park to finish, but I realized that was no excuse to not have a life, or to not be present in mind to those who I loved and who depended on me.

Judgment Day

On November 10, 2015, Taylor Swift was playing at the Mercedes-Benz Arena in Shanghai. Howard Brown had tickets, but he was outside the arena, dialing into a conference call. I was also on the call. I was in a room filled with Disney executives, including Bob Iger. It was 6:00 a.m. Orlando time, and we were drinking coffee in a small breakout room in the Four Seasons Hotel. Howard was barely audible, and he couldn't really read the room over the phone. It was the last day of Bob Iger's company workshop, something he held every two years. After the wrap-up party the night before, most of us should have been sleeping in. But it was an intense call. It was the last day for a call on what day Shanghai Disneyland Resort was going to open. Everyone on the Orlando end (except me) was voting for May 2016, seven months from this point. Howard, and the opening WDI team, plus Philippe Gas, president and general manager of Shanghai Disney Resort and Andrew Bolstein, the vice president of operations, all spoke in agreement. We were holding out for a June 15, 2016, opening. It's always a tough question: If you can be ready for June, why can't you be ready a month before? We knew even June 15 was a date that would require heroics. It would demand a phased turnover of attractions, giving Andrew a very tight training schedule. But we stood by it.

It felt to me that we were about to be overridden. We'd made articulate arguments, but they weren't playing. May was an important month: the start

of summer holidays, with kids out of school, and the weather perfect. It was finally Bob Iger who settled it. "The world is watching," Bob said, "and we can't have anything that's not ready." We closed the meeting, settling on June 15, 2016.

Bob Chapek had been chairman of Walt Disney Parks and Resorts for only eight months, but he'd started coming to Shanghai with Bob on his monthly reviews. He was an exacting executive who didn't like risks, so he didn't want to set a date and not make it. He wanted assurances from us, which we gave with caveats. Bob didn't like caveats, and he didn't like percentages unless they were in the upper nineties.

A few days earlier, Bob Chapek had invited me up to his suite at the Four Seasons along with Tami Garcia, head of human resources. I was hoping I wasn't about to be fired. But I had gotten to know Bob through his role as head of Disney Consumer Products, so I was pretty certain it was not that. But he told me his direct reports had informed him that there were only three things wrong with the parks segment, and they were, in order, "WDI, WDI, and WDI!" I didn't agree, but I had already found him to be a difficult guy to disagree with. He was smart and he was skeptical. I was as disconnected from what was happening at WDI as I had been from life in general in the United States.

By the end of our meeting, Bob had asked me to take the reins as president of WDI. It was exciting and painful at the same time. These were my friends, and besides, I was hoping to finish Shanghai and maybe take a year off to catch up on life. Bob was unrelenting in a nice kind of way. He wanted me to start right away, even if he knew my time would be divided until Shanghai opened. He was wrong about the only creative R & D operation started by Walt Disney himself, and I was determined to prove it to him.

Six More Months

Six months might seem like a lot of time. That's how much time was left before a ribbon would be cut, speeches would be made, and Shanghai Disneyland Resort would officially open.

There were plenty of things still to do outside the theme park, including finishing up work on two hotels. Finishing a hotel is a project in itself, with complex interiors, furnishings, restaurants, rooms, and back-of-house services that enable staff to operate the hotel while welcoming guests daily all vying for attention.

There was also Disneytown, which involved primarily third-party companies that owned and operated the retail shops and restaurants, though WDI still held storytelling and art direction responsibilities.

And the crown jewel in the heart of Disneytown was the Walt Disney Grand Theatre, the first dedicated Walt Disney Broadway house to be built in China. We were in the process of completing the theater at the same time rehearsals were underway for the premiere of the popular Broadway show *The Lion King* to be performed entirely in Mandarin. The rehearsals and cast were wonderful, and we were excited for opening day. I remember the first time I brought Thomas Schumacher, president of Disney Theatrical Group, to see the Walt Disney Grand Theatre. Tom has been a mentor to me, an idol, someone I highly respect and have learned a great deal from. I watched from a distance

his incredible career in animation and in building Disney's theater business into a global powerhouse.

We had worked closely with Tom's team as we conceptualized the space. Sometimes executives come in and spend a few minutes and point out a few notes and congratulate the team and then, by necessity, move on to the next project. When Tom and I walked into the theater, he became a director. "Would you mind if I'm just quiet for a while?" he asked.

Theaters hold a special reverence for those of us who believe they descended from the art of storytelling dating all the way back to the Greeks, and they are a somewhat religious church-like space where people come together to celebrate and share their emotions. It was clear that Tom was feeling the space. He saw it from every angle of the house. Once I got used to the fact that he wasn't going to say much, he just wanted to feel it, I was inspired and loosely followed him in case he had a question.

~ ~ ~

"All of our dreams can come true if we have the courage to pursue them," said Walt Disney. When you're working eighteen hours a day for long periods of time, it takes courage to keep on going. To keep on chasing that dream even when faced with a roadblock, finding a work-around to allow you to keep on going until the dream is achieved. The park's opening team displayed nothing less than courage and stamina in those final months, days, and even hours.

Everywhere you turned, teams were pushing forward, making progress, pursuing excellence. The Adventure Isle's Roaring Rapids attraction is a hurdling turning ride vehicle that runs down waterfalls and across splashing hills with guests getting soaked. But the degree of soak has to do with the fall, as well as the force of the turning and dropping. Even with computer simulations, some of those things are simply unknowns until you actually get out there, run water in the trough, and see how the boat behaves. During ride-testing, Stan Dodd and the team were making adjustments to the waterway to enhance the experience, and to control the level at which guests would be getting wet.

There are always stories to tell, figures to program. During this stretch of a project, what Imagineer Joe Rohde calls the "micro adjustments" phase, the slightest change can be the thing you need to do to reach the emotional impact you dreamed of providing. A slight change in the boat's motion, the cue for a figure to react, the start of a projection, or the start of a music cue can have a huge impact. "Micro adjustments" are critical, and they take time.

The final testing of rides is essential to Disney, and there are protocols for how many and what types of tests are required. Software and hardware tests might include hundreds of thousands of items that have to be cleared. Often, the entire facility needs to be closed so that the ride can run safely without worrying about anyone walking around. That means an art director or a designer or a technology expert who needs to fix one wire, or someone who wants to touch up a wall, might have to wait until 2:00 a.m. until the ride-testing is finished to be able to go inside the facility. I remember a team was riding Pirates of the Caribbean and came into one of the most dramatic scene reveals, and there was a security guard in a folding chair sitting in the middle of the scene asleep. He wasn't even dressed as a pirate!

~ ~ ~

Extraordinary heroics—there's no other way to describe the performance that members of WDI's team demonstrated the whole time, but especially with opening day approaching. To have a few people in a boat, all night, night after night, with the programmer (with her laptop) seated in the back, taking the ride again and again, and adjusting the cues again and again, and getting the software right, getting the story right—it is an amazing sight to see.

Our entertainment team was diverse, talented, and dedicated to being "authentically Disney, distinctly Chinese." They were committed to delivering live, exciting, and interactive experiences for guests. Every project they had, and there were many, needed help. They needed supporters to share their enthusiasm and to make sure that no one tried to cut them out or keep them from delivering on the full scope of what they had dreamed of doing.

In one major show, Eye of the Storm: Captain Jack's Stunt Spectacular, we had the idea that we should celebrate the physical comedy that was prevalent in the Pirates movies. The massive scale of the actual ride would capture the drama of a descent down into the depths and abyss of the ocean, and then the return up to the top. In addition, the ride would immerse guests literally into the oceanic world of pirates. The stunt show was to feature a human cast with real people bouncing on trampolines, manipulating puppets, engaging in fights. In contrast to the actual ride, it would be a charming and funny human-scale show. Still, it presented challenges.

We needed something big as a finale. The creators, Matt Almos, Jon Binkowski, and Lisa Enos Smith, said they wanted Jack Sparrow, the lead pirate, and his adversary to have a sword fight during a typhoon literally in midair.

"In midair?" we collectively asked. Yes, it could be done by using a technology that had been developed for tourism, which uses a giant fan that creates an air cushion that allows a person to float in midair! It would be a first for a live stage show, putting two people in the same fan space in midair for a few seconds at the end of the show. Captain Sparrow and his opponent would battle in the middle of the air, creating a thrilling experience for guests, not to mention the performers!

It was a stunning idea, but exceedingly difficult to do. It required a specific group of artists and engineers to build the massive fans and learn how to perform in them. Plus, it required an incredibly complex technical installation in the theater, and there were untested challenges using these high-pressure devices. The structure had to be mitigated to make sure the theater would always be safe. On top of all the challenges, only a few days before a critical Bob Iger review, something went wrong in sewage control and the basement literally flooded with, well, yeah.

What did the team do? They didn't fly home. They didn't retreat. They had the *courage* to pursue their dream no matter what happened. We cleared and cleaned and antiseptically prepared the entire basement so the team could get on with their rehearsals and their tests. The tests continued to be difficult. They worked up to the deadline to be ready for a final rehearsal with Bob Iger. And we still didn't know if the midair effect would work.

Then, hours before Bob Iger was to arrive, the control system of the sewer, which had not been properly fixed, flooded the theater a second time. Everyone again jumped in to clean out the basement and completed it just before the show rehearsal. I sat a few seats away from Bob, along with others, as our whole team watched the show. At that moment, I was not certain whether the sword fight in midair would happen or not. The actors had been practicing it. They had been hoping to have it, but they had a work-around in case it didn't work.

The initial stunts all worked! The effect was astounding. Even a jaded in-house audience applauded the wonderful cast. And then the moment came for the sword fight. The tornado moved through the scenery, and then I felt it in my heart, in the depths of my diaphragm; I could feel the fan turn on and I saw Jack Sparrow pull up his sword and jump into empty space, flying in a circle of a thrilling wind. Next, his adversary immediately jumped in, and the two of them started circling in a whirlwind, fought for a few seconds, and then jumped out of the cyclone onto platforms that had been prepared earlier for their safe exit.

Everyone in the theater went wild. It remains for me one of those great

moments that I will never forget. And when the team assembled for notes, I'm not sure how much they heard. That's because they were so exhilarated—and so exhausted. But they had managed to make it happen.

~ ~ ~

There are people who can use their force of will to get things done. And there are those who can use their force of will to get impossible things done. That was the case with Craig Russell. The tools that Craig Russell uses are the site walk and his optimistic tone. He walks and he walks, and he walks . . . and he walks fast. And anytime there was a roadblock on the site that could not be worked around, anytime it was predicted that something was not going to make it on the schedule, Craig would gather the relevant parties and they would hustle across to where the trouble was. He would look at it and would talk to each member of the team, and they would talk it through, and they would find a way out. I never saw Craig come back from a site walk saying, "I don't think we're going to make it" or "It's impossible to get there." He always came back saying, "We know how to do this." It was nothing short of remarkable.

There are so many daily miracles that you start to think it's normal. Miracles happen because project managers and schedulers and engineers and analytical modelers sit in crowded cubicles all day with computers and propose work-around solutions. The site is so massive that there is a sense of having a control tower that lights up and says, "There's a conflict here. There's a conflict there." Without these geniuses, without ride engineers who, despite pressure, methodically will go through thousands of protocols; without schedulers who will do thousands versions to get something to work; without the genius of so many people, these projects would never come together.

Back to Glendale

As I flew back to California, I was abducted by aliens on the plane. They replaced the tired creative head of the Shanghai project, who loved his team and loved working in the dirt, with a *president* of Walt Disney Imagineering. And when I landed in California, I realized that things had changed. I knew that being president would be different, and I knew being president for six months while Shanghai was being finished would be a nearly impossible scheduling and coordination challenge.

And here I was being introduced as the new president of WDI to people I had known for twenty or thirty years. Originally I thought, *I'm already working on the biggest project WDI is doing. Let's say that it's three projects that size and you're doing it at a pretty high level, so it should be fairly straightforward.* Nothing could have been further from the truth.

The first day that I was in the office I had to discipline someone. It was appropriate because the person had violated rules that were important to the company's ethics. My day then went into a cycle of legal and communications and human resources and developing an introductory talk that I would give. Every talk I'd given in Shanghai was based on what was happening at the time; I never had prepared remarks. I just spoke extemporaneously. Sometimes I would have an index card or two. I usually just tried to define three messages: 1) we all have to focus; 2) we all have to work together; but we also need to

3) get plenty of rest. Three messages. But everything could always fit somehow into those three messages and leave a clear impression.

Now I needed messaging that had to speak to a broader constituency—many, many people I did not know, people who didn't necessarily know what I had been doing the last six or seven years, and probably at least a percentage of people who were unhappy that I had somehow come in to take over. And I'm sure in some ways, some also resented the fact that I was going to be in Glendale for about a week, and then on my way back to Shanghai. My administrative partner and EVP, Anthony Connelly, and I approached WDI trying to understand where we could impact the organization, both from the standpoint of Imagineers and from a management perspective, and, very importantly, with the intent to boost morale.

I gave the speech. I introduced myself to the Imagineers. I shook hands, I thanked people, and I tried to stay on message.

Message one: Imagineering should be a creative company, an innovation company. It had to be an R & D company and we should not do conventional work. We should make sure that there is something special about every Imagineer that cannot be found in a consultant. And when projects get big, as Shanghai had, we could bring lots of consultants in to help us get work done. But first and foremost, we needed to be a company of unique people.

Message two: We need to have great relationships with our operating partners—Walt Disney World, Disneyland, Shanghai Disneyland, Tokyo Disneyland, Disneyland Paris, et cetera. I didn't feel too worried about that, because I always had great relationships with the partners, and I had them with our Shanghai team, but it became more and more obvious that the operating relationships with WDI were strained by schedules and finance, and there was a lot to do to rebuild the credibility of WDI and the relationships with those partners. That seemed to be a big item on the to-do list.

Message three: WDI had been *overworked* by projects, which is okay, but we had been overworked for a very long time! We needed to what I called "refresh the pipeline." The pipeline meant new ideas, fresh ideas, ideas that we didn't know how they were going to be done or where they might be done, but that a certain amount of our creativity needed to be devoted to our future, not just to our present, despite all the challenges of current projects.

I repeated it everywhere: 1) be a unique R & D creative organization, always looking to the future; 2) establish great relationships with our partners; and 3) refresh the pipeline of new ideas.

When I went back to Shanghai, I couldn't wait to get back on-site. I huffed and puffed through many walk-throughs with Craig Russell. I went out with Howard. I went out with our teams. I found out how everything was going, and I got to ride the attractions, make notes, go into theaters, make notes, see live entertainment experiences, and make notes. I had the advantage of being away for a week. The on-site team didn't have that; they saw progress hour by hour. By going away, I came back and saw giant leaps forward, and I tried to convey to everyone that these giant leaps were heroic, and everyone was really delivering something very, very special.

I did dinners, I did lunches, I did breakfasts, we did bagels . . . we did everything we could do to give people something; even an unexpected cookie was a recognition that they were there, and they were making it happen every hour of the day. Fortunately, the people themselves were resilient. They would figure out if someone was sick and needed to get off-site for an extended period; there were people who pooled together their vacation time or medical leave time to give it to a team member if they needed more time. There were teams that held their own little celebrations. As longtime Disney executive Mary Niven once said, "Every day should be a celebration. Every event should be a celebration." There was occasional craziness, but those things sustained teams.

I was staying at the Four Seasons. I woke up early and went to get some coffee. Bob Iger was there with his iPad, probably reading the *New York Times*. I tried to grab my coffee and slip out, but he waved me over to the seat next to him. I sat down. He asked me how it was going. I told him we were excited about the progress and what we were about to show him that day, and then added that as far as I was concerned, I didn't see anything that was going to be a deal-breaker for opening. It was just going to be lots of hard work and lots of time, and to the degree that he could spend time inspiring the teams, it would be an amazing energy boost for them to have him there.

But then he asked me how it was going at WDI, and I explained my first trip after the promotion a little bit and the challenges that I saw I had. He said, "What can I do for you?" And I said, "Well, you can answer a question for me." And he said, "Sure, anything." And I stopped for a second and I thought, because I wanted him to think about the question. I said, "There's two ways to think about WDI," an organization that is incredibly important to The Walt Disney Company and has been since Walt founded it in 1952 to create Disneyland. The first way was to think about WDI as a golden goose. WDI was like Pixar Animation Studios or Walt Disney Pictures . . . or like Walt Disney

Animation Studios. WDI was a creator of experiences, and we worked with our co-creators at Marvel, Lucas, Disney. But we also created original things that people could experience in physical space. It's different than a movie. It always has been from the days Walt was building Disneyland. But our first aim in life as an organization was to be an engine for the growth of Disney through our creativity and our groundbreaking work.

The second way to think about WDI, I said, was as a service organization to our park partners. That meant when they needed a new attraction, they'd give us a few suggestions about where and how and what demographic they needed to reach—and we would go to work quickly with our other content partners, and we'd create something that matched what the park was asking for. "But," I said, "that will never yield the Tron ride, the new Pirates ride, or a *Star Wars* land. It will not necessarily yield those things that will break the ceiling over the existing norm of attractions versus being a creator."

Bob stopped me and he had the answer immediately. It was clear. "WDI is a golden goose. You are like Pixar. You are like Disney Animation, and I expect you to be content creators, constantly developing new ideas for the parks and things. Because when WDI invents, it truly does radically change the history of our projects. You proved it on DCA [Disney California Adventure], you're proving it on Shanghai. Walt Disney Imagineering definitely is a golden goose, period," he said.

I had my direction.

Two Jobs Again

I was back on the shuttle, practically and figuratively. I was in Shanghai, where the race was on to finish, and I was in Glendale, and the race was on to show I knew something about what I'd been asked to do. I found the Glendale job a lot more difficult.

Norita Cullen had been managing my office, travel, and schedule for more than seven years. But she had also worked in the front office of WDI; in fact, for Marty Sklar at one time. She knew the ropes of so many things it would have otherwise taken me months, and multiple faux pas, to figure out. As I was back and forth, she'd already moved us from our base down Grand Central Avenue to the gold coast, and me right into Marty's office. I had some hesitation about moving into Marty's space; I felt like an upstart, moving into a space that Marty had occupied for so many years. Marty, the Disney Legend; Marty, who'd worked with Walt himself; Marty, trusted by generations of Imagineers. Norita's insight was always keen—she said people expected me there. Whether I was comfortable or not was not the point.

~ ~ ~

In the run-up to the completion of Shanghai, Bob Iger had said many times his two most important initiatives were the return of *Star Wars* to the screen and to the parks, and the success of Shanghai. Bob had been personally involved in

the early development of new *Star Wars* park initiatives, as he had in Shanghai. From the beginning, a new *Star Wars* land was thought to be unprecedented in size and scope, entirely new, and Bob wasn't waiting around for it. The initial, highly confidential planning called for the building of two large *Star Wars* lands, in almost the same time frame, one inside Disneyland, and one inside my alma mater, Disney's Hollywood Studios. They'd open just months apart, leaving no time for any kind of lessons learned from the first one to be applied to the second one.

To understand the massive *Star Wars* initiative, I reached out to Scott Trowbridge. I knew he was a tremendous leader with a depth of experience and deeply immersed in a complex and important project. I immediately felt a sense of confidence in Scott and his team, especially Jon Larena, Robin Reardon, Jon Georges, Margaret Kerrison, and Chris Beatty. But they had a lot of challenges lined up, new and complex ride systems to check out, and many untried show ideas. These things actually never scared me. What is always difficult is combining the completely new and untried with a fixed budget and an accelerated schedule. It was too early to assume we had a handle on all three.

As *Star Wars* was just emerging from concept, Pandora – The World of Avatar was just being completed at Walt Disney World's Animal Kingdom. Pandora shared certain characteristics with the early *Star Wars* ideas. It was massive, completely new, with unproven technology, a tight budget, and an accelerated schedule. Pandora had increased in scope multiple times. The team felt they were in sync with management under Tom Staggs. But when Tom moved out from Parks, the perceptions changed.

Bob Chapek's concern at the time, and it was certainly valid, was that the two *Star Wars* projects were much larger than Pandora, which was huge. If those *Star Wars* projects were allowed to increase in budget at the same percentage as had happened with Pandora, even with approval, it could be a major burden on the park's business plans.

I accepted Bob's concerns, but I thought we were going about it in the wrong way. Senior financial executives were visiting WDI daily, sitting down to approve or disapprove budget items, even tiny ones, line by line. The first thing I wanted was WDI to be handling WDI's business. This meant the team had to be aggressive, forceful, and committed to business as well as creative goals. I knew this to be the case, but it was not clearly visible. And I knew for something this complex I needed the best implementation leader in the business. That would be Craig Russell, who happened, at the time, to be a little otherwise

occupied opening Shanghai. But I was trying not to panic; it was time to be purposeful and methodical.

Pandora opened barely a month before Shanghai on Memorial Day weekend, 2016. I have never thought that success heals all wounds, but if you're over budget or behind schedule, it definitely helps if you're successful. In the case of Pandora, the success was unprecedented. I had sensed it in my first test ride in the massive simulator facility at WDI, where the team was doing the final programming for Avatar Flight of Passage. Jim Cameron, creator of the original movie; Joe Rohde, consummate artist, storyteller, and leader; and Imagineer Amy Jupiter, driving a new kind of visual production, had achieved a ride experience no one had ever imagined before. I thought it was emotional, aspirational, almost cathartic. Jon Landau, Jim Cameron's producer, was critical to the mix, as were many cutting-edge WDI artistic, ride, and technical talents working collaboratively with Lightstorm, Cameron's production company.

Pandora was a huge success. It drove an explosive attendance increase at Animal Kingdom, and Flight of Passage quickly became the most popular and sought-after ride in all of Walt Disney World.

Shanghai Opens

I remember so many things about openings, but at the same time I remember so little.

But mostly I remember people who have extraordinary talents and apply them in a way that looks like magic, even at the eleventh hour. Walt Disney's genius was great storytelling, and then making his film stories into real places, where people could truly live them. Even today, the diverse talents who accomplish this bring an incredible backlog of their own internal knowledge; they may bring a brush or a movement or any slight twist to a program, and we suddenly can see it move from being something ordinary to something that is completely enveloped in story.

Then I remember the environment in which we all work. I think of an environment that is crowded with construction materials moving in, waste materials moving out, people being trained, carts of merchandise being dropped off, carts of food coming in, custodial teams trying to clean streets, lights being hung, decorations for opening being installed, media and public relations groups documenting the park for the onslaught of international press about to begin. It's a mad rush that has its history in the opening of Disneyland.

To a casual observer, it might seem like there is no apparent traffic control. It would be a complete mess were it not that every group is courteous to the other groups and knowledgeable of the other groups' part in creating the total

picture. As a result, it is a clumsy yet choreographed few days as it all comes together.

For me there is usually some kind of rich memory, some epiphany, something that stands out that pulls it all together, that has such simplicity but is so meaningful. In Tokyo it had been elderly Japanese women in kimonos and Mickey Mouse ears coming through the gates with their grandchildren, showing broad smiles and tears of joy on their faces. At Disney-MGM Studios we'd all had this sense that the love of movies had really left Hollywood and come to life in a new way at Walt Disney World. And at Disney California Adventure, it had been the sense that if you don't have heart, you can't get there . . . but if you do, you can go anywhere.

Thirty-three years after the opening of Tokyo Disneyland, I walked a wide circle around Shanghai Disneyland the night before our preopening, when families and friends would be invited to experience the park for the first time. My walk was usually the same. But this time it was taking a bit longer to complete. I usually came in from our offices, headed right into the middle of Fantasyland, around toward the castle, traversing the pirates' Treasure Cove, through Fantasia Gardens, and up to the castle stage, before stepping into the broad expanse of Tomorrowland (where the Tron vehicles raced like comets through the misty air, as if set free from the building that might have once contained them). Then I'd go past the entry to lively, brightly lit Disneytown, and down Mickey Avenue.

I was pleased to see almost everything in place: lights, trees, facades. Attractions were operating. Restaurants were being tested. It really felt like we had achieved something. Certainly, there were a few things missing, and we had promised Bob there'd be everything in place. There were a few scaffolded areas where rockwork was still being completed or aging was still purposely in progress. A few trees were still being planted. There were a few spots where there were fences because an underground pipe had failed. In the middle of this perfect park, for example, a big hole had to be dug to get down and replace a pipe. But even with those things, it was all coming together.

I circled back toward Adventure Isle and had one of those epiphanies. As I walked along the sidewalk, there were a bunch of flashing lights along a fence railing. I could not figure out what they were. Did we have fireflies in the park? I got closer and realized there was a large group of elderly Chinese workers, mostly women, all bundled up. They had bonnets on their heads, and they had paintbrushes. They were painting the railings.

And the amazing thing was they were painting the railings by the light of their iPhones.

~ ~ ~

First thing the next morning many of us crowded around the "Walt" statue between the castle and Mickey Avenue. Tissues were at the ready. We'd all seen this drill before, but it never got old, and the emotions were no easier to contain. So many of us—one dream, one team, one family, from so many diverse disciplines and places, from WDI and from every business unit—all there to see the same thing, the first guests. They had waited hours. We had waited years. They were exhilarated, we were exhausted. They didn't know what they were about to explore, and we had no way of knowing how they'd react to what we had collectively created. For a fraction of a second, we made eye contact with parents, grandparents, children, friends, lovers, as they raced to round the corner ("no running, please"), and on to the attractions. The parade of guests would continue for hours. We would share a few hugs and tears as a team and be on our way home. To pack, or to sleep. From that moment on, any work remaining would be on the late-night shift.

Disney Parks, once opened, we thought, do not close.

Part 5

2016–2022

WDI President

When I got back from Shanghai, I figured I had about a year, at the most, to show an impact on the greater Walt Disney Imagineering.

I wanted to prove that WDI was every bit as professional and dedicated to the business as any other division of Parks. But there was one difference about WDI: we were the growth engine that created sustainable new value. WDI was the creative and R & D lab, created by Walt Disney himself, that delivered on new ideas and experiences so unique, so one of a kind, that they drove attendance growth and every other category of revenue.

We would have to show others that the innovation and creativity had to come from somewhere. And as Marty Sklar had said many times in his lifetime, it came from talent, and from a safe environment that fostered talent and encouraged free thinking.

With strong business-supporting partners, first Anthony Connelly, who'd come out of Parks, and then Kareem Daniel, who'd come from Consumer Products, we developed WDI's internal management strength, respect, and credibility. And we took Bob Iger and Bob Chapek behind the scenes to see it. Previously, their primary focus would have been to see creative projects in development. Now I wanted them to see the whole picture, a world-class creative, technical, innovative, design, engineering, and project-management

organization, capable of delivering a highly sophisticated and integrated project unlike anything else in the world.

I had less time than I thought. Not because I got fired (although a couple of times I thought I could be), but because Bob Chapek became a "believer" faster than any of us would have predicted. He became a believer, perhaps reluctantly, because he realized he needed what only WDI could do. The massive business growth that had occurred as the result of WDI projects like the reinvention of DCA, Shanghai Disney, live entertainment events, and Animal Kingdom's Pandora could not be denied or glossed over. Capital devoted to new ideas from WDI provided dramatic returns for the company.

Bob's criteria became obvious. He wanted stability and predictability, and he wanted to focus on the company's franchises. Bob had emerged from years at Disney Consumer Products, and he knew that known characters and stories had impact. He began to see the tremendous creativity of WDI as a genie in a bottle, and he wanted it to focus on success, and on stories that would ignite attendance and value.

I got it, and I only asked for a couple of things in return. He had to understand WDI needed to be managed as a creative, innovative organization, and that some risk was inherent to invention. We'd predict it, we'd report on it, but life with no risk was not WDI . . . and it wouldn't yield the big hits he was looking for, either.

Our biggest risk, in scale, was *Star Wars*, with it premiering at two parks at the same time and featuring all innovative attractions. But we had an excellent team on it, and by adding Craig Russell I felt we were infusing additional strength. Scott Trowbridge was deeply immersed in the company's reinvention of *Star Wars* and was right on franchise, and right on explosive creativity at the same time.

Marvel: Iron Man
Overtakes Hong Kong

Marvel had a slower start with parks. Lucas characters had been around since Star Tours opened at Disneyland in 1987. It took longer for WDI and Parks to get the right approach to how powerful the Marvel brand was about to become. Kevin Feige, president of Marvel Studios, told me that his parents had taken him as a kid to Walt Disney World, and that his visit to Disney-MGM Studios had inspired him to become a filmmaker. I was determined we'd live up to what he instinctively knew WDI could do with his rapidly expanding film franchises.

Hong Kong Disneyland was queued up to get the first major Marvel attraction. It had been in development for some time. Iron Man Experience was a large-scale simulator attraction, and it opened at Hong Kong Disneyland in January 2017, just six months after Shanghai Disneyland had its debut. There had been dire predictions for how Hong Kong Disneyland might fare after the larger Shanghai Disneyland opened, but Hong Kong Disneyland had great attendance, and the Iron Man Experience put them on the map for innovative new immersive storytelling.

In November 2016, we had announced Ant Man and the Wasp would be coming to Hong Kong also in the form of a new immersive game attraction.

Next came planning for a significant complement of new attractions to build Hong Kong Disneyland into a larger, more fully developed and diverse

park, including a major new land based on Frozen, elegantly developed by Imagineer Michel den Dulk.

For some time, Imagineer Doris Woodward and I had been stressing the need for Hong Kong Disneyland to have its own castle. The Shanghai castle had become something of a landmark in China. The Hong Kong Disneyland castle, while charming, had never had the same impact on the Hong Kong audience. The castles in our parks had become the centers of massive multimedia attractions, spectaculars that gave guests great entertainment value and drove attendance and length of stay. We decided to propose a major and risky move.

For the first time, we would completely rebuild a castle, inside an operating park. Doris developed a new castle and it fit neatly right behind the existing one. It had more story, more richness, and just happened to be slightly taller than the castle in Paris. But WDI and its contractors would need to design a unique project and build it safely in a tiny space without disturbing park operations and by prefabricating as much as possible.

Tokyo Disney Resort

By the time I got back from Shanghai, the Tokyo Disney Resort team, led incredibly well by Daniel Jue, was already well underway on development for Tokyo Disneyland, bringing major new concepts for Beauty and the Beast and Baymax attractions and a lavish new theater to a portion of the park that expanded both Tomorrowland and Fantasyland. They had also added a reinvented version of Soarin' Around the World to TDS. It was first thought that this massive expansion might cap the TDL Resort, for a while.

Daniel came over and showed me a communiqué from the OLC group that was groundbreaking. They wanted WDI to explore a very large and pivotal piece of land sitting right between TDL and TDS. That in itself was not completely surprising. But the program they wanted was a little shocking. They proposed three new lands, including three or more major new attractions, and two hotels. Although aggressive, we quickly recognized that this was one of the last truly undeveloped land parcels on the TDL site and, as such, was one of incredible value to park expansion. Work began on what would become the most densely packed yet elegant plans ever conceived, Fantasy Springs. Thanks to Dan, and a great team, including the creative leadership of Rob't Coltrin, the site would become home to three major Disney stories, through beautiful and innovative immersive environmental storytelling.

Our hotel team, led by Bhavna Mistry and Bryan Diviney, carved out the space to include two elegant integrated hotels. The concept for a third hotel, squeezed into a challenging site along the waterfront, followed, and it became the first true Disney IP hotel along the loop, bringing Toy Story to life for resort guests.

To Paris

I went to Paris with Bob Chapek. Paris had built a remarkable team around Catherine Powell, who had also come out of Consumer Products. Disneyland Paris, however, was now lacking in new attractions and basic maintenance.

The second park, Walt Disney Studios, Paris, had not lived up to its potential,* and despite some significant attractions, it was a drag on the success of the resort. (If this sounds like Disney California Adventure it should, except the situation was much more serious.) It had languished. And there were radical solutions being proposed: close the second park, or perhaps combine it with the first. Catherine and I, along with Tom Fitzgerald, made a pact. We would put the best talent in a room in Paris until we found an exciting solution. We would in effect lock the room and slide fresh baguettes under the door.

Disney Studios Paris was not even half a park; it was a third of one. Like DCA it lacked a sense of place, a sense of heart. And it was steps away from one the most beautiful parks around. We shared the development of Frozen Land from Hong Kong Disneyland. We would develop a new "allée" with beautiful trees and small attractions. We would radically rethink the backstage tour.

But there would be two major storytelling shifts. A large section of outdated

*The version we'd put in the drawer years before was never built. What was built was much smaller and cheaper and lacked both charm and Disney warmth.

"studio" backstage facilities would be converted into a whole new Avengers Campus, bringing new and converted attractions and Marvel characters and stories right into the middle of the park. And we would expand the park's physical layout, bringing in a wide beautiful lake, landscaping, place-making, and the kind of entertainment and spectacular scope it lacked.

Soon we were in front of Bob Chapek, Bob Iger, and, in record time, the Disney Board of Directors. It was a radical shift in strategy, a new attitude to think big, and think Disney. And it would require Disney control over the park's financial standing, and a commitment to significant investment over an extended period of time.

Within months, the consensus was to boldly move ahead with the plan. We all believed we could change the history of Disneyland Paris by transforming the second park.

Disneyland Resort

Right outside my office in Glendale I had a huge animation layout table with tall stools around it. It was my favorite place to meet teams, and many ideas originated there.

Joe Rohde showed up with some of his team one day, early in the morning. Joe was never one to fear bold ideas, and this day was no different. The Twilight Zone Tower of Terror at DCA was popular and fully utilized. But it was also re-programmable, as it had been since we'd conceptualized it with Bran Ferren in the 1990s. It could be completely re-skinned—given a brand-new concept and story using the original building and the original ride system. The concept was bold: to convert The Twilight Zone Tower of Terror into a ride experience based on the Marvel hit *Guardians of the Galaxy*. It would be by far the fastest and most incredible introduction of Marvel into the resort. And we would do it in a year! We pitched it that week, make Tower of Terror into *Guardians of the Galaxy*, and we did it in a year, a ridiculous time frame with an equally ridiculous (small) budget. Sometimes I look back and I wonder what we were thinking. But we thought we could do it; the team was confident; Kevin Feige was on board. Despite thirteen years of success, the final day of operation for The Twilight Zone Tower of Terror at Disney California Adventure was January 2, 2017. There was a website created where guests protested the change. But

we were confident what we were creating was going to be a success, assuming we could do everything we promised.

The acceleration of Marvel's entry into the park's world was a priority for me. I had already asked Scot Drake, who'd done such a great job on Shanghai's Tomorrowland, to start to think about a Global Marvel WDI team, with shared initiatives across all park locations. Scot and an expanding group of Marvel influencers conceived of an Avengers Campus idea that could be deployable in every market and be made up of attractions that could also be used repeatedly. The look and feel of Avengers Campus quickly adapted to the DCA site, just between Tower of Terror and Cars Land, and would include a new idea for an immersive Spider-Man gesture-recognition experience. There was also development for a major thrill "E" ticket ride based on Marvel. All the plans would be complementary to the *Guardians* redo of the Tower of Terror.

At the same time Jeanette Lomboy, an Imagineer who'd long partnered with Disneyland and Aulani, contributed to WDI's understanding of Disneyland initiatives to energize the resort's ability to draw young families, considered critical to Disneyland's core audience. This would eventually lead to an initiative to redevelop Mickey's Toontown into an even more family-friendly space, and to introduce Mickey & Minnie's Runaway Railway to Disneyland.

But all roads to the Disneyland Resort flowed through the Black Spire Outpost, meaning everything was dependent on the successful deployment of *Star Wars: Galaxy's Edge*. It was a team with tremendous talent and drive, but it was a huge and challenging project, with Disneyland and Walt Disney World essentially being delivered in the same time frame. Rise of the Resistance would ultimately become a groundbreaking attraction, but it was a challenge to complete. With the help of Bob Iger, the team had the confidence to take the time that was needed to make sure it was done right and opened successfully.

Planning for the future of Disneyland Resort also became a priority. The masterplan had been done prior to DCA and represented an older style of planning, with attractions, retail and dining, and resorts occupying separately planned districts. Tokyo DisneySea, and Disneyland Paris, with integrated in-berm resorts, and the newly planned Fantasy Springs, also for Tokyo, made clear we needed a more integrated planning approach to Anaheim, and we worked with Disneyland to lay out a vision that could be communicated to government and the public.

Challenges

None of these moderate successes were quite as easy as they sound. Plus, we were retooling WDI at the same time. Like students on a charrette, we were revamping our departments and processes as we were racing down the street, advancing projects at a very fast pace. That meant change, which is always difficult and especially hard in the middle of challenging projects. It meant adjusting to new ways of working. The completion of Shanghai meant saying goodbye to many of our close co-workers.

We reached out to our park colleagues, seeking perspectives on how they thought we could be better partners. *Partners* is the word I always used. I held to the mission of WDI being a unique creator within Disney, that we were there to bring new ideas and help make them successful. That meant we were partners, not service providers.

I was also worried about WDI lacking the kind of freethinking necessary to keep everyone innovative and sharp. We invested time rebranding ourselves, from a mission standpoint, in words, and in reinventing our out-of-date graphics. And with thanks to Debra Kohls, WDI's dedicated communications executive, for the first time in our history, and twenty years after the founding of Google, WDI had a directly accessible web page.

WDI had been criticized for being too much fun. Too creative. It seems laughable to me now. We were always overcommitted with work; wasn't having

a little bit of fun a part of designing fun? We had Halloween on the patio, something that was always a little risky. A mass of scientists, engineers, artists, writers, managers, and entertainers creating costumes? It was usually a mix of politics, insanity, and the zeitgeist of the times.

We created something we called Jump Start. It was an internal design competition. We handed out a prompt, and anyone who wanted to, and I mean anyone, could submit an idea. And if theirs was among the best, they presented it at an event. It was a raucous presentation, with lots of nontraditional thinking, and a lot of new talent got put into the spotlight. And it was talent expressed by anyone; they didn't need to come from a so-called "creative" department. My philosophy was if you were at WDI, you were there to *be* creative! Otherwise, there were a lot of easier places to work.

Message from Marty

Sitting in my office, Marty Sklar's office, I would occasionally think, *What would Marty do in this situation?* I thought it, I didn't even say it out loud. But somehow the message got to Marty anyway. One day an envelope arrived. Marty was known for sending small notes on cards, usually in red felt pen. When you received one, you weren't always sure if it would be a thank-you or if you were about to get chewed out for something. But this one was different. It was full-size pages. I would frame it, all six pages would be on the wall, and I would consult it quite often.

When Marty set out to write, he usually had a lot to say:

Each generation feels that their challenges are the most difficult Imagineering has ever faced. That's appropriate—after all, yesterday is always over. Today is here, and what we do now is the key to who we become tomorrow. There is one thing that does not change, even though the times and the projects do. That's the need for Imagineers to trust and follow their leaders, especially in the hardest of times . . . when things seem confusing and unsettled . . . when they see old friends and mentors walking out the door.

That's the time when their leaders need to be the most visible. That's the time when Imagineers need to hear words of reassurance.

Marty's notes struck me like a truckload of blank reams of paper. I needed to be more present. More accessible. I needed to get to know all Imagineers, every corner of the place. I'd missed a huge part of my responsibility.

Reviews

The development and review schedule drove the calendar relentlessly. The priority had been to grow every property at every site. Every other week, or sometimes every week, we'd stage a half- or full-day review with Bob Chapek; and every few sessions we would include Bob Iger. Imagineer Josh Gorin had been a rising star in R & D, so I borrowed him, and he became the mastermind for our presentations. Josh had a filmmaking background, and I told him I wanted every review to be a spectacular story, fast paced, and memorable. In any given session we might be presenting brand-new ideas, follow-up to existing ones, status on projects already in the pipeline, and new entertainment events and initiatives. The teams presenting had to work within tight time slots. I tried whenever we could to include a behind-the-scenes look at something innovative that was happening in architecture, or ride engineering, or R & D, or animation, or other Imagineering studio teams.

We had agenda items queued up months in advance. And we worked hard to ensure our park partners were both present and briefed ahead of time.

We filled the WDI pipeline for five-plus years. I remembered Marty's adage, that 20 percent of an Imagineer's time should be applied to purely creative thinking, research, or self-development. We were nowhere near that and I worried our pace was not sustainable. I pushed for Imagineers to take

advantage of our self-directed development allowance funding, enabling them to take an art class, or visit some attraction they might want to benchmark. But the take rates were low—everyone, it seemed, was too busy.

Trimming the Bushes

It was early when my office phone rang. I picked it up. The voice on the other end clearly yelled at me, "I'm trimming the damn bushes and I don't care what you think!"

I had no idea who this was or what bush trimming I was objecting to. It turned out to be Karl Holz, a very tall guy with a giant personality to match. I didn't really know Karl. But by the end of the call, I understood some native plants in the Aulani hotel in Hawai'i had, in his opinion, grown so high they were blocking the view to the ocean. Someone had lit Karl up by saying WDI had to approve any trimming, and even had to qualify the trimmer! As hard as I had worked to partner, we still had these WDI-isms, urban legends about how impractical we were, that followed us around. And sometimes the stories just got more and more ridiculous.

I told Karl the bushes would be trimmed if I had to fly to Hawai'i and trim them myself. It seemed to lighten his mood a little. A few weeks later Karl showed up unannounced outside my office. Remember that big animation layout table? Well Karl was there, and he had a huge set of drawings just the right size to roll out. I canceled my morning schedule, and I was sure glad I did.

Karl gave me a master's degree on the design of a Disney Cruise Line ship, and I never forgot it. Karl was head of the cruise line and had just been approved to build two new ships. I couldn't wait to work with him on them.

Anthony Connelly was also passionate about the business and knew it very well. Before long we were debating new deck plans to improve the next generation of ships, for the business and for the guests. I took cruises to the Bahamas, went to Castaway Cay, and took my parents on what would turn out to be my favorite cruise, to Alaska.

As with so many jobs in my project history, I could tell that the dreams behind the new ship were bigger than the business plan had accounted for. I went to Meyer Werft, the shipbuilder in Papenburg, Germany. It was an impressive operation. The family-owned business had been building ships since the 1790s, but in recent decades they had professionalized the process. They knew how to build ships with the efficiency and quality of factories that built luxury cars.

As the improved operations and ship layout came to life, I was missing a lead creative person, someone with a vision for the story and the emotional connection of these new ships, something more than their organization. And with so much focus on brand, I felt we needed some new ideas, restaurants, bars, rooms, theaters, play spaces. They all needed to be more Disney, and more unique.

I was nearly convinced we didn't have anyone in house I could assign to this endeavor. Then it was pointed out to me that Laura Cabo, the manager of our architecture team, could do it. I had seen Laura performing management tasks for other designers but had not seen her designing in her own right. It is a lesson I will never forget. On every level of every organization, there is underutilized talent. I had a brief chat with Laura. Within a few weeks she'd changed the entire discussion. The concept of the *Disney Wish* had been born. A new kind of ship, rich in story, rich in characters and design, and a striking advancement from the previous generation of ships.

Laura and the team, along with designer Claire Weiss (no relation) and Philip Gennotte, the lead project manager, quickly presented the new ships to Bob Chapek and Bob Iger.

Within a relatively tight few months, the design for the first of the two new ships was proceeding. There was so much excitement that when Meyer Werft approached Disney with a potential slot available, we went to the Disney Board of Directors, and from there it took just a few moments for the board to approve a third new ship.

Walt Disney World

With so many projects moving, it's hard for me, looking back, to imagine we were launching them all. Walt Disney World had one driving agenda: the reorganization of Disney's Hollywood Studios to create space for *Star Wars: Galaxy's Edge*. But Kathy Mangum and a team were also developing a new Toy Story Land, including a brand-new attraction, Slinky Dog Dash, a family-friendly coaster that would turn out to be a massive hit.

Imagineers Kevin Rafferty and Charita Carter had a creative secret weapon: the first major ride at any Disney Park starring Mickey and Minnie and the other Fab Five characters. The attraction, called Mickey & Minnie's Runaway Railway, was fast-moving, warm, and fun; it combined new imaging technologies and character animation that was blended seamlessly with real dimensional scenery and figures. The technology to do the ride had been rising with the design. For the first time, it seemed doable. But there was no space for it anywhere.

The resort team and the WDI team decided to try to sell Mickey & Minnie's Runaway Railway as a replacement for The Great Movie Ride. The Great Movie Ride had been a landmark for its time, a tribute to movies, a new kind of attraction format, and especially a credit to a new kind of role-playing live cast. But we all agreed it was tired, had run its course, and Mickey & Minnie's Runaway

Railway would be a perfect new landmark, right in the center of a newly revitalized Disney Hollywood Studios.

But the team had to meet a high bar even though the idea sold itself; it was overscale for the venue, and overscale for the budget. But they were entrepreneurs, they wanted the project to happen, and they worked tirelessly, jumping over every hurdle put in front of them.

Animal Kingdom Theme Park's explosive attendance (driven by Pandora), meanwhile, opened up an intriguing possibility. Animal Kingdom had not been designed as a nighttime experience, though we all knew it was a magical place at night. Joe Rohde and his team went to work on a nighttime show arena, in keeping with the quiet requirements of the animal habitats, as well as night lighting, and a magical projection and musical presentation on the Tree of Life. The finale was a chance to take the Kilimanjaro Safaris ride at night. The team took great care to introduce lighting in a natural and unobtrusive way. The result was a safari that came to life, since many of the animals are nocturnal and more active at night, and a way to experience the Animal Kingdom in entirely new ways.

With the great success of Tron in Shanghai, we brought it to transform the Magic Kingdom's Tomorrowland. And collaboratively with the resort, we reinvented the Coronado Springs Resort with an all-new Gran Destino Tower and story, built the Riviera Resort for DVC, and reenergized the resort experience from the air with a new guest favorite Skyliner, a gondola system that takes guests high in the sky.

EPCOT

The challenge defined by Marty Sklar, from the very beginning of EPCOT, was to keep it refreshed and relevant. In anticipation of all the major projects coming in throughout Walt Disney World, we knew EPCOT needed an update. The job was daunting, but Jodi McLaughlin, Zach Riddley, and Tom Fitzgerald were up to the task, bringing together new talents and new perspectives. There were obviously smart things to do, like bringing the Ratatouille attraction, which Tom developed for Disneyland Paris, to EPCOT's France pavilion. It met all the objectives. More family, more Disney, and more relevant were the key mission points.

Tom Fitzgerald, Scot Drake, and a strong team conceptualized something bold and almost impossible for Future World. It would be the next Marvel anchor, and it would be the largest attraction ever. Everything starts with story, especially with Tom. The Xandarians from Xandar, of *Guardians of the Galaxy*, would, like any country, come to be a part of EPCOT. And they would use a pavilion as a way to welcome visitors to their planet. It was a new idea, but definitely in keeping with the EPCOT ideal, and the mandate for more family, more Disney, and in this case, more Marvel.

But another trick was also up the team's sleeve, a new kind of ride and story. Coasters are always popular, and they usually come with the biggest, tallest, most loops, or something else. The team countered with story, and something completely untried and unique. Tom wanted a coaster that would

tell a story, allowing the vehicle to be thrilling yet move guests to see story elements as they unfold, instead of moving through a dark star field or facing straight ahead. The result: Guardians of the Galaxy: Cosmic Rewind attraction was created. There would be no inversions, no barrel rolls, but instead high-speed cars capable of rotating so guests could focus on the story: a space rescue that required them to work with the Guardians of the Galaxy. And with the capacity of the ride to tell the story came the ability to move in sync with the music. The ride could *dimensionalize* Marvel's Peter Quill's ability to play, fast-forward, and rewind time, space, and music. And every ride would be set to a different song, making it unpredictable each time.

It was a tall order. The ride system, co-developed by Walt Disney Imagineering ride geniuses and Vekoma, would have massive runs and backward accelerations. The load area would include a story sequence introducing Xandar and would magically, instantly, transport guests into space. And there would be a raucous space battle, with a massive new creature.

The ride would require the largest show building ever constructed at Disney. And the team found it: the structure that once housed the Universe of Energy, which had been the largest show facility at EPCOT. It would be repurposed (more family, more Disney, more relevant). But that would just be the beginning. The rest of the ride would be housed in a new eighty-foot-tall structure, just outside the existing service road of EPCOT. It was a bold move. It would take many iterations to make it work. The team always came back to what their main goals were, and through multiple budget and schedule and technology hurdles, they never lost their passion.

EPCOT would also be reinvented with entertainment, a global artistic lagoon spectacular, and the kind of spatial richness that made guests want to come for the attractions and stay for the entertainment, dining, shopping, and inspiration. Spaceship Earth would feature new animations, an incredible feat of artistry and technical innovation by the team in the outer shell of a forty-year-old geosphere.

And who better than Moana to host a rich environmental immersive journey through water? The goal was to immerse guests in a lush environment with familiar shapes, images, and favorite characters from the animated film *Moana*. As we began to build it, water scarcity would become an even larger challenge for so much of the world.

It was all a tough sell, but no one believed that EPCOT didn't need it, and everyone believed EPCOT deserved it. EPCOT was, after all, Walt's dream and had become over the decades a beloved guest brand onto itself.

Stuntronics

One of the signature developments of this period was Stuntronics, which was developed by our R & D team. It was something that literally gripped my heart and made me emotional, because it epitomized the ethic of what Walt Disney Imagineering could be. I was always quietly in awe of Jon Snoddy, head of R & D. I wished we could run the entire company the way he ran his group of artists, scientists, and idea people.

Stuntronics started as a crude metal model of Rocket Raccoon from the Guardians of the Galaxy film series. Tony Dohi, a highly creative researcher, fashioned the model and figured out a way to throw it across a long plat-form and have it land predictably. At the same time, Imagineer Morgan Pope, a research scientist and PhD in mechanical design, was experimenting with the way objects move through 3D space, and especially how we as humans sense space, and how with microadjustments to our bodies we, especially athletes, can do amazing things. So why, they asked, could we not create a self-contained, animated robot that could fly through the air, perform stunts, and predictably land again?

This for me was one of those defining moments of my time leading WDI. It said to me, *Be excited, be supportive, make sure the team has what they need . . . and then get out of the way!* Within a year, Tony and Morgan's crude raccoon had become a humanoid, independent-thinking athlete, leaping great distances

into the air and doing what a stuntperson or Cirque du Soleil performer could do. A role as Spider-Man was obvious. It took Josh D'Amaro, then head of the Disneyland Resort, to step up and be the one to approve it for Avengers Campus.

Shanghai

Shanghai didn't escape our optimism and capital outlay either. It took the team many months to develop the right next steps. At first the enthusiastic direction was put toward the development of a second park, a complement to the first, and an exponential expansion of the resort. The team presented a highly creative new kind of park, with elements of nature, culture, the arts, and an overall deeply immersive environment that suggested a new-generation version of EPCOT. Many viewers who witnessed the presentation gave it a standing ovation.

But the full-on park we presented was deemed too early in the development cycle for Shanghai, and other options were quickly explored. As we had approved Mickey & Minnie's Runaway Railway for Disney's Hollywood Studios, we thought, why not do a two-for-one design and bring this great ride experience to Shanghai?

Often when you are working on a concept, you're actually chasing another concept. It's just that you don't know it yet. WDI had periodic meetings with Pixar Animation Studios and Disney Animation Studios to stay connected with new films far before their releases. I upgraded our WDI theater so that we could screen rough versions and have evening sharing sessions between the film directors (and their teams) and teams from all around Imagineering. The early screening of the upcoming film *Zootopia* had struck a chord with all of us.

When *Zootopia* became the most successful animated film ever in China, someone finally connected the dots. We could convert Minnie & Mickey's Runaway Railway ride system (and basically the same size and show technology) and make it into a Zootopia ride for Shanghai. By using the Runaway Railway as the base, we could get the experience and capacity there sooner, which was what the park needed. *Zootopia* gave the Shanghai team a fantastic pallet of immersive environments, enough to turn a major ride into an entire mini-land.* So many people contribute to how these ideas evolve, and in this case I have to credit the head designer, Dustin Schofield, who worked tirelessly to get Zootopia into the pipeline for Shanghai.

* Actually, Dustin and a small team first proposed ideas that filled Zootopia Land in the WDI Jump Start design competition.

D23-Stay Relevant

It can be difficult to stay relevant without facing controversy. We faced issues head-on. For many years we had received thoughtful and insightful letters about the Pirates of the Caribbean "auction" scene, where pirates auctioned women. Something that was once considered funny was no longer accepted as comedy or appropriate storytelling today. We were committed to changing the scene. WDI artists came up with a great new concept, all the while channeling Disney Legend Marc Davis. Had he still been alive I think he would have approved of it. The pirates would auction loot, not people, and an empowered female pirate would be one of the lead auctioneers. "Redd" became a new character and we thought she'd be a valuable addition to the ensemble.

Like any change, it came with fan responses from both sides of the fence. And this one raised a lot of controversy—so much that it even became a panel discussion on July 14, 2017, at the D23 Expo in Anaheim. There were audible boos in the audience when we presented, but we thought transparency was the best way to go. Eventually, Marty Sklar asked to speak. It was a dramatic moment that I will never forget. Marty, the legend, the ambassador, the man who had attended the opening of every Disney Park. He told the audience that Walt wanted us to always move forward, to stay with the times, to be respectful of history but willing to evolve over time. "We're Disney," he said, "not a museum."

Marty said it all in a few words: "We keep moving forward." The boos went silent, and the applause brought down the house. I always respected Marty, I was grateful for him, but, if it was possible, my respect went up by even more after that moment.

I remember getting a golf cart to drive Marty over to the Parks pavilion at the expo, where we had exhibits of many of the next projects that we were racing ahead with, including the major reveal of *Star Wars: Galaxy's Edge*.

It's hard to describe what a visit from Marty meant to Imagineers. They crowded around the entrance to our D23 exhibit to greet him. He shook hands, patted shoulders, and posed for selfies.

He shared the art and design with enthusiasm and spoke to every person by name.

July 28, 2017

It was a normally busy Friday. But then I got a call from Human Resources informing me that Marty had died suddenly at his home in the Hollywood Hills section of Los Angeles the night before, July 27. It was just a few days since he had riveted the D23 Expo audience, and just ten days since Disneyland had celebrated its sixty-eighth anniversary. He was eighty-three.

Marty had been my friend and mentor, a North Star in my career, and my connection to Walt Disney and the deep meaning that makes all of what we do matter. I canceled all meetings and started calling people. I saw Tom Fitzgerald in person; I called Orlando Ferrante, Mickey Steinberg, Doris Woodward, and Marty's daughter, Leslie. (Leah, Marty's wife, was hospitalized recovering from hip surgery.)

I also called Frank Stanek, my first boss and mentor at Disney. He'd been responsible for my being at Disney in the first place, and especially for introducing me to Marty and helping me break into the creative development side of the business.

Frank said he was driving along a country road near the vineyards where he lives. I thought I should call him back when he got home, but he said, "I'm just driving, what's up?" I was stuck. I told him as gently as I could.

"Hold on," Frank said, "I'm going to pull over, there's a tree here and I'll park in the shade of it. This will be Marty's tree."

The idea that Frank had stopped under a tree to absorb the news stayed with me. Throughout the day so many Imagineers had memories, stories, little note cards they'd kept for years. It was the moment the lead storyteller handed over the mantle, and his story became ours.

Leah asked me to speak at Marty's memorial. I said this about him: "How lucky we all are that Walt Disney took a chance on Marty. He knew Marty would follow through on his dreams. But he couldn't know how many new dreams Marty would launch, and how he would inspire new generations of dreamers to enrich the lives of millions of people around the world."

I thought also of the six-page letter he'd sent me. It was even more meaningful to me now than ever. I once again focused on a particular section: "Each generation feels that their challenges are the most difficult Imagineering has ever faced. That's appropriate—after all, yesterday is always over. Today is here, and what we do now is the key to who we become tomorrow."

I actually *did* feel that our generation's challenges were among the most difficult Imagineering had ever faced. But Marty's wisdom would always keep it in perspective. His most important message was always, "We keep moving forward." Somehow, I thought, we all would have to.

Moving Forward

The next steps were becoming clear to me. We'd built a sense of trust with leadership, a strong diverse management culture, and one of the largest and most aggressively creative portfolios of work we'd ever had to do in a four- to five-year period. There were projects all over the world, something in every one of our parks, not to mention three new cruise ships to be built in Germany and a new environmentally sensitive island in the Bahamas.

Every day I reminded myself all this work came from a healthy and vibrant culture. Feeding and caring of Imagineers in a safe, creative, technologically curious culture was essential if we were to continue to be the WED that Walt Disney had envisioned. I tried to walk the halls as Marty suggested. It took discipline to move meetings out of the gold coast and make sure they happened in other buildings, close to where the work was being done. I visited the model shops, usually unannounced, and ate in the commissary. We did peer reviews and listening sessions. We held events and life-drawing classes, and we finally had a gym.

The agenda for the next five years was set. The creative was mostly agreed on, the investments and schedules were locked, teams were in place at home and around the world. Construction was getting underway in every one of our markets.

And then in one day, everything we knew about our world changed.

April 2020

I needed to go somewhere. Anywhere. I loaded my bike onto the back of my car and drove around looking for a place for a short ride. The loop around the Rose Bowl, which by now I'd done many times, looked like there were a few too many people. Back in my car, wandering, not really paying attention, I found myself in the Disney Glendale Grand Central campus. It was the middle of the week. I pulled into my old parking space. There was not a car anywhere in sight. There was not a single person on the street. I brought down my bike and made a loop down Flower Street, past the main Imagineering office, then right, passing 800 Sonora Avenue, where I'd been hired nearly forty years ago. Down past MAPO, where street parking was normally at a premium, and where now every space was open. I looped into R & D, the wide parking lot they shared with the Tokyo Disneyland team; it was also empty. Squirrels ran freely up and down the still perfectly trimmed trees. I peeked through the gates into the KABC commissary, where the outdoor tables still had tablecloths, and there were little baskets on the tables with ketchup, mustard, and salt and pepper shakers, as if lunch were about to begin.

I rode back to my car, loaded the bike, got in, and then just sat for a few minutes. I pulled out my WDI ID card. I thought about it, sure that it wouldn't work. What the heck, I tried it. The door made its familiar beep sound and unlocked. I held the door handle for a moment, then pulled it open and went in.

It felt to me like an air lock. Like fresh air was being let into something that had been sealed for a long time. I walked down to my office on the gold coast. I looked up and down the normally active passageways. The plants in the hallways had all died. The candy dishes had all been emptied. The printers were off. All the food was removed from the refrigerators. The coffee and water machines were turned off and DO NOT USE signs had been posted on them. I went into my office and stood for a few minutes, looking at the walls, the few papers scattered around. I felt the history, the meetings with Marty, his mountains of paperwork, my creative brainstorming there, frank discussions, practical jokes—it all seemed like it had been a dream.

I took a few of my books, some note cards, a stash of felt pens, and soon I was back in the car on my way home.

Unimaginable

Four months earlier, Imagineer Keith Gallo was in Los Angeles on home leave from Shanghai. Keith had done such a fantastic job in Shanghai, from initial construction to keeping the park up and running these past few years. His combination of solid MBA training, highly creative background, and development and people skills had proven to be a perfect match for what was needed in the early years.

I invited Keith, his wife, and his two teenagers over to our place for an American-style BBQ. My wife, Jun, and I were settled into our new place in Pasadena. My young daughter, Isabella, was going to the Disney preschool, literally across from my office. And Jun's parents were on an extended visit from Shanghai. The conversation was casual and fun. They were anxious to hear what was new in Los Angeles, and we were missing Shanghai.

At some point, however, the conversation turned. Jun and her parents had been following a story on their Chinese news websites, and they wanted to know what Keith and his family were hearing there.

A wholesale seafood market in the city of Wuhan had closed due to fears of a possible reprise of the 2002–2004 SARS-CoV (severe acute respiratory syndrome coronavirus or SARS-CoV-1) outbreak. Within a week, health officials were concerned about scores of cases of pneumonia of unknown etiology.

It seemed so far away from us, except that at some point Jun's parents

would be headed back to Shanghai, and Keith was certainly concerned about returning soon with his family.

Within only a week or so, the unthinkable was beginning to happen. Wuhan, a city of more than eleven million people, was in complete lockdown. Other cities in China were preparing to follow.

By January 25, 2020, less than four years since opening, the gates of Shanghai Disneyland closed. Hong Kong Disneyland closed the next day. The Tokyo Disney Resort closed February 29.

On March 14, the Disneyland and Disneyland Paris resorts were both closed. The next day all of Walt Disney World closed, less than a year after opening *Star Wars: Galaxy's Edge*, and only a few days after the opening of Mickey & Minnie's Runaway Railway.

Bob Chapek had only recently been appointed CEO of The Walt Disney Company, and I had a new boss to get to know, global head of all parks, Josh D'Amaro. Suddenly, we were all flying blind through a storm we'd never anticipated.

Heroism and Resilience

At the time, WDI consisted of about two thousand employees among Glendale, California; a large crew near Disneyland; and sites around the world. By the end of that weekend in March, WDI had gone from large teams of Imagineers in creative offices in six locations across the globe, to a couple thousand individual offices, each housing one Imagineer—at a kitchen table, a folding table in the garage, a dressing table, the foot of their bed, or a picnic table set up in the middle of their living room. Just imagine how many extension cords were involved.

First there was the mass exodus from the offices. Imagineers were encouraged to take everything they might need for at least a few weeks away from the office, including computers, files, drawings, and contact lists. But for an Imagineer on a large project, that could mean a truckload of drawings, models, mock-ups, or equipment. Imagineers take their jobs and their deadlines very seriously; people were observed stuffing tons of boxes into their cars, and even high-tech equipment, without knowing how they'd get it into their house or apartment, or how they'd even manage to get it all working again.

At the same time, families were gathering. Schools closed and home-schooling was beginning. Kids were returning home from college. As we experienced our first Zoom calls, we had no idea that our co-workers might be

seated elbow to elbow with their nine- or nineteen-year-old all studying and working from home.

It was a remarkable feat of resilience—to get everything, and everyone, home and, by the next day, to have Zoom calls already starting, to have project teams up to almost their same daily review schedules.

I was on calls with people in their cars, because they needed to park outside a Starbucks to get a better Wi-Fi signal. One co-worker had to sit next to his teenage daughter to make sure she did her math; otherwise, she'd be playing a game on her phone. I remembered the old days of conference calls from home, when I worried someone might hear my daughter talking or a toilet flush. But now that we were one big global family, we saw what we were cooking for lunch; kids sabotaging computers, adding characters or animation; and cats walking across people's shoulders or sitting down on computers, putting their butts against the camera.

In a WDI all-hands meeting, my daughter came down the stairs, made faces behind me, and flew a cookie around my camera. Life, it seems, had been life all this time, and humanity, in crisis, still sought relief through familiarity and a sense of extended family. Misery loves company. And humor, it seemed became a frequent antidote to misery.

Unfortunately, the coming weeks and months of activities had mostly to do with dismantling the robust project load we'd spent the last few years building up. With nearly every business impacted, and Parks and Resorts (including Disney Cruise Line) completely shut down, there was quick direction to hold capital spending. Negotiations started immediately to place big projects on hold. This was not an easy task, with huge global contractors involved, logistical challenges to stopping any big project underway, the need to preserve open construction from the elements, and pressure to figure out what to do with Imagineers who were assigned to support projects, many of whom were now confined to their apartments, or hotels, and unable to get back to their families in their home country.

I had a setup in my living room. I brought in a big table from outside, and as many extension cords as I could muster. It looked organized unless you could see behind the scenes or the floor. My son was home from college and my daughter was now being homeschooled, with a small amount of teacher-classroom interaction every day. Josh Gorin graciously came over—we were both masked—and he helped me set up my office technology, including getting ready for lots of Zoom calls.

I once thought that all your experience prepares you for the next job you're going to do. I now realized all your experience prepares you for the job you never dreamed you'd have to do.

Bob Chapek and Josh D'Amaro assured our executive committee that Disney was resilient. We all agreed to an executive pay cut. We agreed to close all construction sites, a rolling decision that took several weeks to institute. We agreed to stop all construction on the first new cruise ship, the *Wish*, at the Meyer Werft facility in Papenburg.

A major "E" ticket thrill ride we were developing with Marvel for Disneyland, which was already proving a difficult sell, was canceled, unfortunately, with a significant write-off of development costs.

My son and I would ride our bikes on the trail around the Rose Bowl, masked along with most other riders and joggers. The children's play areas in all the parks were closed, cordoned off with police tape. I took Isabella to the park one day, and I teared up remembering how much she loved slides and climbing. The police tape became too much for me.

The next day I drove her to a Firestone store. Even masked, Isabella looked cute. We sat on stools at the sales counter. I told them we were here because I wanted to make her a tire swing, because all the parks were closed. The salespeople asked her if she wanted to pick out a tire and said she could have any one she wanted.

Isabella, of course, started picking her favorite one from all the brand-new tires! They eventually satisfied her with a nice tire from the recycle stack, and we were on our way. After some makeshift chain design, and no damage to our tree, the tire swing was working. Isabella and one other friend seemed to have a good time swinging on it, both in masks. I had designed many rides in my life, but there was probably none more important or as timely as this one.

Because Zoom could happen anytime, it did. Zoom calls could begin early morning from Europe, then on to Walt Disney World, local WDI and Disneyland, and off to Hong Kong, Tokyo, and Shanghai. Before you knew it, you'd worked an eighteen-hour day. I started asking people to respect people's lunch and dinner hours and reminding people that whenever you were watching a Zoom call there could be a partner, a couple of kids, a parent, maybe a cat or a dog, just off camera. Meetings needed to run on time. I tried to cut meetings off at academic hours, ending at fifty minutes past the hour, reminding everyone people might want to go the restroom, get a snack, or just run around the block once.

College students complain about the "college fifteen"—the fifteen extra pounds students often put on studying and eating dorm food. We started talking about the Covid-19, for there were snacks around at home all the time.

It is remarkable today when I think back on how much we didn't know. My wife, Jun, didn't allow any of us to go into the grocery store. She'd go alone, looking like one of the people who came to get ET, wrapped up, gloved, double masked. Then we'd clean all the stuff she bought before we took it into the house.

On April 2, my dad's birthday, I knew we wouldn't be having any BBQ or anything but a phone call. He didn't know how to use FaceTime or Zoom.

On the same day, we announced that we were going to have a large furlough. And there was a lot of fallout.

There was uncertainty about who would stay and who would be sent out on furlough. We knew it was going to be a small team who remained, and those not selected would be without salary, though their benefits would continue, and their job would be held for them until things improved. We had no idea when that would be. I was surprised at the positive reaction to furlough. Imagineers wanted to do something, they wanted to help preserve the company and WDI and their projects. It was like everything else I'd ever seen at WDI, a selfless sensitivity to the ideals of the company Walt built. Sometimes it was hard to keep my emotions in check, the gracious nature of Imagineers was almost too hard to accept.

But things went on too long, longer than any of us expected. We had furloughed most of the Imagineers. They didn't like being out, not knowing when their projects would start and having no idea when the furlough would end. As a leader I had many days feeling utter helplessness.

Occasionally, I would just call someone out of the blue and ask how they were. Not Zoom, not scheduled, just an old-fashioned damn phone call. People started having cocktail parties on Zoom, or they cooked together, played cards.

The story did start to improve. Imagineers brought their innovation to new problems, which had been the case so many times in our history. We began to figure out ways to continue construction on projects. We had to think about how to work safely and with fewer people on-site. We had to discuss new ways about thinking about personal protective equipment, worker check-in, and density of people in a work zone. But we did it. Imagineers did it because they wanted to move forward, to see progress.

Creative meetings were stilted, hard to manage, hard for people to think freely, but they did it. People couldn't fly, so we had approvals via iPad instead of in person. We got special permission for very small numbers of Imagineers to go into the office to complete sculptures or to have access to specialized equipment so they could finish what they were working on and not hold up progress.

We worked closely with the parks to design all the safety elements and graphics that would be needed if operations were to restart under new rules. Entertainment worked at all hours and around the world to rethink how Disney live shows, parades, and character interactions—such important parts of the guest experience—might be presented.

There were side benefits to all of this. WDI bonded internally, and with our park partners. We were all facing the same challenges, the same unknown world, and trying to save our company, our world, and the joy of our guests. Another thing happened: WDI became by default a more global and diverse company. With our not being able to travel, Glendale had to rely on the abilities and talents of our global teams. And they never disappointed us. The global teams were empowered, and that was an inspiring thing to see.

Slowly, the sites started back up, the projects got moving. The furlough numbers were reduced as Imagineers came back, happy to be working on their projects again.

I remember one long Zoom meeting where we updated Josh D'Amaro, plus Bob Chapek and Bob Iger, on everything that was happening around the world. I wanted them to see a slice of the projects, and a slice of the process improvements, along with a bit of what Imagineers were doing to overcome the limits Covid had placed on our process.

At the end, Bob Iger said, "You know, if I had attended this meeting, and I didn't know we were in the middle of a Covid crisis, I would have thought that Imagineering was just doing what it always does so well."

It felt like the greatest compliment for WDI I'd ever heard.

May 11, 2020

We'd all seen this drill before: that day finally arrives when a park opens for the first time; it never gets old, and the emotions never get any easier to contain.

But this time it was different.

Shanghai Disneyland was about to reopen after being shuttered for four months. I called Keith and asked him if we could make a Zoom event of it. He agreed to send us as much from his iPhone as he could. We gathered for a Zoom call; it was dinnertime on the West Coast. So many of us, one dream, one team, one family, from so many diverse disciplines and places, from WDI and from every business unit, all there to see the same thing, the first returning guest. Many of us had not been there in person since the park's opening four years earlier.

The guests had waited hours. We had waited four months. They were exhilarated, we were cautiously optimistic. But we had the same tears and cries of joy as we'd had the first time we'd watched those guests being welcomed in. Maybe more.

It was hard to see them in the blurry iPhone video, all of them with masks, but there was one thing still apparent: unbridled joy, the reason we all continued to fight to do what we do.

For each fraction of a second, the universe and time slowed down. Through the wonder of Keith's iPhone, we saw images of an event occurring more than

6,200 miles away; we felt contact with parents, grandparents, children, friends, lovers, as they raced around the corner ("no running"), and on to attractions. The entry would continue for hours.

We shared a Zoom toast or two, and a shared question. Could this be the event that starts a road back to some kind of new normal? Was healing on the way?

We had no idea. But we had hope.

Our sense of hope was quickly shaken. Just five days after the first re-opening of Shanghai, a tragedy of deep consequences shook our collective spirits.

George Perry Floyd Jr. (October 14, 1973–May 25, 2020), a Black man, had been murdered by police officer Derek Chauvin during an arrest in Minne-apolis, Minnesota. The tragic scene played over and over on television. The incident opened a raw wound in America, exposing a sense of unresolved racial injustice.

There was a sense of helplessness, and all Imagineers were asking for meaningful and safe dialogue. Kareem Daniel, Avis Lewis, Debra Kohls, and I knew from previous experience that sometimes it's best to start with a lis-tening session. We thought it was better to bring together Imagineers, listen, and allow people to air feelings in a safe and conducive venue first, rather than come out with actions or recommendations. Now it was that much more difficult, trying to promote open dialogue in a large Zoom call. But thankfully, it didn't take long for Imagineers to open up honestly, frankly, and with deep emotion. As Kareem would often say, once you see something it is impossible to unsee it.

Imagineering and our idealized creative, diverse, egalitarian environment had in no way escaped the kinds of racial unfairness and inequities that were being exposed and debated nationwide. Inequities existed in management and on projects. The work of diversity and inclusion was unfinished, by any measure. Work that often seemed to start in earnest, dialogue that opened, often seemed to be extinguished or simply lost for lack of follow-through. This time we all expected better of ourselves.

Carmen Smith had been a friend and collaborator for many years, an ABC producer, and a creative Imagineer with a distinct sense of purpose and with belief in our organization. Carmen had taught me that even busy organizations had the capacity to do good work, to contribute, and to progress social issues as essential to the vibrancy of an inventive and diverse storytelling culture.

Carmen quickly rallied her tremendous network of passionate experts, story-tellers, and change agents. Carmen and Jodi McLaughlin worked in close concert with Kareem, Avis, and me, WDI's senior management, and all of the senior creative and technology leaders. If Covid-19 had been a problem handed to us, something we couldn't always affect or change, this was completely us, this was completely in our power to change. It would not be easy, but it was a transformation no less necessary than anything else.

If, as Marty once said, each generation thinks their time is the most difficult, we knew this time presented the most opportunity, and it was time to act.

Epilogue

November 24, 2022

Dreams and a Wish

I was freezing. Shivering in the shade and the cool afternoon breeze. My daughter, Isabella, had insisted we ride the AquaMouse for the fifth time. She'd been sick for a few days but had recovered enough that we were able to spend the day on Castaway Cay, Disney's special island in the Bahamas. I wanted her to ride the AquaMouse as many times as she wanted. It was our last full day aboard the brand-new *Disney Wish*.

Later that evening, after a hot shower, a wonderful dinner with Elsa and Anna in Arendelle, and now all bundled up, I was happy to take a long, almost meditative walk around the new ship. I visited everything. The ship had all the dreams and experiences we had set out to place on it four years ago.

Despite Covid, Chris Kubsch, Laura Cabo, Philip Gennotte, and their relentless team had delivered something groundbreaking, industry-shaking, but most important, heartwarming and fun. And they'd done it all during quarantines and travel restrictions, with all of WDI's buildings locked down. It was an amazing feat.

I'd seen the *Wish* on paper many times, but only twice in reality before this cruise. In June 2019, I'd met with the team with Meyer Werft in Papenburg, the ship builder who was building all the next generation of Disney cruise liners. We'd started advanced design and the team was relocating to new offices established in the shipyard. The Meyer Werft team had even given us an honorary dinner on board the historic and restored *Prinz Heinrich*, a ship more than one hundred years old, with Bernard Meyer as our host. Perhaps most important, we had approved the new story-driven room mock-ups, which would then be duplicated by the hundreds and ultimately lifted onto the ship's superstructure.

The next time I visited the *Wish* was June 2022. The *Wish* was now, for all practical purposes, a ship. It had left the Meyer Werft shipyard and sailed down the river Ems, to Eemshaven in the Netherlands. It had endured three sea trials, and by the time I got there, it was in final completion mode and readying for its first Atlantic crossing.

Covid-19 had delayed the completion of the *Wish* by a year. But the team had taken full advantage of the time to make it better and better and invented new ways of delivering our complex, integrated resort-ship experience, given

new restrictions on work process. And now everyone, from engineers, to designers, to entertainers, and all the operating divisions of the ship's hospitality infrastructure, was readying for the crossing.

Russia had invaded the Ukraine in February 2022. It might not seem relevant, but the construction talent working on the ship was tremendously diverse, and many crews came from Russia, Ukraine, and the surrounding areas. And here they were, literally working on top of each other, long hours, limited space, sharing a commissary, and with one goal in mind: to make this new ship the best it could possibly be. It was a community of talent, marooned in a shipyard with only one ship in its berths, dedicated to guests—guests whom they'd never meet, who would be enriched and inspired by their work for decades to come.

But now those days were behind me, and I just looked ahead at the stars and moon as they were perfectly reflected in the black ocean, only broken by the vessel's bow as it cut through the silence.

I felt a sense of wonder. When we all watched the reopening of Shanghai Disneyland on that late evening in May 2020, we had no idea that Covid and its impacts would dog us for another two years, and that the structure of WDI would adapt to meet the continuing challenges. Shanghai would close again, open again, close again, and open. We would work with each park on a journey to return, to reopen, and to welcome guests for whom Disney Parks were a reassurance of the positive aspects of life. And every project we'd developed on our menu, around the world, would eventually be completed.

After forty years in the business of chasing dreams, I had gone to Josh D'Amaro, thanked him, and asked to follow, again, in the footsteps of Marty Sklar. To be an ambassador for Walt Disney Imagineering, to be a mentor, and transition out of the active service of creating new ventures. I felt it was time to hand over the reins to new talent.

There is no way I could have dreamed of all the projects I'd had a chance to work on and contribute to, nor could I have imagined their global social impact.

I had seen things people would probably not believe. Creative, technologically groundbreaking, immersive, and heart stirring. I'd been to Russia, to China, to Singapore, Mexico, Peru, Morocco, Sydney, India, across Europe, through the Middle East, the Arctic, around the South China Sea, throughout Japan. I'd met people whose talents seemed unfathomable, and whose passion was a well that was constantly refreshed. I'd seen people who could make the impossible possible. And they did it every day, no matter the circumstances.

And yet, it was time for me to move on. At a ceremony on the WDI patio a few weeks later, Josh D'Amaro awarded me a window on Hollywood Boulevard at Disney's Hollywood Studios. It's perhaps among the greatest honors a person in parks like me can imagine.

And Bob Iger honored me with a "Mousecar." A small simple Mickey statue, in bronze, the Mousecar had been Walt Disney's answer to the Oscar, and he made a limited number of them. The first he awarded to his brother Roy O. Disney in 1947. Ever since, Mousecars had been awarded to Louis Armstrong and Marc Davis, and so many icons at Disney. I humbly accepted. But more than anything, it was Bob's support I would always cherish, and Shanghai, as hard as it was, we'd willed to happen.

By my last day, I'd packed up my office. I'd served breakfast at the commissary, with the wonderful team there that I have always appreciated. And I'd thanked as many people personally as was humanly possible.

My feet felt a little tired. But a new pair of running shoes seemed to have solved that. Dreams are elusive, and always pulling at you. They seem always to be right around the corner. But you never really know what you're chasing, until you catch it. If it turns out to be real magic, the chase will have been worth it.

If a dream is truly a "Wish Your Heart Makes," then I plan to keep chasing them for a long, long time.

FLOWER STREET PICTURES

BOB WEIS
STUDIO HEAD

"OUR PRODUCTIONS ENTERTAIN THE WORLD!"

Bob Weis

In Appreciation For Decades of Making The Magic

Acknowledgments

It turns out that writing a book is a big dream, and even harder than I imagined it to be. So, I wish to thank some of the people without whom this book truly would not have made it to press.

Dreams happen because others have faith in you. For that I am enormously grateful to Wendy Lefkon, editorial director at Disney Editions. Thank you for our rich collaboration and for believing I could do it, when sometimes I had my doubts.

To my parents, who sadly didn't see the day when their son had a book published. My father often asked if Imagineering was really a job anybody would pay you for. And my mother tried for years to break my habit of ending a sentence with a preposition.

My wife, Jun, who had to endure my spending hours writing during prime family time; my daughter, Isabella, who wonders why all my rides seem so slow to her now; and my son, Gabriel, who has miraculously stuck with me as I've stumbled my way through so many of life's lessons.

Barbara Phillips, for editing my early drafts, and at times even having to interpret my dictation or, worse, my impossible handwriting. No one should have to suffer such a fate, and you did it with patience and empathy.

Kathy Mangum, retired senior creative leader of Walt Disney Imagineering, my mentor, friend, and collaborator for decades, for being a beta reader, and for having a great memory.

Thanks to Nancy Lee. Despite all she does at the top of the Disney whirlwind every day, she always finds time to help do those things that matter to people, and she does it all with patience and positivity.

And to designer Winnie Ho and artist Grace Lee: I have worked with designers and artists of every kind, developing parks and resorts around the world, but your ability as book people to turn plain words and a few images into magic one can hold in their hands is remarkable.

Senior Disney leaders who afforded me opportunities of life-changing impact, including Bob Iger, Michael Eisner, Frank Wells, Marty Sklar, Josh D'Amaro, Tom Staggs, Marty Katz, Sean Bailey, Jay Rasulo, and George Kalogridis.

Senior Walt Disney Imagineers who likewise gave me opportunities through their trust and collaboration, including Wing Chao, Jon Georges, Bruce Vaughn, Craig Russell, Frank Stanek, Mickey Steinberg, Debra Kohls, Avis Lewis, Maggie Elliot, Dick Kline, Tom "Harvey C." Jones, and Jon Sorenson.

My mention of individual Imagineers or operating development teams in this book is meant to illustrate points about the process. They represent a tiny percentage of the people who dedicated themselves to these projects. It would be impossible to credit them all, but I add my sincere awe and gratitude to my many partners and collaborators, Imagineers past and present. There are extraordinary people in the world; among them, Imagineers are even more dedicated and extraordinary.

Forty years is a long time, and I want to thank these generous friends whose phone conversations, written notes, and emails helped jog my memory:

Bruce Laval
EVP Operations Planning and Development
Walt Disney Company, Retired

Leah Sklar and Leslie Sklar

Andrew Bolstein
Senior Vice President, Operations
Shanghai Disney Resort

Frank Stanek
Chairman, Stanek Global Advisors

Mickey Steinberg
EVP Walt Disney Imagineering, Retired

Craig Russell
Chief Design and Project Delivery Executive
Walt Disney Imagineering

Mike Reininger
Real Estate Development Executive

Randy Printz
Theme Park and Resort Project Management Executives

The dedicated team of the Marty Sklar Archives at Walt Disney
Imagineering:
Lindsay Frick
Show Producer, Walt Disney Imagineering
Norita Cullen
Design Asset Specialist Lead
Wynter Salazar
Design Asset Specialist

Aileen N. Kutaka
Walt Disney Imagineering, Chief Librarian

Dr. Herman J. Viola
Curator-Emeritus of the Smithsonian Institution and former director of
the Smithsonian's National Anthropological Archives

Monisha Chandanani and Ravi Rao for the many insightful spiritual
conversations along the way that uplifted me and burned into my
memory so many important learnings in my journey

Carmen Smith for lighting my way, reminding me so often that even
busy people have the capacity to do generous things, and that hope is
something that should be on everyone's agenda, every day

The many creative and design business team members who contributed
to the success of Design Island Associates, especially:
Tim Steinouer
Susan Clippinger

Lisa Miller
Diane Fredel-Weis
Joseph Reyes
Shim Yokoyama
Michael Devine
Mellissa Berry
Ned McLeod
Dave Wallace
Greg Jones
Cameron Roberts

My gratitude to all partners and clients of Design Island Associates, it would be hard to name them all, but these specifically were involved in projects highlighted in the book:

Luis Berrios
Senior Design Specialist, NASA KSC

Rob Speyer
Chief Executive Officer, Tishman Speyer

Chris Shehadeh
Senior Managing Director, Tishman Speyer

Leadership Conference of Women Religious

Benn Aaronson
Department of Defense Modeling and Simulation
Navy Civil Service, Retired

James G. Parlier
Photographer
U.S. Navy Retired

Jon M. Peterson
CEO of Peterson Companies, and his father, who was a mentor and
collaborator for many years, Milton V. Peterson

Paul Allen
Microsoft Co-Founder

Kurt Haunfelner
Senior Vice President, Exhibitions
California Science Center
Previously Museum of Science and Industry, Chicago

Steve Geis
Director of Guest Relations
Thomas Jefferson Foundation
Previously Kennedy Space Center

Van Romans
Retired Imagineer, and Retired Executive Director
Fort Worth Museum of Science and History

Kevin Gover
Under Secretary for Museums and Culture at the Smithsonian Institution

Thank you Leslie Iwerks for recording the depths of the Imagineering
story, the breadth of which helped me immensely and put the dedicated
Imagineers in the spotlight for their passion and dedication to the
experiences of our valued guests. And thank you to all the teachers who,
despite their best intentions, managed to instill in me at least a small
amount of English, math, and other refining and technical sciences, in
between my larger and more passionate intake of color, design, theater
arts, music, film, art, obscure facts, politics, and geography, and my
passion for growing succulents.

And thanks to all those guests, the many millions of them across the world, for whom all dreams are dreamed and, when built, I hope, fulfilled.

Index

Index

Index

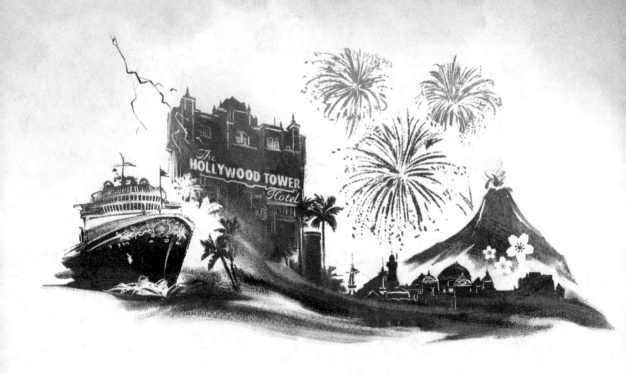

To DREAMERS everywhere, dreams are a gift,

something that comes in from midair, or while we're sleeping.

They are ours to pursue, and I hope this book convinces you

that the CHASE is always worth it. Pursue yours, and

I'd love to hear about them.

Bob Weis